STAR WARS™

STORYBOARDS

STORYBOARDS

——— THE ORIGINAL TRILOGY ———

Edited by J. W. Rinzler

ABRAMS, NEW YORK

ART IDENTIFICATION KEY

R1, R2, R3, etc. = row 1, row 2, row 3, etc.
(starting from the top)

L = left panel; **R** = right panel

R1L, for example = row 1, left panel

R2:4 = rows 2 through 4

Note: If no particular panel is indicated, the artist
named drew all the storyboards for that page.

Artists:

Ivor Beddoes Gary Myers
Roy Carnon Ken Ralston
Dave Carson Nilo Rodis-Jamero
Steve Gawley David Russell
Paul Huston Ronnie Shepherd
George Jenson Alex Tavoularis
Joe Johnston Brook Temple
Ralph McQuarrie

Sketch of artist Ralph McQuarrie. » Ken Ralston

CONTENTS

FOREWORD

How can I write an introduction about events that happened thirty-six years ago? . . . I asked myself after agreeing to come up with a thousand words about storyboarding the original *Star Wars* trilogy. It's ancient history. I was a kid fresh out of industrial-design school and had really only taken the art job at a slightly run-down warehouse out by the Van Nuys airport in the San Fernando Valley—on a space movie called "The Star Wars"—because it cut at least a half hour off my commute. I had been working at Chuck Pelly's DesignworksUSA out in Malibu, and I loved the job, but the commute from Long Beach was killing me. The money was exactly the same, three hundred dollars a week, money you could actually live like a king off of in 1975. Well, maybe a lower-middle-class king.

But then I started to think about the days following August 12, 1975, the date I began working at Industrial Light & Magic, and I realized that there were so many moments seared into my memory from that frantic, exciting, fun, and terrifying time. . . . I could easily recall what it was like, and now I wasn't sure if a thousand words would do it justice.

I didn't know what a storyboard was when I started working for George Lucas, and I was smart enough not to ask. If I had, I'm sure that visual effects supervisor John Dykstra would have patiently explained it to me and then wisely pointed me toward the parking lot. The first time I met George I was sitting at a giant light table in the animation department sketching a side angle of my favorite car in the world. This skinny guy in a plaid shirt came up behind me and said, "Huh, 300SL." He then went on to point out that the wheel wells were not round at the top; they were flattened out by these "eyebrow things" on the fenders.

It was smooth sailing from that moment on. We talked a little about various ships in the rebel fleet. They all needed to be redesigned to make them photographable in front of a bluescreen. George went on to describe the attack on the Death Star, with the X-wings moving past camera as their "S-foils lock into position." When I seemed a little confused, George said, "Here, it's sort of like this." He took a pencil and pad, and sketched a sequence of shots—the Death Star growing closer as we push in on it, and the X-wings moving past camera relatively slowly, but the speed being indicated by how rapidly the Death Star was growing in size.

It was a very influential moment for me and my career, initially as a storyboard artist and designer, and later as a director. Here was a guy who couldn't really draw at all, but who, through five or six crude and childlike drawings made with graphite on paper, was able to clearly communicate the excitement and energy of a cinematic moment that has since found its way into popular culture. That was all the explanation I needed about what a storyboard could do.

To get a sense of the rhythm and dynamics of another key sequence, the TIE fighter attack on the *Millennium Falcon*, George had cut together some grainy black-and-white dupes of aviation-themed war films. A B-17 represented the *Falcon*, Messerschmitts became TIE fighters, and the waist gunners with their .50-caliber machine guns turned into Luke and Han at their laser cannons. I was free to translate the cut footage any way I wanted, within reason, and was even encouraged to add shots if I felt a moment was missing. This freedom that George was giving me was astounding to me. *I could do anything I wanted? Watch this!*

The wake-up call came when George arrived to look at the sequence pinned on the art department wall. I heard a lot of, "What do you need *that* shot for?" I would try to explain, but he would just say something like, "Yeah, but if you move this shot up to here, and put this one here, you can lose this one, and this one, and this one, too," his explanation accompanied by the sound of drawing paper hitting the floor. I didn't know it at the time, but those one-on-one storyboard sessions were a crash course in editing, film language, camera movement, camera placement, and a whole lot of things that aren't taught in film school.

As the sessions continued into the fall and winter, the amount of paper I had to pick up slowly shrank. I even heard, "Oh, OK. Good idea," a couple of times. As I began to understand George's "style" of storytelling, I could predict his reactions to the sequences. He liked to keep it pretty simple and straightforward, avoiding unnecessary visual gymnastics that can distract a viewer from the story being told.

Then came the move to Marin County for *The Empire Strikes Back*, with more and bigger sequences. We had to top ourselves, as is always the case with trilogies. I hired a new designer, Nilo Rodis-Jamero. He quickly became well versed in the art of storyboards. The Battle of Hoth alone filled three long walls of the art department, and was drawn and redrawn more than any other sequence in the first trilogy, but is still my favorite.

Return of the Jedi was more, bigger, faster, and different, but with the same amount of time to draw and design it all. I hired professional storyboard artists out of Hollywood and gave them roughed-in "thumbnail" sequences to get them started, freeing Nilo to design costumes and allowing me to focus on the fun stuff, designing new rebel and Imperial ships.

Storyboarding big action/visual-effects-heavy films has changed with the advent of computer-generated effects. It's now possible to put anything on a movie screen, and I'm sure the storyboards reflect that freedom. For the original trilogy, we boarded what could be shot using models mounted on a blue pylon and composited with planets, star fields, other ships, and explosions. We knew that a team of stop-motion animators was going to spend days animating an attacking force of Imperial snow walkers (we hated the term "AT-AT") following sketches that the art department would dash off in a few hours. For all the restrictions that those models and painted backgrounds gave us in storyboarding, and later the other crews in shooting and compositing the elements, I don't think that CG effects could have added anything to the believability and excitement of those sequences. There is an undeniable charm inherent in an eighteen-inch stop-motion snow walker stomping through a field of baking soda that even the best keyboard wizards are hard-pressed to duplicate.

JOE JOHNSTON
"SUPERSTAR"

After almost ten years and countless thousands of storyboards on the *Star Wars* films and the first two Indiana Jones pictures, I asked for a meeting with George, intending to say, "Thank you, it's been great, but I'm burned out. I can't draw another spaceship or alien creature. I'm going to see the world and spend some of the money I haven't had time to touch since 1975."

George sat quietly for a moment, looking around his office, then asked, as if the answer should be obvious, "Wouldn't you rather go to film school?" It was all I could do to not burst out laughing with, "Where do you think I've been for the last ten years?"

Joe Johnston

INTRODUCTION

When Joe Johnston showed me the empty second floor of the house where I was going to work, I had no idea what I was in for. At that time, I thought it would be nothing more than a temporary design gig, where I would hopefully learn new things and move on. Never having worked on movies, I didn't even know that they were "designed" or "storyboarded." For some mysterious reason, I'd been hired anyway.

In the early days of *The Empire Strikes Back*, before Industrial Light & Magic (north), Joe and I worked on separate floors. What a grand feeling to be left alone to imagine things, sequence ideas, and create make-believe machines into completed scenes! No . . . it wasn't like that. I was beyond scared, not knowing anything about movies, having been dropped in the deep end with only the sketchiest hint of what I was supposed to do or come up with at the end of the day.

Before this fear completely paralyzed me, Joe walked me to an art store down the hill in San Anselmo to pick up supplies. The feel of markers, pencils, and pens and the texture of paper on the hand was comforting, reassuring. By day's end, the ground didn't feel as slippery, and, along with Joe's casual company, a sense of security overtook the fear.

Joe never showed me how to design a scene or how to storyboard a sequence. Instead, he simply left me alone—like him—to imagine.

Our ideas frequently shared orbits when George stopped by—often with Ralph McQuarrie—to chat about things. It was never about anything specific, but almost always about something oblique and off on a tangent. All the while George would be browsing through the storyboards, sketches, and designs. There was never a sense of an issued "assignment" or schedule, but rather one of just sharing ideas. Often these ideas changed so rapidly that it was impossible to know who started what and how.

Over the following few weeks and months, what we imagined grew. And then we reimagined everything over and over again, expanded, and compacted, until all the elements connected perfectly. Finally it was buttoned down and compiled in storyboards to become the visual bible of what the movie was going to be. Always with the same pen and paper—the simplest of tools for imagining.

What an incredible opportunity it was to storyboard *The Empire Strikes Back* and *Return of the Jedi* . . . and to meet amazing people comfortable enough to let you imagine.

It was a design gig whose reverberations were to last a lifetime.

Nilo Rodis-Jamero

Caricature sketches of Joe Johnston and Nilo Rodis-Jamero. » Joe Johnston

PREFACE

Working on "archive" books at Lucasfilm is often fun. I get to hang out with the archive folk—Laela French, Joanee Honour, and Katherine Smeaton—and I get to work in the archive itself: a treasure trove of artwork in two and three dimensions. The only problem is that I never have enough time to go through the material as slowly as I'd like to. Deadlines loom and unanswered e-mails accumulate at an alarming rate.

Going through and choosing storyboards for the original trilogy was no exception—indeed it was worse—as hundreds of fascinating boards were drawn for each of the three films. Fortunately, I knew them from before, having already gone through the folders while writing the "making of" titles. The upshot is the book that you hold in your hands, which combines the most dynamic with the never seen before, creating the most complete collection of storyboards so far for the classic trilogy.

Like our Prequel Trilogy storyboard book, however, not every sequence from the films is represented. Only those scenes needing visual effects, or those heavily action-oriented scenes, required sequential shot planning. And then, for the more complex sequences, early boards were sometimes reused in later iterations, shots were omitted and added, and numbered boards were moved around, so that it becomes very difficult to establish exact storyboard order with original artwork—which is a roundabout way of saying that these boards are sometimes out of order or sequenced in a certain way to enhance the book's design.

To enhance the boards, stellar artists Joe Johnston, Nilo Rodis-Jamero, and Alex Tavoularis have provided exclusive commentary, as have more occasional but essential storyboarders Paul Huston and David Carson. Hearing Joe, Nilo, Alex, Paul, and Dave reminisce about such fun, though stressful, and, above all, creative times made me feel as if I were there in some small way. Hopefully, with their comments mixed in with these classic storyboards, readers will feel that camaraderie, too. Alas, other contributors have passed on, among them: Ivor Beddoes, Roy Carnon, and George Jenson. I found some notes written by Beddoes, but

Carnon, who worked in the UK with director Richard Marquand, and Jenson, who worked at ILM, remain mute.

The highlight of working on this book was spending several hours in the Lucasfilm Archives with now director Joe Johnston. In order to write his commentary and foreword, he wanted to reacquaint himself with his prodigious output of decades before, when he was just a "kid." He drove up (in the coolest Porsche I've ever seen) from down south and went through many folders filled with his storyboards from *Star Wars*, *The Empire Strikes Back*, and *Return of the Jedi*, while telling the occasional story or providing insight into the process. Before him on a table were laid out his artwork from iconic sequences—the attack on the Death Star, the battle of Hoth, the speeder-bike chase, and the very first opening shot of the Star Destroyer pursuing the blockade runner—while behind him were models of vehicles he'd either helped design or designed from scratch: the X-wing, the *Millennium Falcon*, the walker, the Star Destroyer.

Going the extra mile, Johnston provided never-seen-before boards from his own collection. Paul Huston, who works at ILM just downstairs from me, also mentioned that John Bell, another longtime ILMer, had saved some art department joke panels. Consequently, these are published here for the first time. These recent discoveries and most of the storyboards have been rescanned specially for this book in order to provide the best reproductions possible. Last but not least, Johnston, Rodis-Jamero, and Huston all chipped in to make sure that even hard-to-tell-apart early storyboards from *Star Wars* and *Empire* were properly attributed.

In the end, these iconic storyboards are part of an overall onslaught of creativity and craft that served George Lucas in his difficult job of bringing his stories to cinematic life. That imaginative life has added so much to the real lives of millions upon millions now, spanning several generations—so that we at Lucasfilm and Abrams are very happy to bring them to you in this most beautiful format. We hope you enjoy *Star Wars: Storyboards—The Original Trilogy*.

J. W. Rinzler

A NEW HOPE

"The ship coming over the top of the frame—that was pretty spectacular. You know, I didn't board that as well as I could have. I think I should have had a shot in between where you see the underneath of the ship, where you really get the feeling of this giant thing coming into the frame. I don't think I got the drama."

Alex Tavoularis

The earliest storyboards reflect the story as written by George Lucas in his second and third drafts of what he then called "The Star Wars."

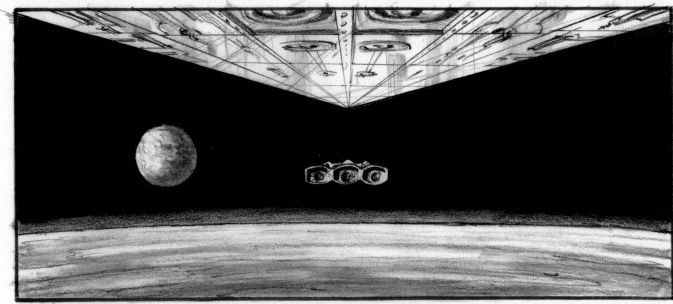

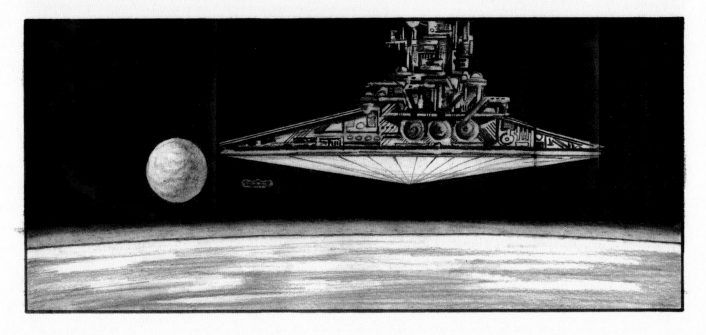

A lone rebel ship is pursued by four Star Destroyers (not all were depicted). » Alex Tavoularis

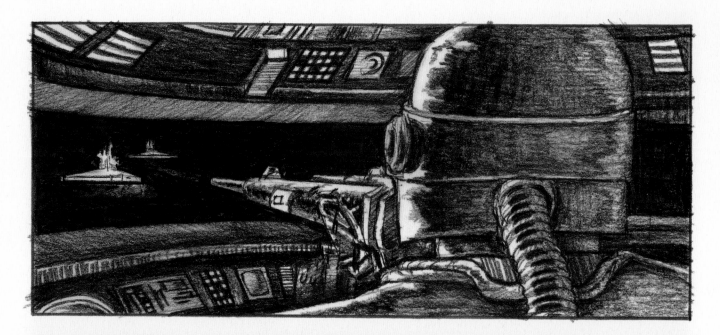

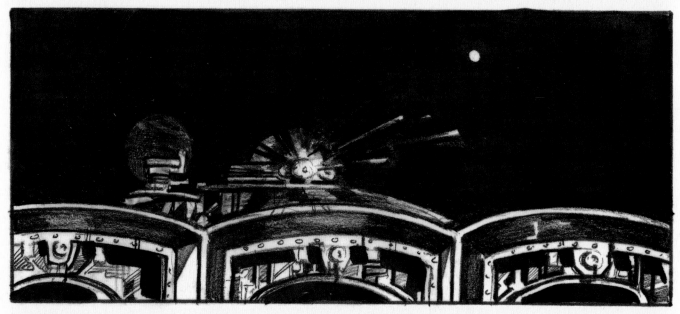

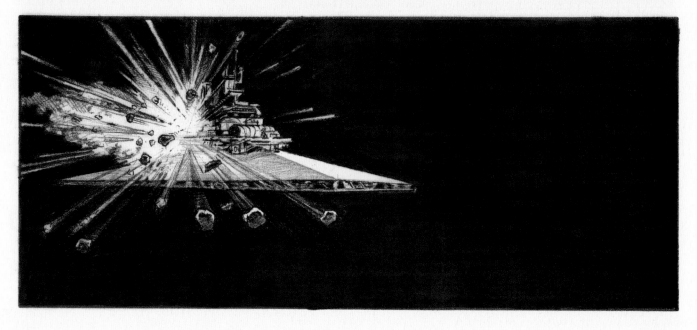

Rebels and Imperials exchange fire. One of the Empire's ships is destroyed. » Tavoularis

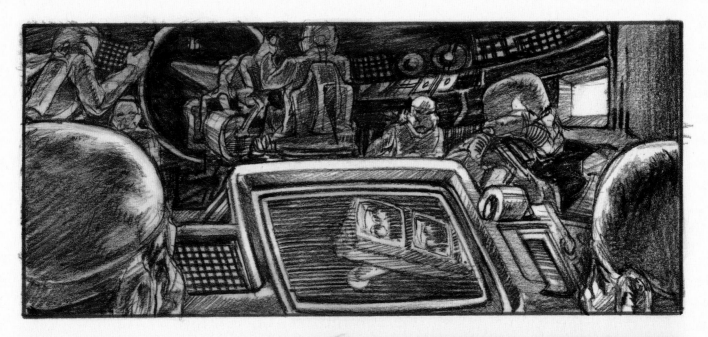

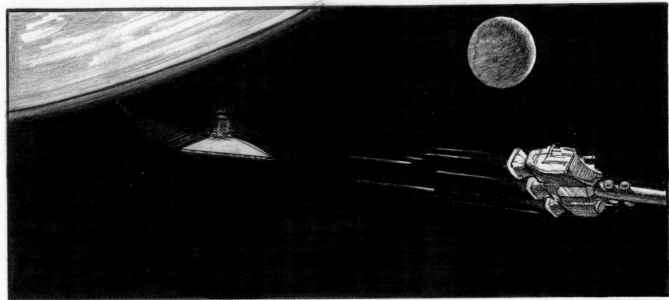

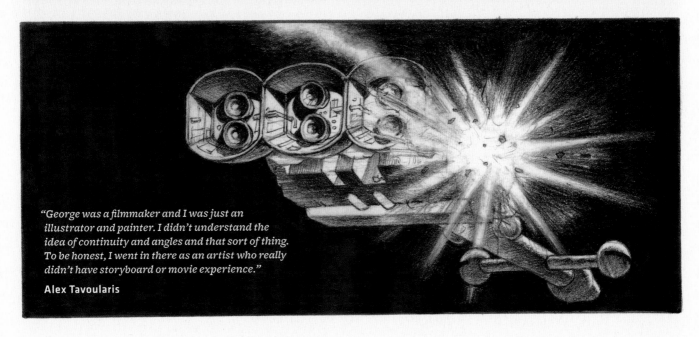

*"George was a filmmaker and I was just an
illustrator and painter. I didn't understand the
idea of continuity and angles and that sort of thing.
To be honest, I went in there as an artist who really
didn't have storyboard or movie experience."*

Alex Tavoularis

The rebel vessel is crippled by a Star Destroyer blast. » Tavoularis

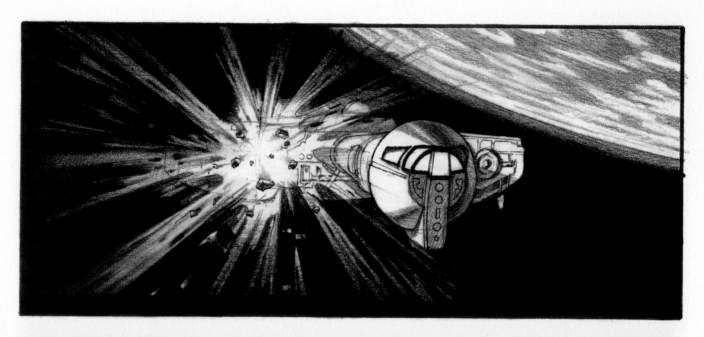

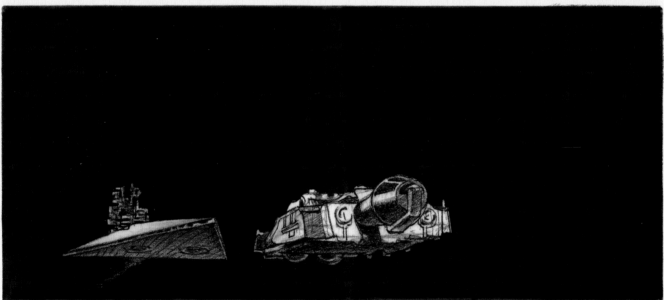

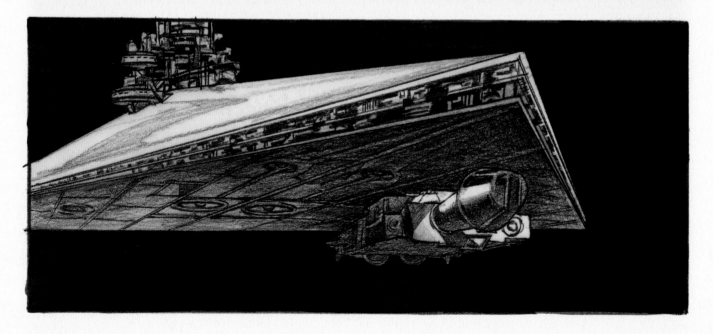

A Star Destroyer maneuvers close enough for its troops to board the rebel ship. » Tavoularis

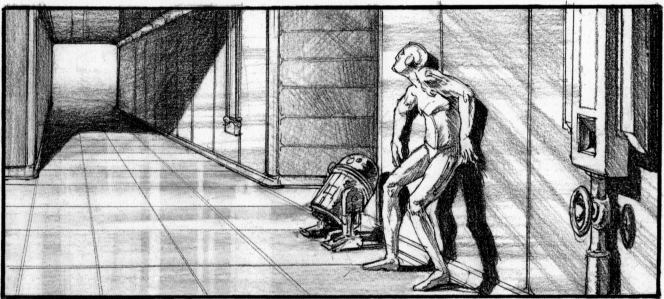

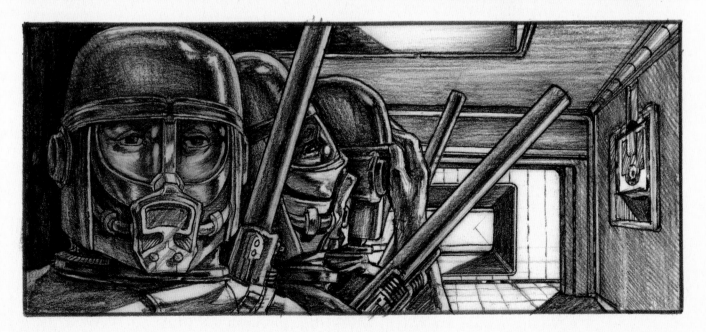

"Construction robots" (per the second draft) R2-D2 and C-3PO are rocked by an explosion,
as rebels prepare to expel the invaders. » Tavoularis

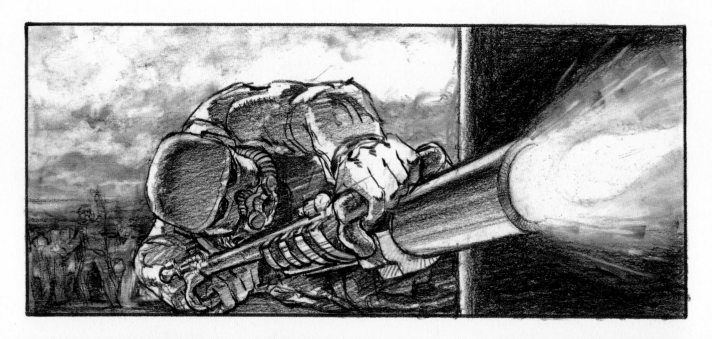

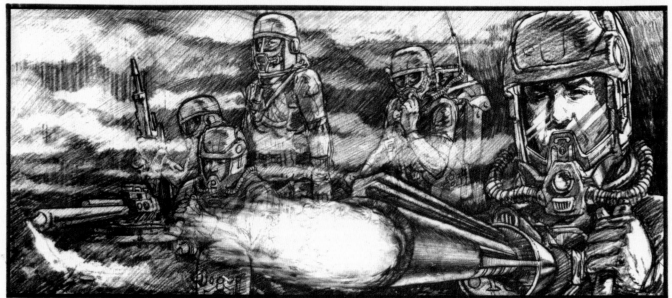

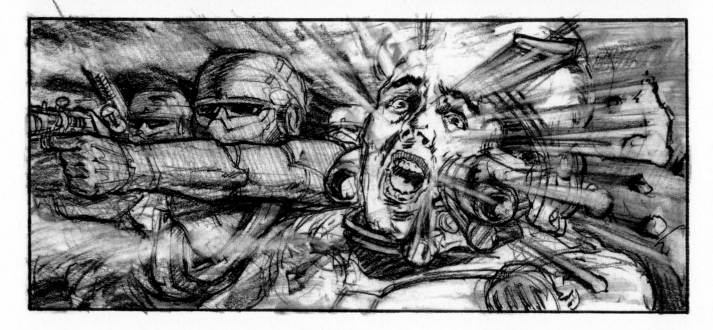

Rebels and stormtroopers exchange deadly fire. » Tavoularis

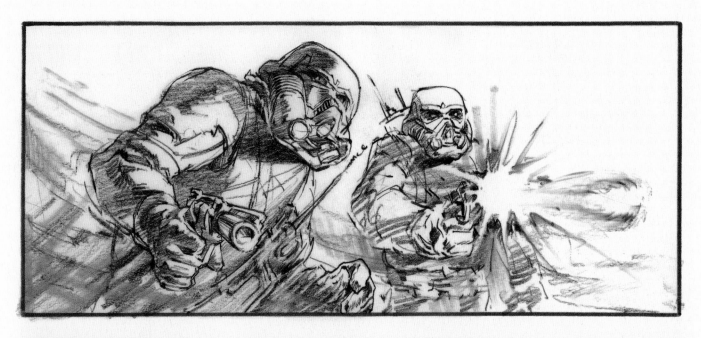

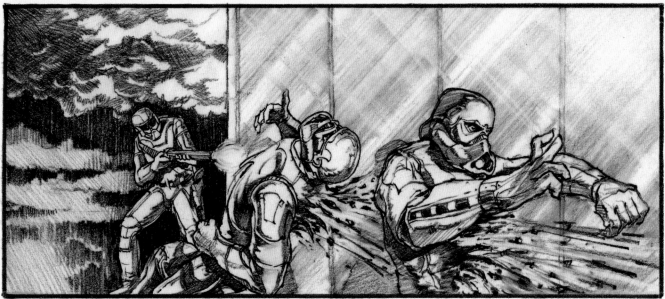

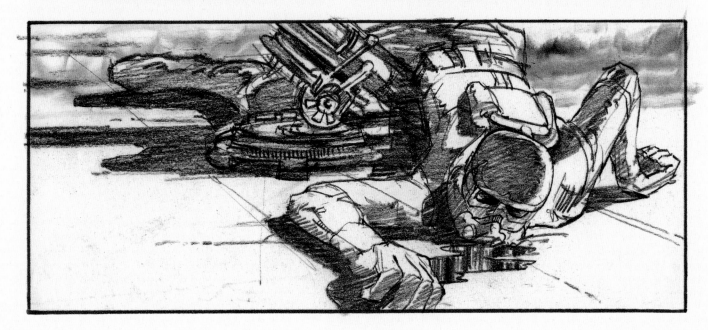

Rebels return fire and a stormtrooper falls in a widening pool of blood. » Tavoularis

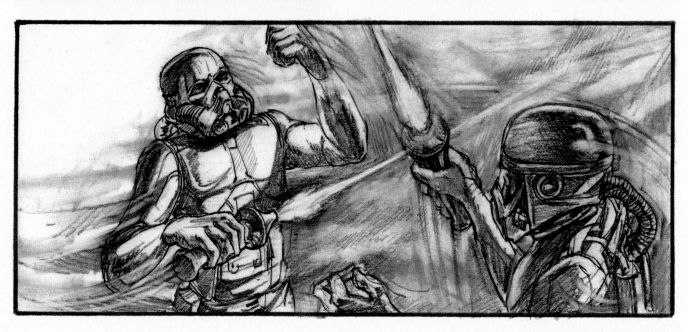

The droids flee while the battle continues. » Tavoularis

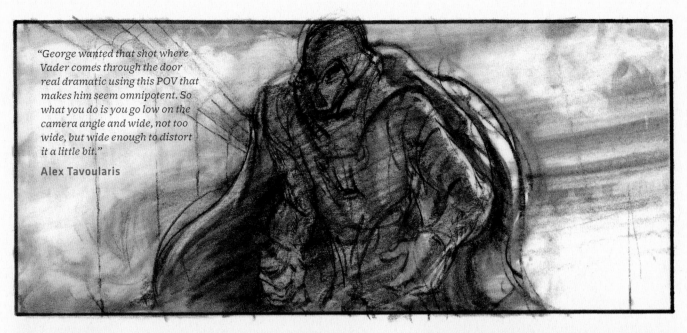

"George wanted that shot where Vader comes through the door real dramatic using this POV that makes him seem omnipotent. So what you do is you go low on the camera angle and wide, not too wide, but wide enough to distort it a little bit."

Alex Tavoularis

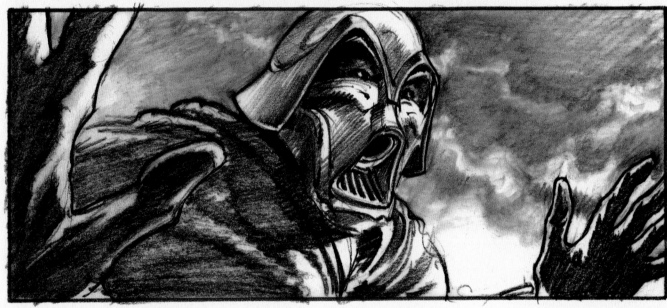

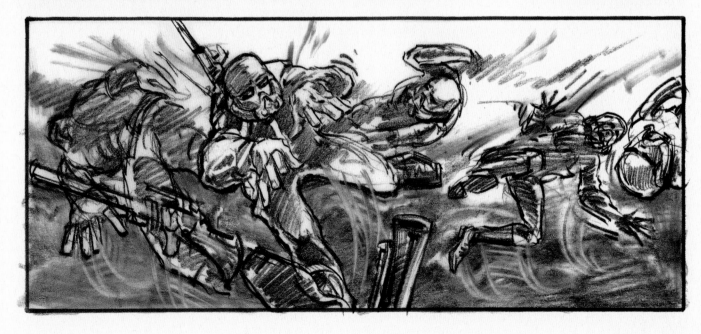

Black Knight of the Sith, Darth Vader enters and his terrible shout sends the troops flying. » Tavoularis

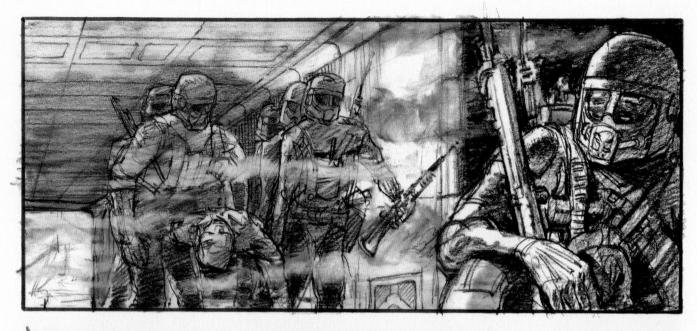

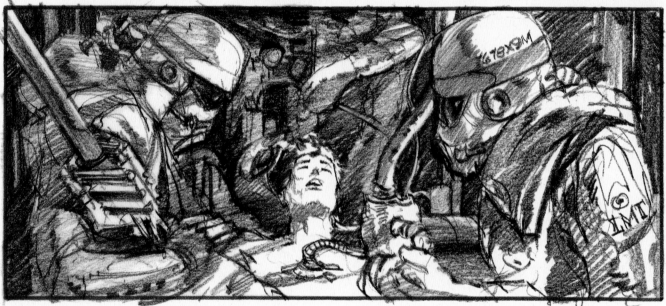

"George was methodical. He was a clear thinker, a logical thinker. Francis Ford Coppola was as well, but his expression was more emotional. Maybe in artistic intent they were very similar, but in the way they expressed themselves, they were different."

Alex Tavoularis (*who worked with Coppola on* The Conversation, *1974*)

Storyboards were executed for a variety of reasons: To explore a scene—these might be very early boards drawn during preproduction, designed to explore action and possibilities while Lucas was writing, and done only as rough sketches. To design possible shots—these boards would be more detailed and refined, but still preliminary and drawn during preproduction. To chart complicated live-action sequences—these would be done, usually, at Elstree Studios in the UK, where the *Star Wars* films were being prepped by their respective directors. To plan postproduction shots to the very last detail—these would be drawn as accurately as necessary during production or postproduction and would list all of the effects elements, from models, star fields, explosions, miniatures, and so on. To show how live-action plates might be enhanced—these would be primarily for matte paintings and would be based on what had already been filmed. In this book, storyboards from all of these occasions are mixed together, so a single scene may go from crude explorations to fully realized shots within a few pages.

The firefight won by the Empire, surviving rebels are taken prisoner. » Tavoularis

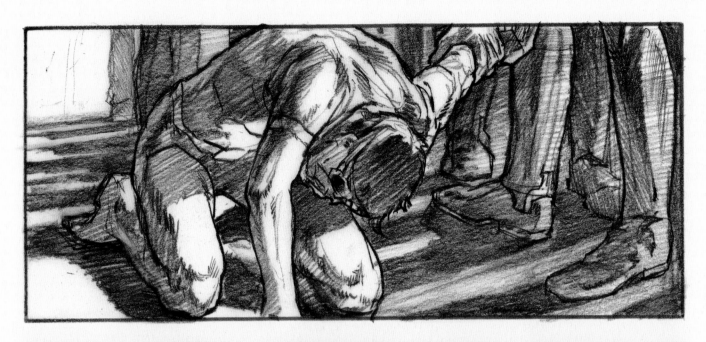

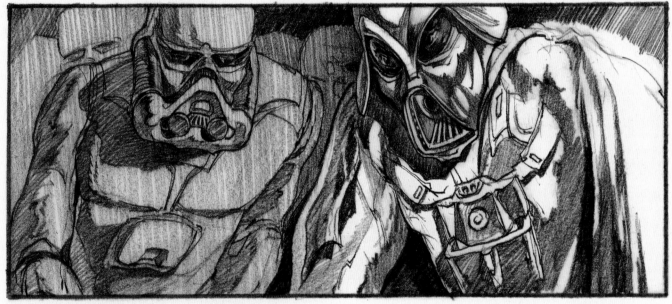

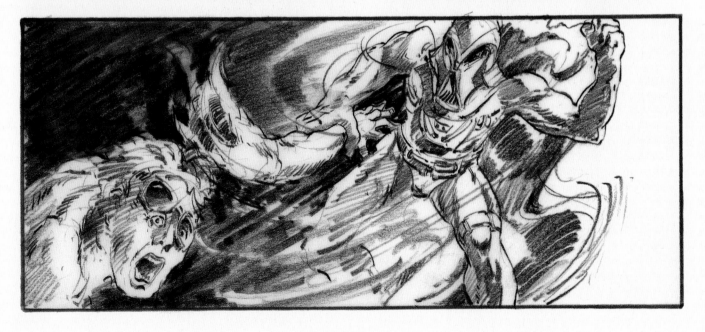

Darth Vader brutally wrenches off the arm of a captive rebel. » Tavoularis

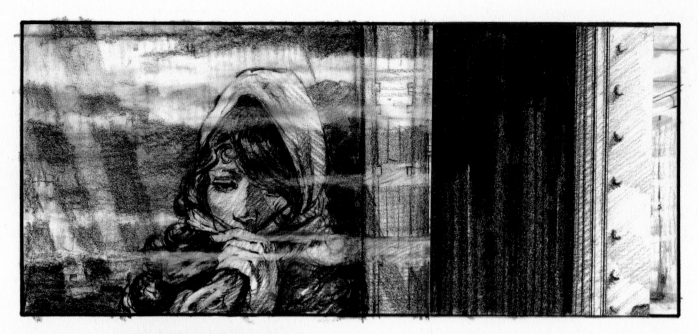

"My inspiration for Leia's look, if I remember correctly, was Alex Raymond's women in his Flash Gordon *comic strip."*

Alex Tavoularis

Princess Leia Organa blasts a stormtrooper, but is captured. » Tavoularis

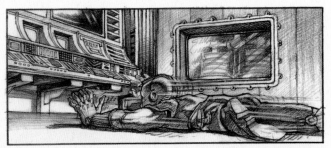
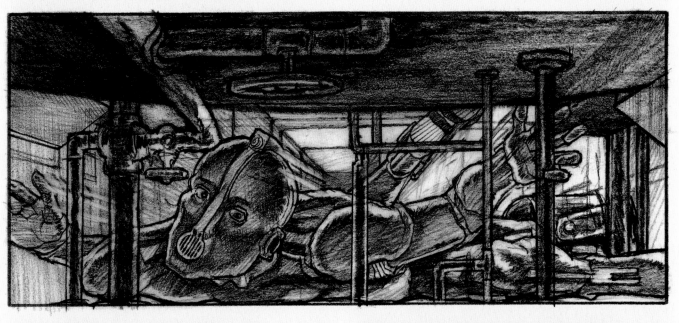

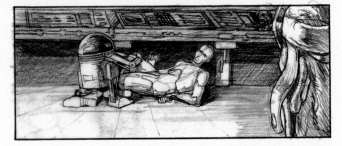

The droids are knocked under a computer console, where the captain's first officer discovers them. » Tavoularis

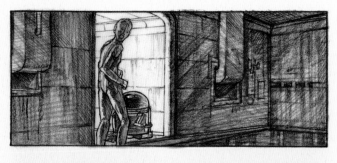
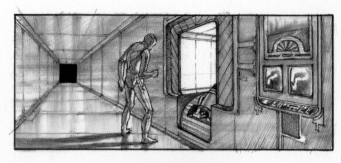
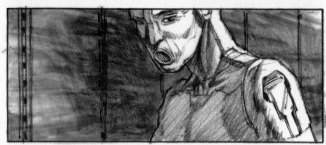
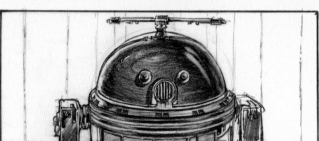
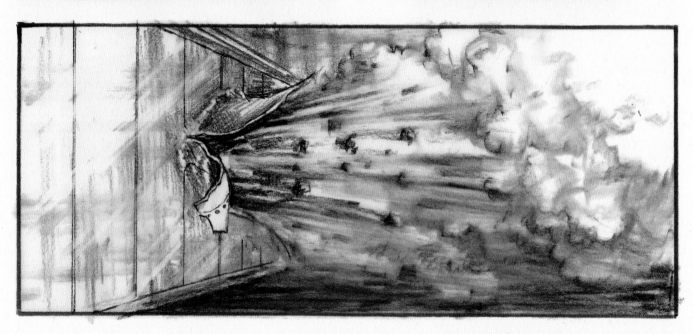
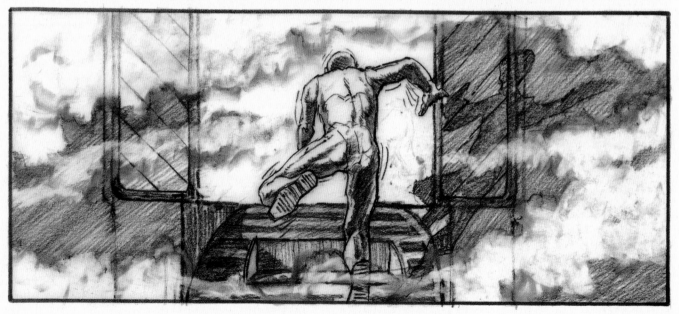

An explosion persuades C-3PO to join R2 and abandon ship in a life pod. » Tavoularis

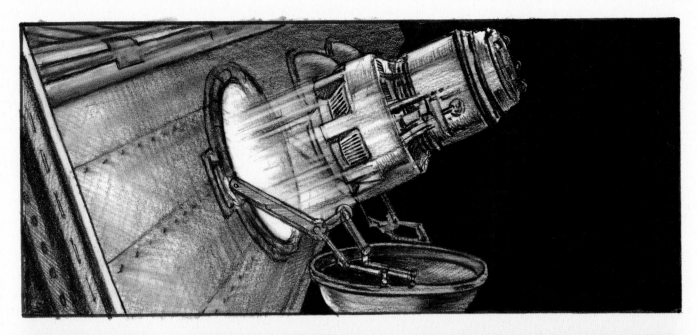

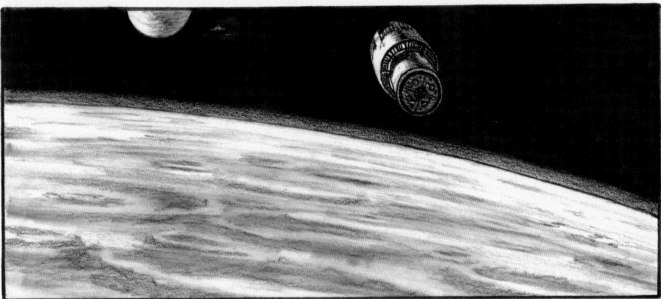

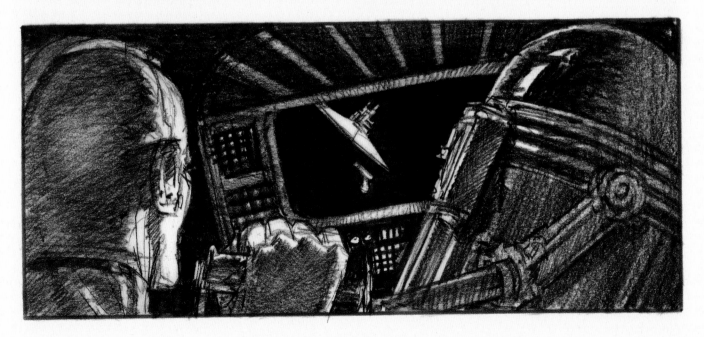

The life pod is jettisoned and the droids look out its window at the Star Destroyer and their former home. » Tavoularis

"My 'style,' if that word even applies, is as basic as they come, at least in the beginning. I tried to draw the boards in such a way that they informed the camera crews of what was required, without wasting a lot of time on making the boards works of art."

Joe Johnston

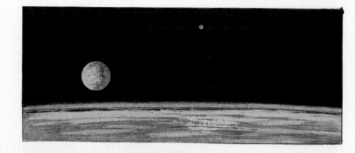

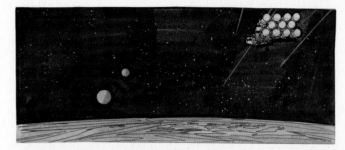
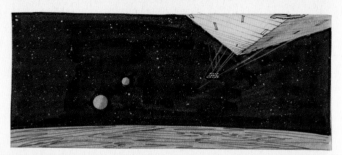

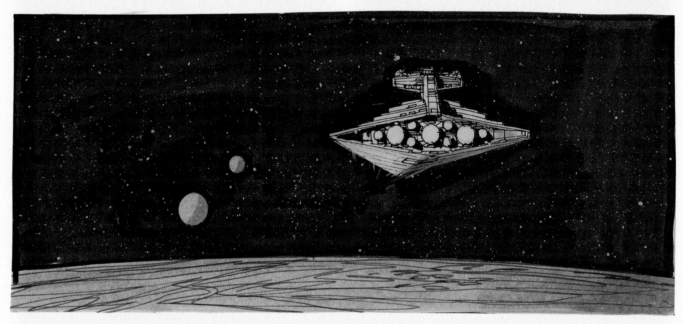

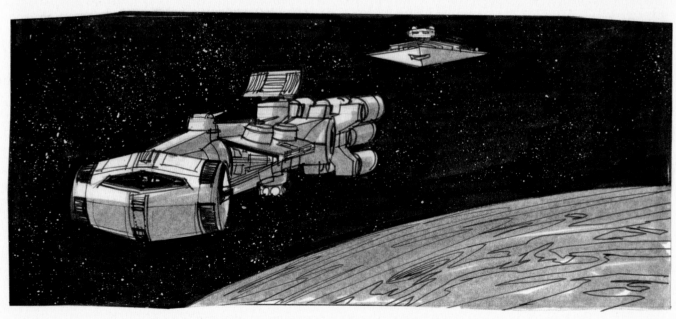

As described in a later draft, revised storyboards of the opening shots reveal a single Star Destroyer pursuing a redesigned rebel blockade runner. » Johnston

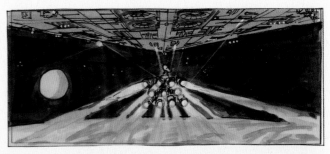

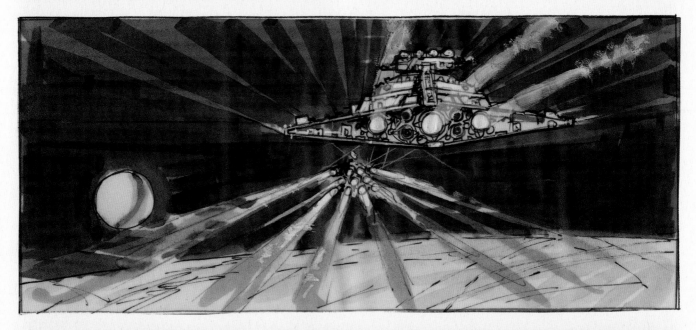

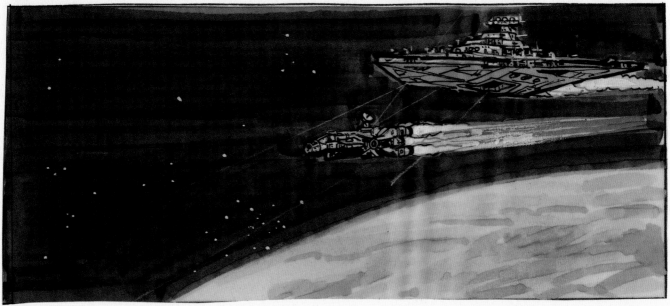

Very little is known about storyboard artist Gary Myers, who
helped out in the art department as work piled up and time was
short at ILM.

The massive Imperial ship closes in on the rebel vessel. » Gary Myers
OVERLEAF: The Star Destroyer zaps the blockade runner, and its "main solar fin . . . disintegrates." » Myers

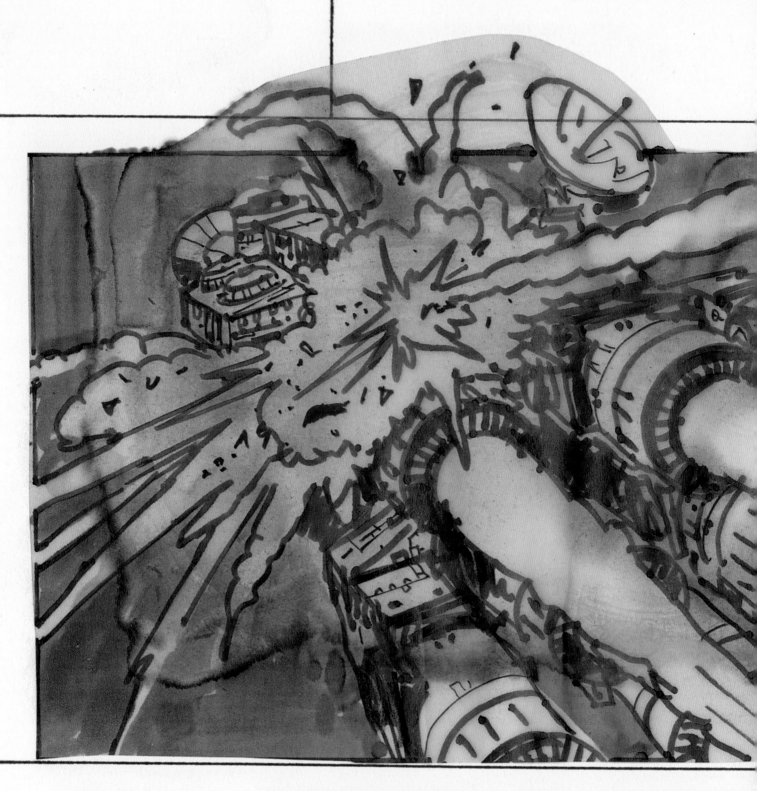

DESCRIPTION: BLOCKADE RUNNER GETS ZAPPED BY
FIN OF REBEL CRAFT DISINTEGRATE:

DIALOGUE:

P.P. #

PAGE # 8

ACKING

OPENING

FRAME COUNT:

BOARD #

7

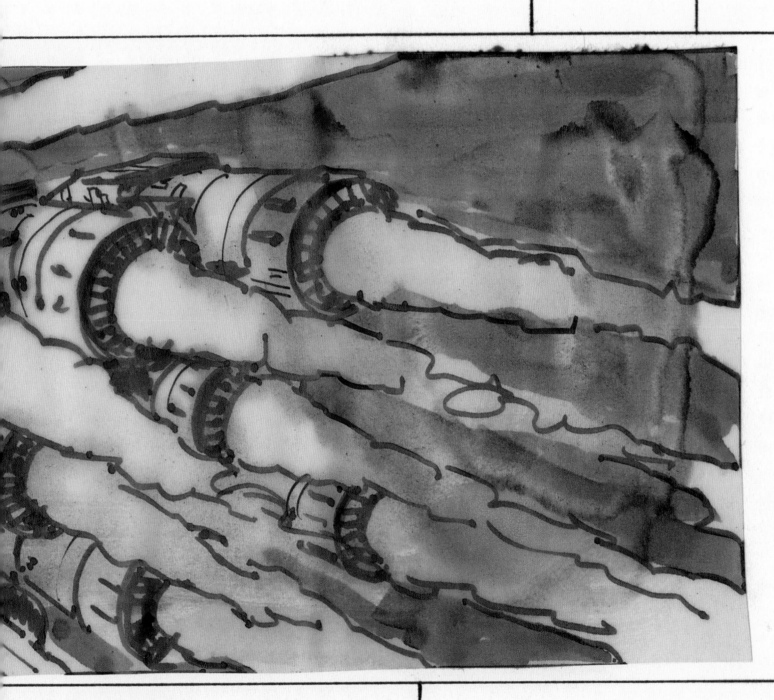

TAR DESTROYER. MAIN SOLAR

ROTO:

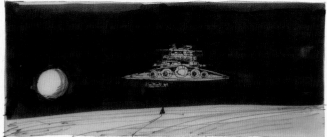

SHOT ENDS WHEN STAR DESTROYER REACHES SIZE OF REBEL SHIP HERE

"I never met Joe Johnston, but I admired his kind of drawing. It was very to the point and basic—what storyboards should really be, more than what I did. You don't need drama in storyboards; they're for the director, they're not comic books."

Alex Tavoularis

Note that the rebel ship's cockpit undergoes a design evolution into a "hammerhead" shape **[R2]**.

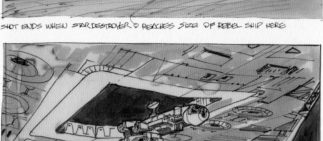

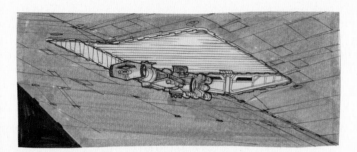

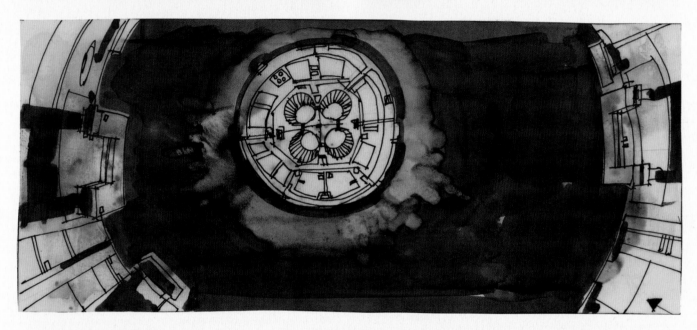

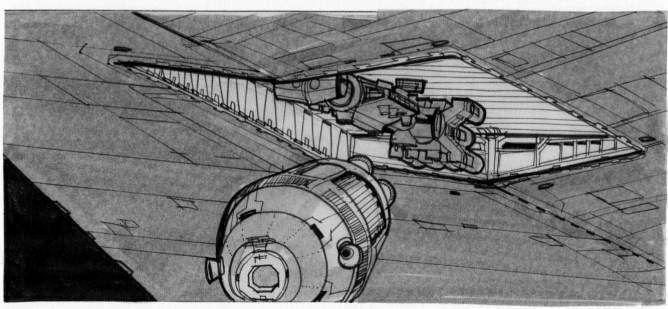

The rebel ship, adrift, is taken into the Star Destroyer's underside hangar. But a life pod escapes (with the droids hidden inside). » Johnston, **R1**, **R2R**, **R4**; Myers, **R2L**, **R3**

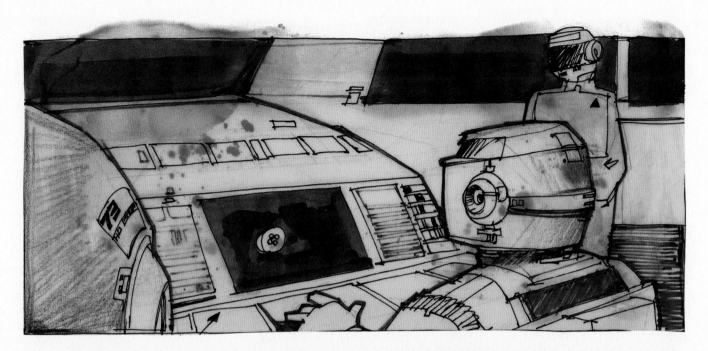

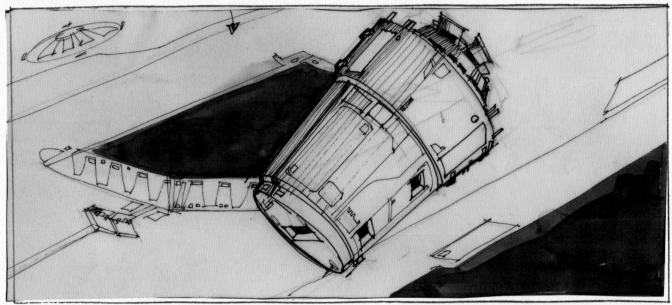

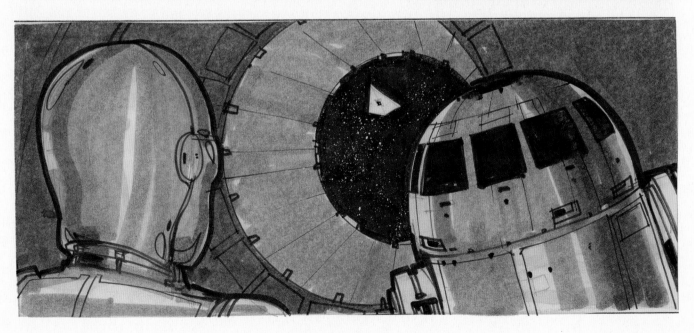

Imperial gunners let the drifting life pod sail by. » Johnston
OVERLEAF: The droids' life pod heads down to Tatooine (or Utapau, in early boards). » Johnston

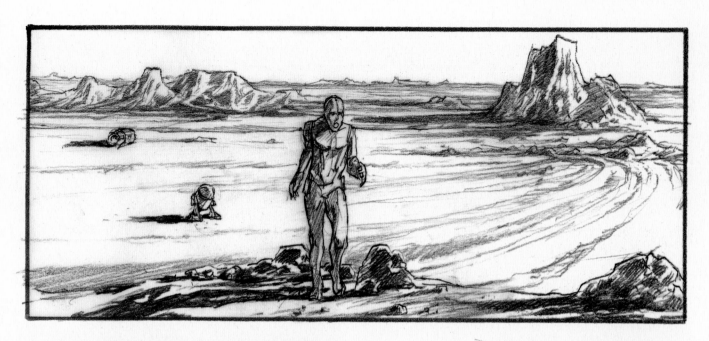

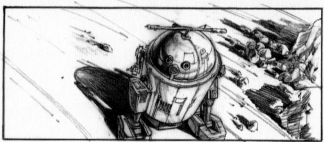

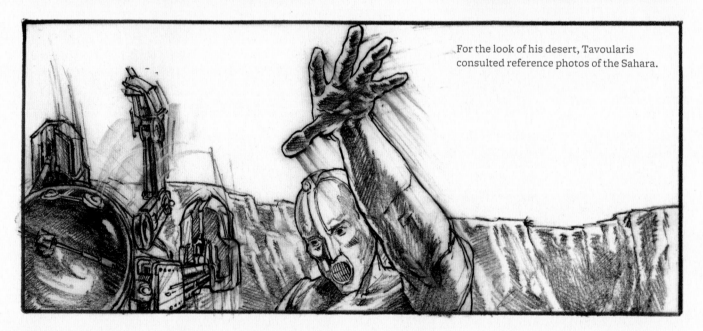

For the look of his desert, Tavoularis consulted reference photos of the Sahara.

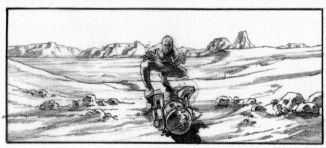

Stranded on scorched terrain, C-3PO and R2-D2 argue about which way to go to find help. » Tavoularis

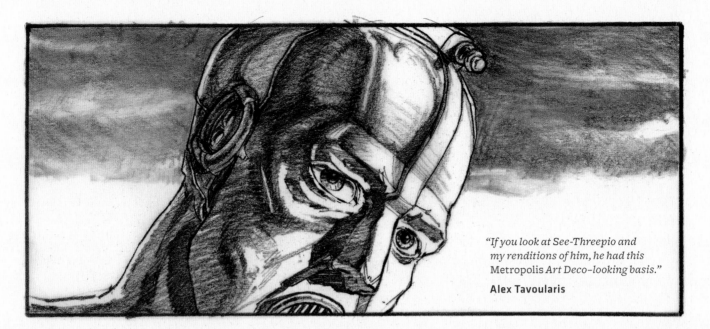

"*If you look at See-Threepio and my renditions of him, he had this* Metropolis *Art Deco-looking basis.*"

Alex Tavoularis

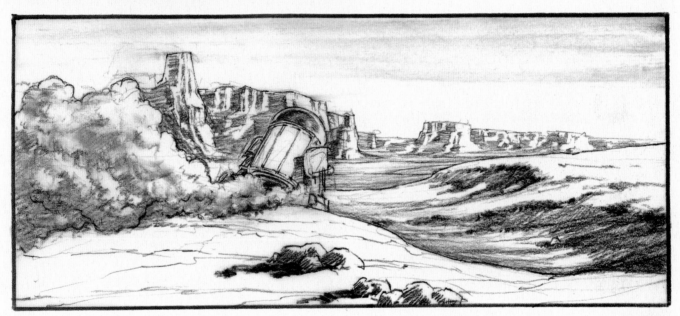

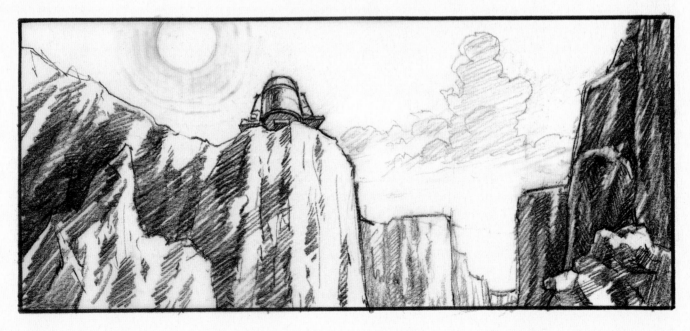

R2 winds up on the edge of a cliff. » Tavoularis

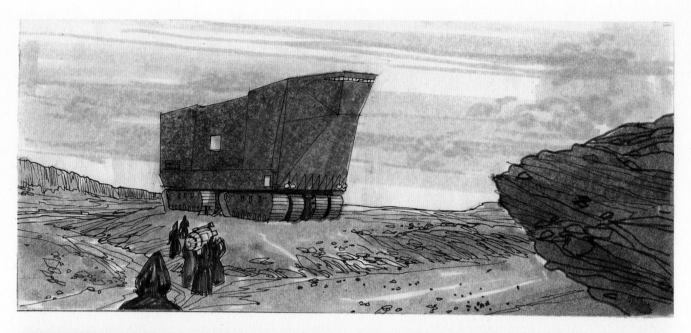

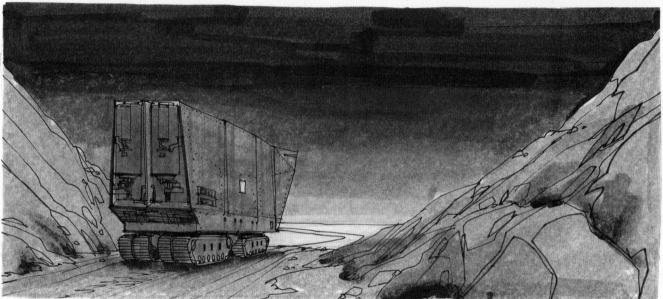

A band of Jawa scavengers abduct R2 and store him in their sandcrawler. » Johnston

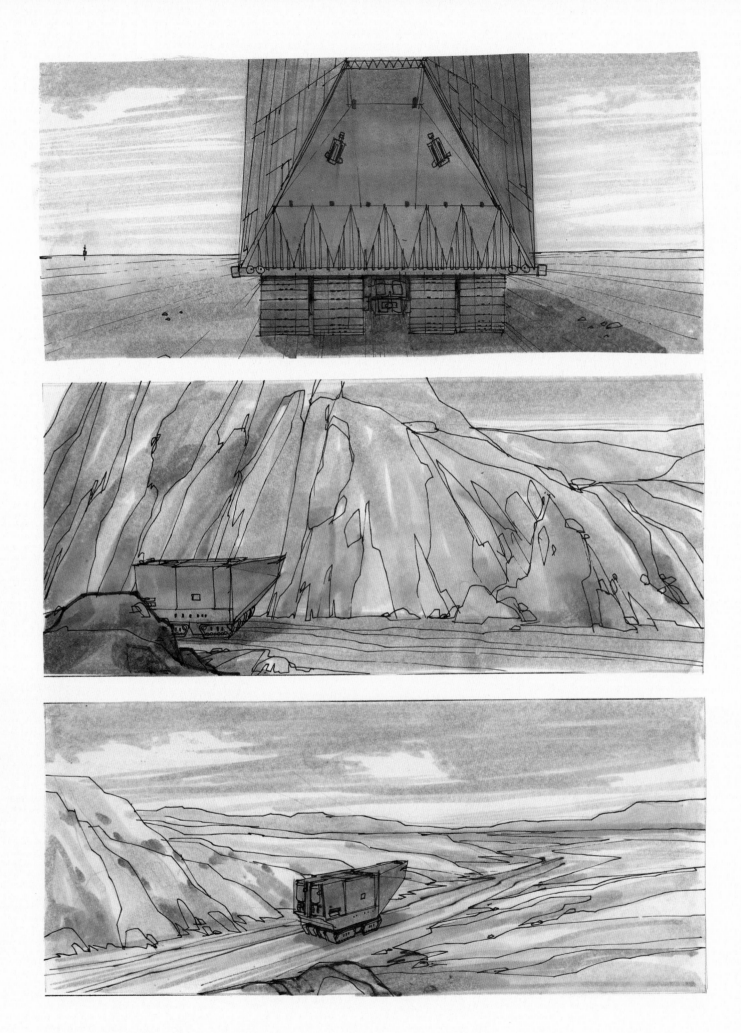

The sandcrawler continues on its journey. » Johnston
OVERLEAF: The homestead on Tatooine, with its twin suns, where Luke Starkiller (later, Skywalker) lives. » Johnston

SHOT #

862-04

OPTICAL:

PUT IN SECOND SUN
FROM FIRST TAKE

BACKGROUND:

I.L.M.

DESCRIPTION: LUKE WATCHES TWIN SUNS A

DIALOGUE:

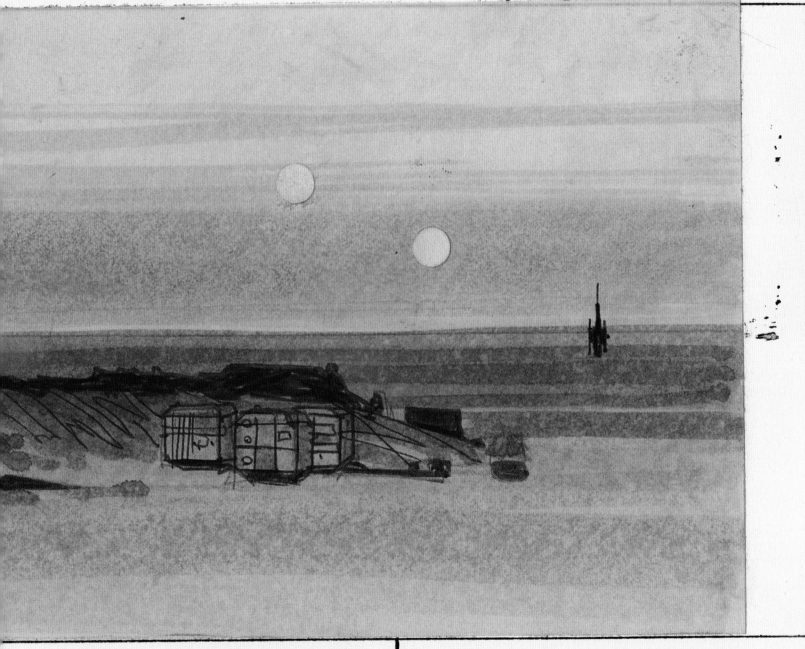

LARS HOMESTEAD

ROTO:

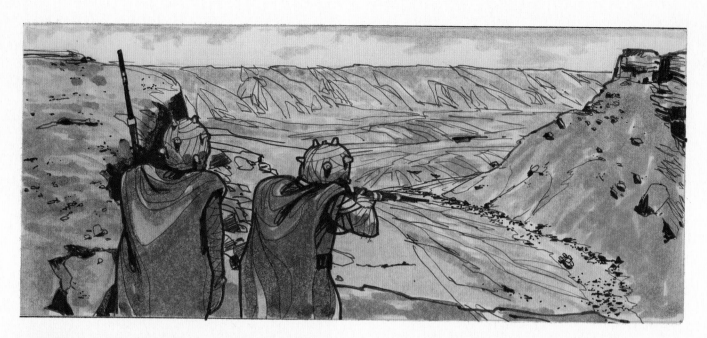

Several storyboards with shots of Luke's landspeeder indicated that a long lens would be used for photography.

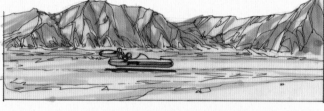

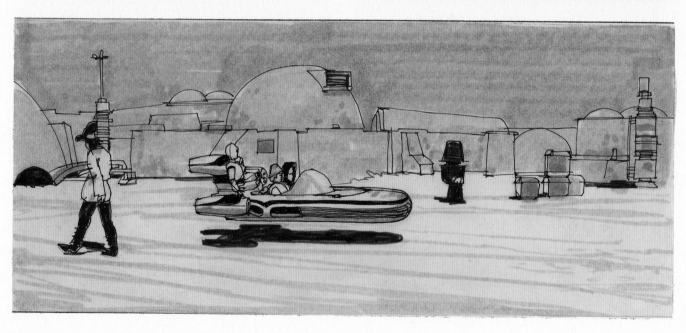

Feared as desert marauders, a Tusken Raider takes aim at Luke in his landspeeder.
Luke and his new friends eventually pass by a power station and enter Mos Eisley spaceport. » Johnston

PIRATE SHIP GOING AWAY →

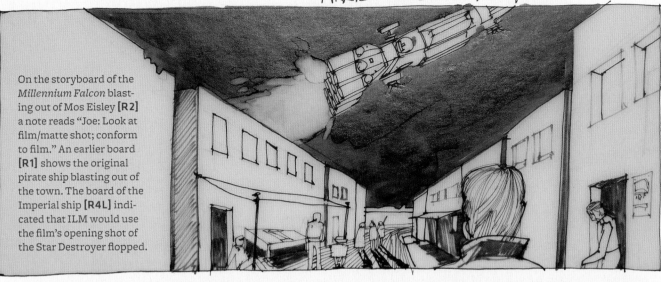

On the storyboard of the *Millennium Falcon* blasting out of Mos Eisley [R2] a note reads "Joe: Look at film/matte shot; conform to film." An earlier board [R1] shows the original pirate ship blasting out of the town. The board of the Imperial ship [R4L] indicated that ILM would use the film's opening shot of the Star Destroyer flopped.

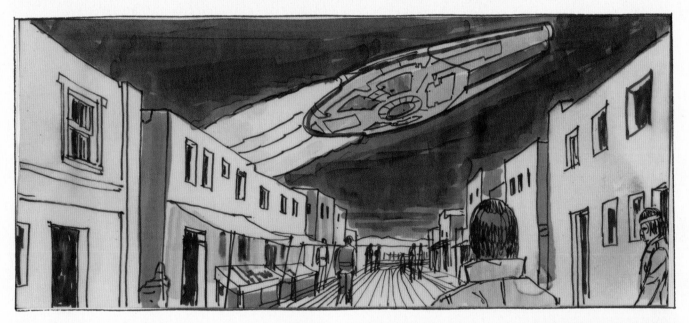

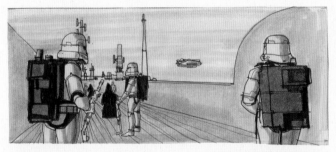

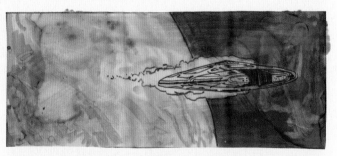

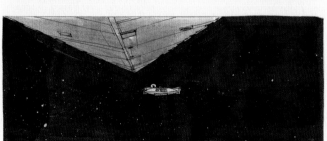

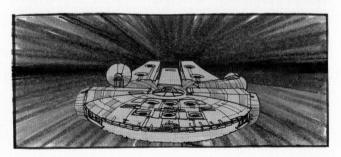

The *Millennium Falcon* escapes from Mos Eisley and makes the jump to hyperspace. » Johnston, **R1**, **R3L**, **R4**; Myers, **R2**, **R3R**

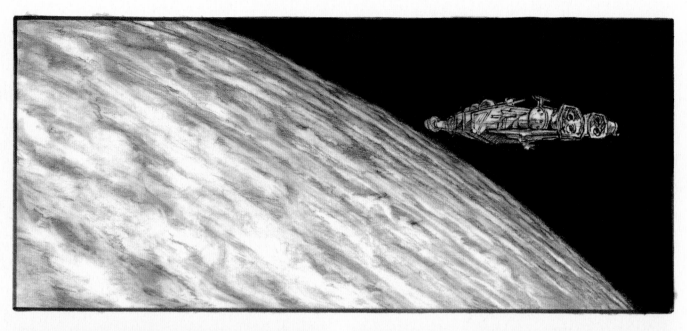

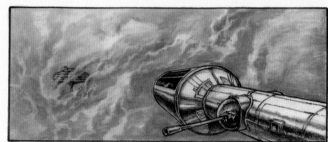

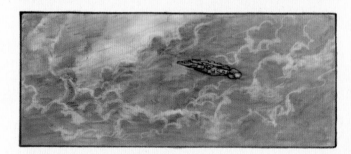

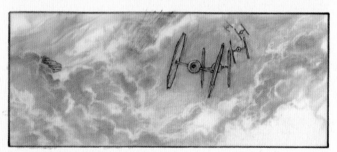

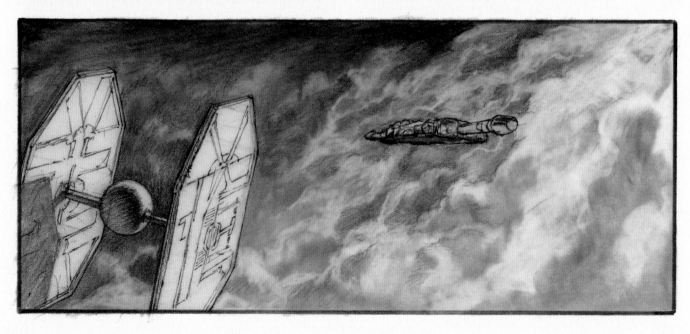

Reflecting the second draft, a seemingly abandoned pirate ship drifts through the upper atmosphere of Alderaan, where it's spotted by patrolling TIE fighters. » Tavoularis

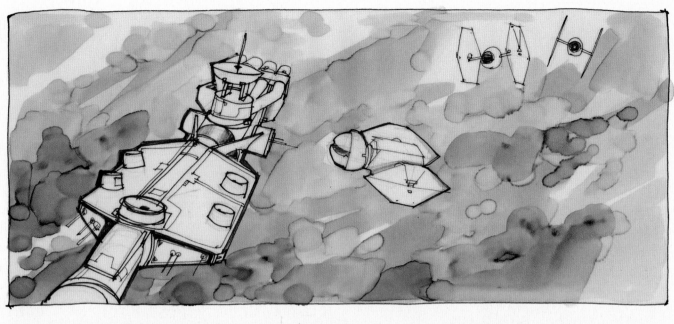

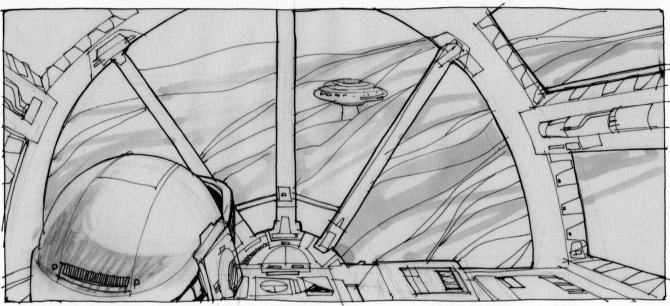

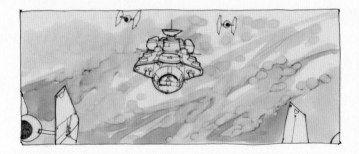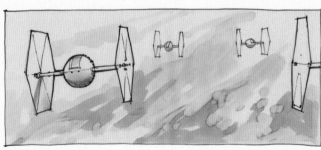

"*For reference, George ran Beta cassettes on a Sony CRT (which was state of the art at the time) of certain World War II movies with dogfight sequences over the Pacific. Wing and a Prayer is the one that stands out for me. I think it was an inspiration for George and a guidepost for me.*"

Alex Tavoularis

A later iteration of the same sequence, with the old pirate ship and the floating city of Alderaan. » Johnston

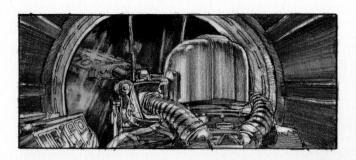
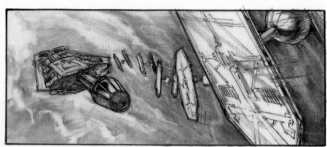
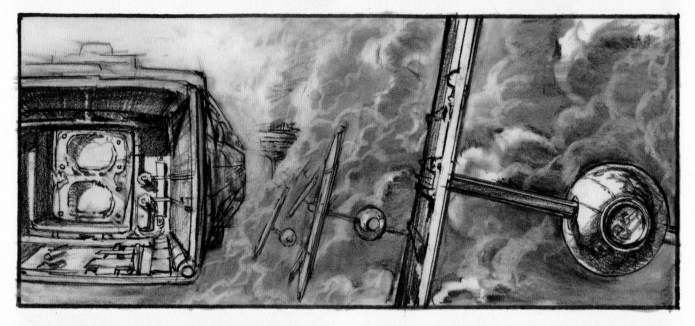

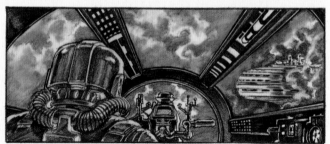
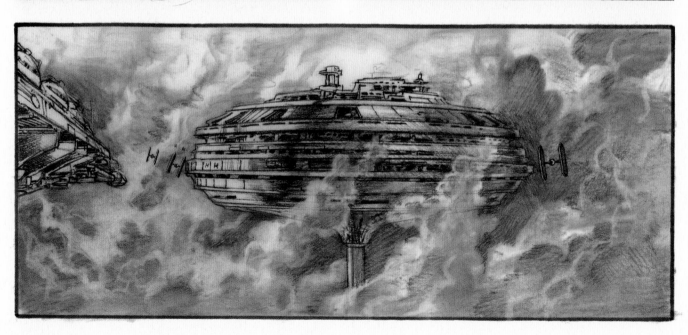

The TIE squadron commander orders the ship to be salvaged, so they guide it toward Alderaan—the Imperial prison, perched mushroomlike on tall, gleaming spires, where Deak Starkiller (Luke's brother) is being held captive. » Tavoularis

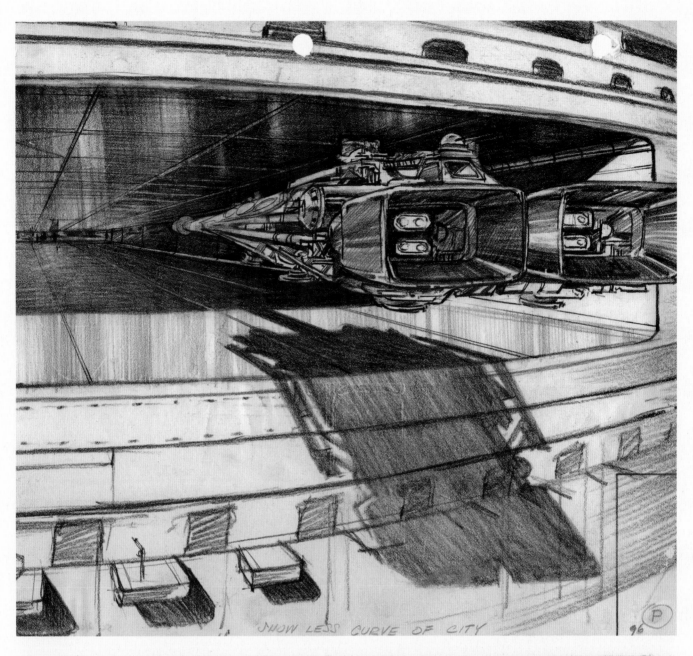

NOW LESS CURVE OF CITY

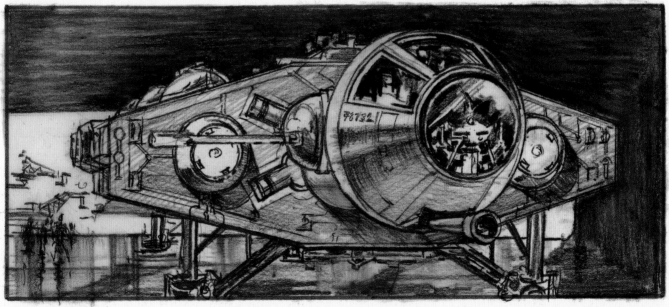

The pirate ship—where Han, Chewbacca, and Luke are hidden—is brought into one of Alderaan's immense hangars. » Tavoularis

These storyboards recently surfaced and are the only known drawings to depict the second draft's scene 82 (perhaps only a fragment from a more extensively boarded scene). Also note that these boards are from the brief period between the second and third drafts when Lucas turned Luke into a girl. Indeed she resembles Leia and is with Han Solo (disguised as a stormtrooper) and Chewbacca—and they are all about to meet the "Dai Noga"—as they hear a low growl and the Wookiee emits a warning howl.

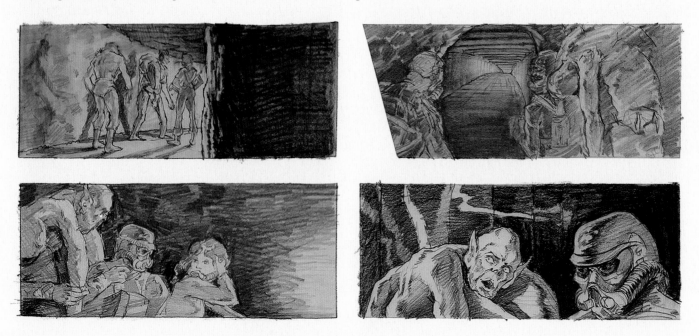

Luke (as girl), Han, and Chewbacca carry the former's brother, Deak Starkiller, nearly dead from torture, as they make their way through the spooky underworld corridors of Alderaan. » Tavoularis

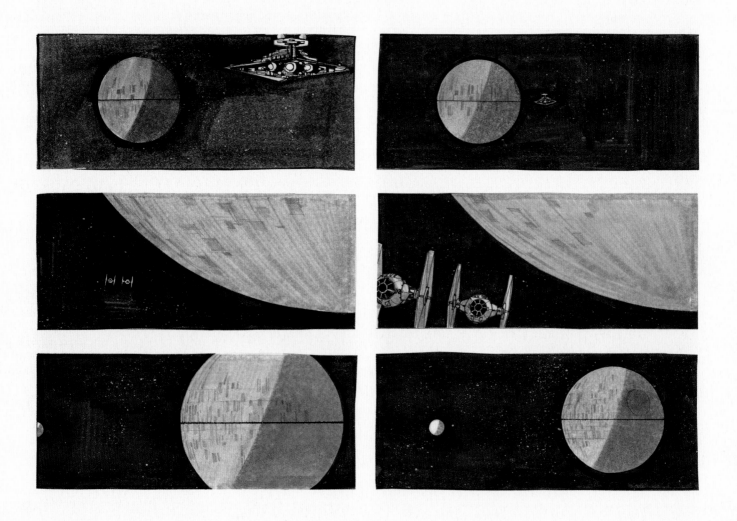

A Star Destroyer flies toward, and TIE fighters fly away from, the Death Star. » Johnston

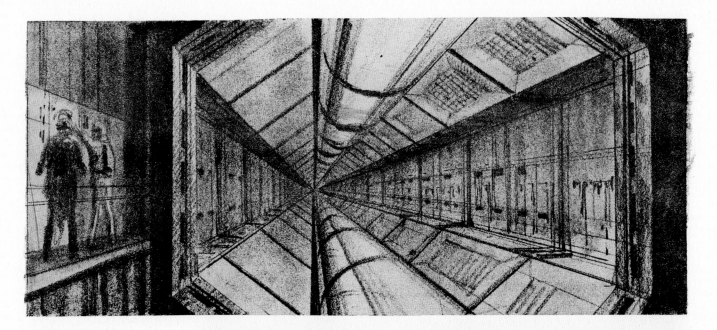

The "wind-up death ray" storyboard (**R1**, a repurposed Ralph McQuarrie sketch) indicates that the long tunnel would be achieved either with a model or a matte painting, and that ILM would insert a shot of two storm-troopers. In fact storyboard artist Joe Johnston would wind up in the shot, but as a technician (with Jon Erland).

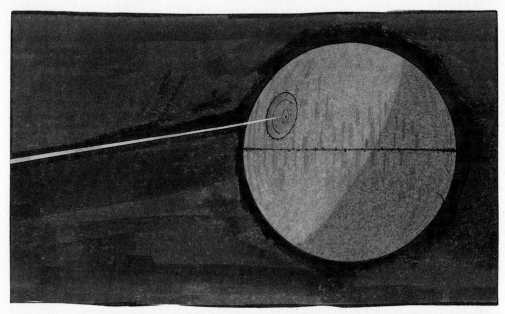

The Death Star destroys Alderaan (which had been changed into a peaceful rebel planet, the home of Princess Leia). » Ralph McQuarrie, **R1**; Johnston, **R2:3**

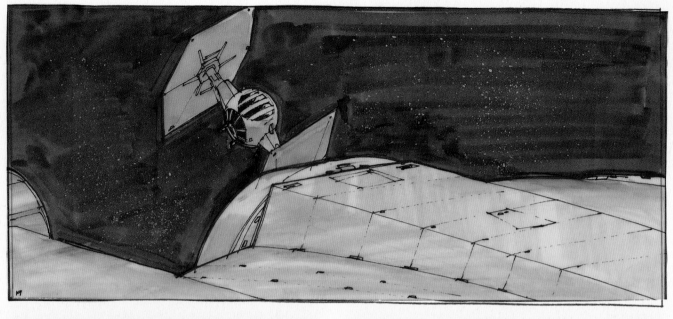

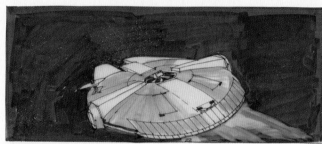

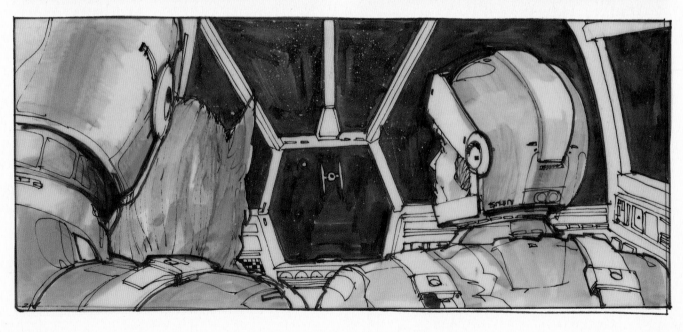

A TIE fighter buzzes the *Falcon* and is pursued. » Johnston

Because these shots were to be completed by ILM in time to be front projected during principal photography at Elstree Studios, storyboards for the *Falcon* being pulled into the Death Star were drawn by Johnston early in the process. The in-camera results filmed at Elstree were ultimately deemed unsatisfactory and the visual effects were achieved instead at ILM in postproduction.

While pursuing the TIE, the *Falcon* is caught in the Death Star's tractor beam. » Johnston

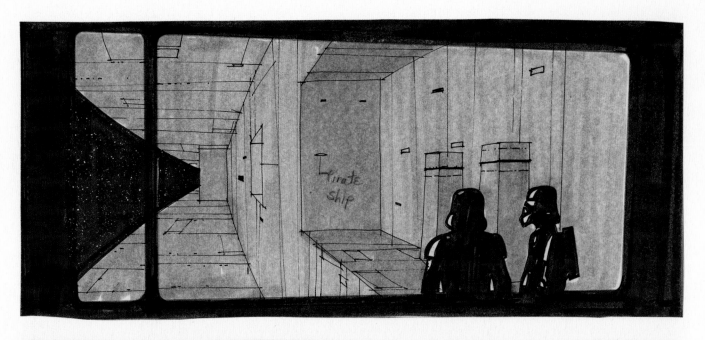

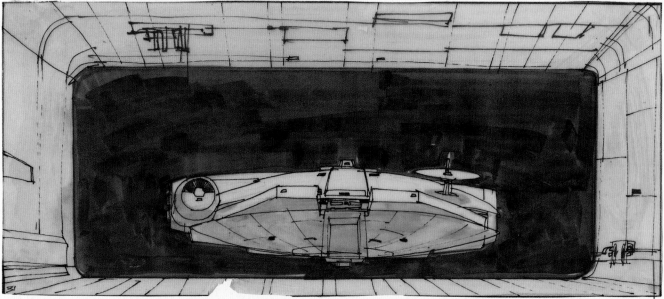

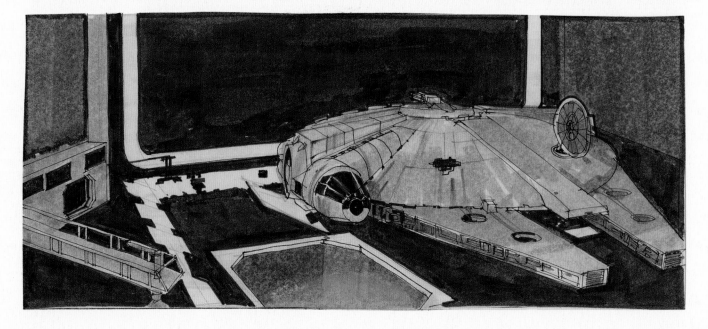

The *Falcon* is pulled into a Death Star hangar. » Johnston

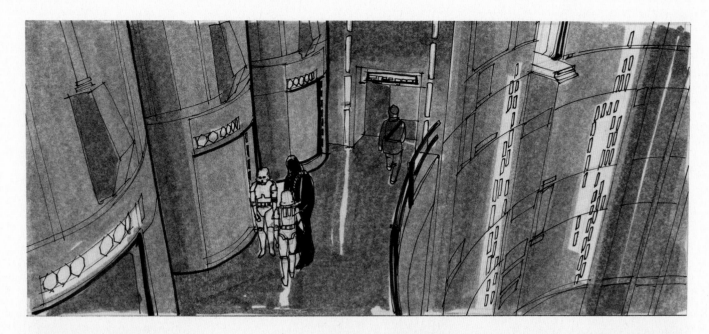

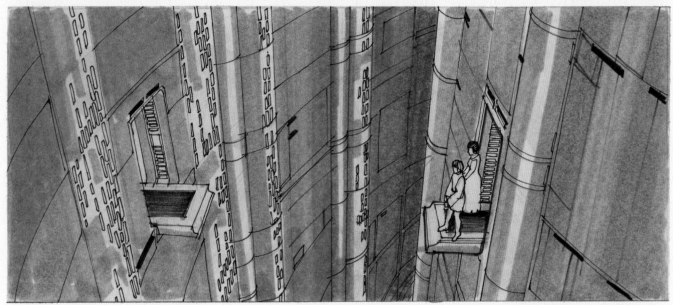

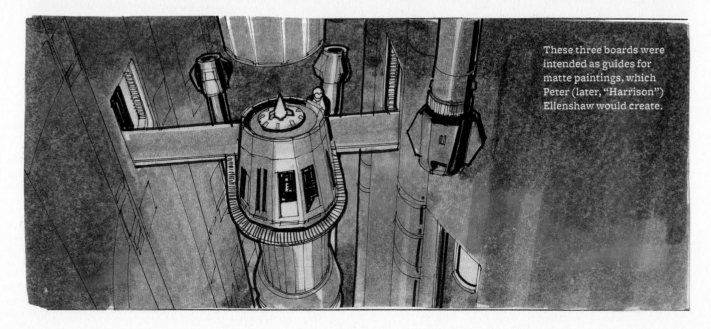

These three boards were intended as guides for matte paintings, which Peter (later, "Harrison") Ellenshaw would create.

The heroes—Luke, Leia, Han, Chewbacca, and Ben Kenobi—infiltrate the Death Star. » Johnston

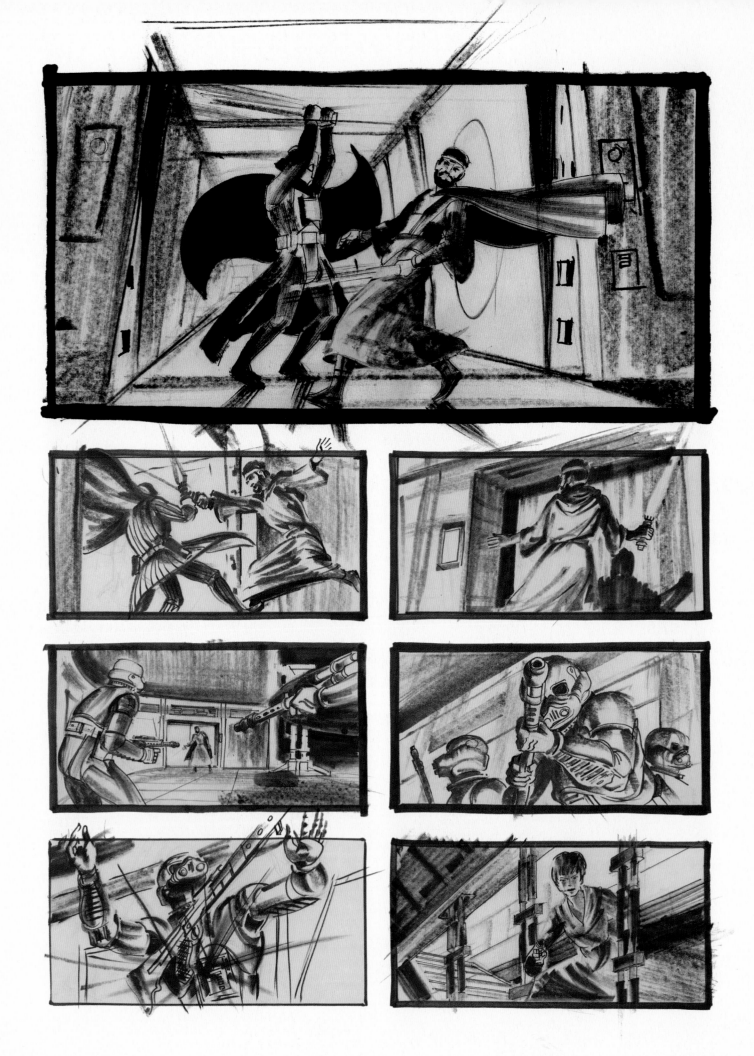

Ben Kenobi battles Darth Vader. » Ivor Beddoes

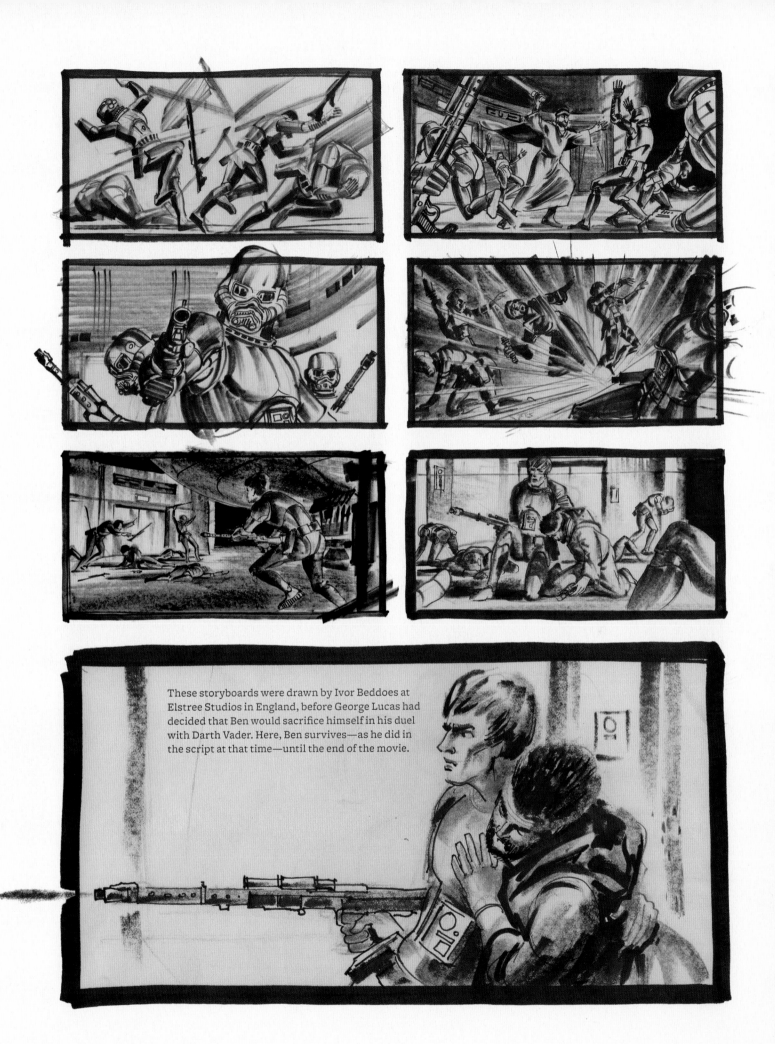

These storyboards were drawn by Ivor Beddoes at Elstree Studios in England, before George Lucas had decided that Ben would sacrifice himself in his duel with Darth Vader. Here, Ben survives—as he did in the script at that time—until the end of the movie.

Ben is wounded by blaster fire, but rescued by Luke. » Beddoes

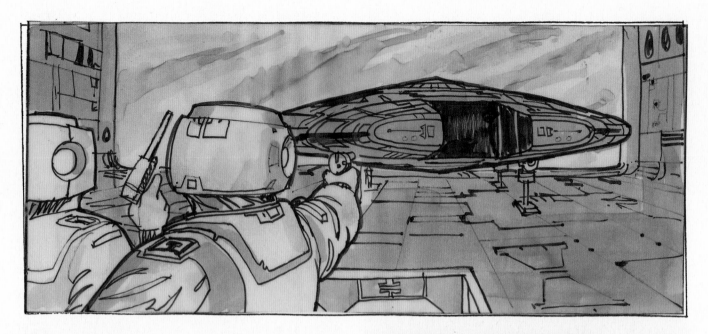

One board [R1] still shows a cloudy sky outside the hangar, instead of a star field, as the drawing originally depicted the locale as part of the floating city of Alderaan.

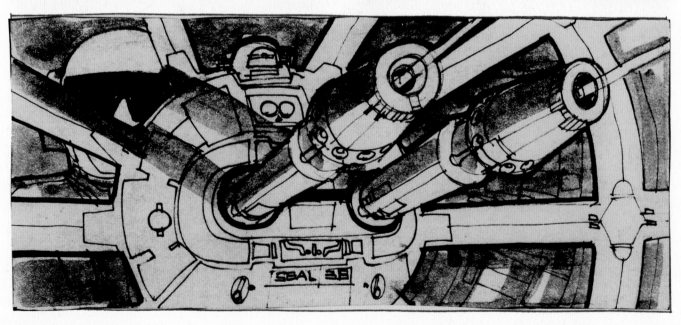

The *Falcon* escapes the Death Star, while Han and Luke man the gun ports, awaiting attack. » Myers, **R1**, **R3R**; Johnston, **R2**, **R3L**, **R4**

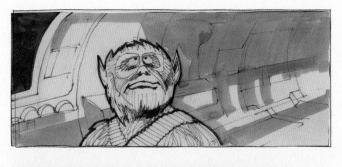

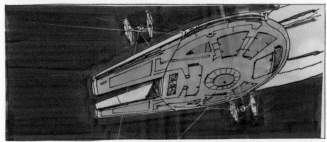
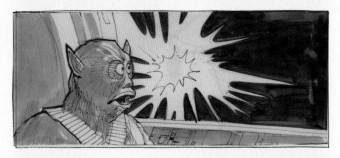
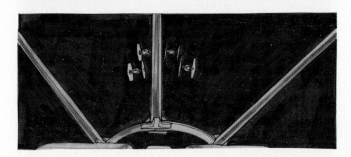

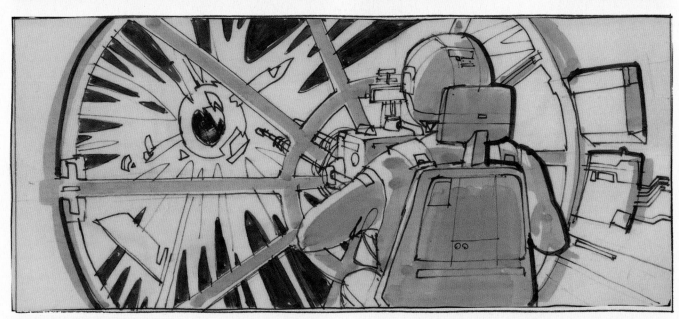
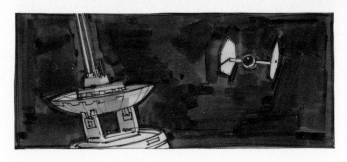
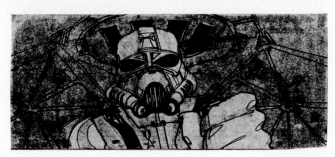

TIE fighters swarm the *Falcon*, which defends itself. » Johnston, **R1**, **R2L**, **R3:5**; Myers, **R2R**

The same note accompanies many of these storyboards: The camera was to "pan and tilt," which was unusual for shots of this kind at that time.

In order to create the random star patterns on the boards, artists used to first fill in "space" with a black marker, then take a toothbrush loaded with white tempera paint and flick the bristles onto the black space—instant stars.

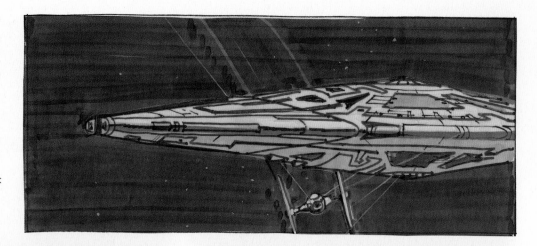

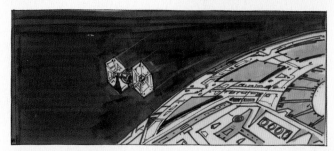

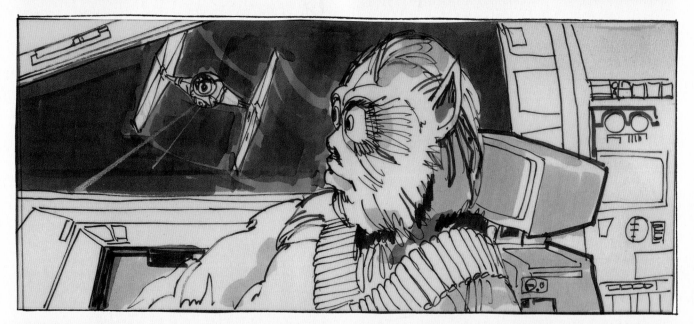

"There were boards where, if it was basically a cockpit interior that I had already drawn [R3], Ronnie Shepherd copied it or lightly traced it to start."

Joe Johnston

Ronnie Shepherd, like Myers, helped with storyboarding during these early crunch times.

The space dogfight continues. » Myers, **R1**, **R2L**; Ronnie Shepherd, **R2R**, **R3:4**

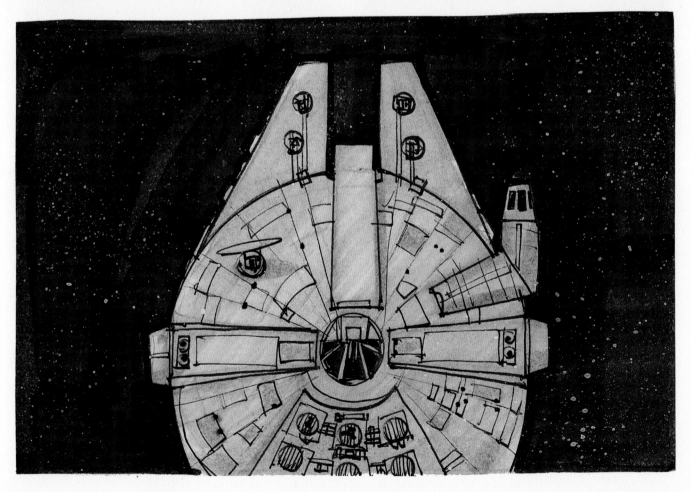

Luke blasts a TIE fighter and Leia hugs Chewbacca; the *Falcon* escapes. » Johnston

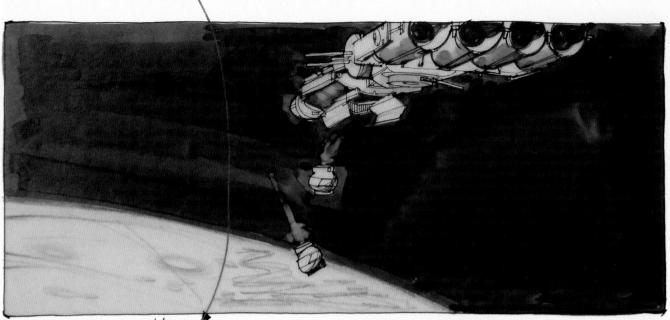

FOURTH MOON OF YAVIN

Recently found storyboards depict moments from the second draft: The heroes descend to the jungle planet from the pirate ship via life pods [R1]—because the dense forest makes it impossible to land—and then make their way on foot to the rebel base, spotting the outpost's watchtower. Note that the two characters in the foreground [R1, opposite] are Ben, who doesn't die in the second draft, and Luke. »

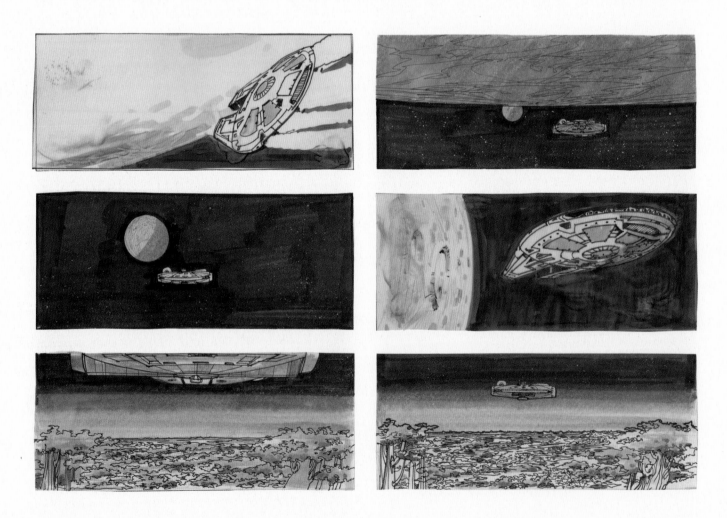

In two iterations, the heroes arrive at Yavin 4, a jungle planet, via life pods and then by landing in the *Falcon*. » Shepherd, **R1**; Myers, **R2L**, **R3R**; Johnston, **R2R**, **R3L**, **R4**

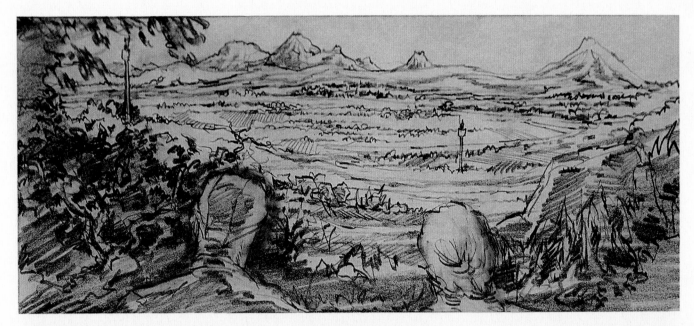

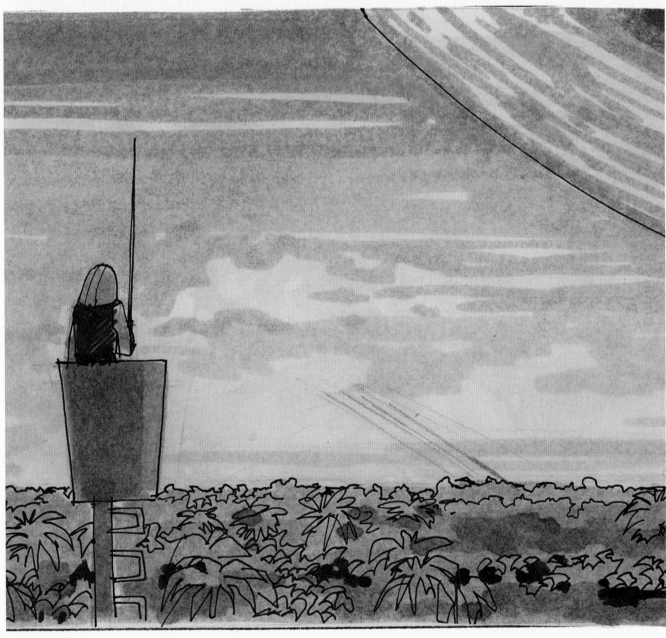

In an early draft the rebels trek through the jungle **[R1]** until they espy a
lone sentry of the secret Rebel Alliance base. » Tavoularis, **R1**; Johnston, **R2**

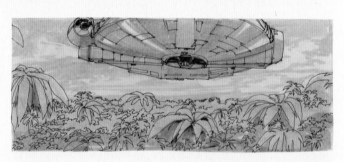

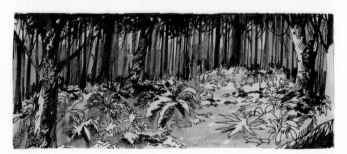

Shots of a lush jungle intercut the pirate ship's arrival. » Johnston

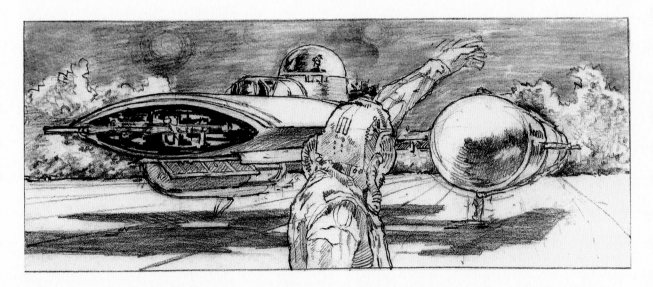

Another recently surfaced board **[R1]** echoes a McQuarrie painting and shows a Y-wing in a jungle clearing, as the rebel base was originally located outside until budget cuts moved it into an interior hangar.

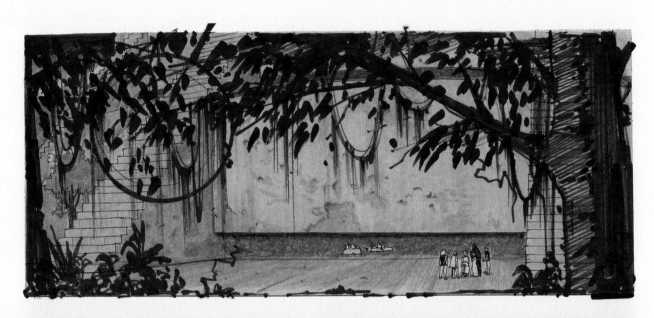

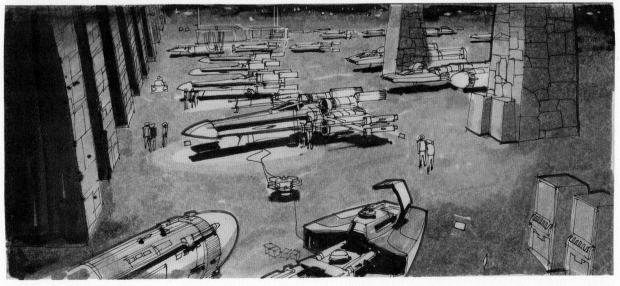

The rebel base is located in a secret hangar converted from an ancient temple. » Tavoularis, **R1**; Johnston, **R2:3**

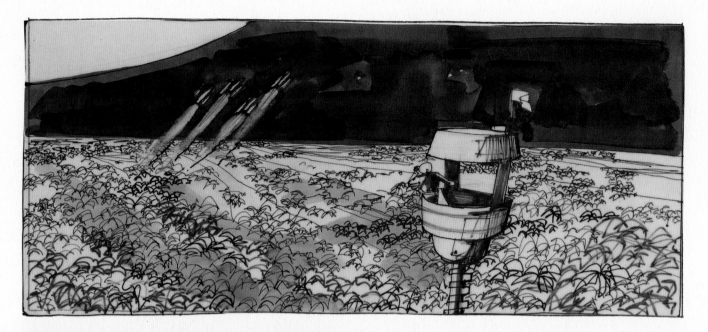

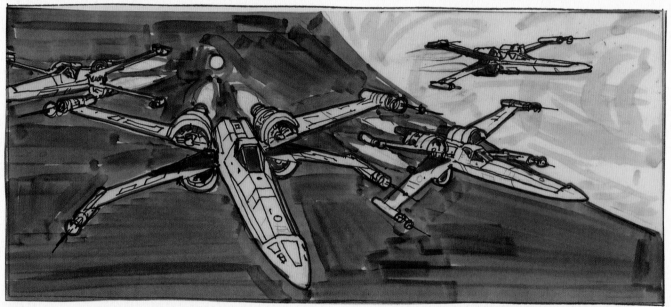

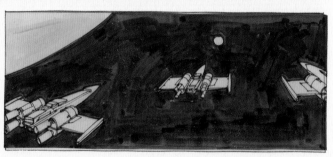

One board **[R1]** has the following note: "Ships are so far away they are spots of light; four 'Y' ships, followed by four 'X' ships, going away."

The surface of the Death Star was to have a thousand glowing lights.

An early iteration of the rebel fighters' departure from Yavin 4 as the attack on the Death Star begins. » Johnston, **R1**, **R3**; Myers, **R2**

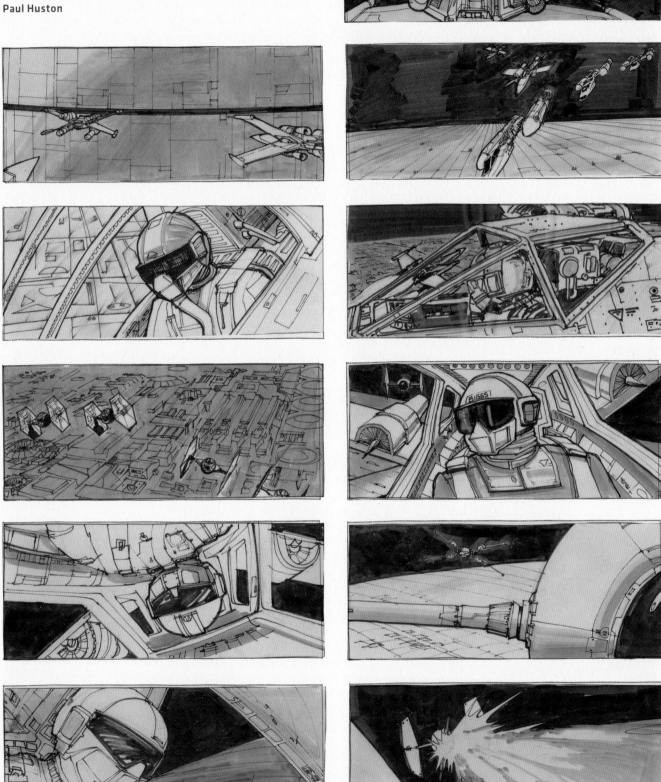

"I was hired in August of 1975 to help Joe put together a set of 'bidding' storyboards to estimate the costs of the visual effects shots. There was a deadline as determined by the studio—and that put the pressure on us. It was very intimidating to think that my drawings would have to be up to the quality to those of Joe, who has an incredible sense of design, a flair for dramatic perspective, rock solid draftsmanship, and nerves of steel! Also, some of the things we had to draw hadn't been designed yet, so we'd have to make things up."

Paul Huston

Fighter pilots—Luke and Biggs among them—peel off; Luke (upside down) rescues Biggs from a TIE fighter. »
Johnston, **R1**, **R2L**; Shepherd, **R2R**, **R5L**, **R6L**; Paul Huston, **R3L**, **R4R**, **R5R**, **R6R**; Myers, **R3R**, **R4L**

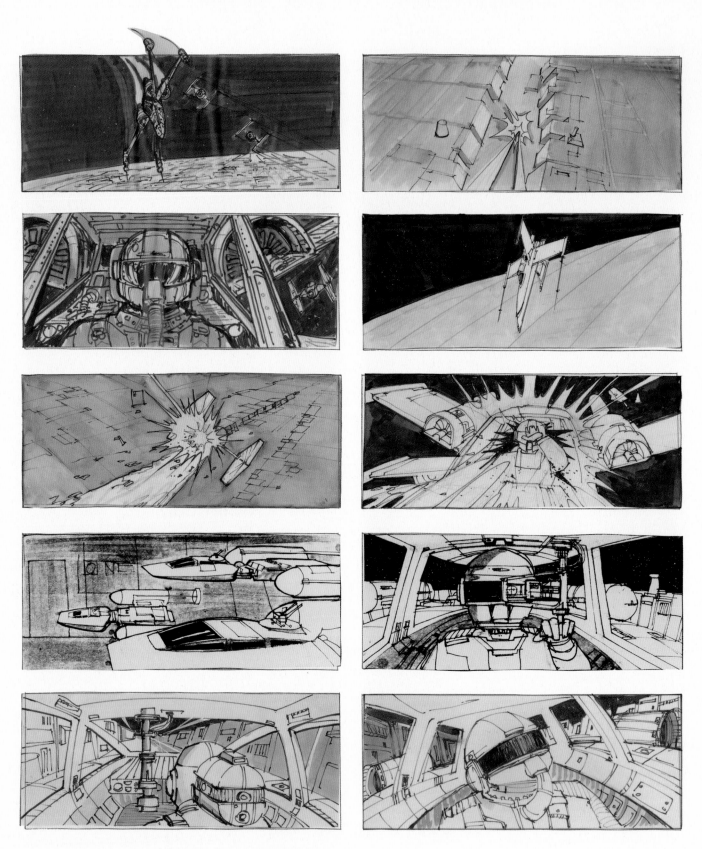

"Even though the doors to the art department were kept closed, it was known throughout the facility that everyone was welcome, if they had questions or just wanted to come in and browse the art on the walls and look at the storyboards."

Joe Johnston

Chewie (a pilot) blasts a TIE fighter following Luke, but Porkins is killed. Red and Blue Leaders begin their attack run, pursued by Darth Vader. » Myers, **R1L**, **R2L**; Huston, **R1R**, **R4L**; Johnston, **R3**; **R4R**; Shepherd, **R2R**, **R5**

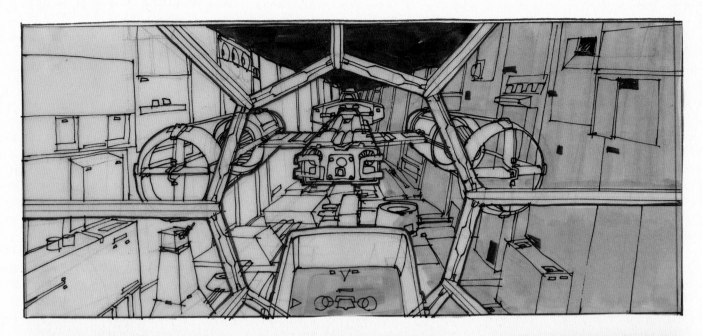

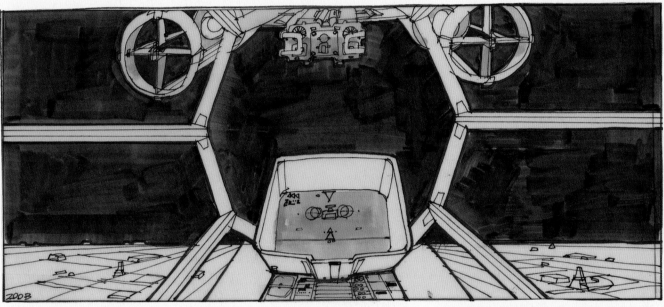

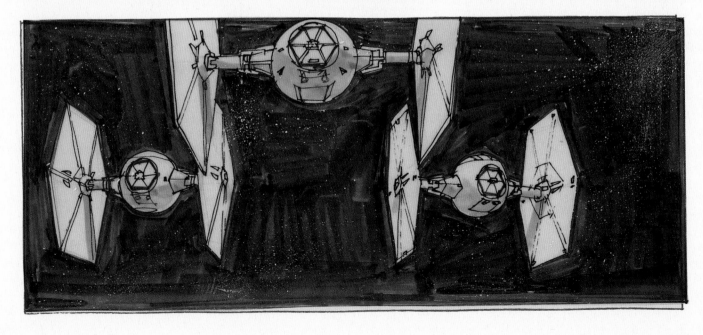

Vader and his cohorts pursue a Y-wing back into space. » Johnston

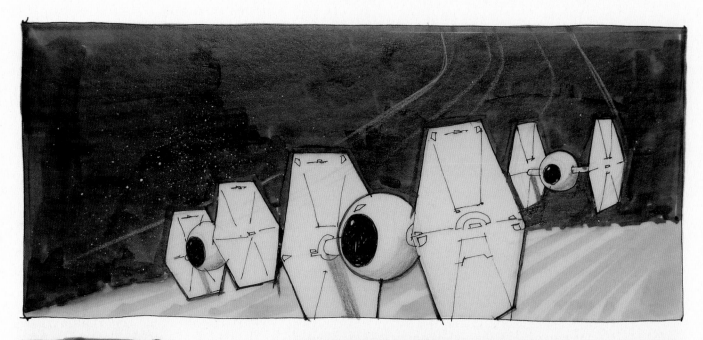

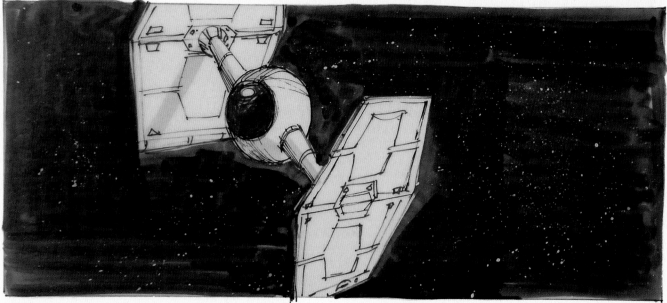

Newly discovered boards show the early TIE fighters in attack formation, as Vader's TIE fighter **[R2]** has yet to be redesigned.

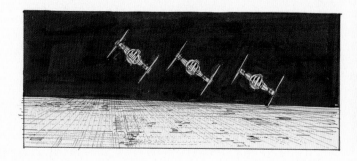

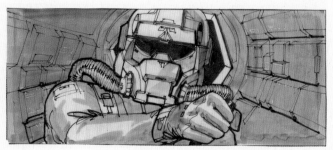

A squadron of three TIE fighters led by Vader hunts for rebel ships. » Shepherd, **R1:2**; Johnston, **R3**

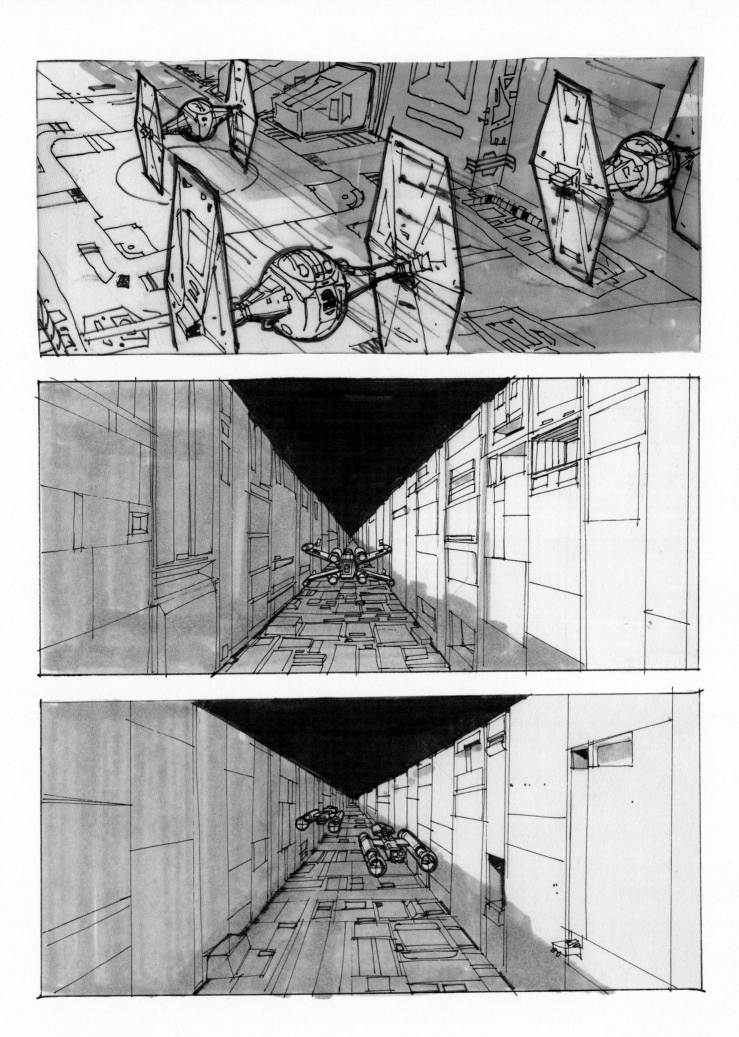

Vader's squad streaks down the trench behind a rebel X-wing and two Y-fighters. » Johnston

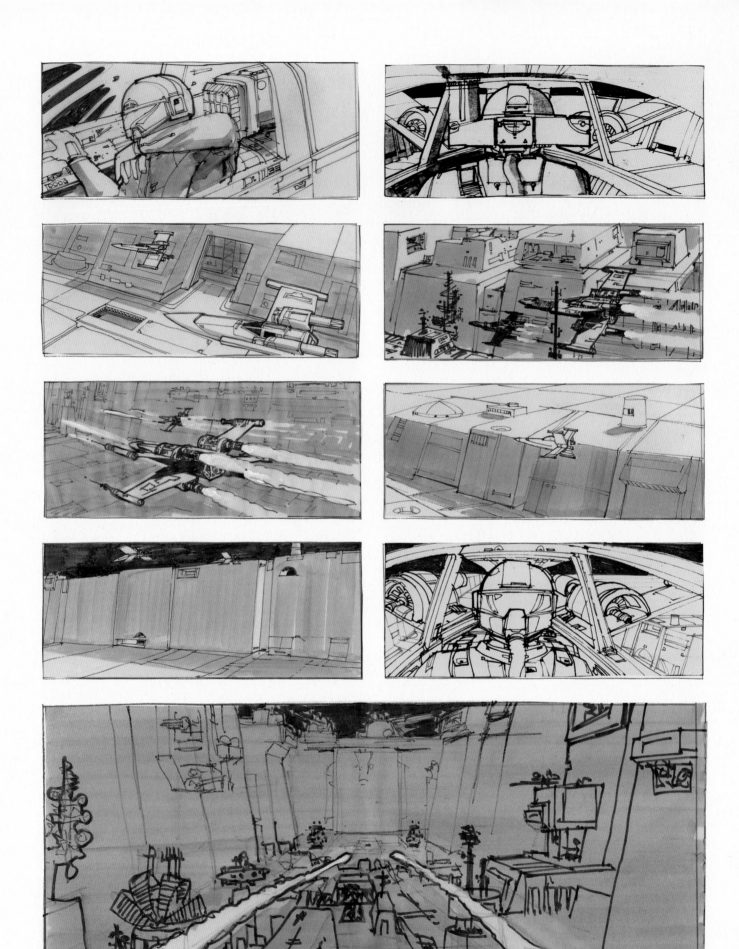

Blue Twelve bites the dust. Luke and Biggs begin their trench run, but Luke's shot explodes harmlessly to one side, missing the exhaust port. » Johnston, **R1**, **R4R**; Shepherd, **R2L**, **R3R**, **R4L**; Myers, **R2R**, **R3L**, **R5**

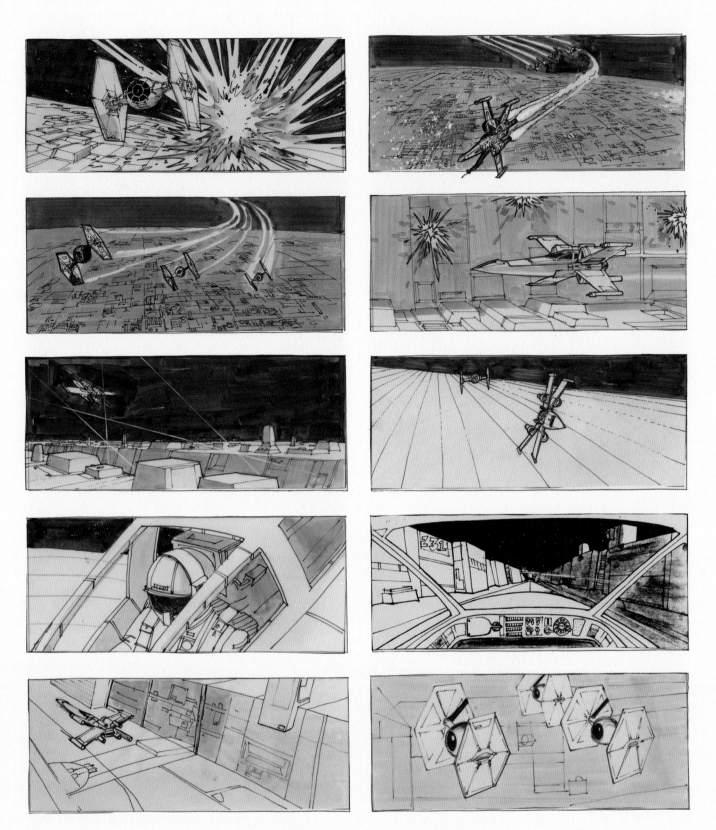

"Luckily, Joe was patient with my progress and we had a great time up in the art department, with its cinder block walls, plywood floor, hollow-core doors on sawhorses for drawing tables, and the Movieola with George's black-and-white cut of the attack on the Death Star made from old WWII war movie footage. Joe would show me a shot of a Japanese Zero flying left to right in front of a conning tower of an aircraft carrier and say, 'The aircraft carrier is the Death Star, the Zero is an X-wing. Do a board like that...'

"George wanted archival quality boards that would copy well, so we had to draw with Rapidograph pens on vellum, which is like drawing on wax paper with a nail dipped in ink. It doesn't help at all if you are nervous, because every little tremor shows up in the stroke and the ink takes a while to dry because the paper isn't absorbent at all. You have to be very careful not to smear it."

Paul Huston

In Luke's cockpit **[R4R]** one of the instrument panels resembles a rotary phone dial.

Luke flies in and out of the trench, pursued by Vader and his relentless TIE fighters. »
Johnston, **R1L**, **R2R**, **R3**; Myers, **R1R**, **R2L**; Shepherd, **R4L**; Huston, **R4R**, **R5R**; Steve Gawley, **R5L**

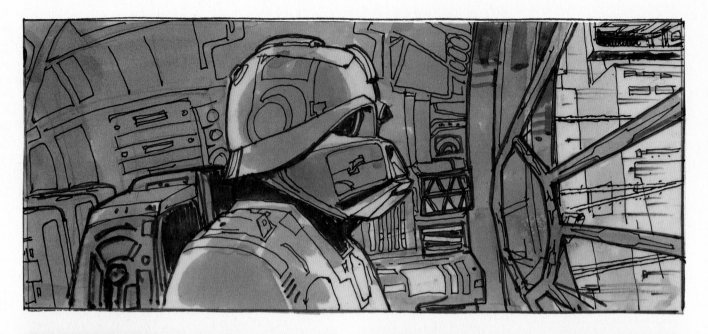

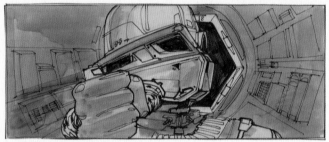

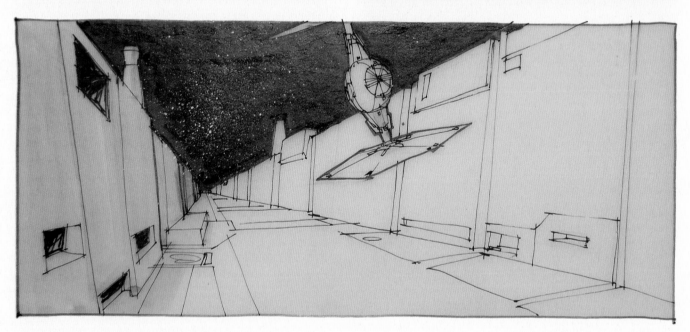

"We listened to the Eagles and Supertramp, Jethro Tull, and seventies pop radio. We were fans of Moebius and The Airtight Garage of Jerry Cornelius, *and eagerly jumped on each latest issue of* Heavy Metal *magazine."*

Paul Huston

In another board **[R1]**, Johnston, who had not seen the final costume, drew a Darth Vader who distinctly resembles a bulldog (the window is also concave).

Han and Chewie come to the rescue, blasting a TIE fighter and sending Vader spinning into space. » Johnston

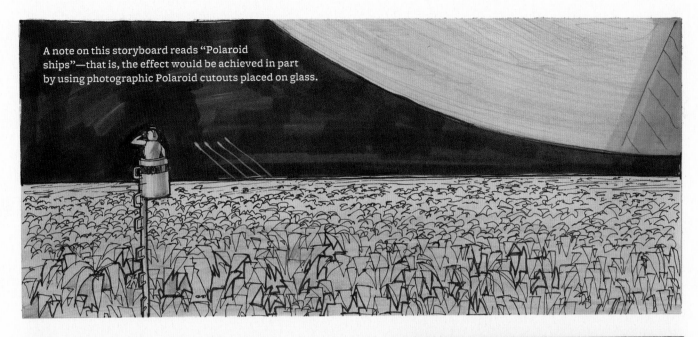

A note on this storyboard reads "Polaroid ships"—that is, the effect would be achieved in part by using photographic Polaroid cutouts placed on glass.

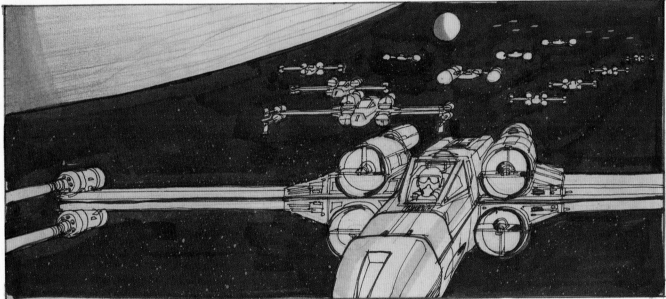

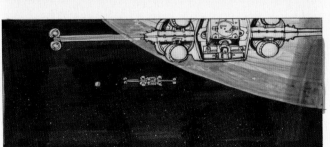

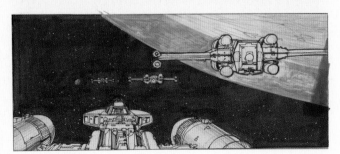

A later iteration of the rebel attack on the Death Star begins. » Johnston

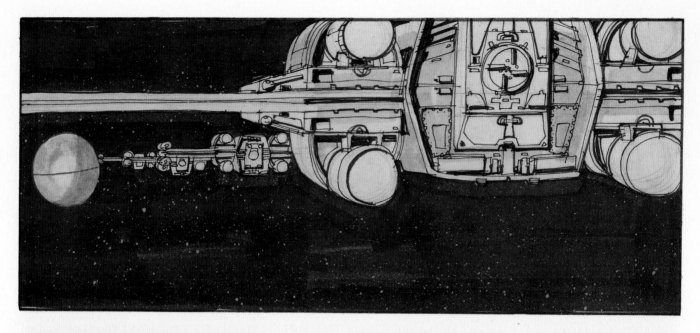

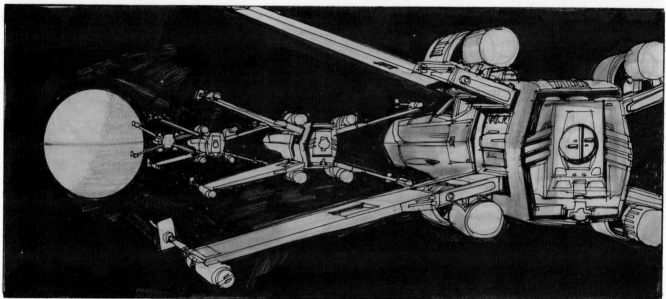

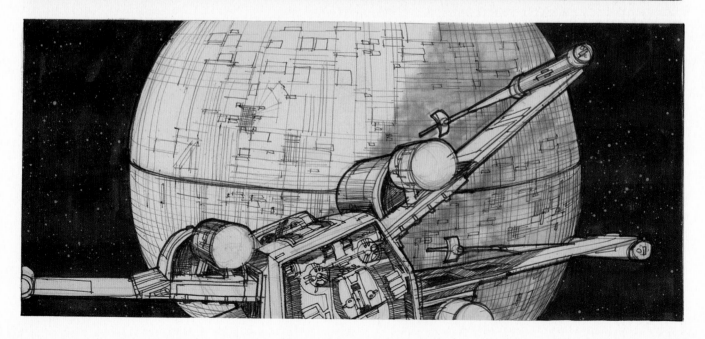

Gold Leader and a phalanx of X-wings lock their S-foils into attack position and accelerate to attack speed. » Johnston

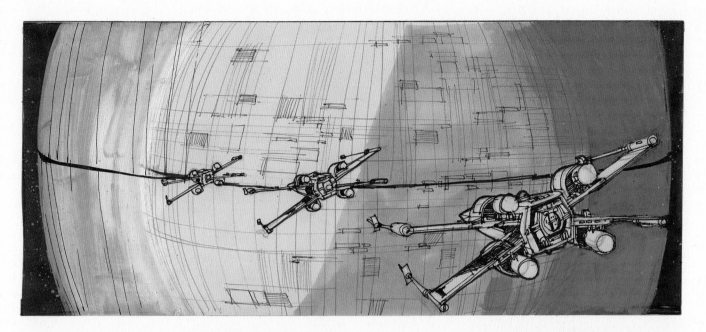

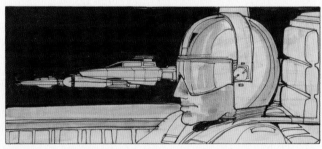

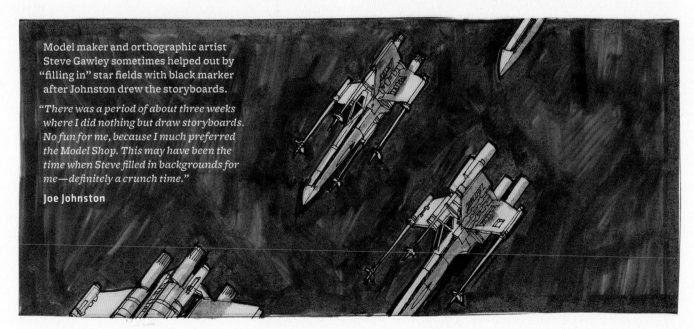

Model maker and orthographic artist Steve Gawley sometimes helped out by "filling in" star fields with black marker after Johnston drew the storyboards.

"There was a period of about three weeks where I did nothing but draw storyboards. No fun for me, because I much preferred the Model Shop. This may have been the time when Steve filled in backgrounds for me—definitely a crunch time."

Joe Johnston

Graceful rebel X-wings dive toward the Death Star equatorial trench as the "armada" closes in. » Johnston

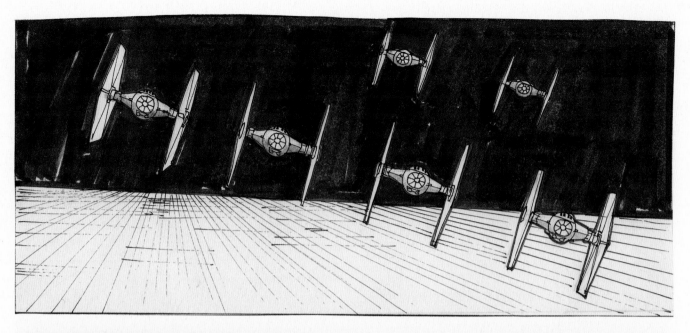

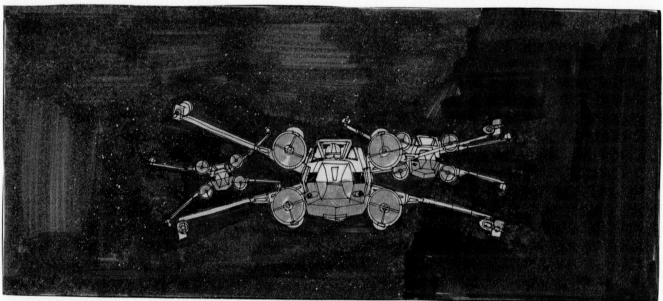

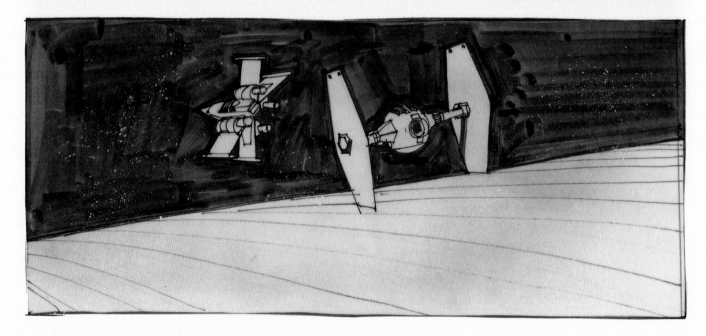

A squad of six TIE fighters attacks the X-wings. » Johnston

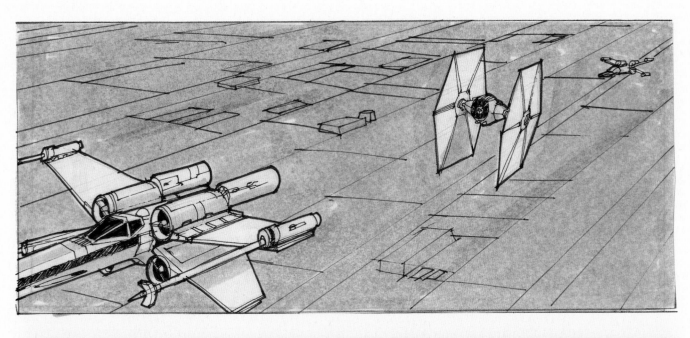

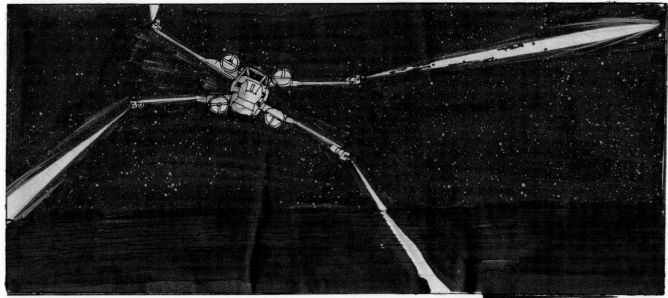

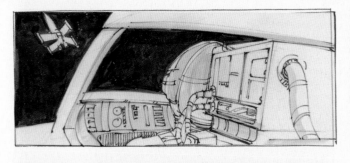

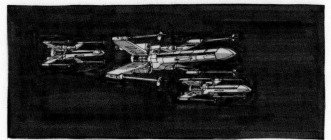

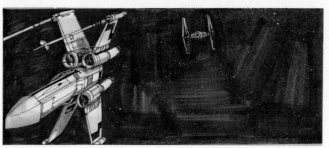

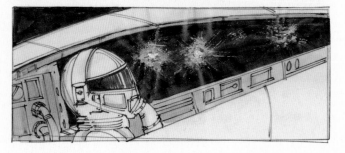

Luke races to the rescue of a fellow pilot as the dogfight intensifies. » Johnston, **R1:2**, **R3R**, **R4L**; Shepherd, **R3L**, **R4R**

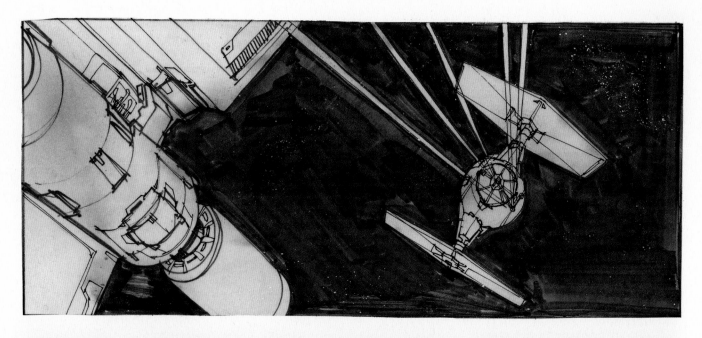

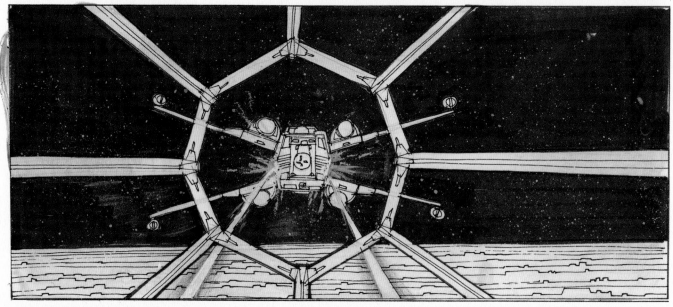

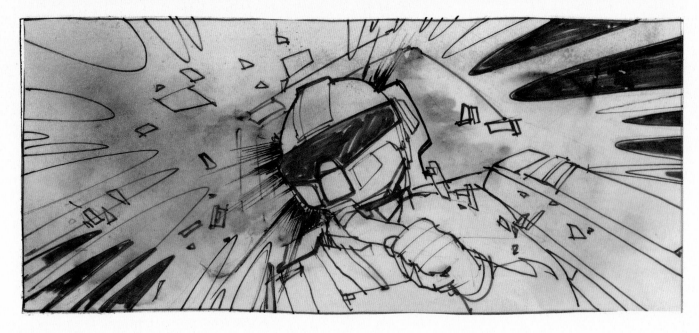

An X-wing is destroyed. » Johnston

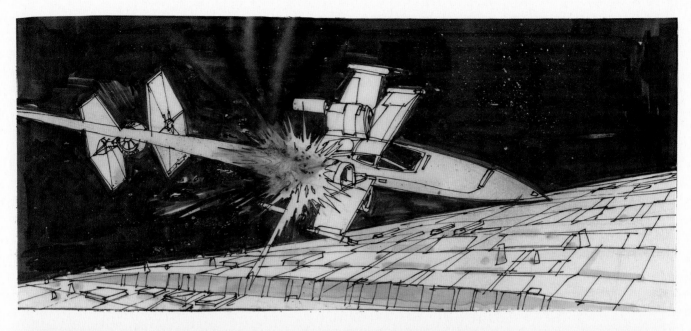

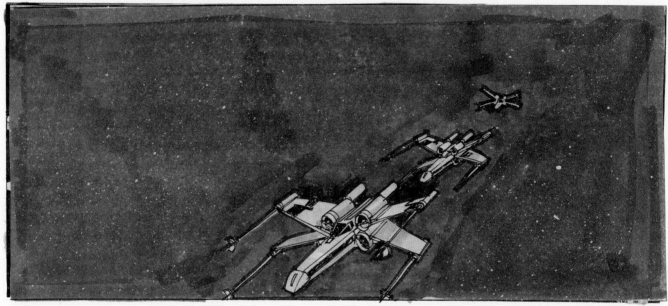

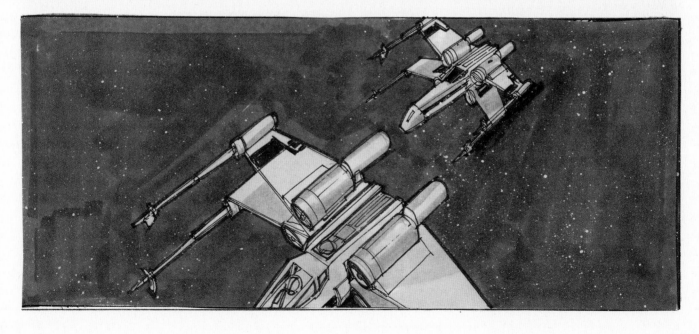

Another X-wing is crippled while a different squadron makes their attack run. » Johnston

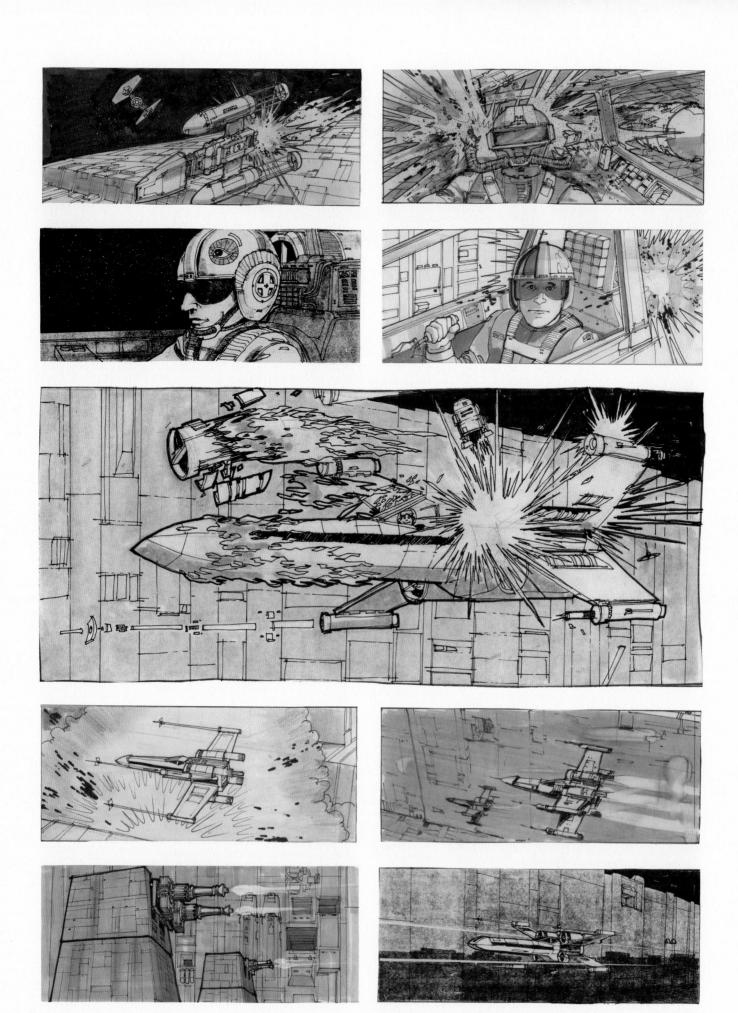

Gold Leader's ship explodes, while Luke (with an all-seeing eye on his helmet) attacks;
Red Ten is also killed (in a somewhat humorous board). » Johnston, **R1:3**, **R4L**, **R5R**; Myers, **R4R**, **R5L**

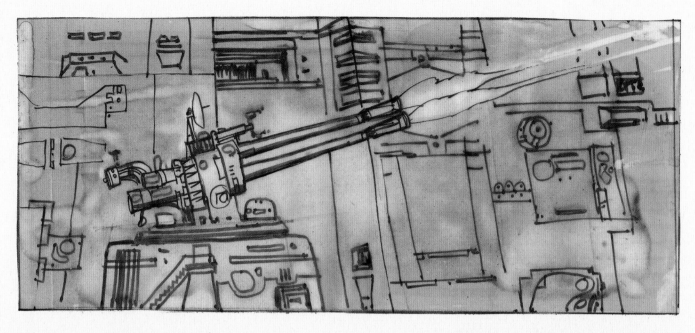

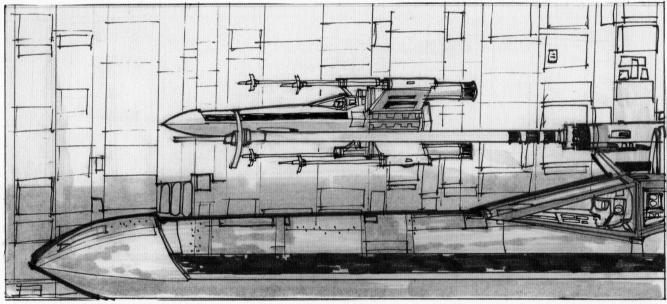

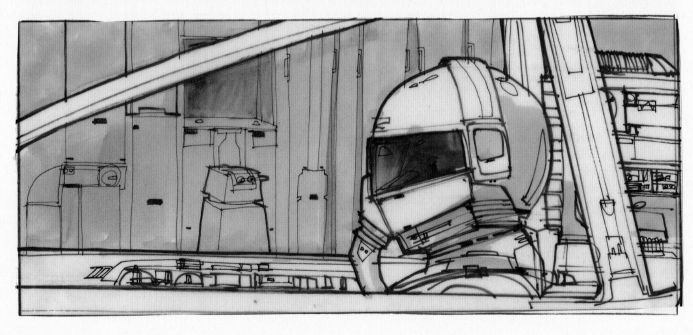

A gun tower (in an early design) fires at X-wings as they make their trench run. » Myers, **R1**; Johnston, **R2:3**
OVERLEAF: Darth Vader zeroes in on Luke Skywalker. » Johnston

'410 AP

OPTICAL:

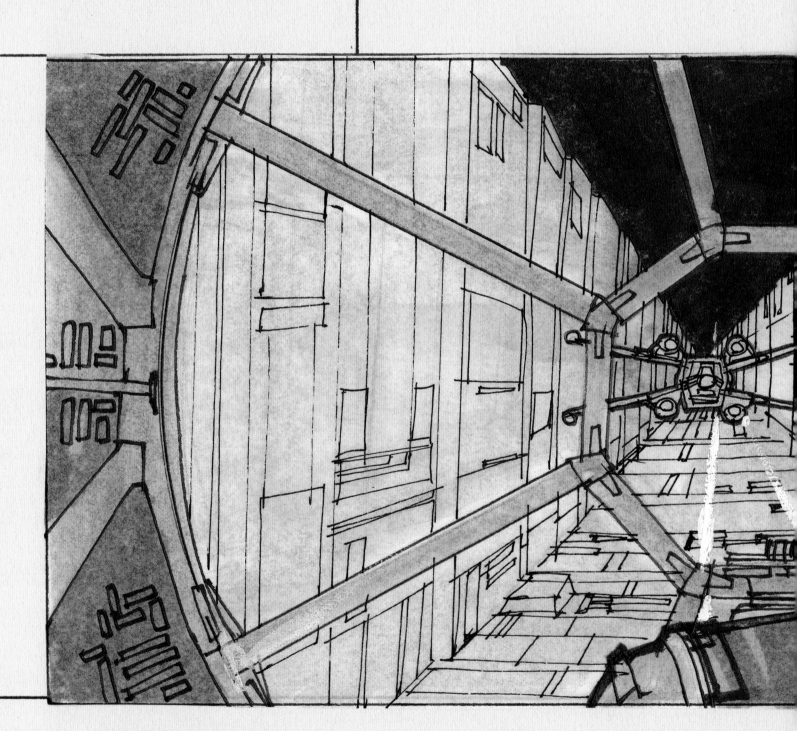

DESCRIPTION:

DIALOGUE:

POV OVER VADER'S SHOULDER OF I

DOWN TRENCH. VADER FIRES LAZ

LUKE

FRAME COUNT:	BOARD #
28	346A

LAZER

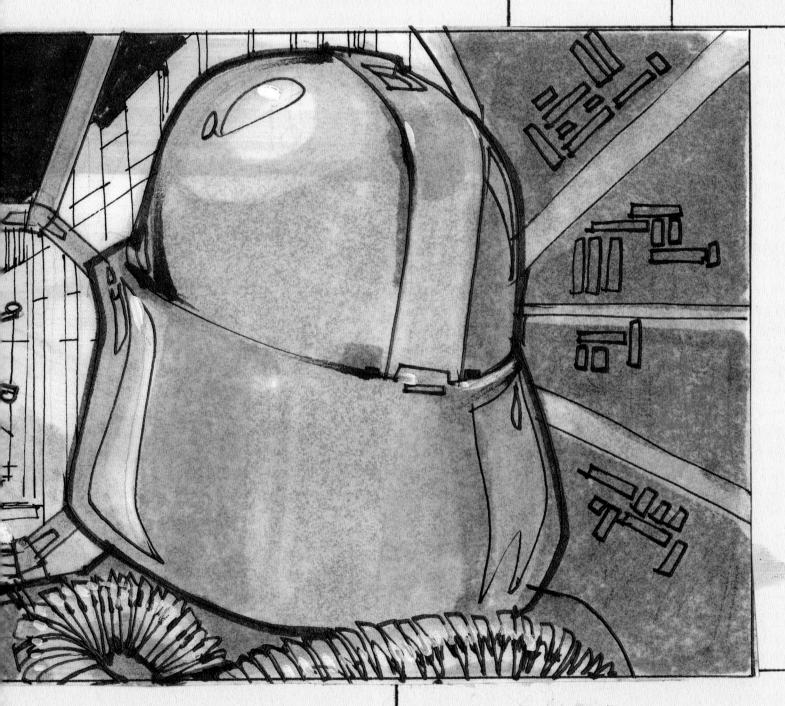

KE'S X WING FLYING AWAY
RS AT LUKE.

ROTO:

LAZER

SHOT #

409 AP

OPTICAL:

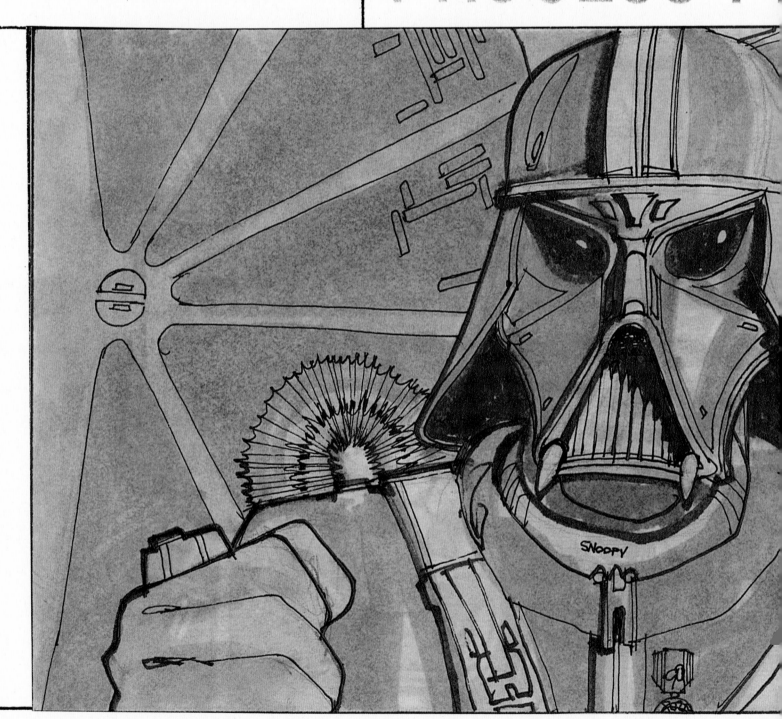

DESCRIPTION: CLOSEUP INTERIOR COCKPIT VADER.
TRENCH IN BACKGROUND.

DIALOGUE:

LAZERS

LUKE

ATE # 8

48

345 A

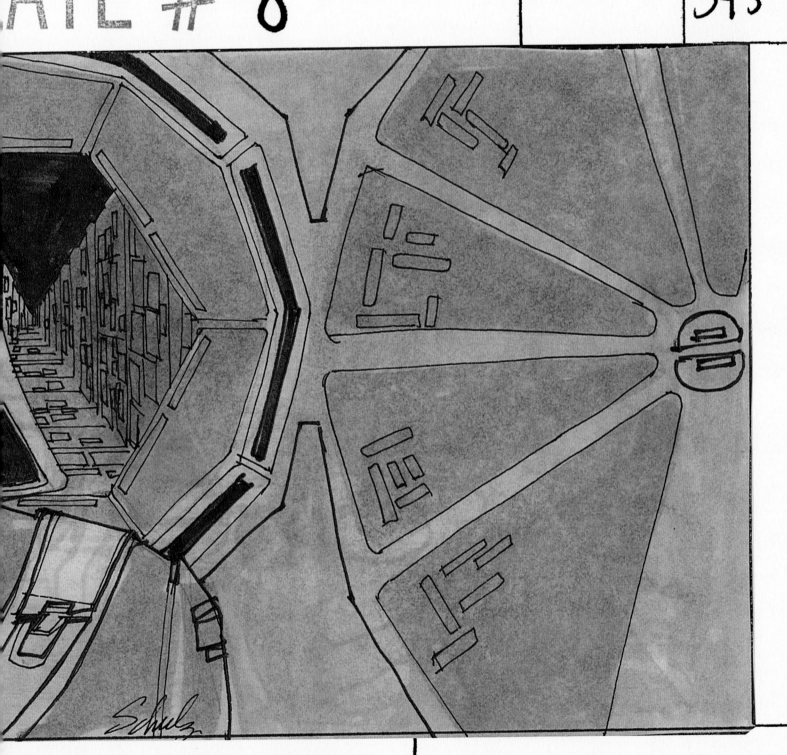

HEXAGONAL WINDOW REVEALS

ROTO:

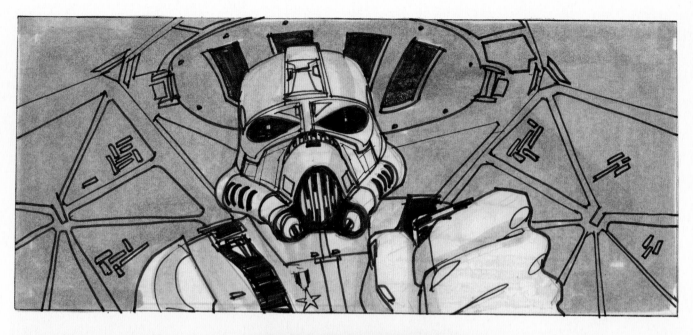

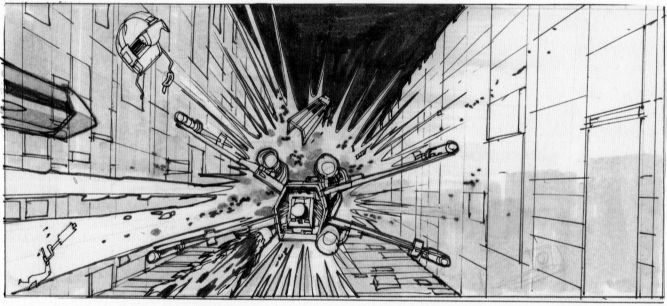

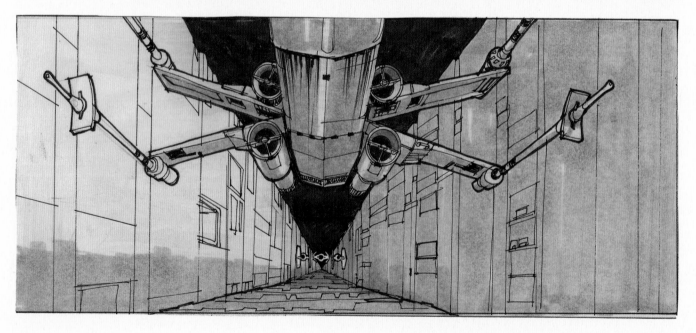

PREVIOUS SPREAD: A close-up of Vader in his TIE fighter. » Johnston
Vader destroys another X-wing, leaving only Luke. » Johnston

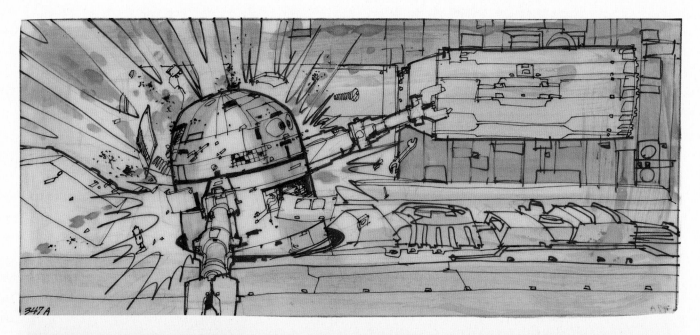

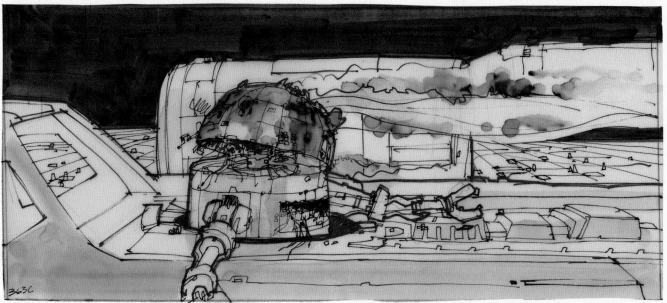

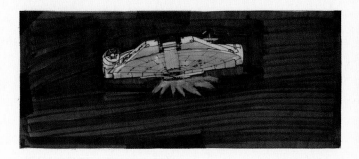

"The problem was that the storyboards kept changing and changing and there was pressure to produce finished storyboards sooner rather than later. Joe drew over forty complete boards in one day! In all my years in the effects business, I've never seen anyone else even come close to drawing that many. In addition, the composition and shot direction of the artwork elements had to tell a story from one board to another so it would make sense to the audience. Joe was exceptional at that!"

Steve Gawley

"I always had an aversion to repurposing older storyboards by making changes to them, something that would have saved lots of time. I usually elected to redraw the entire sequence. Late in the process, George made a bunch of changes to several sequences and the camera crews were waiting for boards for the final attack and trench run so they could keep cranking. One particular day I did forty boards, although I wasn't counting—that was just the highest output for a twelve-hour day."

Joe Johnston

Vader blasts R2, but is derailed at the last moment by Han in the *Falcon*. » Johnston
OVERLEAF: Unseen, the *Falcon* blasts one of Vader's wingmen. » Johnston

SHOT #

413

OPTICAL:

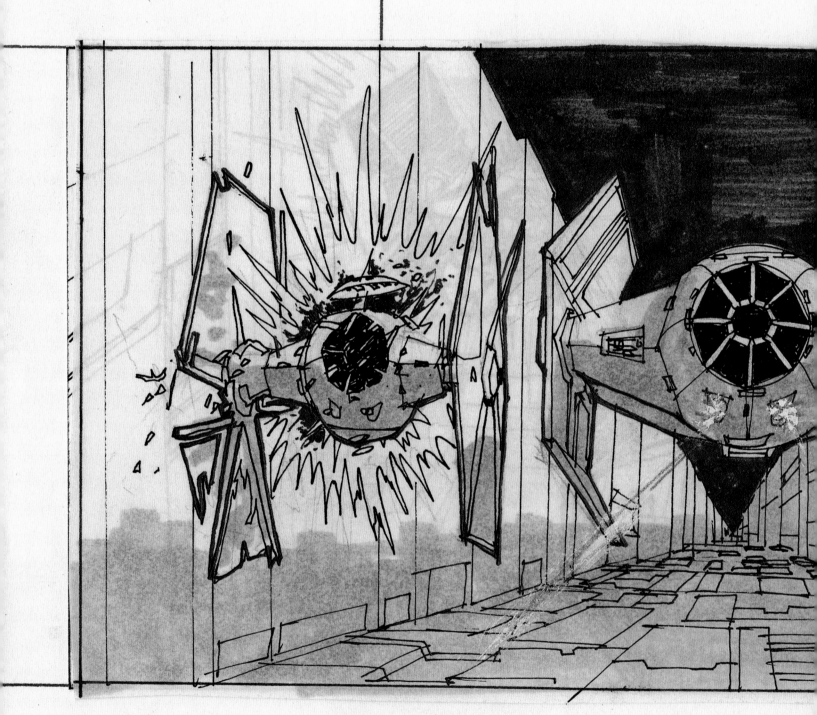

DESCRIPTION: TRACKING SHOT - TIE SHIP OF RIG
CAMERA EXPLODES. VADER STARTS FI
DIALOGUE: POSSIBLE USE 9-10 EXPOLSION. MAK
USE TRENCH AT 90% SPEED. SHIPS (

LUKE

FRAME COUNT: | BOARD #

61 | 349

LAZER

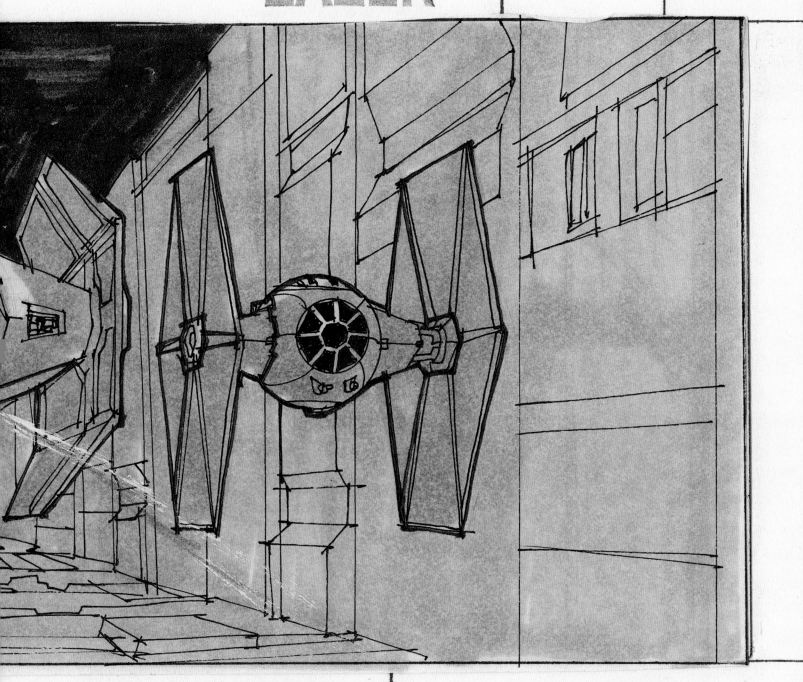

ROTO: LAZER

T AS SHIPS HEAD TOWARD
NG HIS LAZERS.
LIGHT EFFECT IN TRENCH.
IE) GAIN ONLY SLIGHTLY.

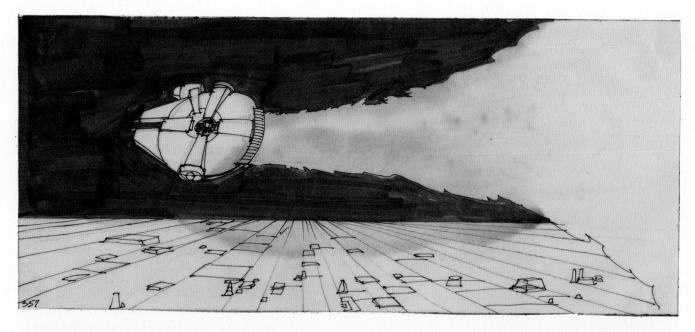

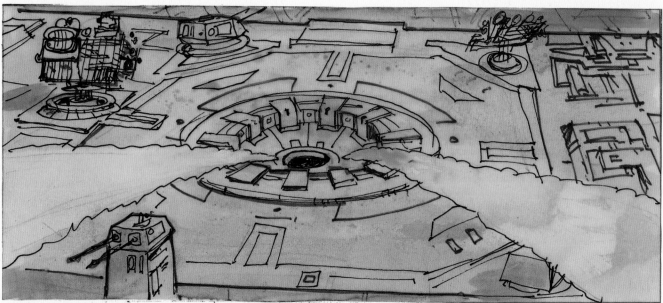

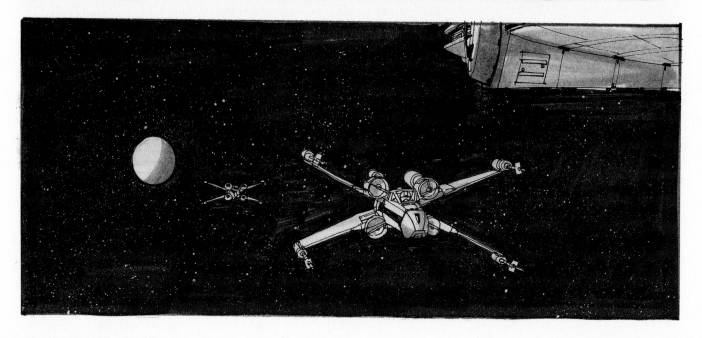

Luke's torpedoes enter the exhaust port. » Johnston, **R1**, **R3**; Myers, **R2**

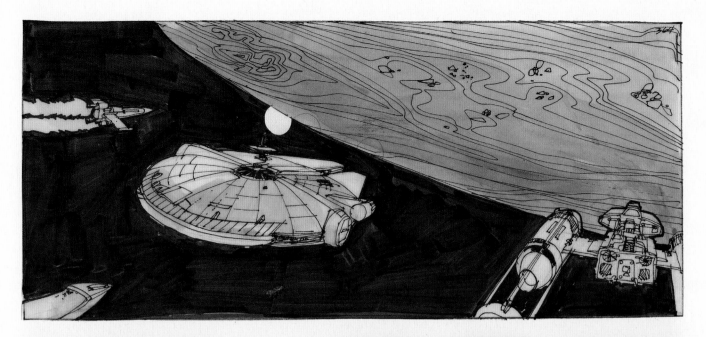

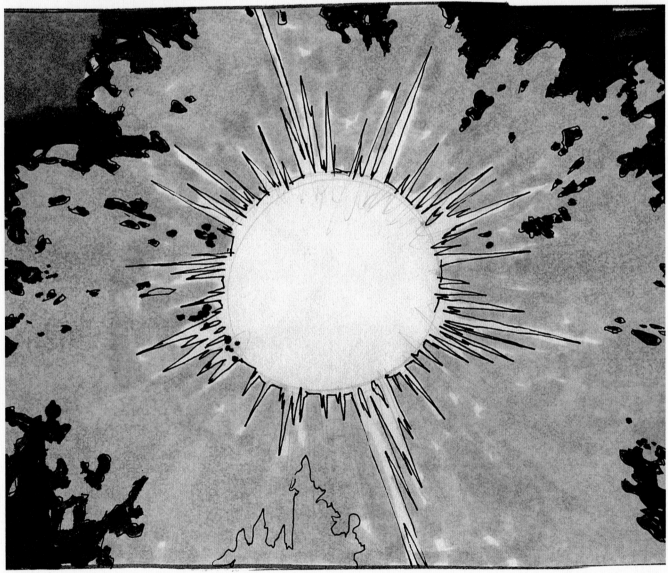

"I didn't attend the crew screening; I just saw it at a local theater in Los Angeles—and I was amazed."

Alex Tavoularis

When the Death Star explodes, what's left of the rebel fleet is heading back to Yavin 4. » Johnston
OVERLEAF: The heroes enter the throne room, victorious. » Johnston

DISNEY

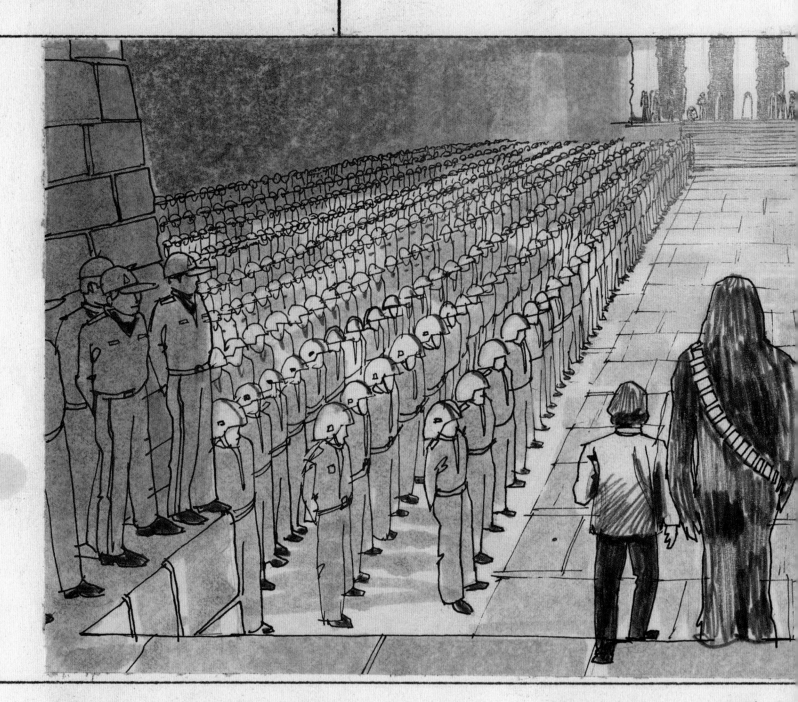

DESCRIPTION: GREAT HALL - TROOPS FAC

DIALOGUE:

This board is marked "Disney" because matte painter Harrison
Ellenshaw ran the matte department there (he was freelancing
from Disney for *Star Wars*).

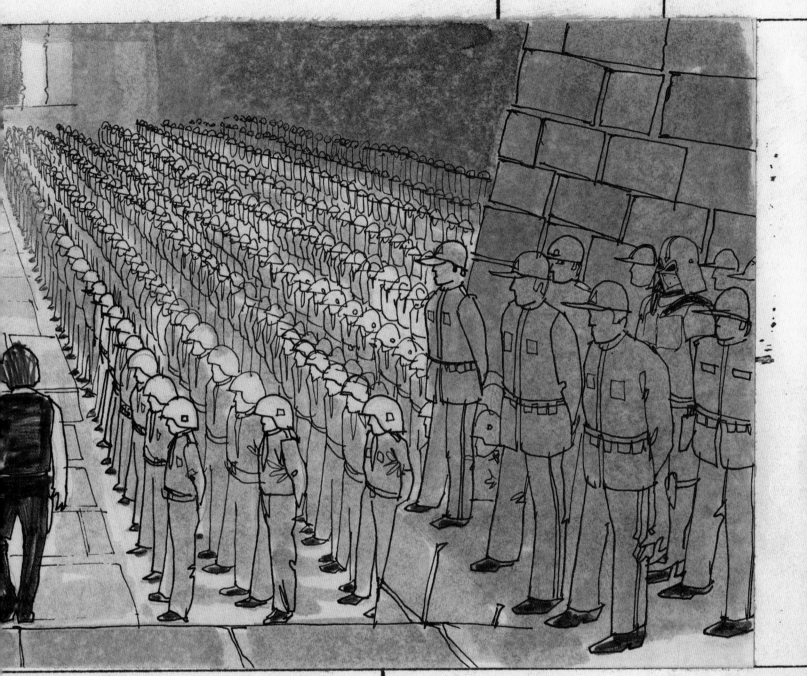

ROTO:

"Joe had a flute and I bought a clarinet at a pawnshop, so, after most people had gone home, we would turn the stereo up loud at night and play along, filling the Van Nuys warehouse with ungodly noise—and was that ever fun!"

Paul Huston

STAR WARS: EPISODE V

THE EMPIRE
STRIKES BACK

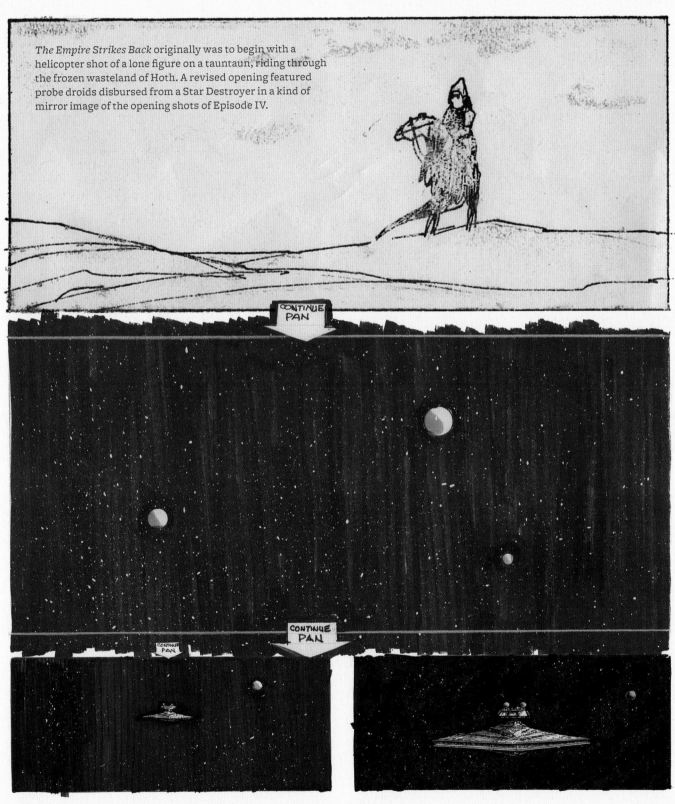

The Empire Strikes Back originally was to begin with a helicopter shot of a lone figure on a tauntaun, riding through the frozen wasteland of Hoth. A revised opening featured probe droids disbursed from a Star Destroyer in a kind of mirror image of the opening shots of Episode IV.

Luke observes a bright falling object while scouting on his tauntaun. A Star Destroyer appears. » McQuarrie, **R1:2**; Dave Carson, **R3:4**

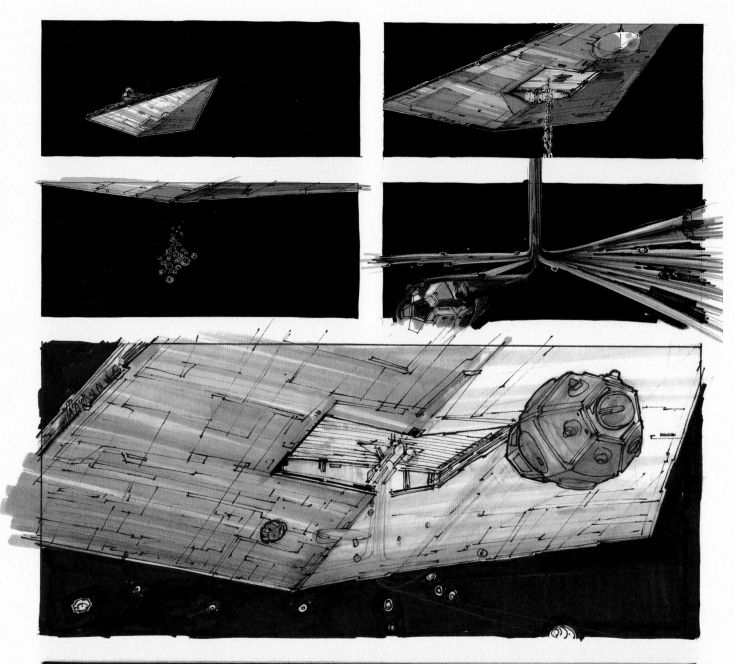

"It was a pretty big thrill to find myself working on the sequel to Star Wars, as I had only been working in the film business for a short time [in Burbank]. After my first week or so in the Model Shop, Joe Johnston found out that I had done some storyboarding before joining ILM and asked if I could help out for a couple of weeks."

Dave Carson

A third revision had "pods" blasting out of a Star Destroyer. » Carson

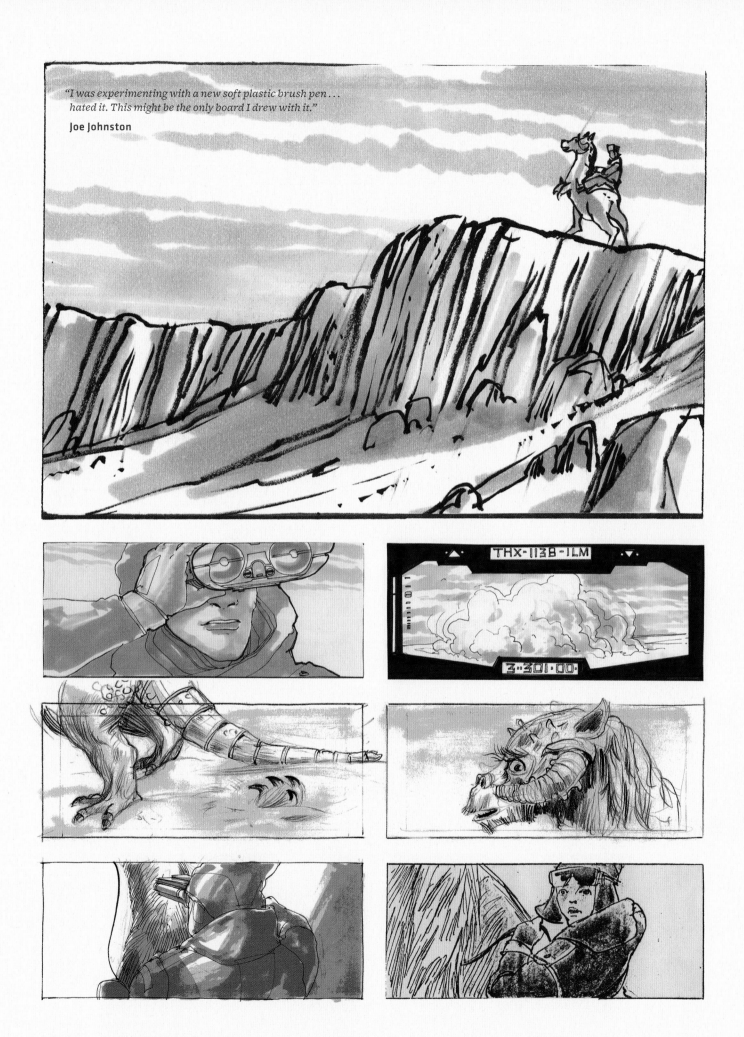

"I was experimenting with a new soft plastic brush pen... hated it. This might be the only board I drew with it."
Joe Johnston

THX-1138-ILM

3·301·00·

Luke spots something crashing to earth, while something else is sneaking up on him. » Johnston, **R1**, **R2**, **R4L**; Beddoes, **R3**; McQuarrie, **R4R**

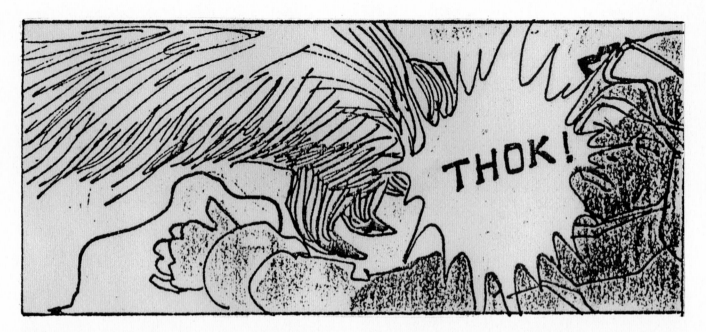

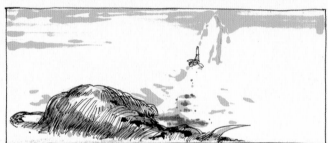

Concept illustrator Ralph McQuarrie also drew storyboards while he was working with director Irvin Kershner and Ivor Beddoes during principal photography at Elstree Studios.

With a comic book–style *Thok!* Luke is felled and dragged off by a wampa ice creature, leaving behind the "grotesque shape" of a tauntaun corpse. » McQuarrie, **R1**; Johnston, **R2**

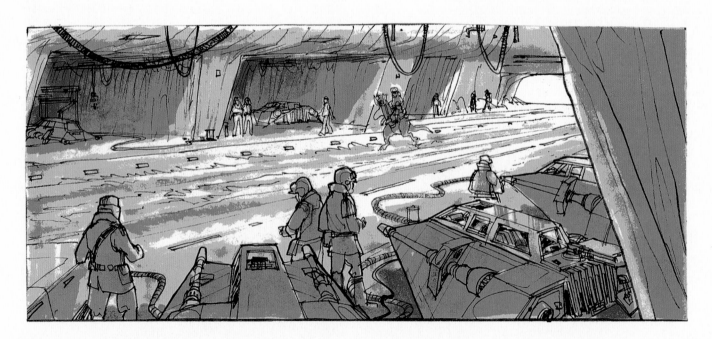

"I think everyone who worked in the art department felt supported in what they were doing. I didn't want to feel like anyone's 'boss' even though, technically, I was in charge."

Joe Johnston

Han on tauntaun enters the rebel hangar and reins to a stop. » Johnston

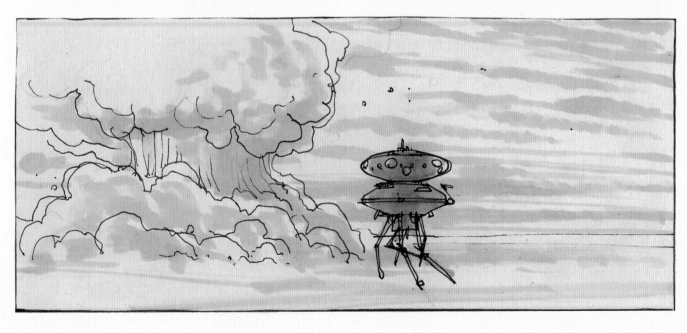

An evil "probe robot" (or "probot") rises from its crater and then blasts a bellowing wampa to smithereens. » Johnston

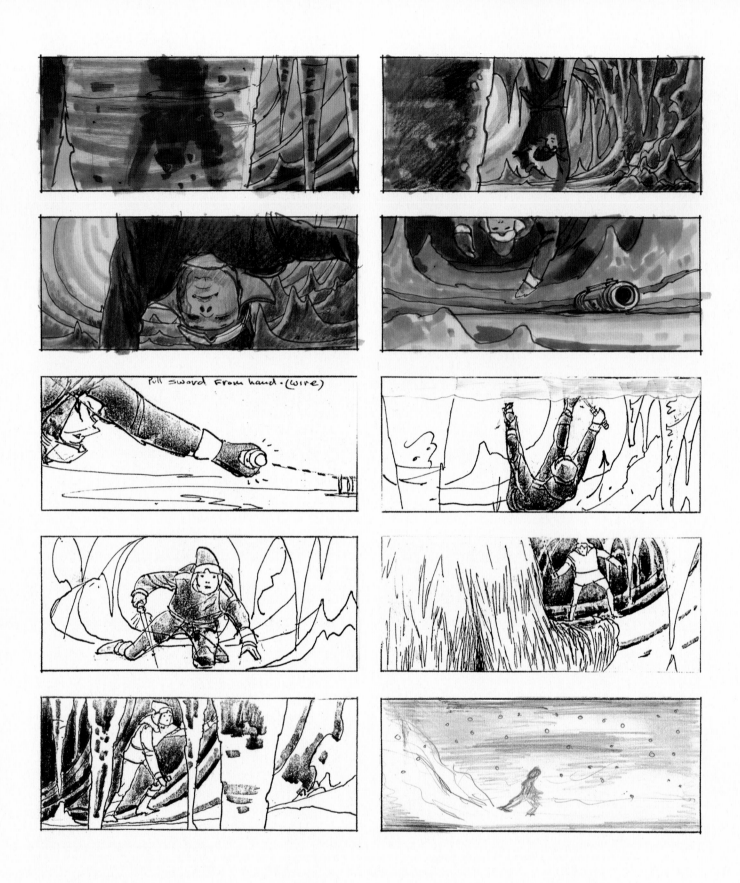

Pull sword from hand. (wire)

Suspended upside down in the wampa's lair, Luke is at first seen through an icicle; using the Force, he retrieves his lightsaber and is able to escape. » McQuarrie, **R1:4**, **R5L**; Beddoes, **R5R**

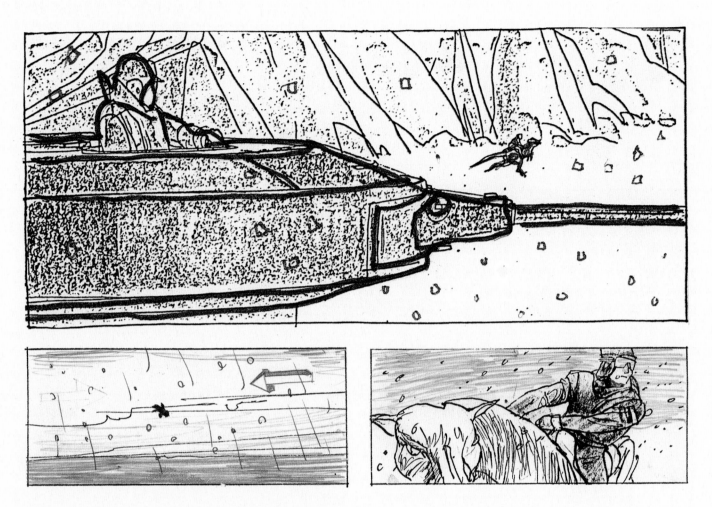

Han on tauntaun goes out in search of Luke. » Beddoes/McQuarrie

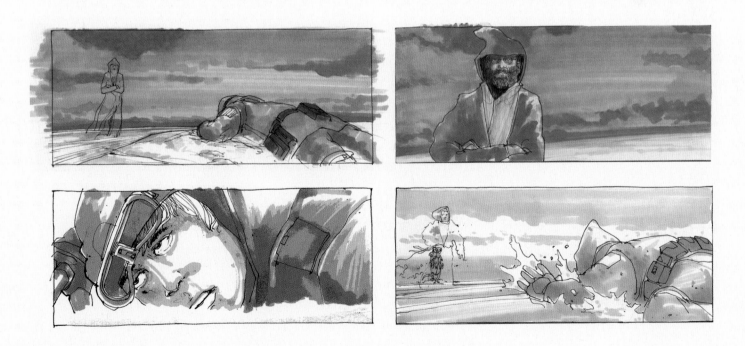

Lying in the snow, Luke sees the spirit of Ben Kenobi, who has helped guide Han Solo to Luke's rescue (mixed iterations); Ben tells Luke to seek out a mysterious Jedi known as Yoda. » Johnston

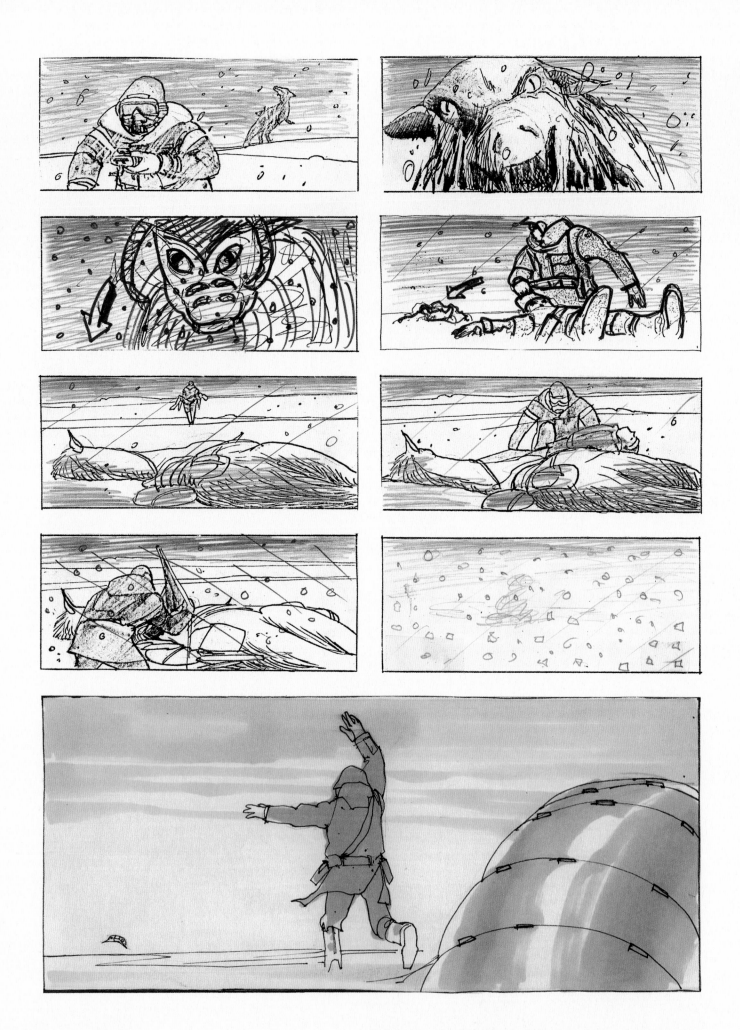

Han's tauntaun dies from exposure, so Han keeps Luke warm by shoving him into the poor beast's innards. » Beddoes/McQuarrie, **R1:4**; Johnston, **R5**

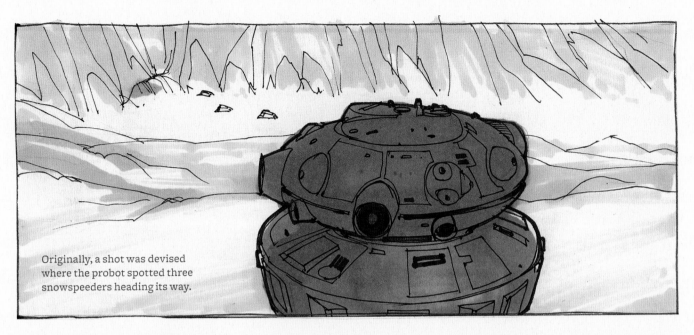

Originally, a shot was devised where the probot spotted three snowspeeders heading its way.

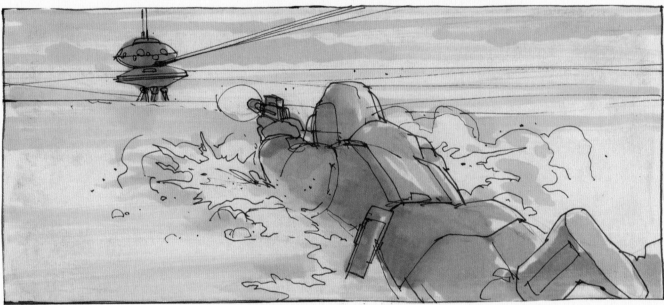

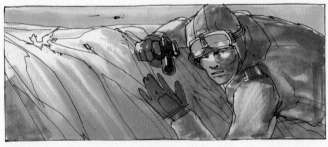

During a shootout with Han and Chewie, the probot self-destructs (various iterations). » Johnston, **R1:3**; Beddoes/McQuarrie, **R4**

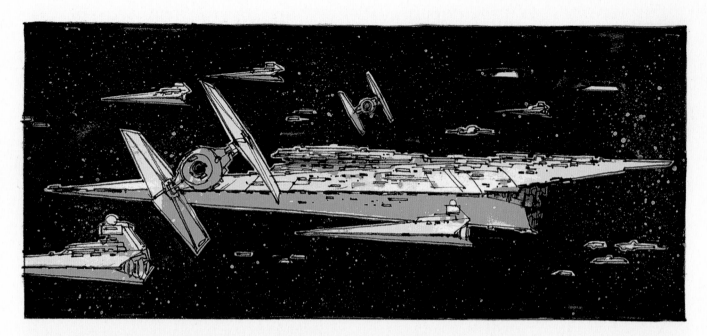

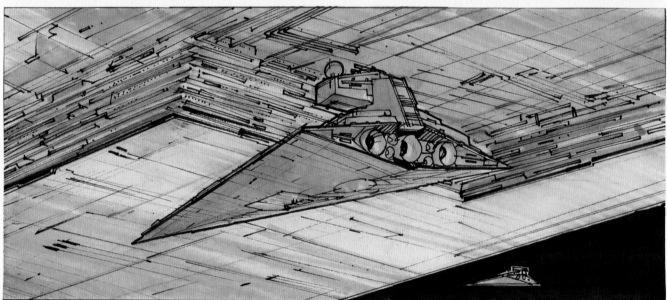

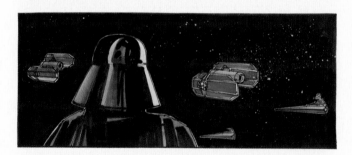

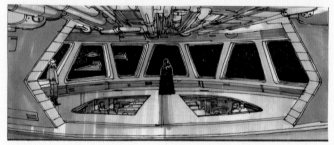

"Like me, Nilo was a designer first, storyboard artist second—but he took to it quickly, like any good visualist. When crunch time came, Nilo was a machine. We would often get an assembly line going where we would each take pieces of a sequence."

Joe Johnston

Vader's "Stardestroyer" or Super Star Destroyer is "larger and stranger" than its companion ships, as the Imperial fleet assembles before its attack on Hoth. » Rodis-Jamero

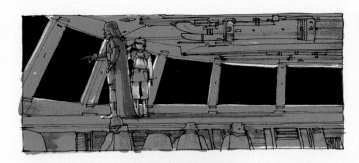 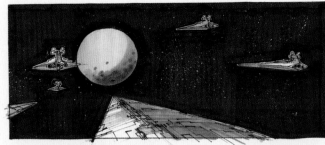

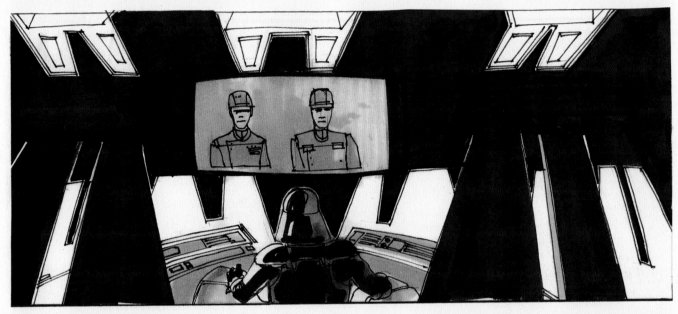

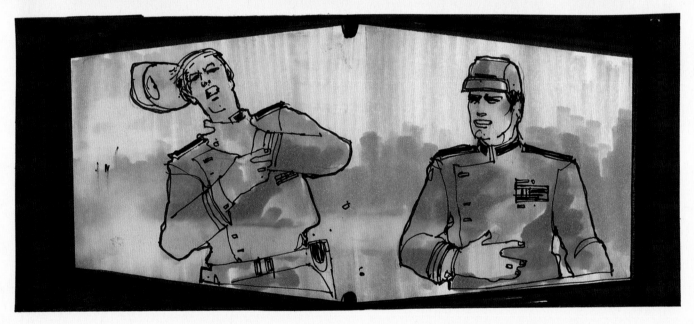

The elements listed on one storyboard **[R2]** consist of a VistaVision plate with "reduction" and a screen insert with "texture overlay."

"Sometimes I can't tell my boards from Joe's."

Nilo Rodis-Jamero

Within his meditation pod, Darth Vader uses the Force to strangle an admiral who has displeased him. » Rodis-Jamero

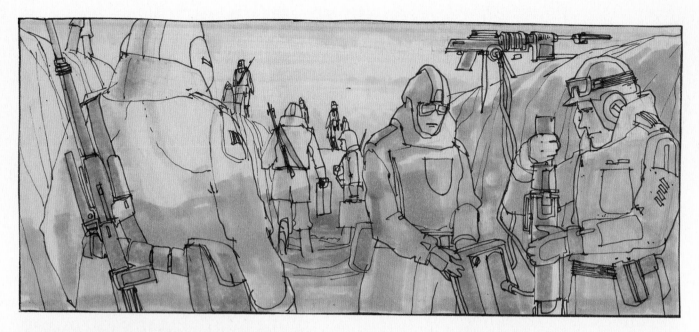

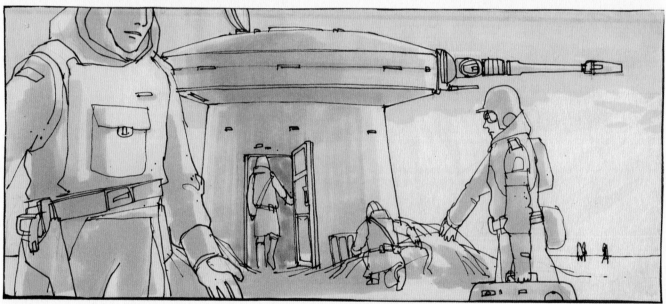

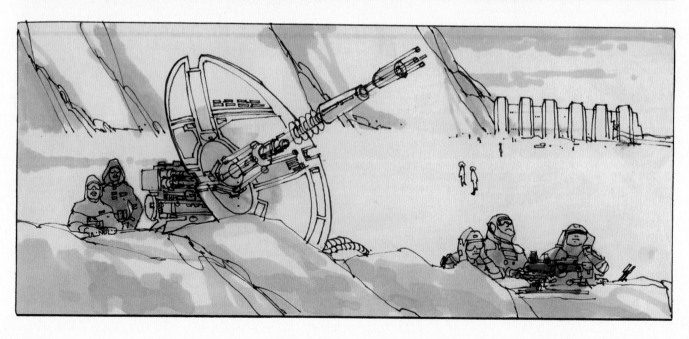

Rebel troops prepare for the Imperial attack; the power generator [R3] was originally going to have "long fingers of energy" flying off its huge cores. » Johnston, R1:2; Rodis-Jamero, R3

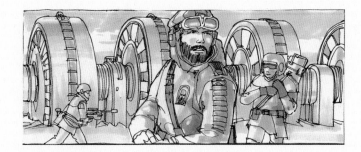

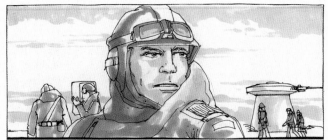

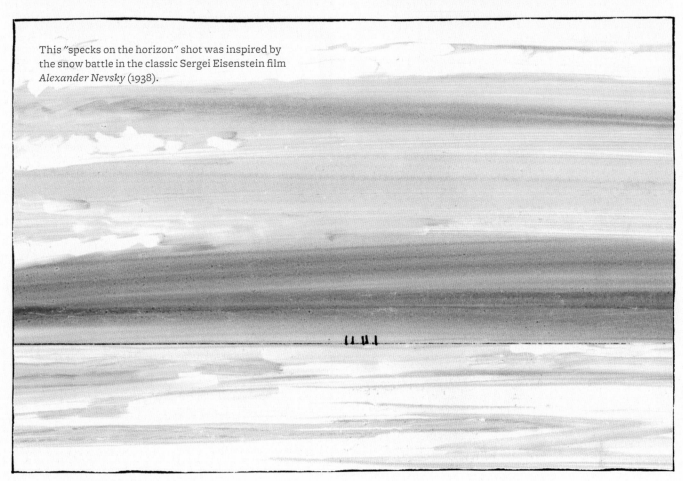

This "specks on the horizon" shot was inspired by the snow battle in the classic Sergei Eisenstein film *Alexander Nevsky* (1938).

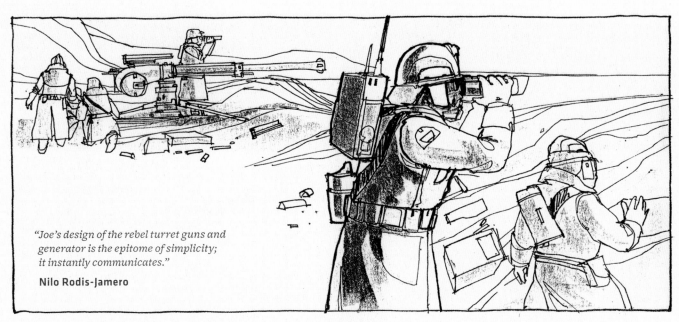

"Joe's design of the rebel turret guns and generator is the epitome of simplicity; it instantly communicates."

Nilo Rodis-Jamero

A *thump, thump, thump* sound is heard and all work stops, as rebel troops use their "electro binocs" to espy tiny dots on the horizon. » Johnston

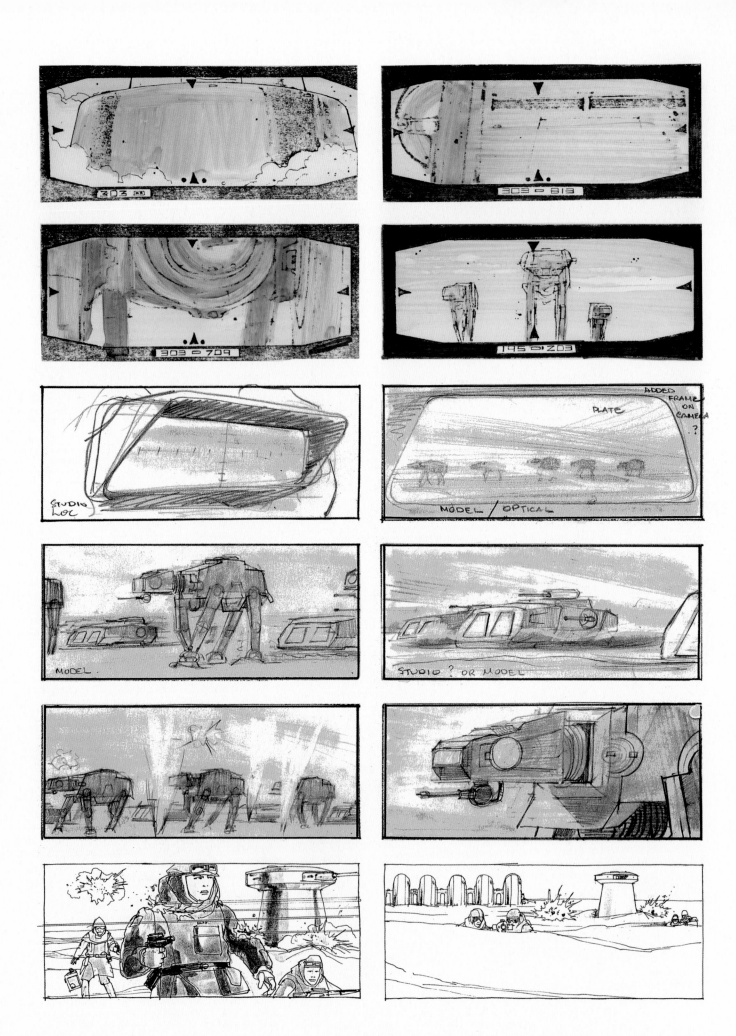

The Imperial walkers are spotted and the battle of Hoth begins (one trooper is hit by laser fire). » Johnston **R1:2**, **R6L**; Beddoes **R3:5**; Rodis-Jamero, **R6R**

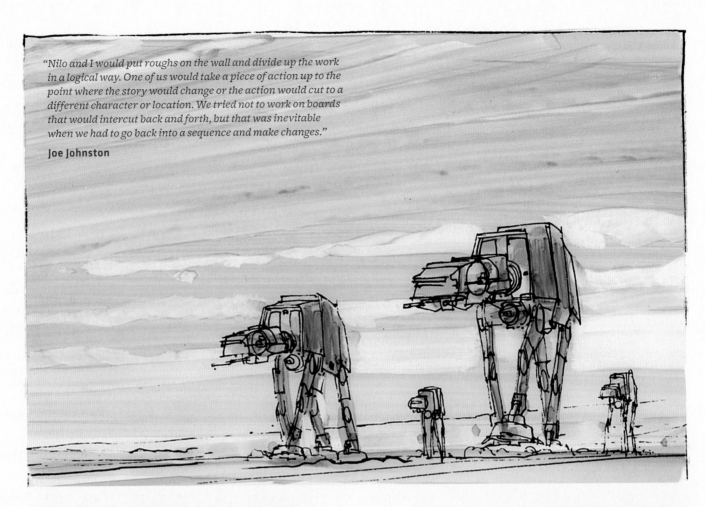

"Nilo and I would put roughs on the wall and divide up the work in a logical way. One of us would take a piece of action up to the point where the story would change or the action would cut to a different character or location. We tried not to work on boards that would intercut back and forth, but that was inevitable when we had to go back into a sequence and make changes."

Joe Johnston

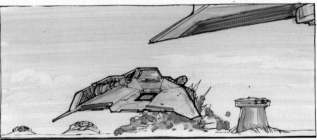

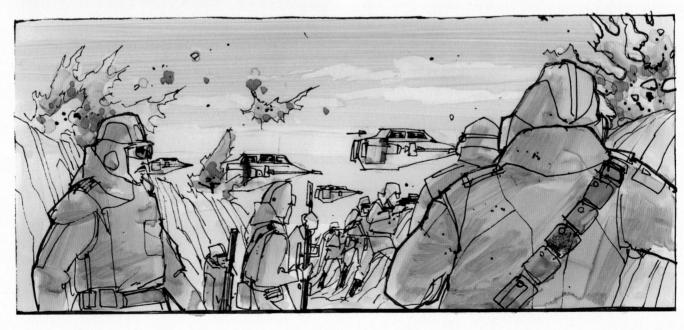

The Rebel Alliance sends in snowspeeders for the counterattack. » Johnston, **R1**, **R3**; Rodis-Jamero, **R2**

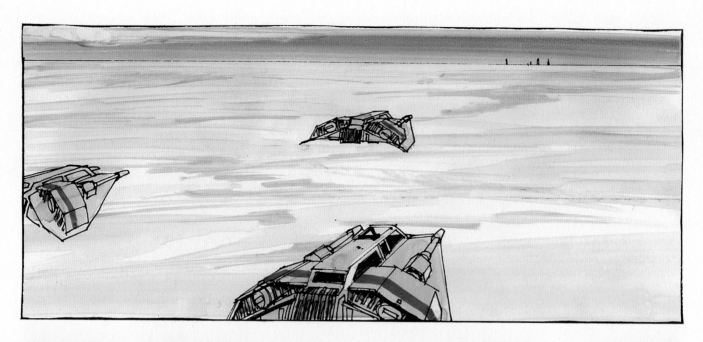

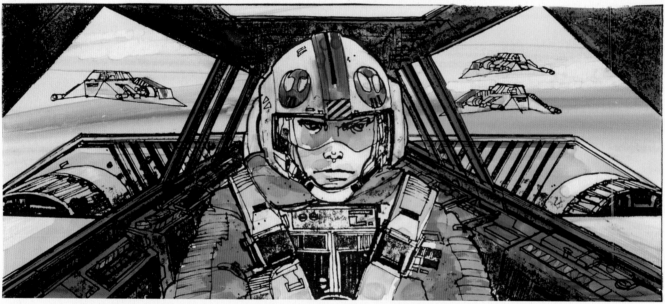

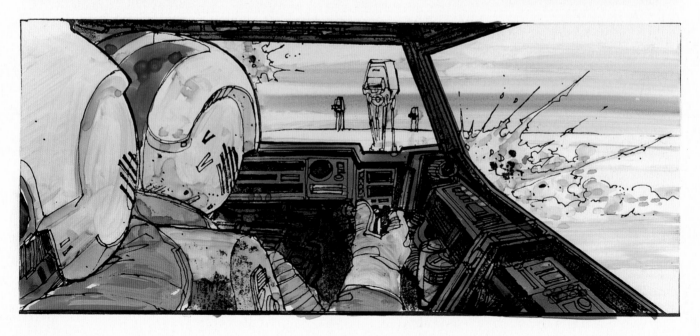

Luke leads his squadron against the walkers, but the "monstrous machines"
fire back, shaking the speeders in a hail of flak. » Rodis-Jamero

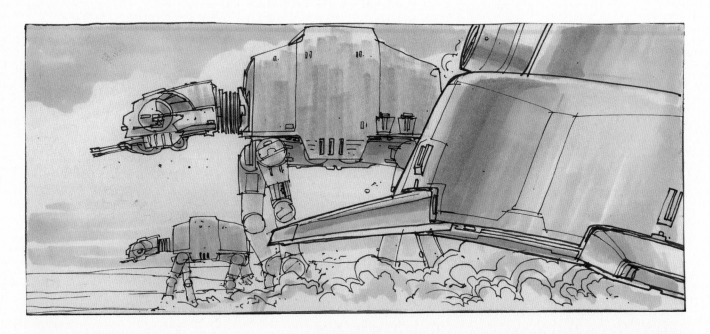

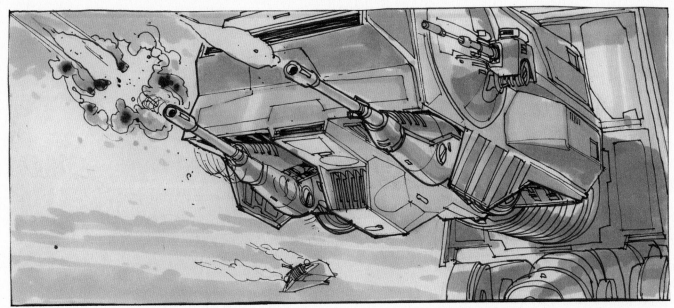

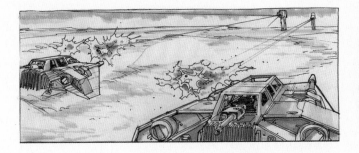

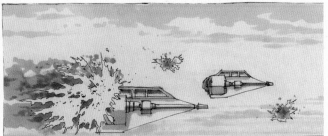

"One thing I noticed that was very interesting is that in some of the sequences where the book is cherry-picking boards from different versions and different artists, it becomes clear that the storyboarding process is spanning the design process and, in many cases, the script writing process. I noticed it most clearly in the Battle for Hoth sequence."

Joe Johnston

One of the rebel snowspeeders is hit and erupts into a ball of fire. » Johnston

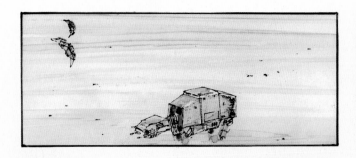

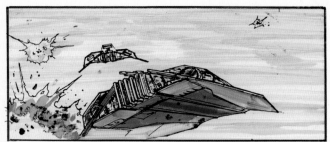

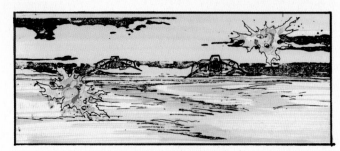

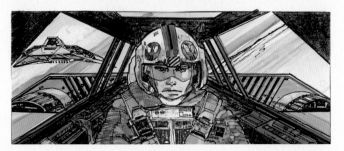

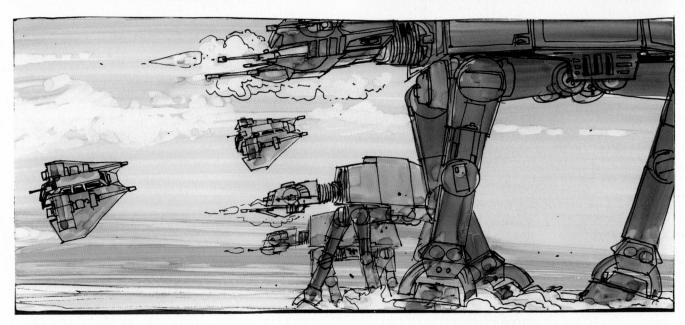

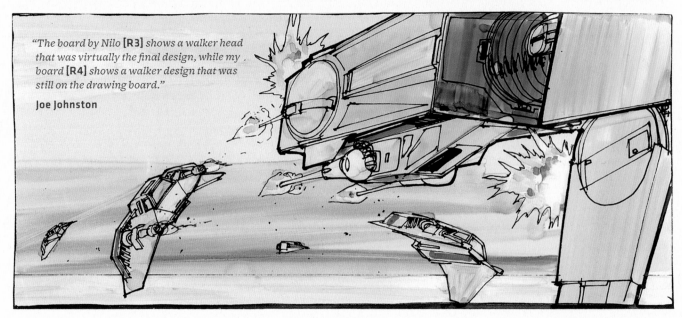

"The board by Nilo [R3] shows a walker head that was virtually the final design, while my board [R4] shows a walker design that was still on the drawing board."

Joe Johnston

Luke and Hobbie fly their snowspeeders right at the walkers, but their cannon fire cannot penetrate the Imperial armor. » Rodis-Jamero, **R1:3**, Johnston, **R4**

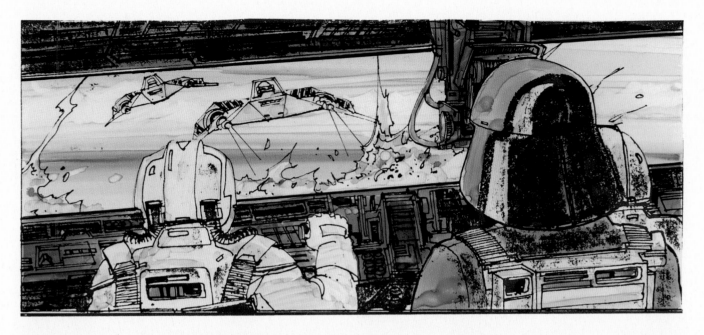

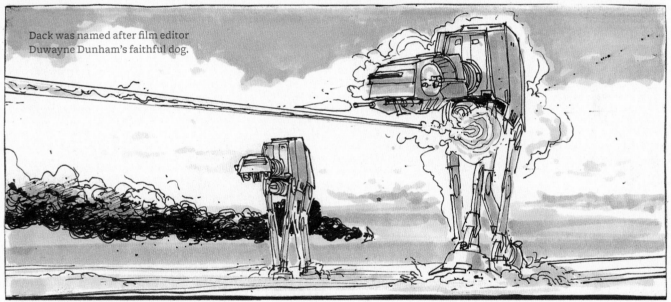

Dack was named after film editor Duwayne Dunham's faithful dog.

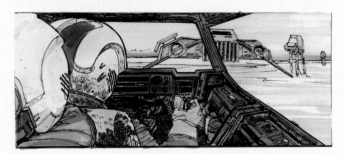

Luke's gunner, Dack, is zapped by a laser bolt, while Wedge prepares to attack another walker. » Rodis-Jamero, **R1,R3:4**; Johnston, **R2**

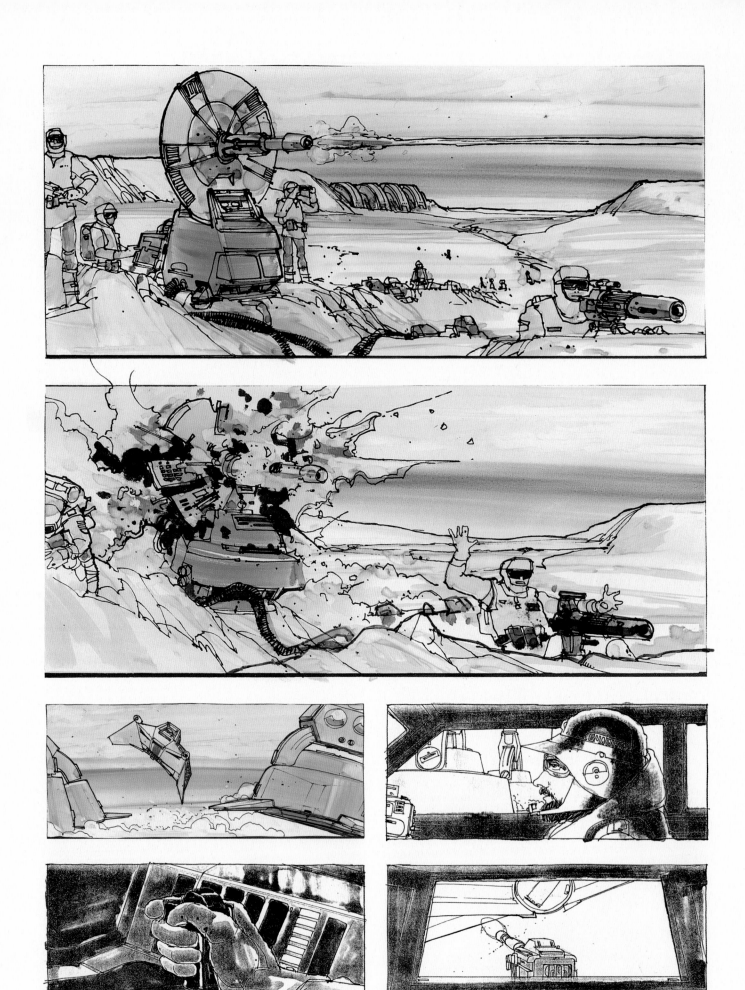

The rebels' "dish ray gun" is obliterated in a huge explosion; a rebel gunner fires his harpoon at the receding leg of a walker. » Rodis-Jamero, **R1:2**; Johnston, **R3:4**

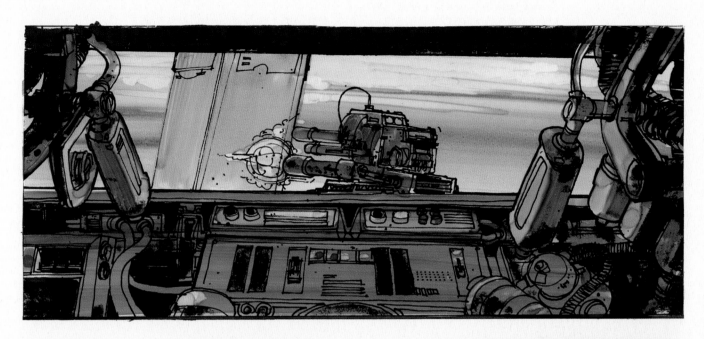

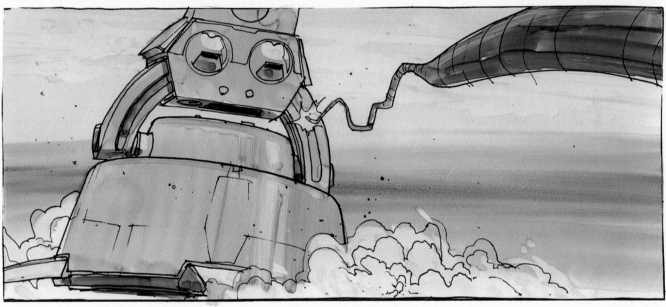

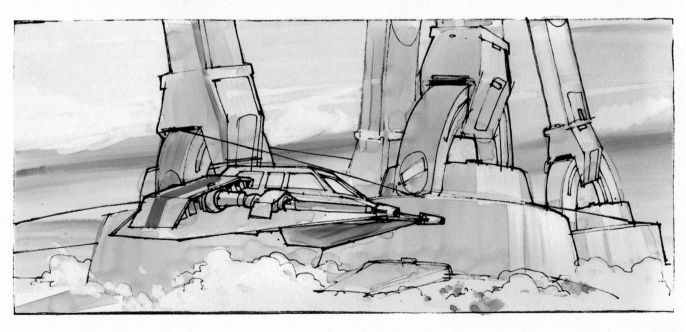

A later iteration shows the harpoon rope flashing out of the gun and making contact, with the snowspeeder then circling the walker's feet. » Rodis-Jamero, **R1**; Johnston, **R2:3**

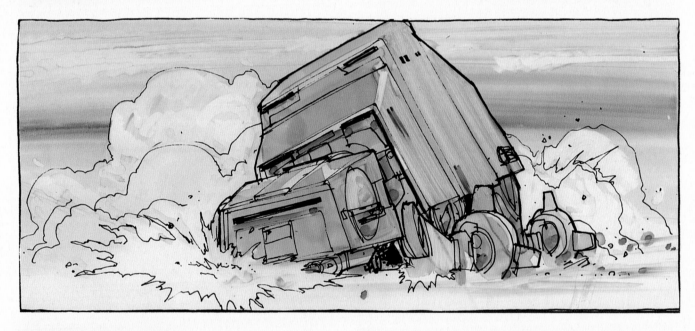

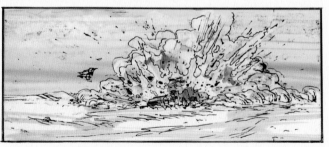

One walker is tripped up and then blown to bits. » Johnston

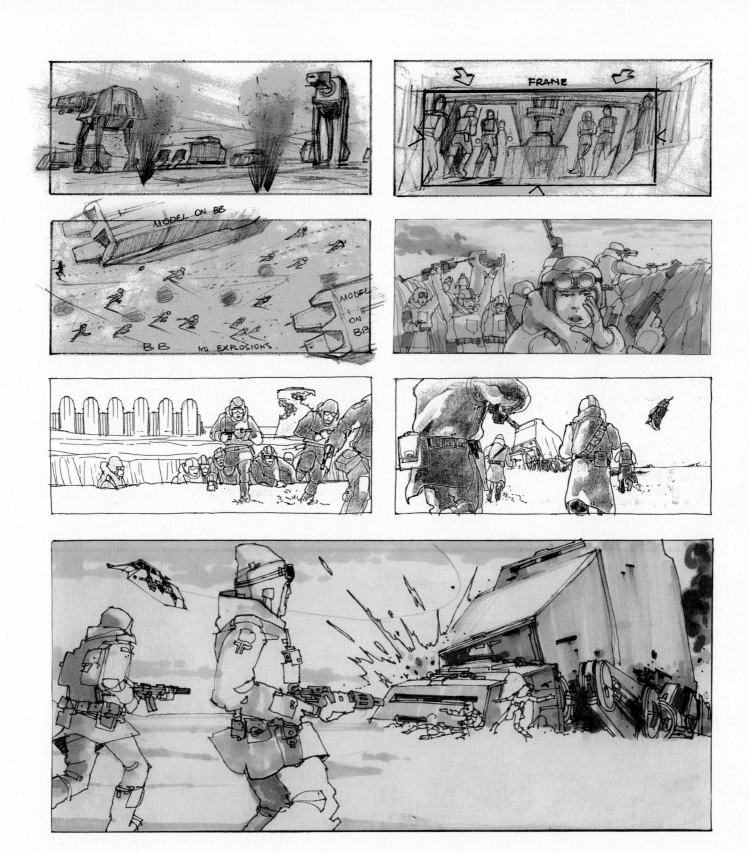

"Both Joe and Nilo were such good artists, it was a little intimidating working with them. But I remember it as a very exciting time. In particular, the snowspeeders were really difficult to draw in perspective, and I redrew them many times trying to get them right. Joe and Nilo seemed to be able to just turn them out effortlessly."

Dave Carson

Snowtroopers emerge from transports, while, in a variation, rebel ground troops finish off a tripped-up walker with laser fire. » Beddoes, **R1**, **R2L**; Johnston **R2R**, **R3**; Rodis-Jamero, **R4**

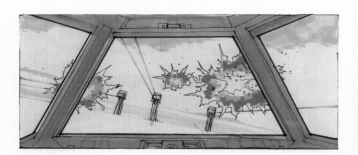
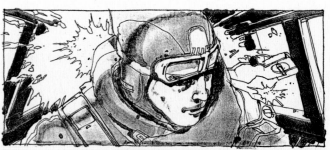
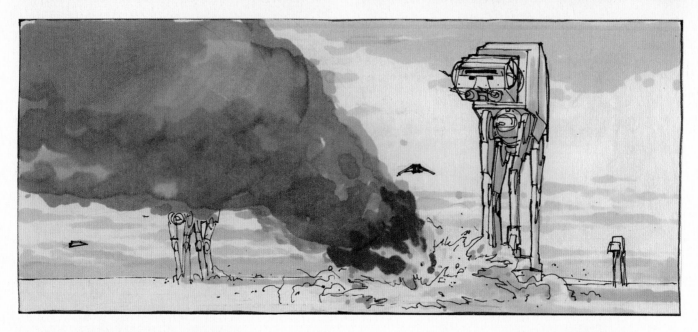
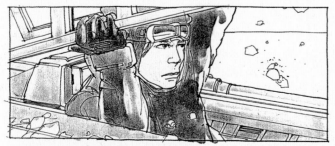
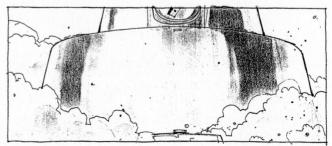
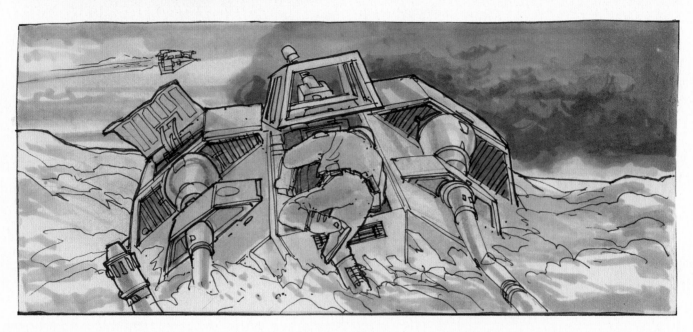

Luke's snowspeeder is shot down; he must then retrieve a "landmine"
from his smoking vehicle before a walker crushes him. » Johnston

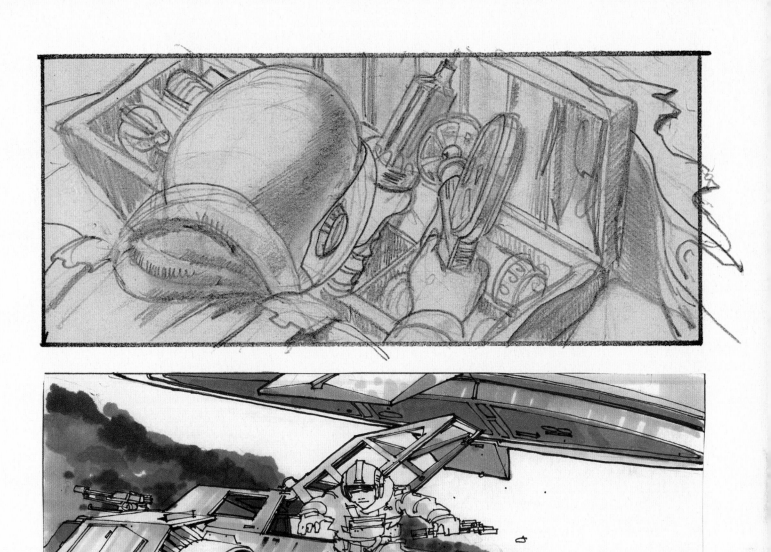

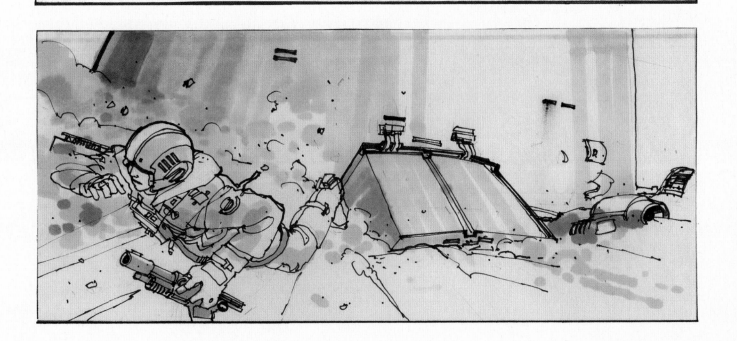

Luke jumps clear of his crippled snowspeeder at the last moment. » Beddoes, **R1**; Rodis-Jamero, **R2:3**

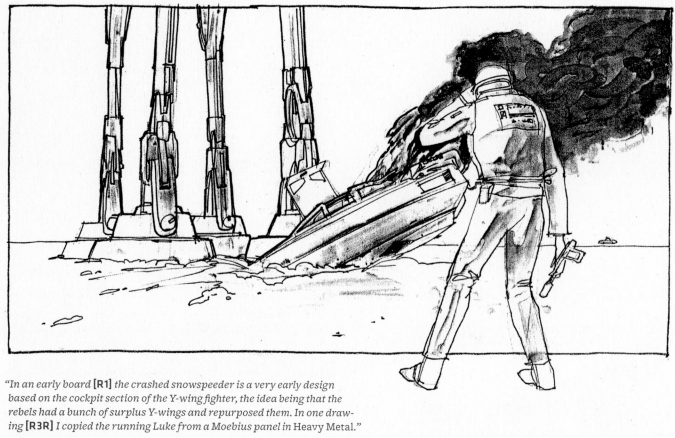

"In an early board [R1] the crashed snowspeeder is a very early design based on the cockpit section of the Y-wing fighter, the idea being that the rebels had a bunch of surplus Y-wings and repurposed them. In one drawing [R3R] I copied the running Luke from a Moebius panel in Heavy Metal."

Joe Johnston

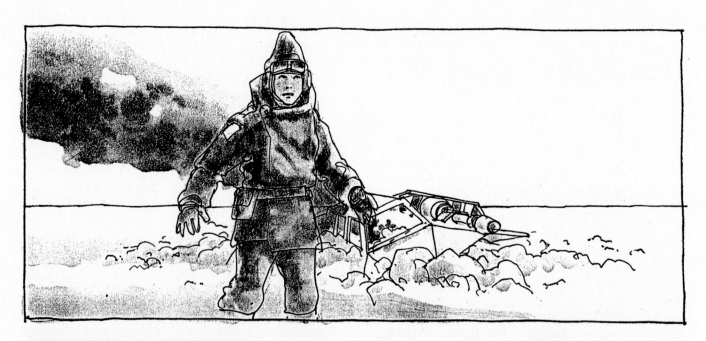

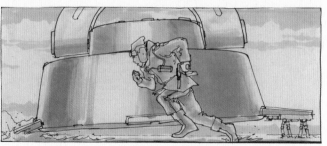

Surveying the wreckage, Luke sees a walker close by . . . » Johnston

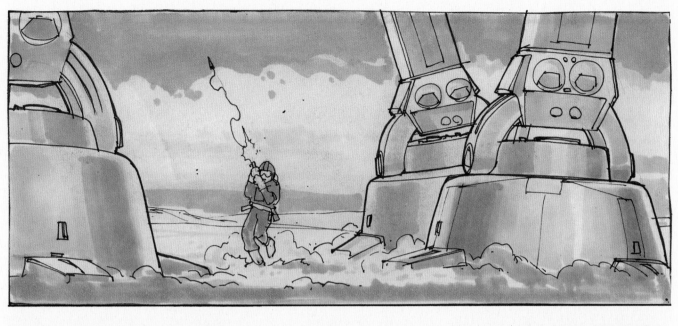

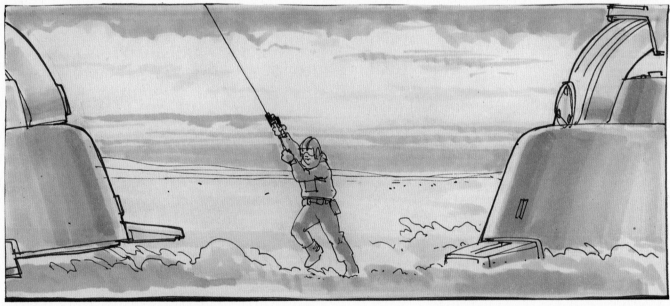

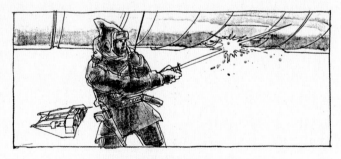

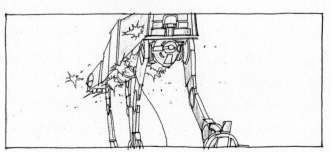

. . . and uses his cable gun to pull himself up; he then tosses in a landmine and watches the walker explode. » Johnston

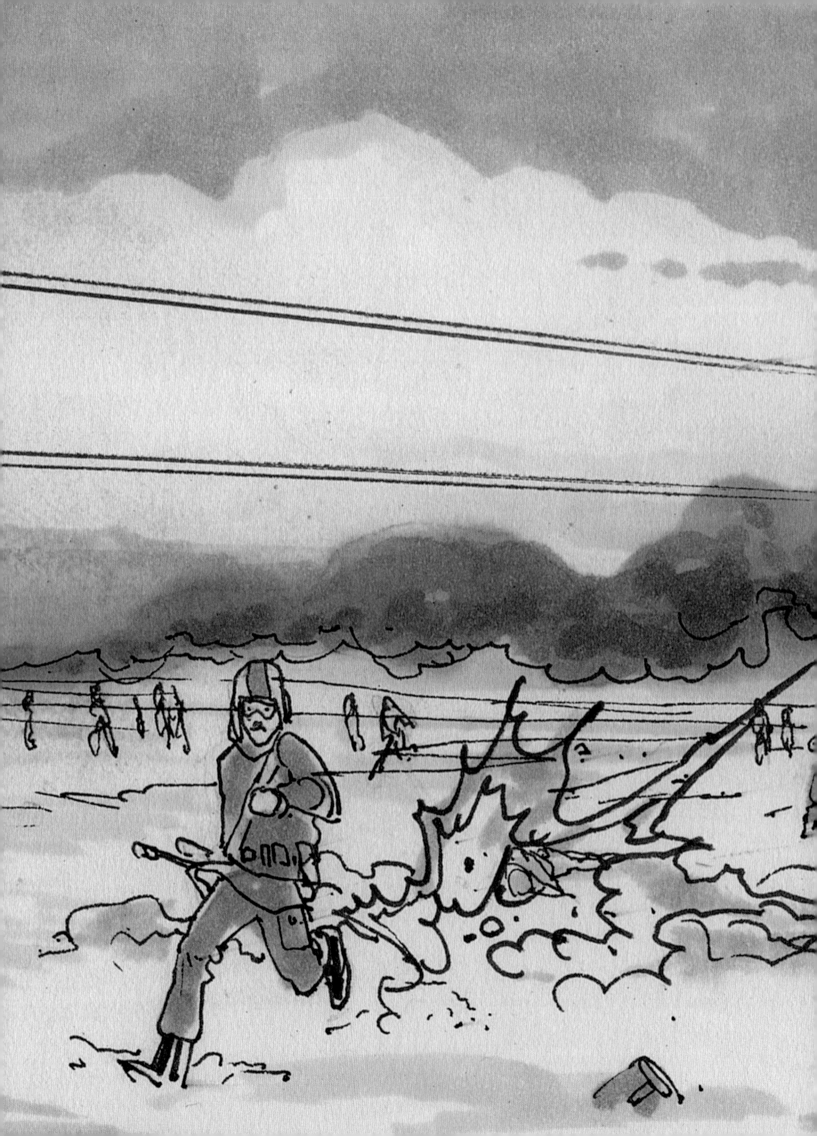

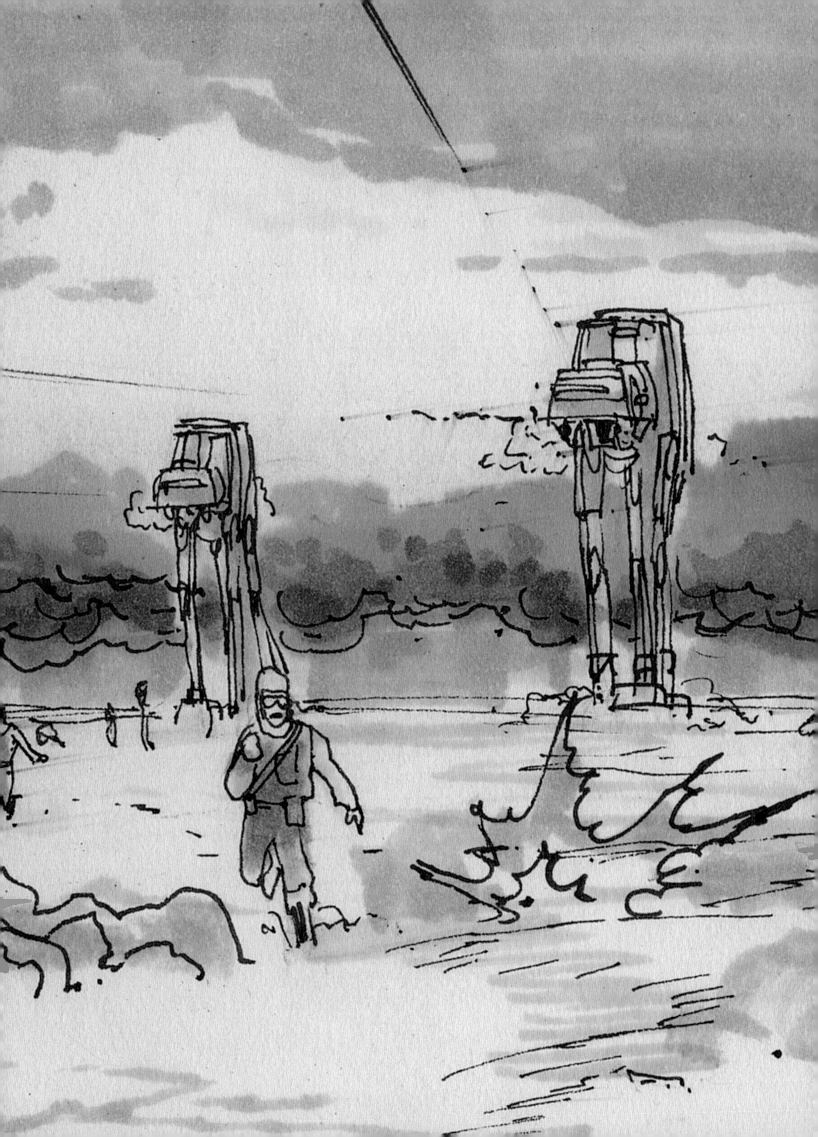

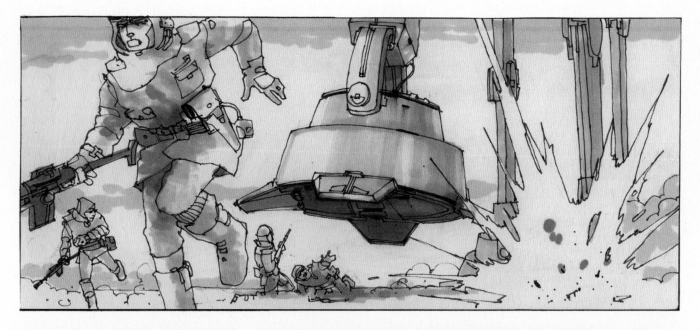

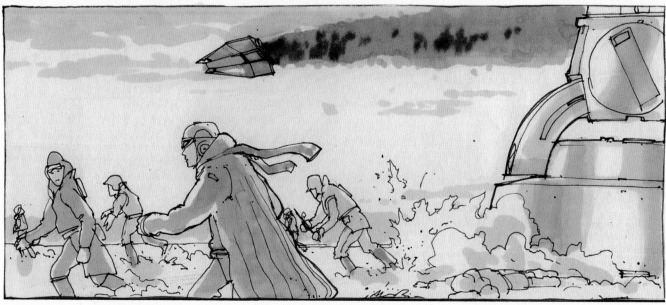

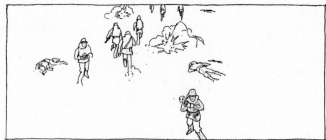

"I love Joe's humor, his throwing in a Moebius character [R2]. I've always admired that about him and his work."

Nilo Rodis-Jamero

PREVIOUS SPREAD: But two walkers remain and the rebels have to retreat. » Johnston
Rebels flee ahead of the victorious walkers. » Rodis-Jamero, **R1**; Johnston, **R2: 3**

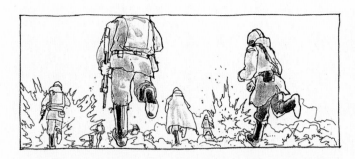
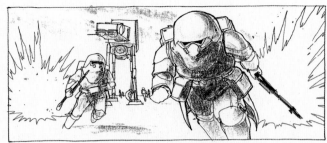
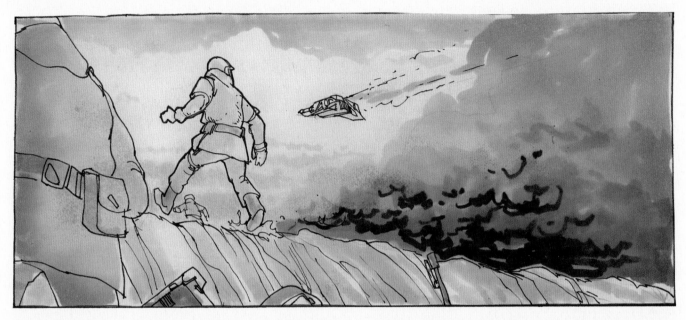
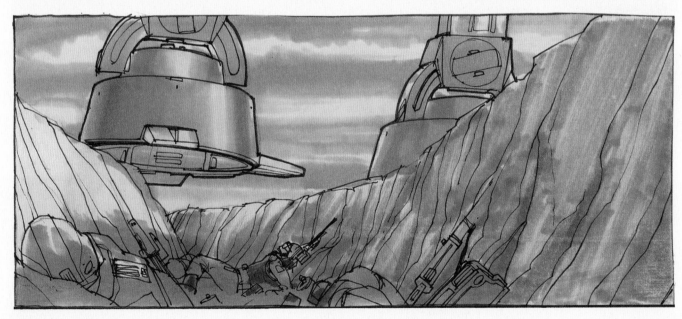

Walkers tower over the now empty rebel trenches and fallen troops. » Johnston

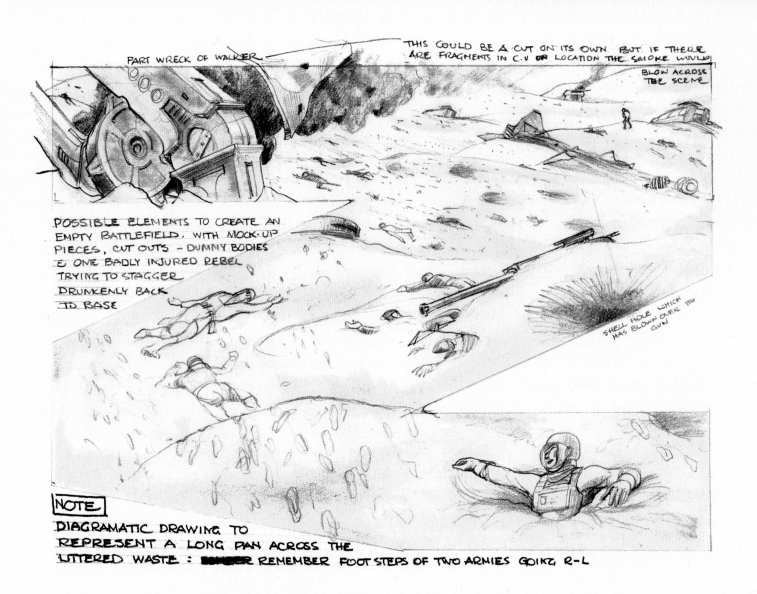

PART WRECK OF WALKER

THIS COULD BE A CUT ON ITS OWN BUT IF THERE
ARE FRAGMENTS IN C.V OR LOCATION THE SMOKE WOULD
BLOW ACROSS
THE SCENE

POSSIBLE ELEMENTS TO CREATE AN
EMPTY BATTLEFIELD. WITH MOCK-UP
PIECES, CUT OUTS — DUMMY BODIES
& ONE BADLY INJURED REBEL
TRYING TO STAGGER
DRUNKENLY BACK
TO BASE

SHELL HOLE WHICH
HAS BLOWN OVER THE
GUN

NOTE

DIAGRAMATIC DRAWING TO
REPRESENT A LONG PAN ACROSS THE
LITTERED WASTE : REMEMBER FOOTSTEPS OF TWO ARMIES GOING R-L

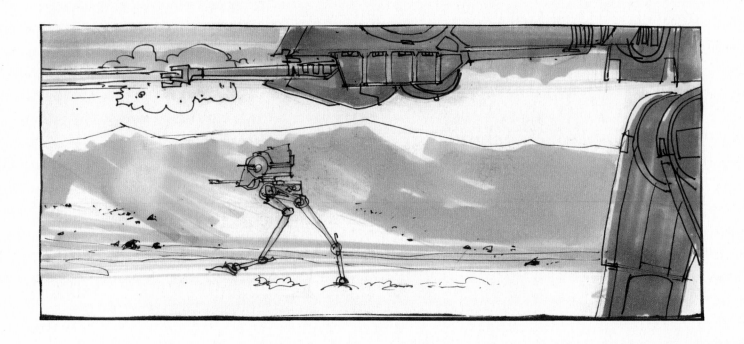

Chicken walkers (AT-STs) mop up the corpse-strewn snowfields. » Beddoes, **R1**; Johnston, **R2**

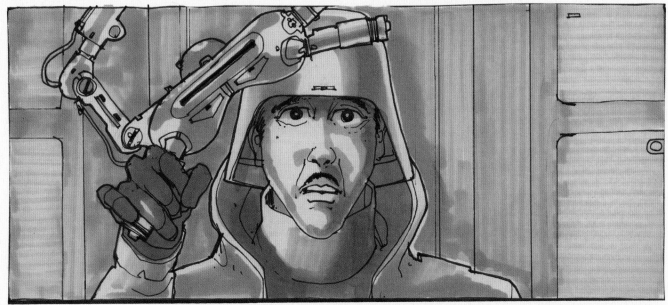

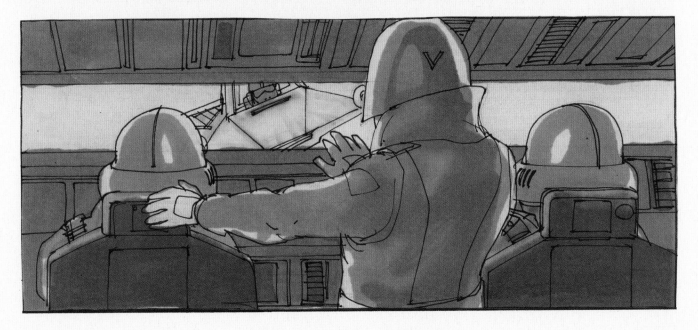

A crippled snowspeeder trailing black smoke heads toward the cockpit of General Veers's walker. » Johnston

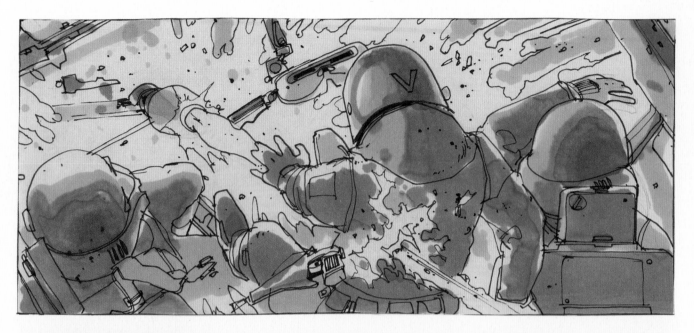

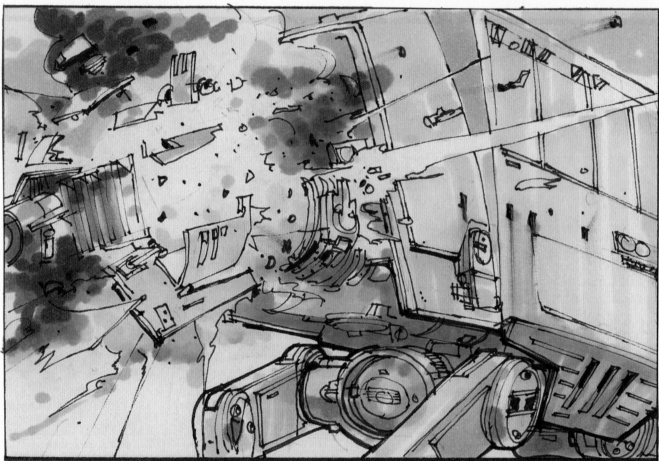

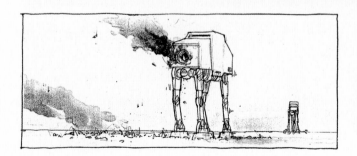

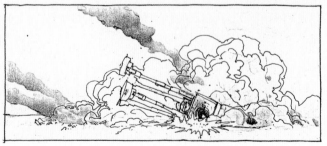

The vehicle smashes through the cockpit window, killing all aboard and capsizing the walker. » Johnston, **R1**, **R3**; Rodis-Jamero, **R2**

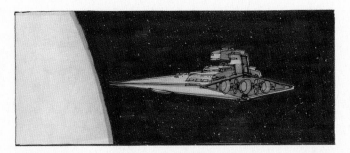

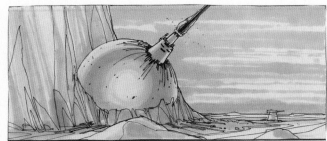

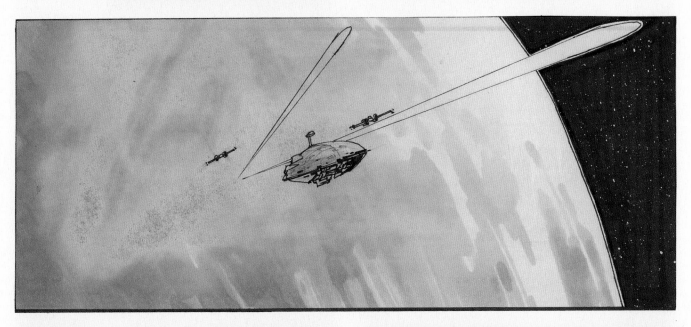

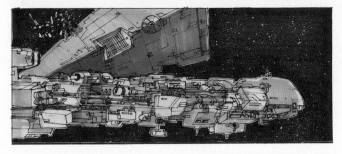

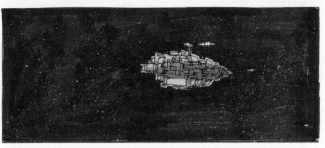

"While shooting this scene at ILM [opposite page], the headless miniature walker wouldn't fall over, take after take. Frustrated, stop-motion animator Jon Berg drilled a hole on the set under the walker's hind foot and finally tipped it over—with a broom handle!"

Nilo Rodis-Jamero

"As originally conceived, the Imperial forces had blanketed Hoth with a protective 'electronic net,' effectively sealing in the rebels. The ion cannon blasted through this 'net,' allowing the fleeing rebel ships to escape. Prior to digital visual effects, however, the look was not convincing enough and was dropped."

Nilo Rodis-Jamero

Thanks to the ion cannon that clears their path, rebel ships successfully evacuate Hoth, breaking through the Imperial blockade. » Rodis-Jamero

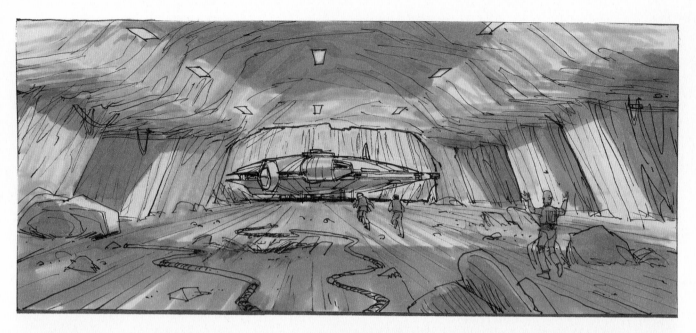

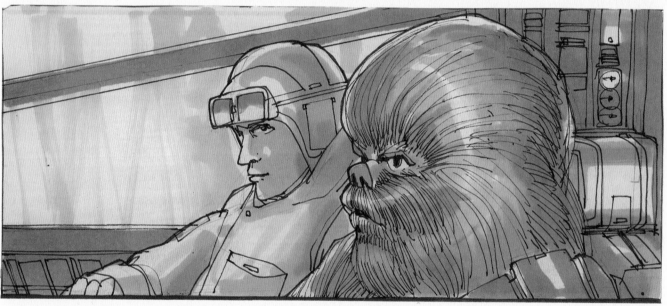

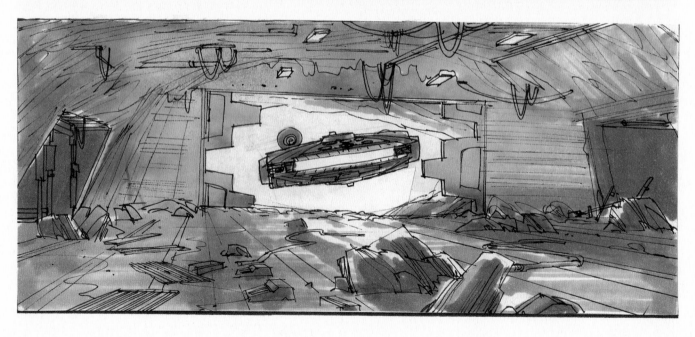

Han, Leia, Chewbacca, and the droids escape in the *Millennium Falcon.* » Johnston

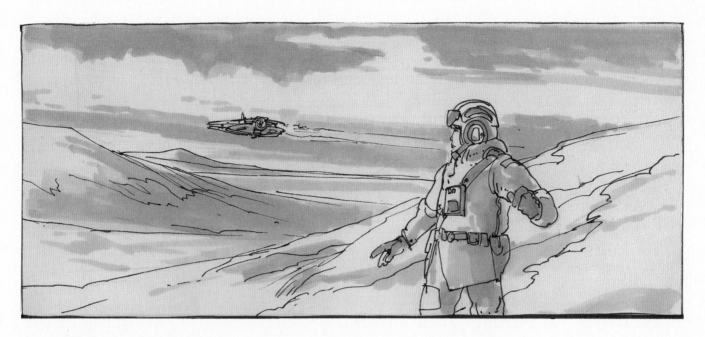

"[R3, opposite] *is a good example of why we tried to never mix warm and cool gray markers. The warm grays always faded faster than the cools and tended to radically change color when they did. I must have grabbed a warm #5 without realizing it. It faded over the years—and turned pink!*"

Joe Johnston

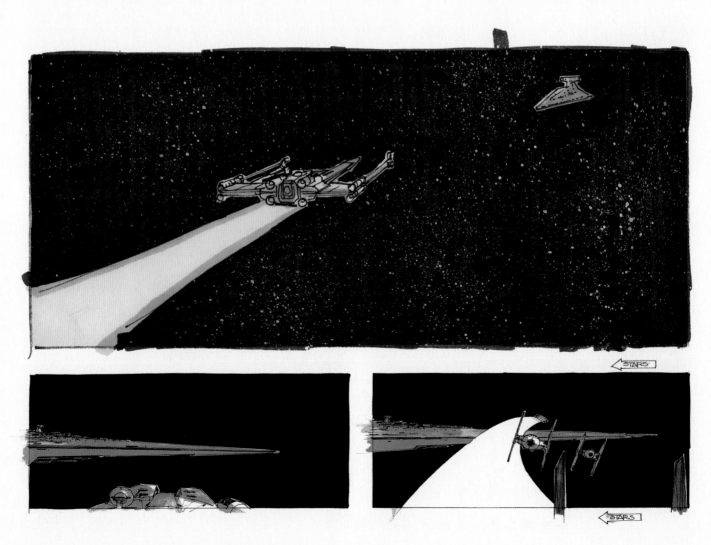

Luke sees the *Falcon* leaving and soon follows in his X-wing. The *Falcon*, however, is pursued by TIE fighters. » Johnston, **R1**; Rodis-Jamero, **R2:3**

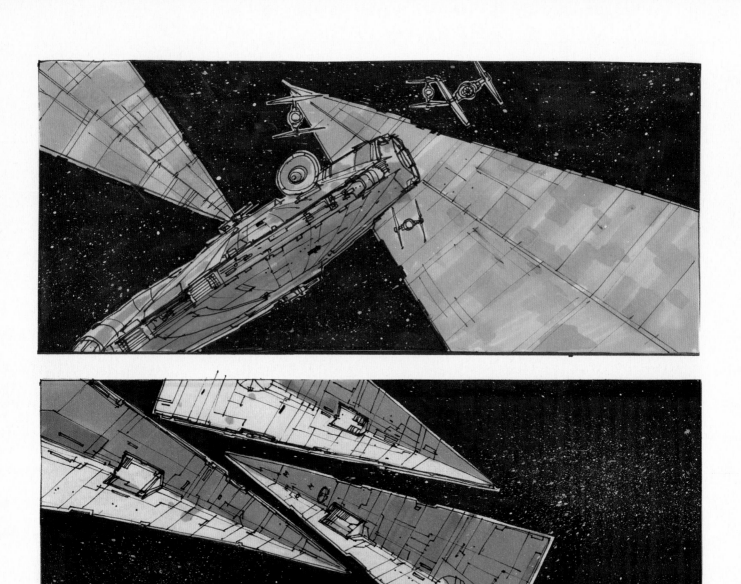

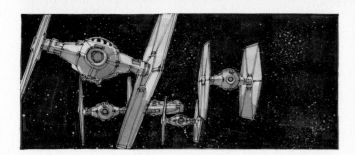

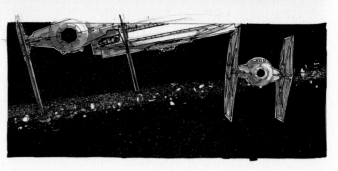

Han in the *Falcon* takes evasive action, pursued by TIEs into a neighboring asteroid field. » Rodis-Jamero

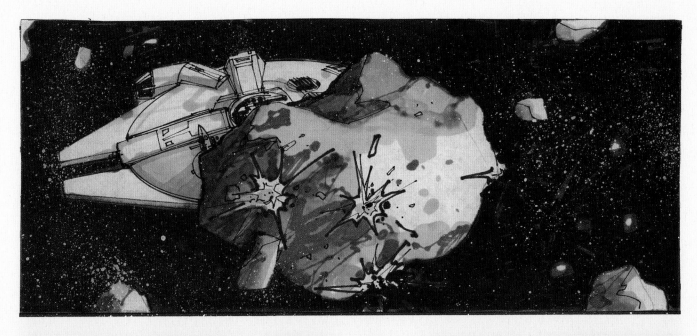

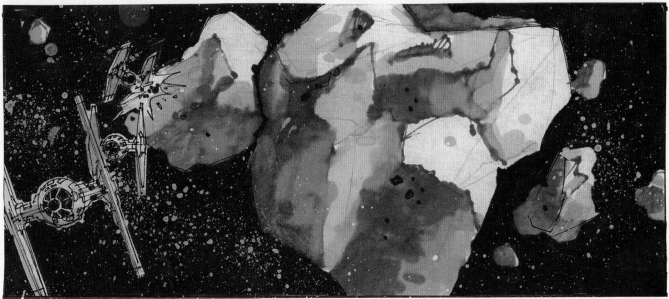

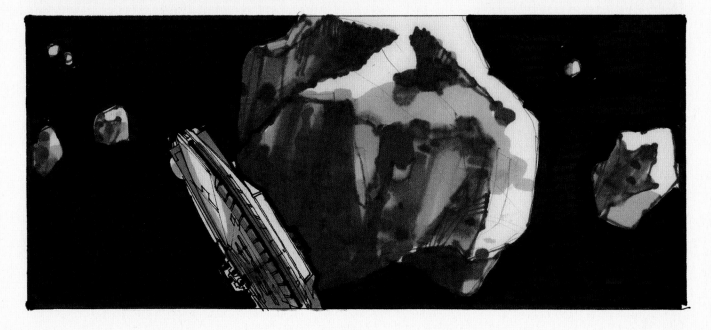

One TIE fighter is pulverized by an asteroid, as Han is the better pilot. » Rodis-Jamero

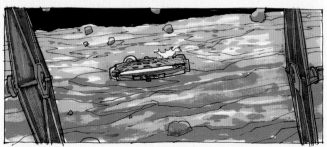

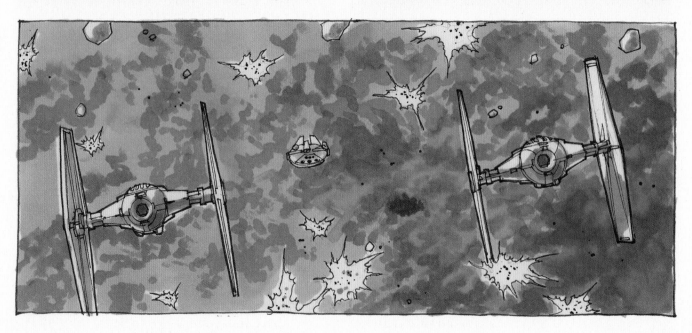

Captain Solo spots a giant asteroid to his liking, but is still pursued by the two remaining TIEs. » Carson, **R1**; Johnston, **R2:3**

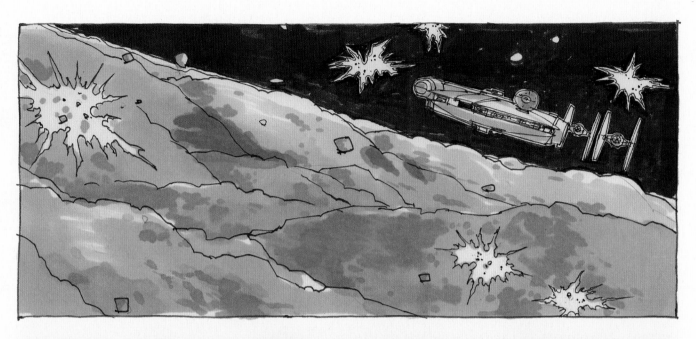

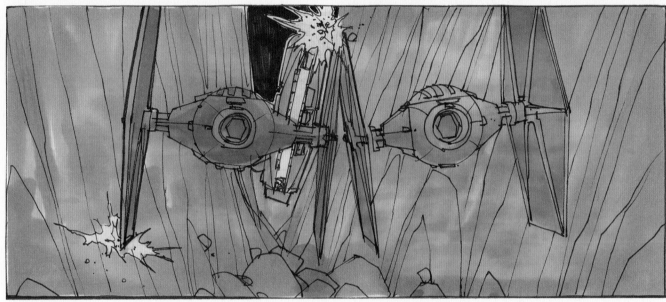

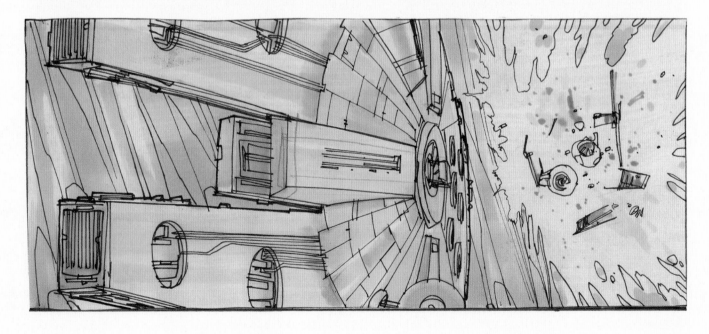

Entering a narrow canyon, the *Falcon* squeaks through—but Han's pursuers explode in a violent fireball. » Johnston

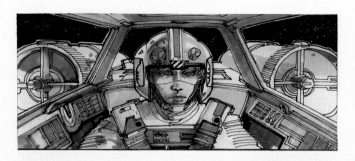

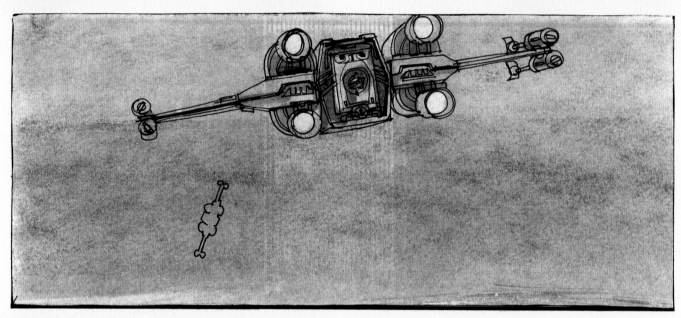

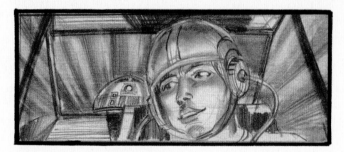

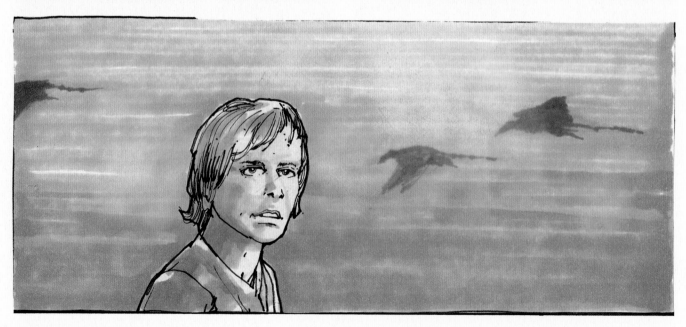

Luke lands his X-wing on the foggy planet of Dagobah, where Ben has directed him. » Rodis-Jamero, **R1L**; Beddoes, **R1R**, **R3**; Johnston, **R2**, **R4**

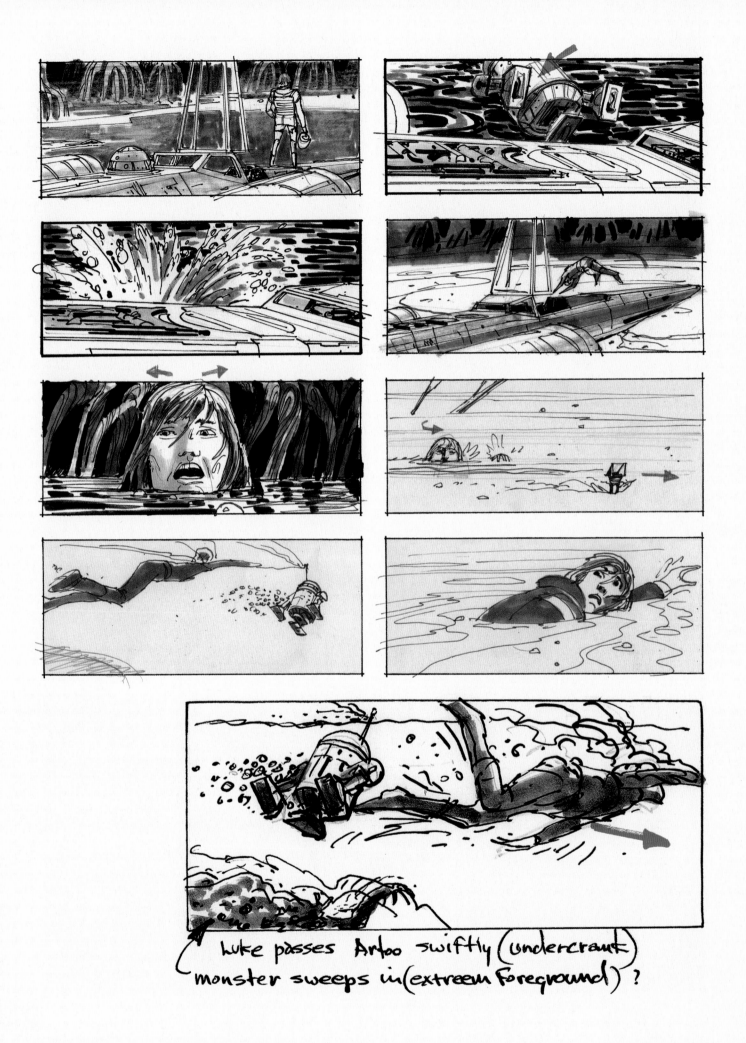

luke passes Artoo swiftly (undercrank)
monster sweeps in (extreem foreground)?

Luke and R2-D2 jump into the swamp and head for shore—but a bog monster closes in on them. » McQuarrie

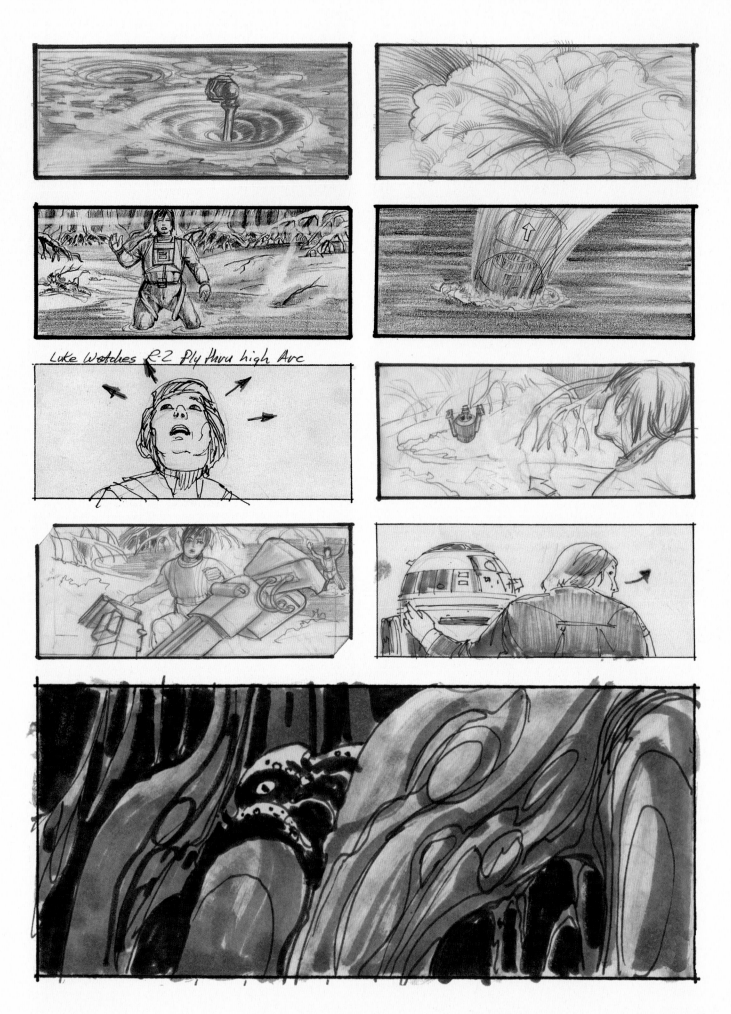

Luke Watches R-2 fly thru high Arc

R2 is swallowed—and then spit out by the bog monster, landing on his head. Luke is watched by another creature that remains hidden among the giant trees. » Beddoes, **R1:2**, **R3R**, **R4L**; McQuarrie, **R3L**, **R4R**, **R5**

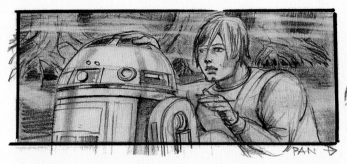 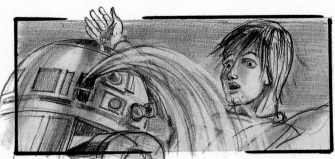

"*Unlike the sketches for the ice planet, which were all on one sheet, this sequence was drawn on separate frames and assembled, cut, changed, and altered as individual sketches or eliminated, while new connecting drawings were made as the script itself was changed around.*"

Ivor Beddoes, February 1979

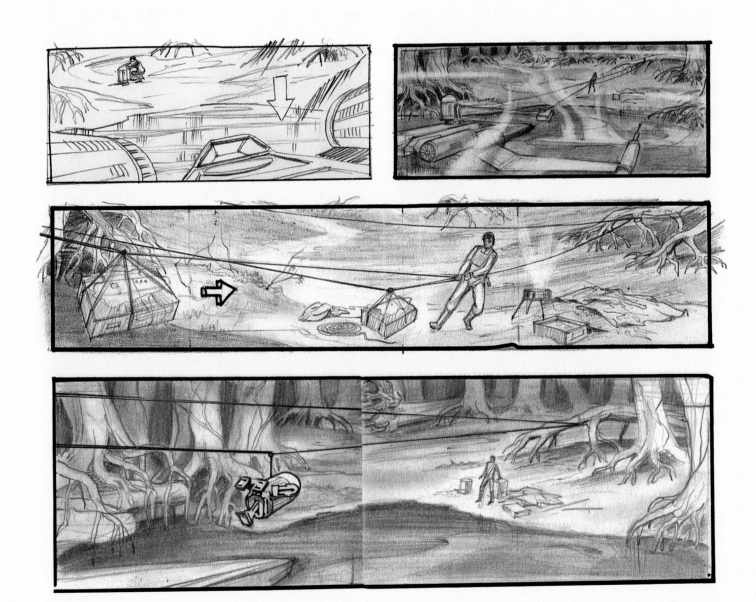

R2 ejects "swallowed" water; Luke then transports supplies via pulleys from his vehicle to shore. » Beddoes

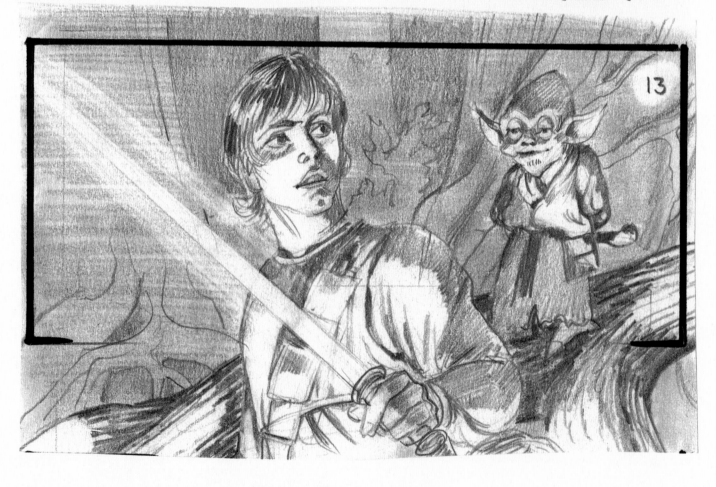

Luke recharges R2–but is surprised by a diminutive green creature who appears behind him. » Beddoes

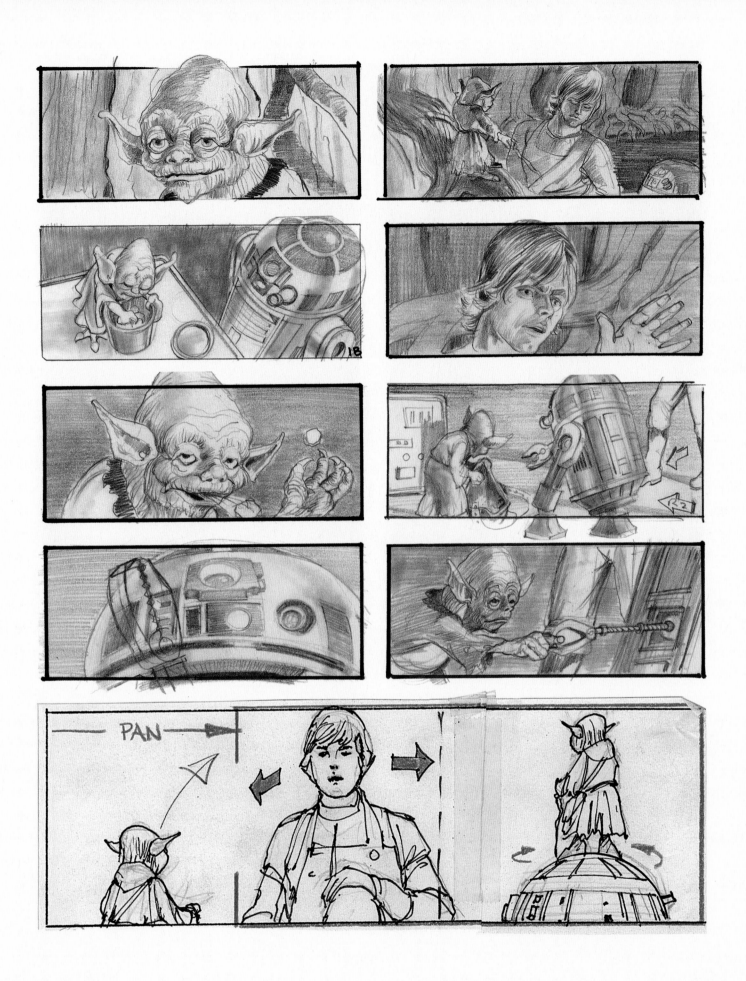

The mischievous imp rummages through Luke's supplies, so R2 tries to stop him. » Beddoes, **R1:4**; McQuarrie **R5**

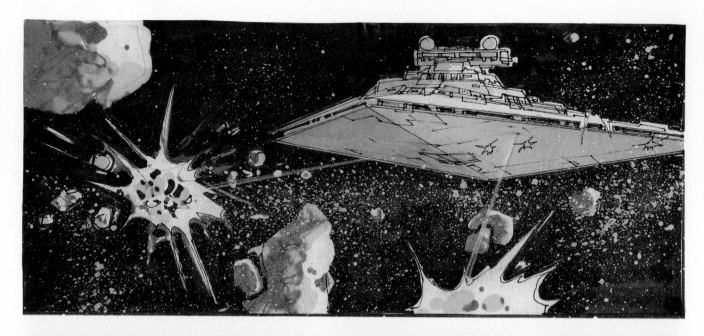

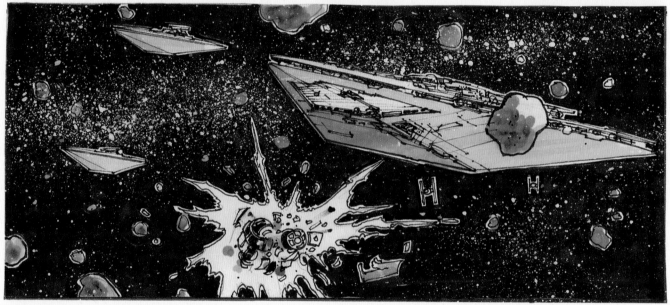

"Joe was a big fan of music from the 1940s, so it was always playing while we boarded."

Dave Carson

Darth Vader's Super Star Destroyer blasts its way through the asteroid field. » Rodis-Jamero

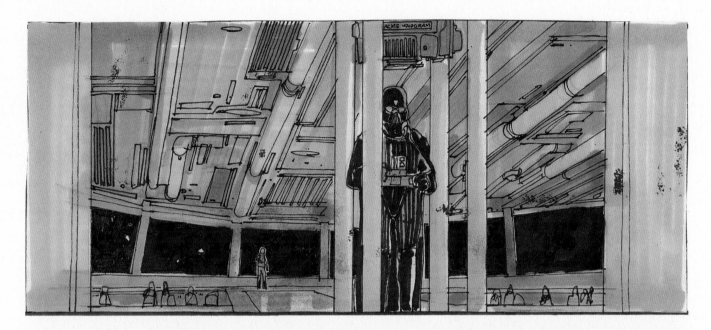

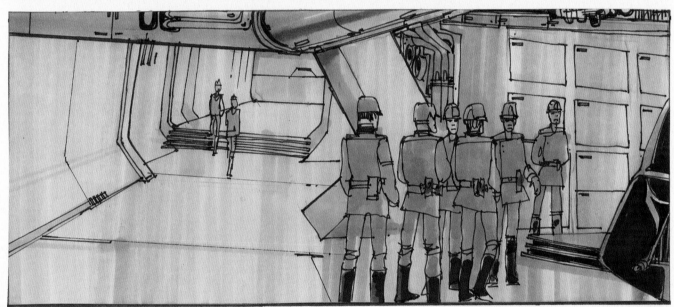

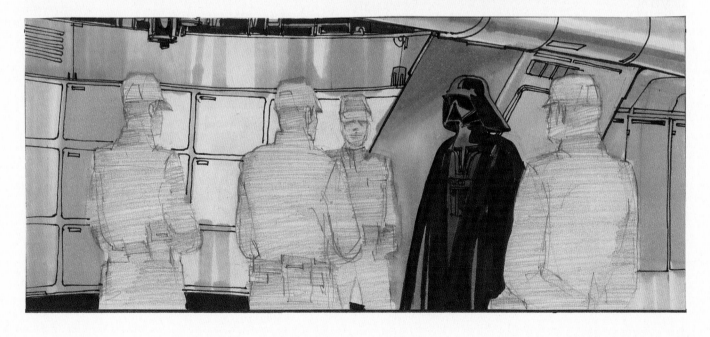

Vader communicates with his admirals via hologram. » Johnston, **R1**; Rodis-Jamero, **R2:3**

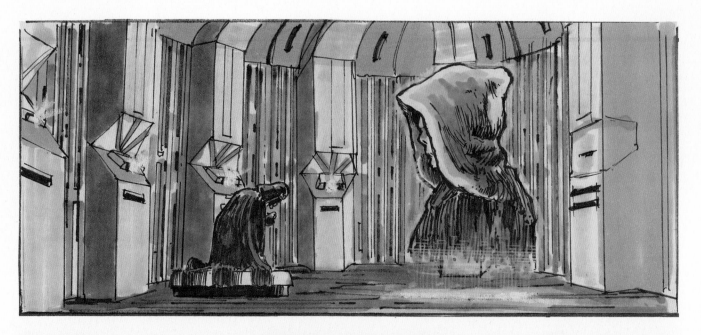

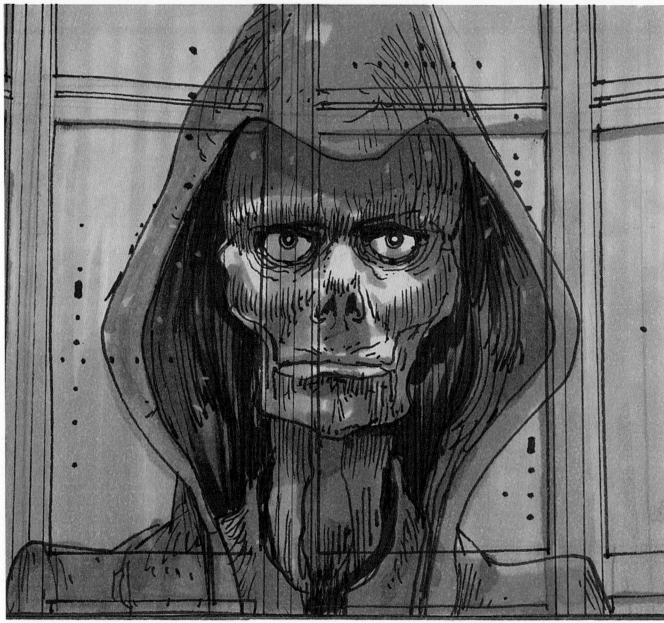

Vader and the Emperor plot to convert Luke to the dark side. » Carson, **R1**; Johnston, **R2**

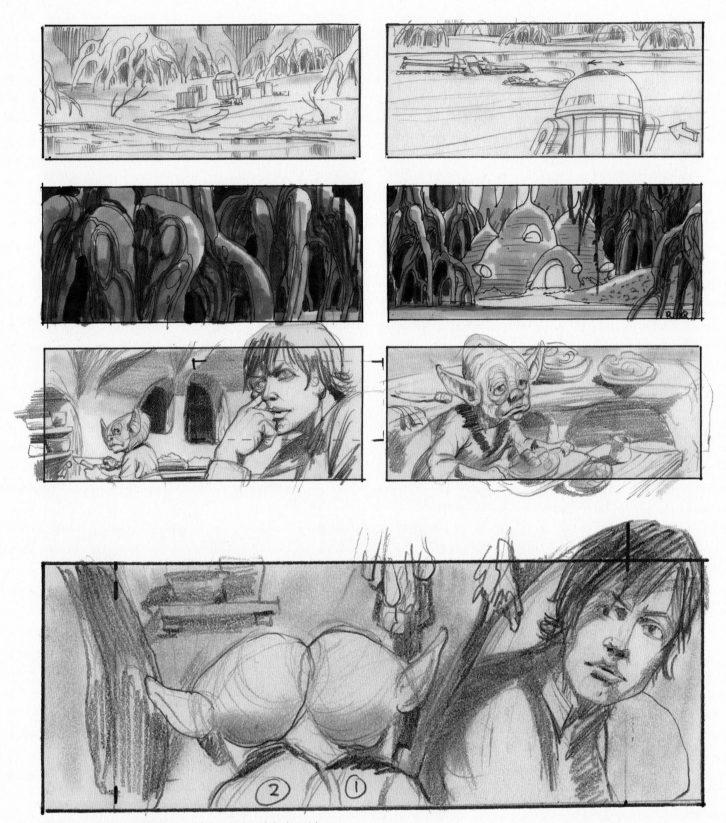

"Kersh made some drawings which went straight into his own script," Beddoes noted. His drawings and those of Beddoes and McQuarrie were then combined, modified, and photocopied as necessary while the scenes and script changed. The result is that many sequences boarded were never filmed and exist only as drawings.

R2 watches the X-wing sink deeper into the bog, while the creature, in his hovel, reveals to Luke that he is in fact Yoda—the Jedi Master of whom Ben had spoken. » Beddoes, **R1**, **R3:4**; McQuarrie, **R2**

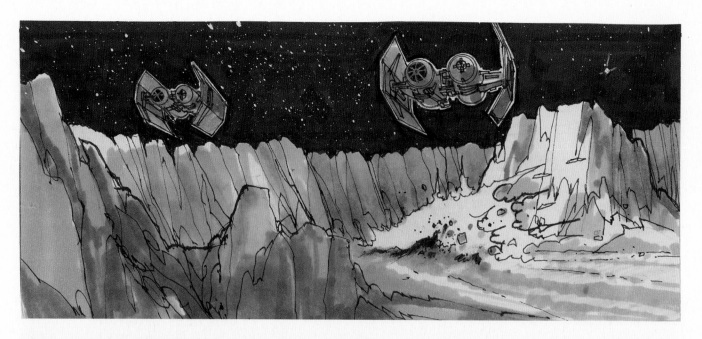

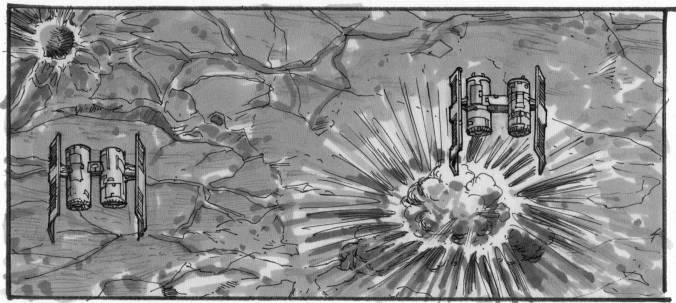

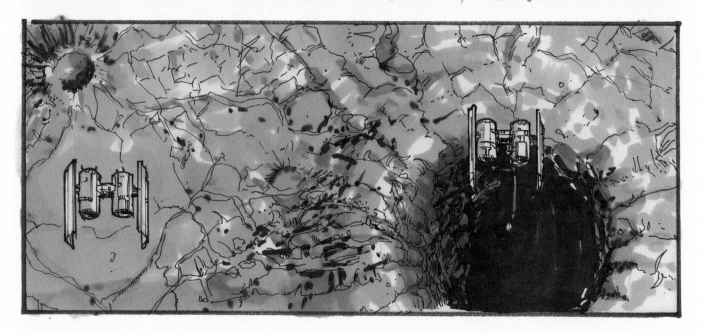

TIE bombers carpet bomb the asteroid. » Johnston, **R1**; Carson, **R2:3**

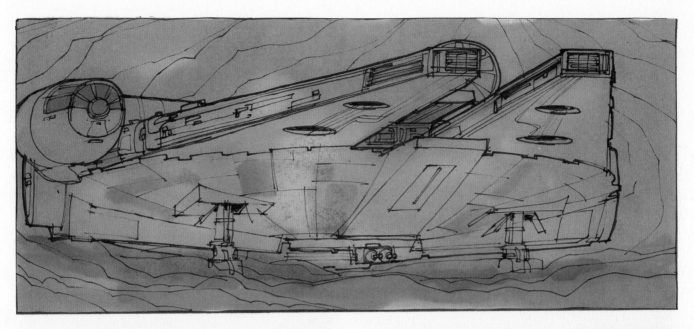

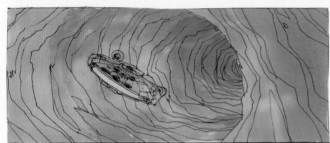

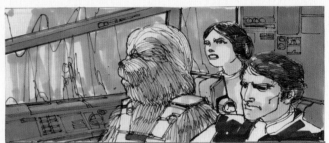

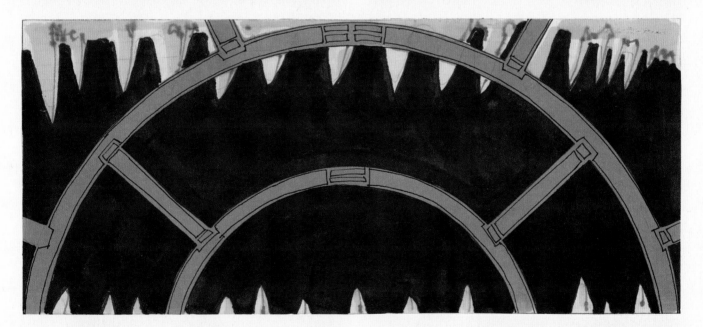

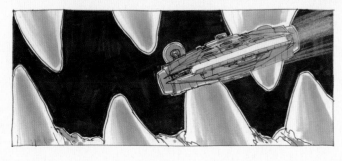

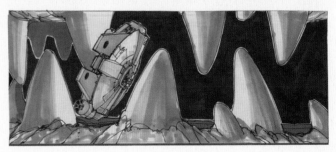

Within the asteroid, Han, Leia, and Chewbacca realize they parked the *Falcon* inside a giant space worm. » Johnston, **R1**, **R2L**; Rodis-Jamero, **R2R**, **R3:4**

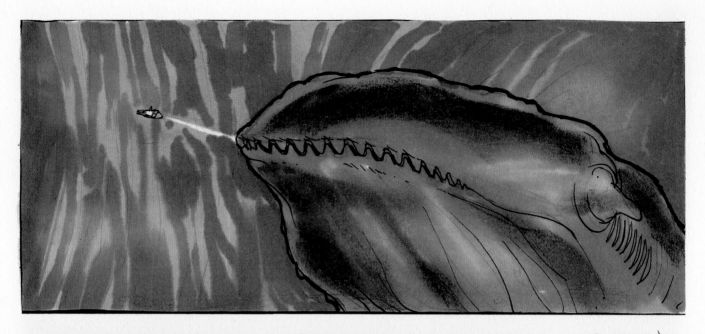

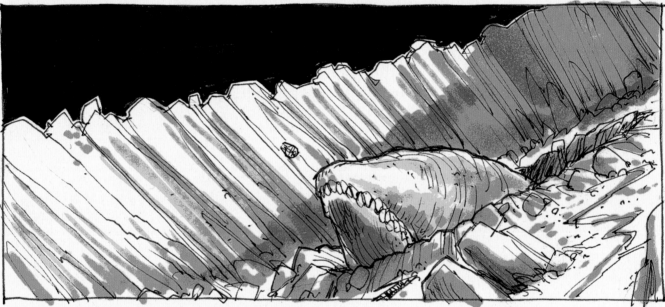

*"I tried to make sure that whatever the focal point of the shot—
the camera move or creature move or ship move—that it was clear.
I hated to have a camera operator come into the art department
and ask questions about things that should have been obvious
from the storyboard. To that end, I added arrows and labels in an
attempt to make it as clear as possible [as on the opposite page]."*

Joe Johnston

The space slug retreats into its hole. » Johnston

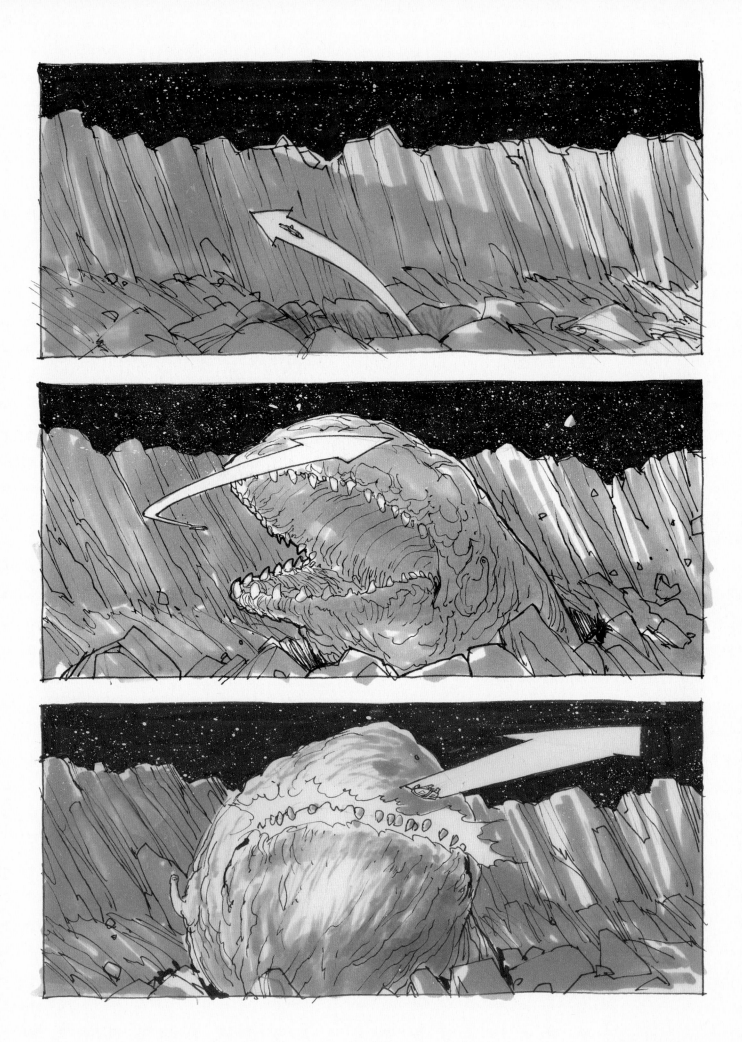

A later version of the sequence had the space slug more actively pursuing the *Falcon*. » Johnston

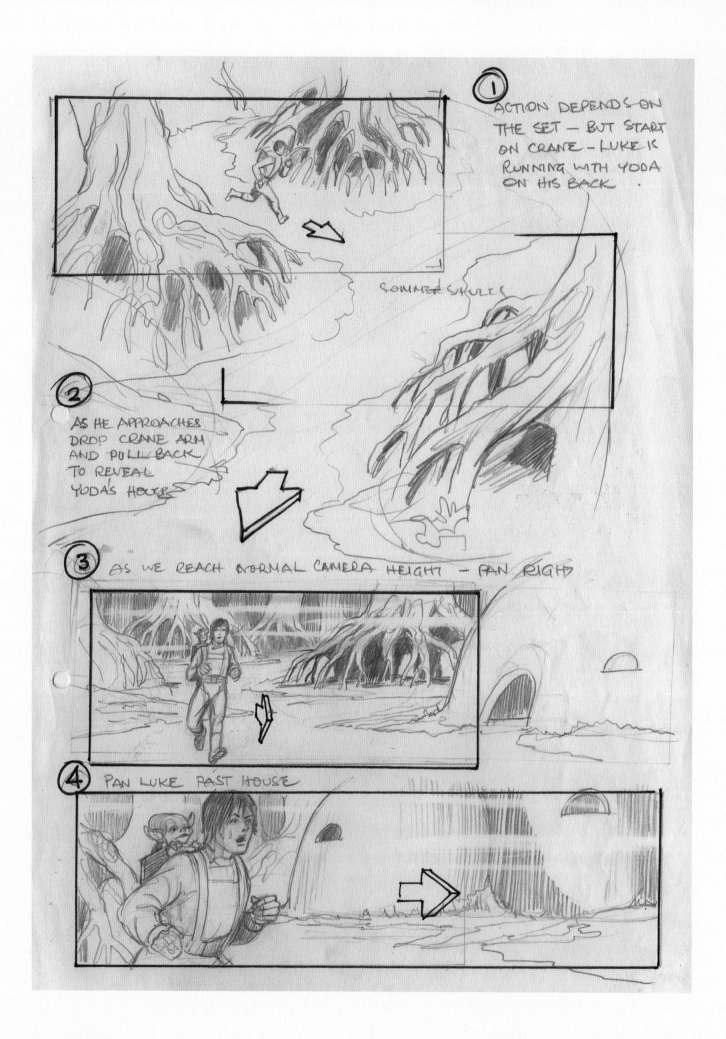

1 ACTION DEPENDS ON THE SET — BUT START ON CRANE — LUKE IS RUNNING WITH YODA ON HIS BACK.

SOMMER SKULLS

2 AS HE APPROACHES DROP CRANE ARM AND PULL BACK TO REVEAL YODA'S HOUSE

3 AS WE REACH NORMAL CAMERA HEIGHT — PAN RIGHT

4 PAN LUKE PAST HOUSE

With Yoda in his backpack, Luke begins his training on Dagobah. » Beddoes

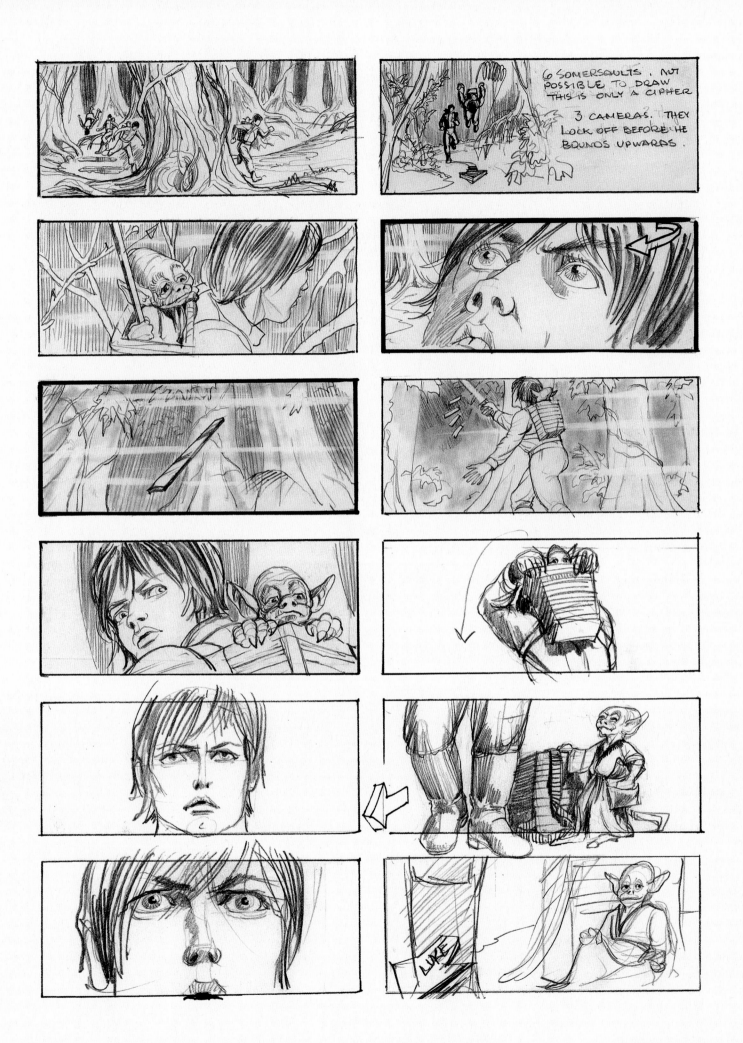

6 SOMERSAULTS, NOT POSSIBLE TO DRAW THIS IS ONLY A CIPHER

3 CAMERAS. THEY LOCK OFF BEFORE HE BOUNDS UPWARDS.

Yoda throws a metallic bar at Luke, who cuts it to pieces—but then feels that something is amiss. » Beddoes

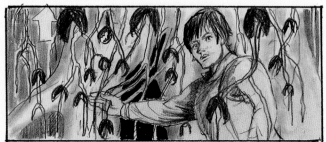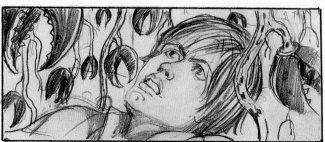

Luke is drawn to a dark, recessed area within an ancient and mysterious tree. » Beddoes

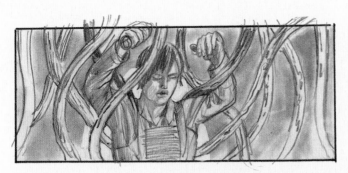

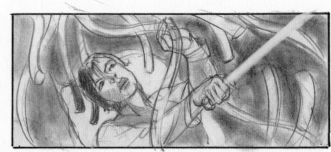

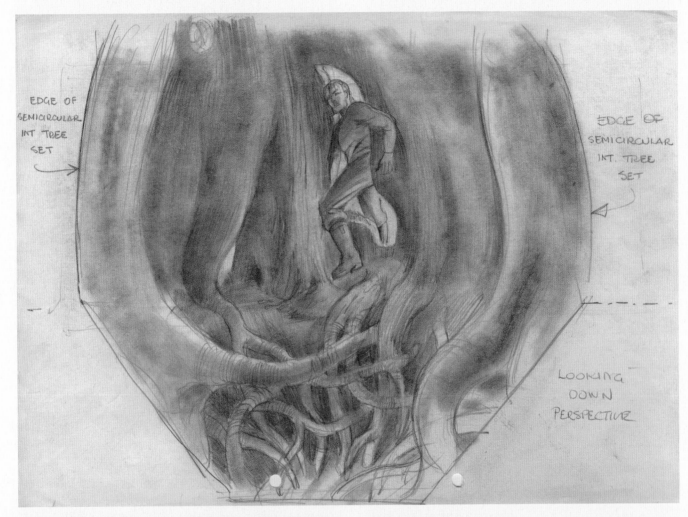

EDGE OF
SEMICIRCULAR
INT TREE
SET

EDGE OF
SEMICIRCULAR
INT. TREE
SET

LOOKING
DOWN
PERSPECTIVE

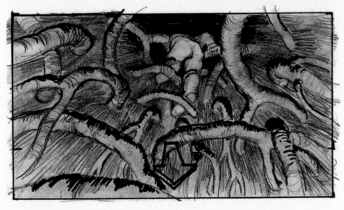

DOLLY

Luke cuts away some vines and descends into the forbidding hole. » Beddoes

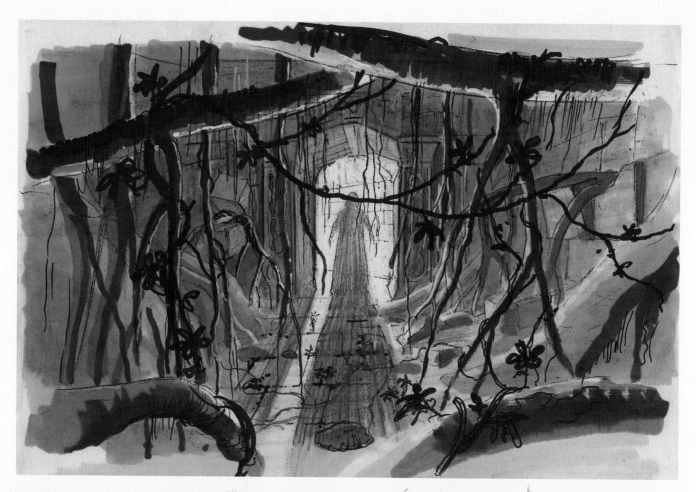

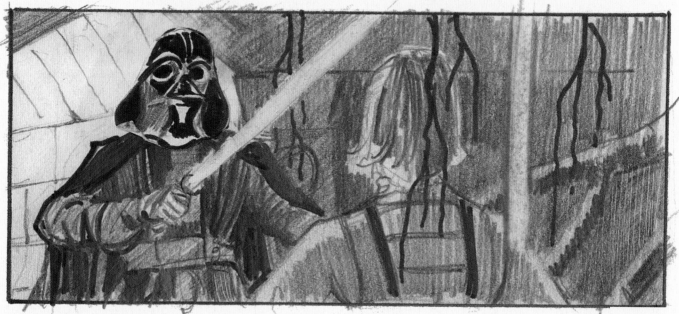

"This is the final assembly agreed upon by Kersh. The throw-outs have been put into an envelope."

Ivor Beddoes, 1979

A sinister silhouetted figure—Darth Vader!—appears in a doorway. » Beddoes

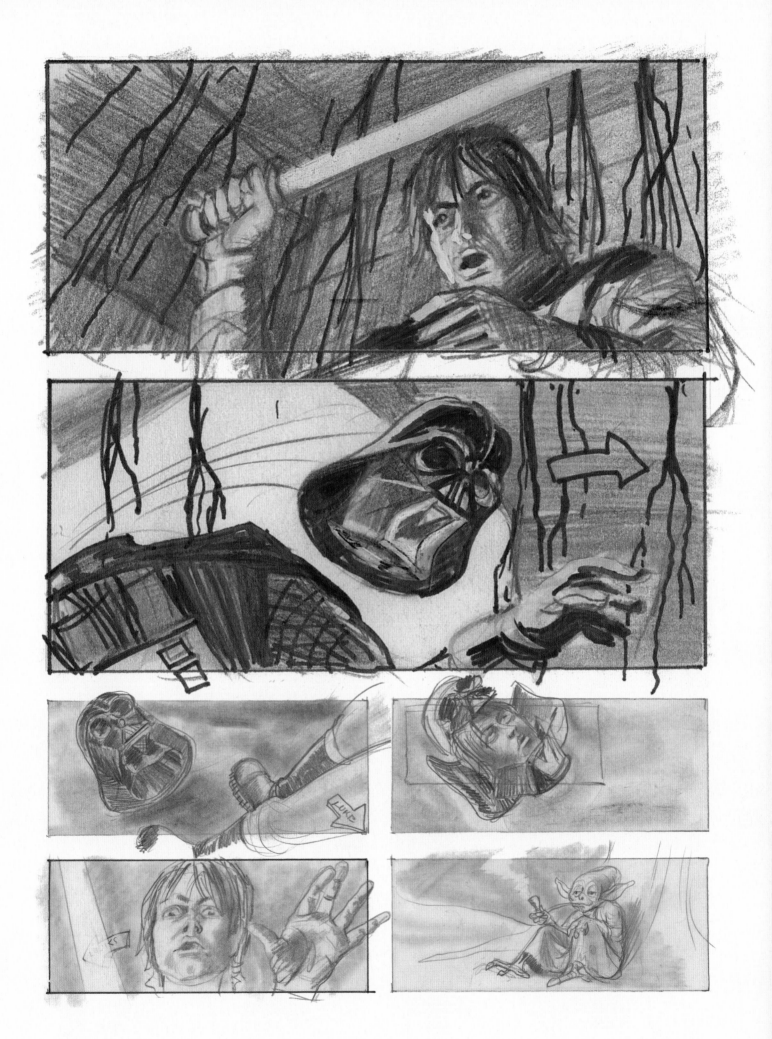

Luke decapitates his arch foe—only to discover his own face beneath the mask. » Beddoes

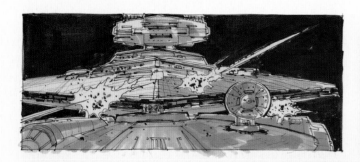
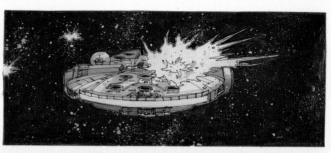
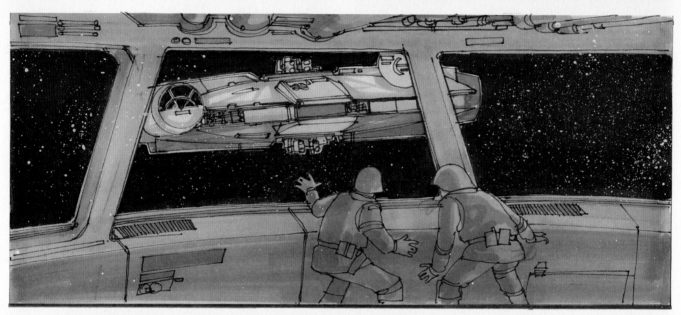
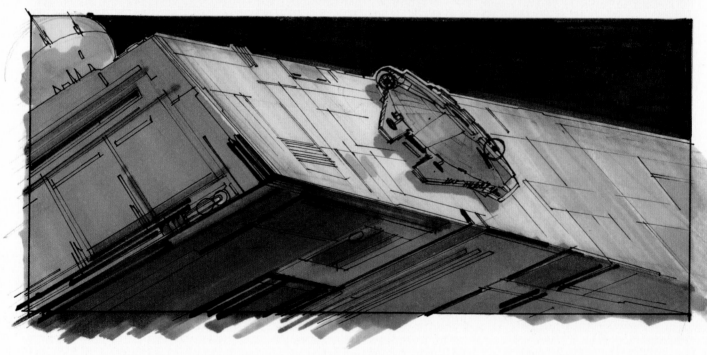

The *Falcon* is pursued but then turns on its pursuer—and executes a neat trick, hiding on the rear of the Star Destroyer's conning tower. » Rodis-Jamero

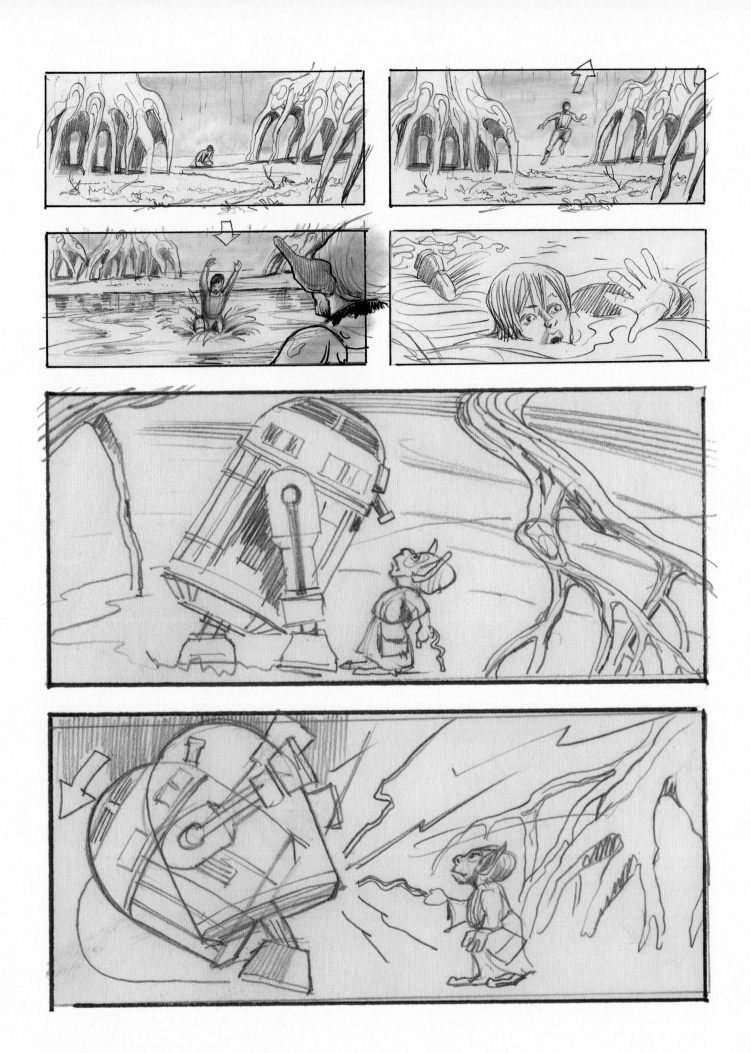

Luke continues his perhaps overly rigorous training, but falls short; when R2 protests, Yoda zaps him. » Beddoes

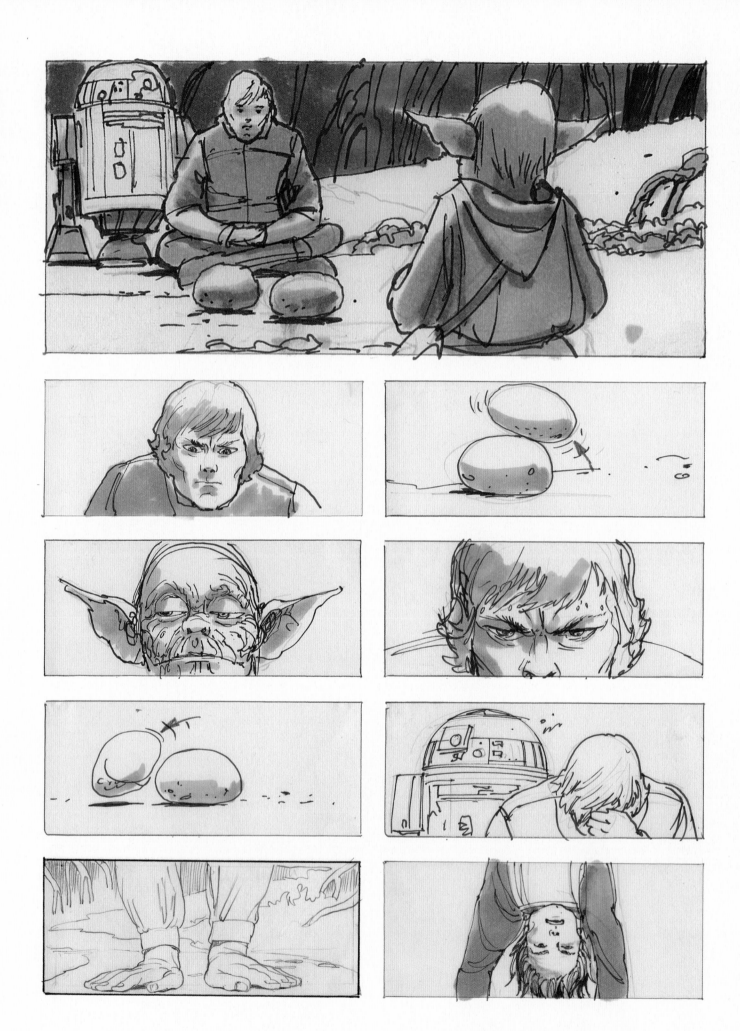

Luke's next lesson, using the Force to move objects, is also too difficult for the boy (R2 beeps sadly). » McQuarrie, **R1:4**, **R5R**; Beddoes, **R5L**

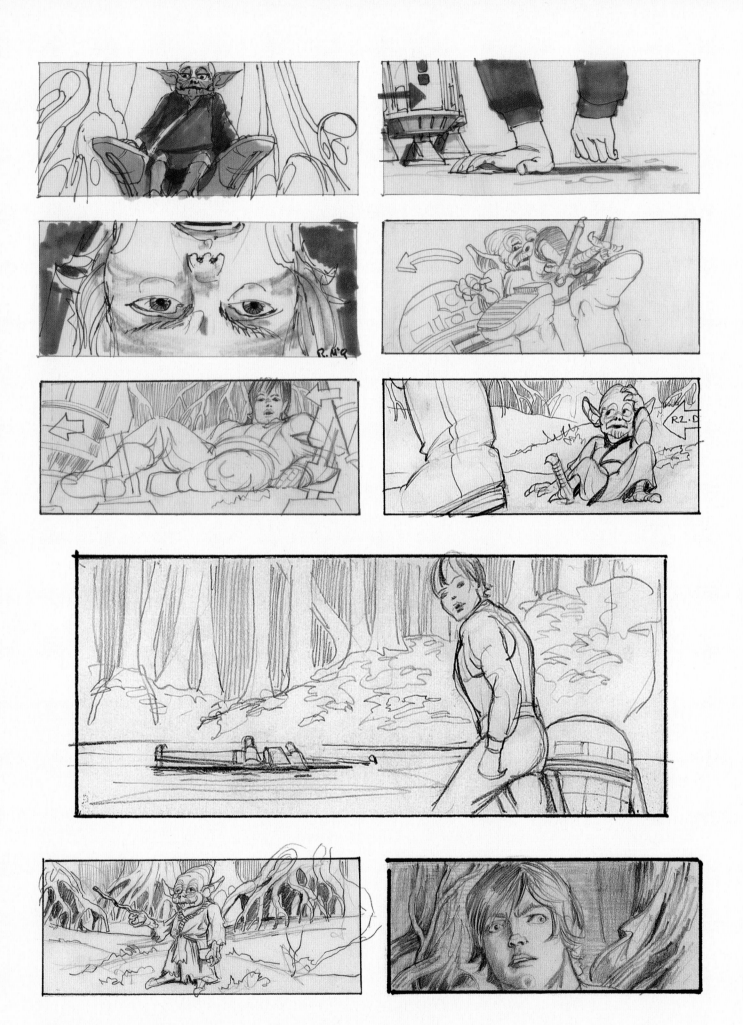

When Yoda asks him to do it on one hand, Luke's handstand fails, too.
Yoda points to the X-wing for a next lesson. » McQuarrie, **R1**, **R2L**; Beddoes, **R2R**, **R3:5**

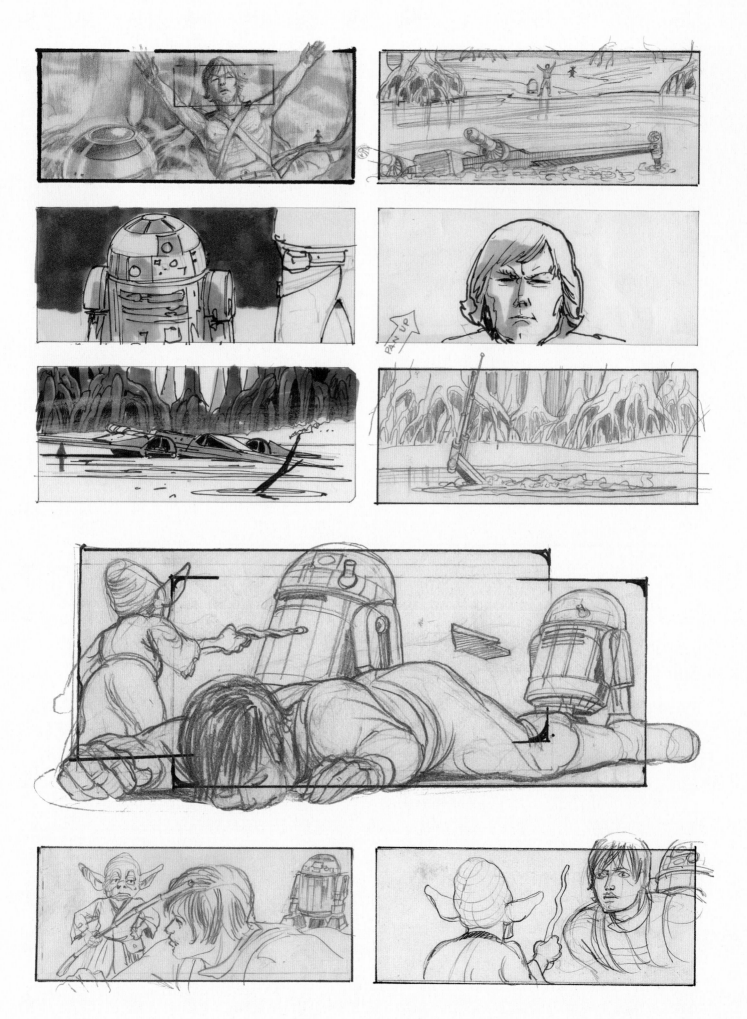

Luke attempts to levitate his ship—R2 "squeals with excitement" as he succeeds—but the effort proves too much. » Beddoes, **R1**, **R3R**, **R4:5**; McQuarrie, **R2**, **R3L**

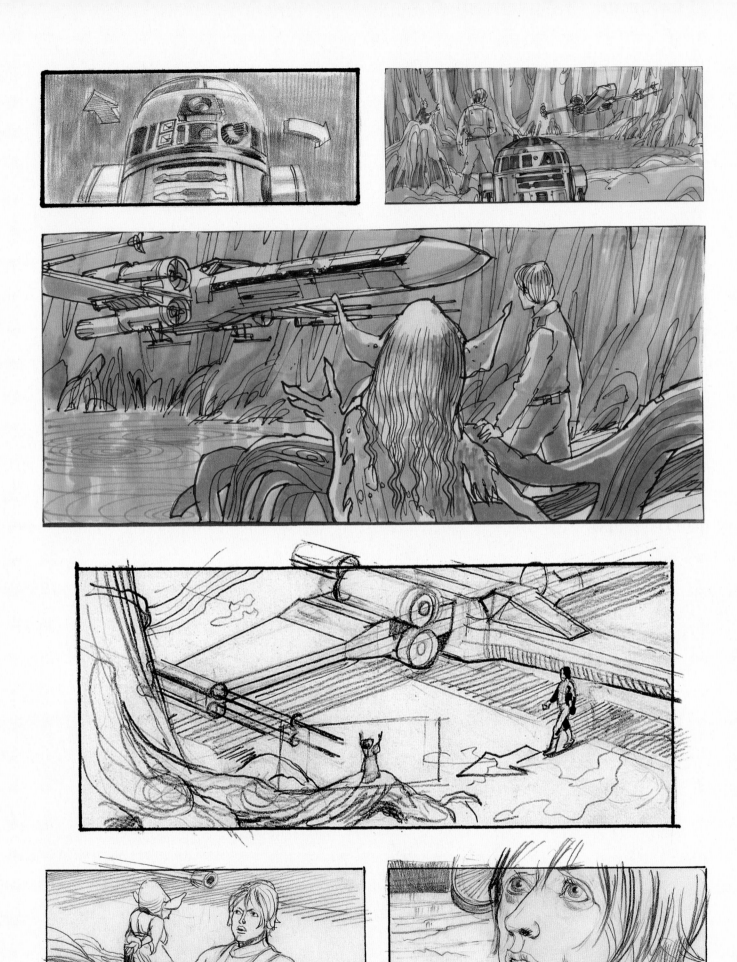

To show Luke how to channel the Force, Yoda levitates the X-wing out of the swamp—to Luke's amazement. » Beddoes, **R1L**, **R3:4**; Johnston, **R1R**, **R2**

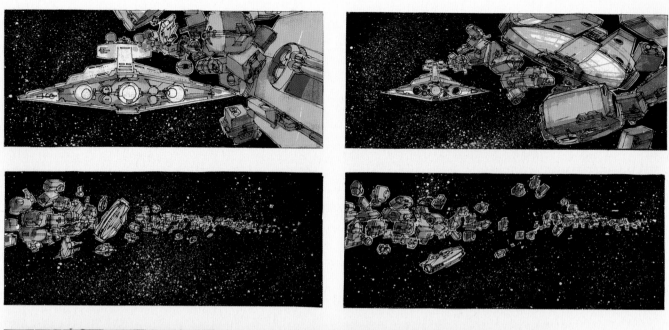

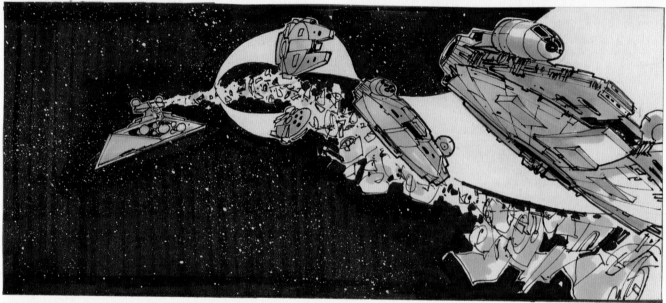

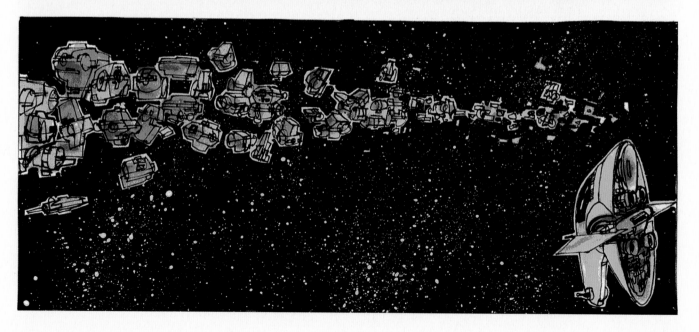

When the Star Destroyer ejects its garbage, the *Falcon* floats away with the refuse . . . » Rodis-Jamero

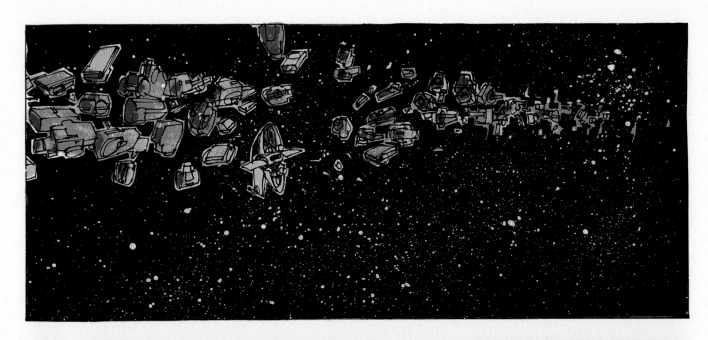

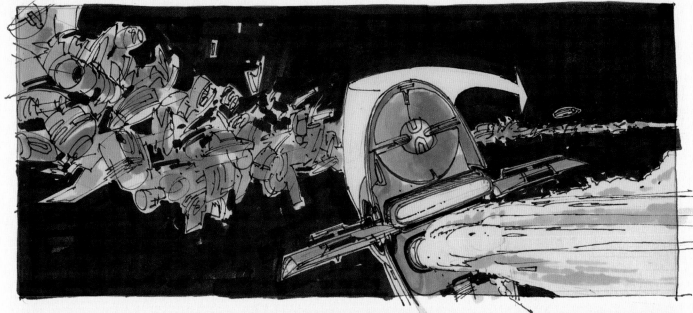

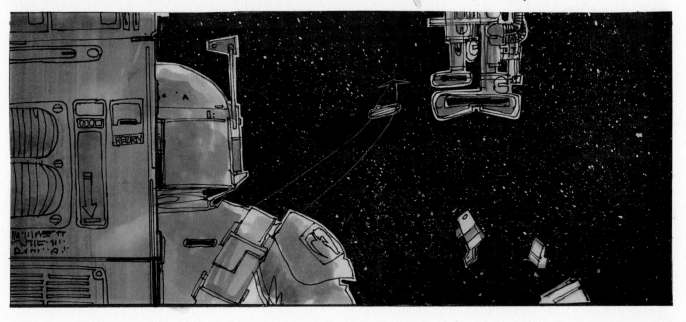

. . . but Han and Leia are followed by a sinister bounty hunter named Boba Fett in his ship, *Slave I.* » Rodis-Jamero

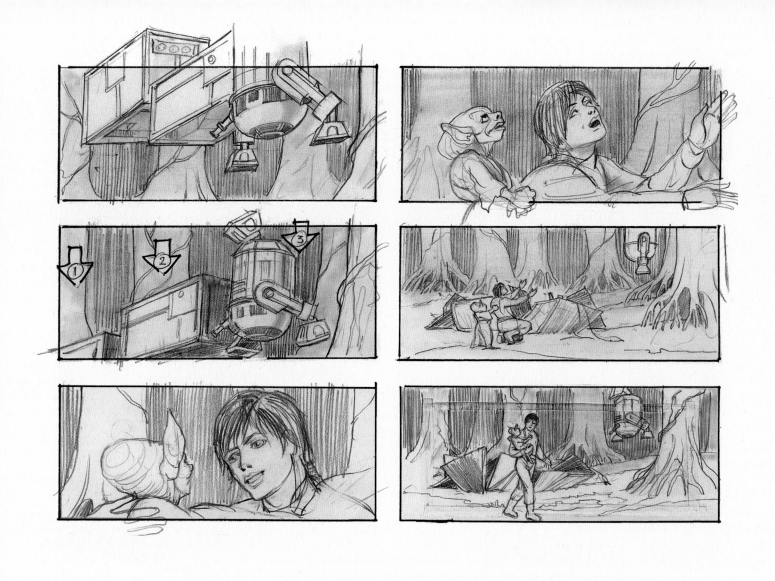

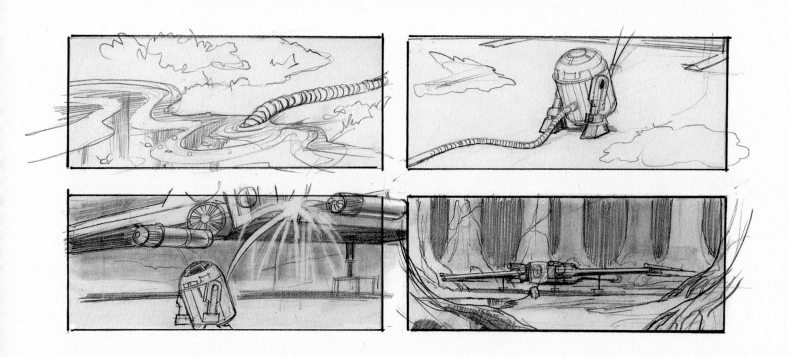

Luke improves his skills, lifting objects into the air with the Force, but forgets about poor R2, suspended in midair and beeping frantically, when he walks away with Yoda. Later, R2 washes the X-wing. » Beddoes

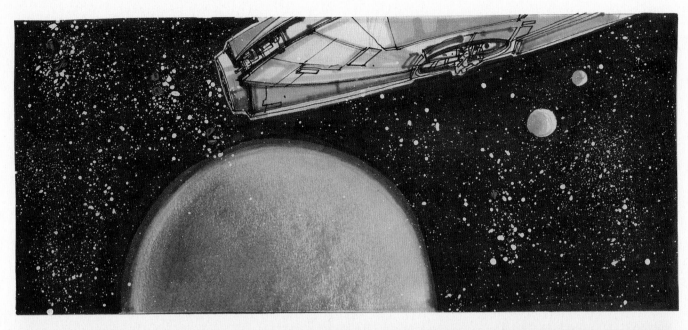

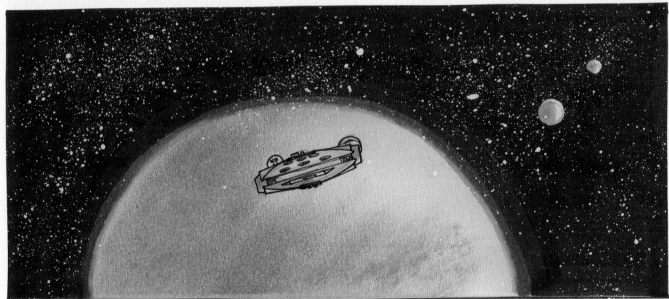

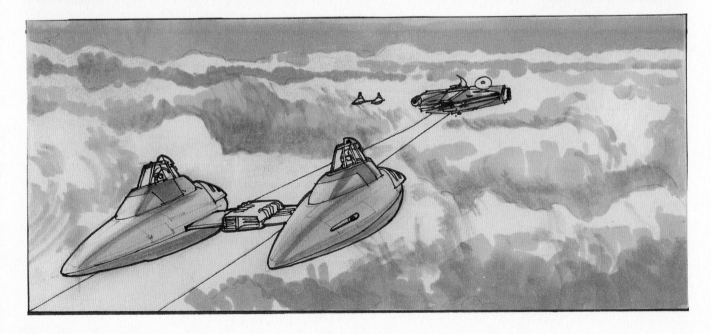

The *Falcon* arrives in the vicinity of Cloud City, where Twin-Pod Cloud Cars intercept it. » Rodis-Jamero

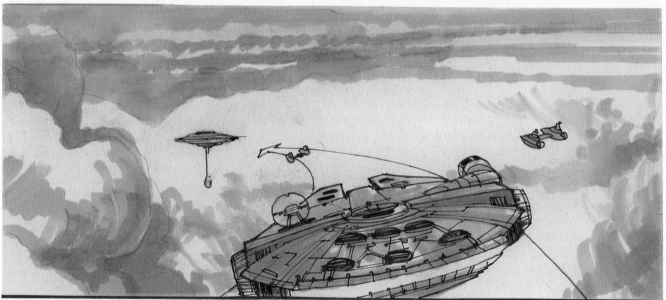

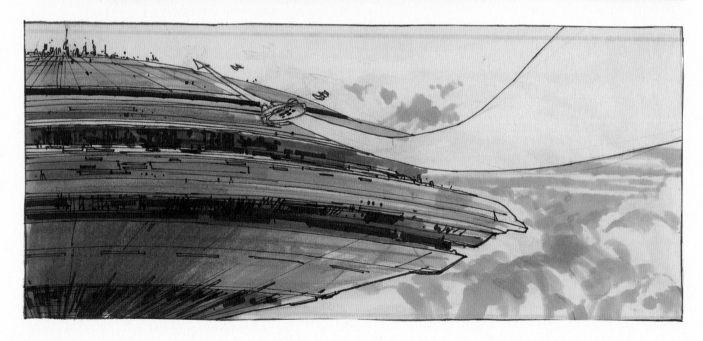

As the *Falcon* nears it, the majesty of Cloud City is revealed. » Rodis-Jamero

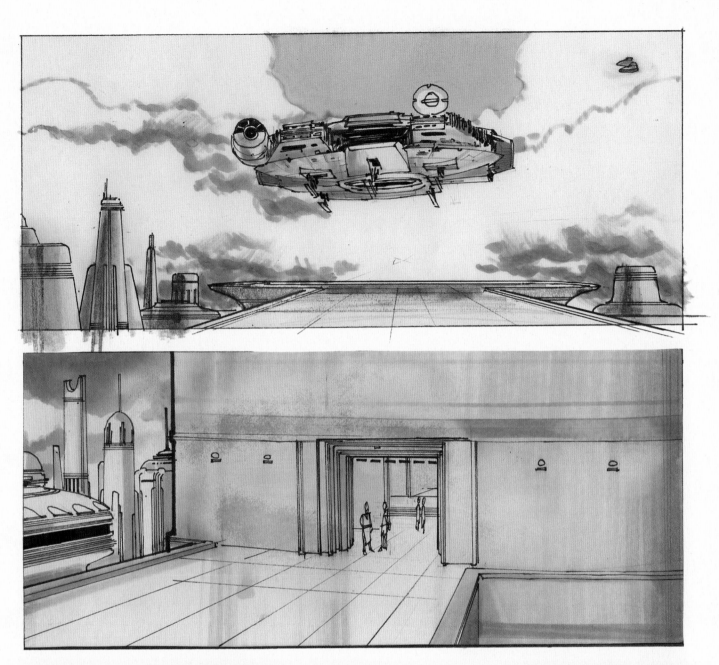

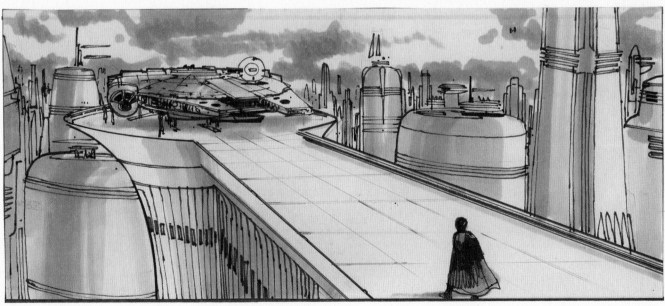

The *Falcon* lands and its passengers are greeted by Lando Calrissian,
administrator of Cloud City and an old friend of Han Solo. » Rodis-Jamero

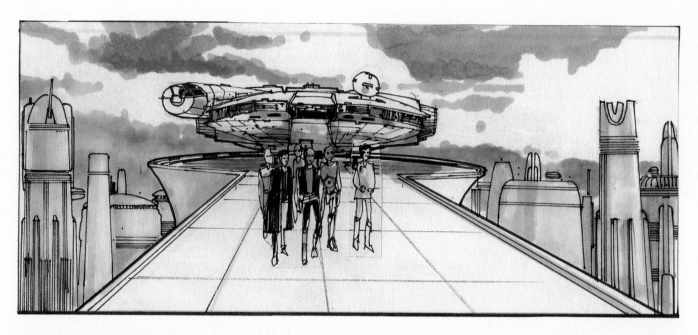

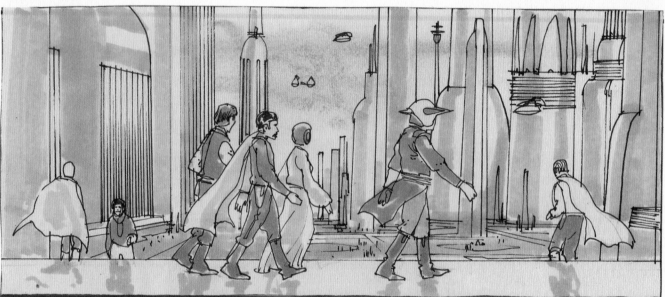

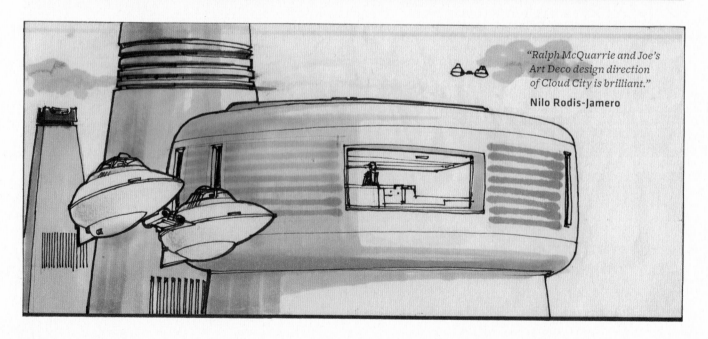

"Ralph McQuarrie and Joe's Art Deco design direction of Cloud City is brilliant."

Nilo Rodis-Jamero

Lando leads Han and Leia to their apartment, touring Cloud City on the way. » Rodis-Jamero, **R1, R3**; Johnston, **R2**

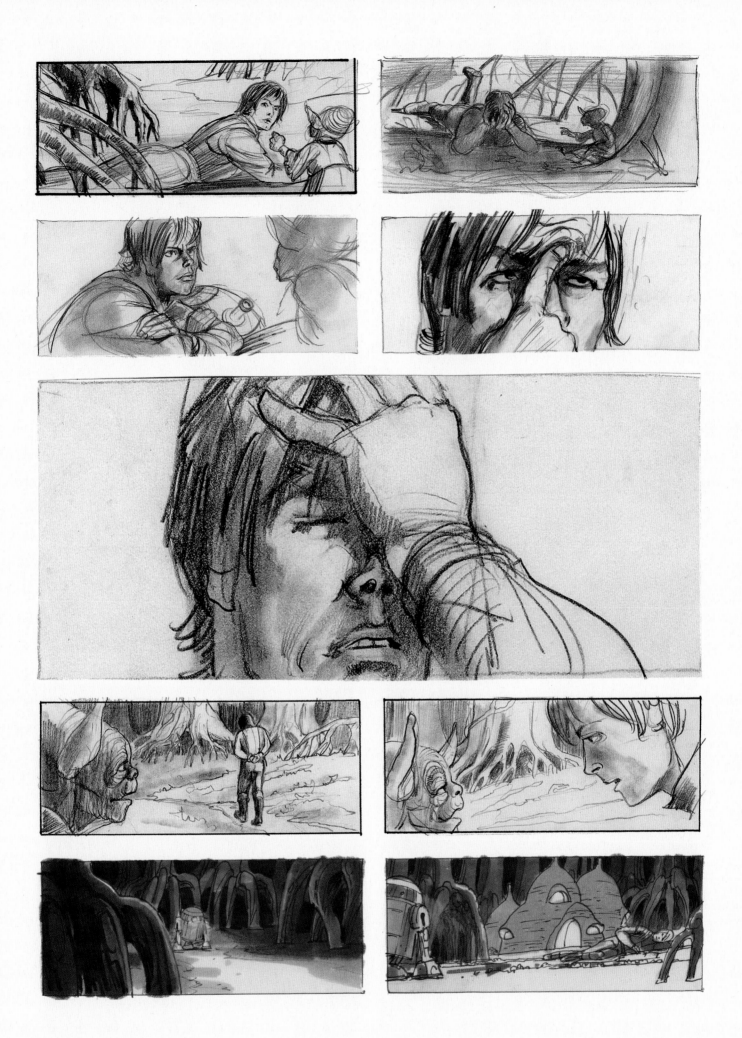

Luke realizes his friends are in trouble on Cloud City; that night R2 approaches Yoda's hovel. » Beddoes, **R1:4**; McQuarrie, **R5**

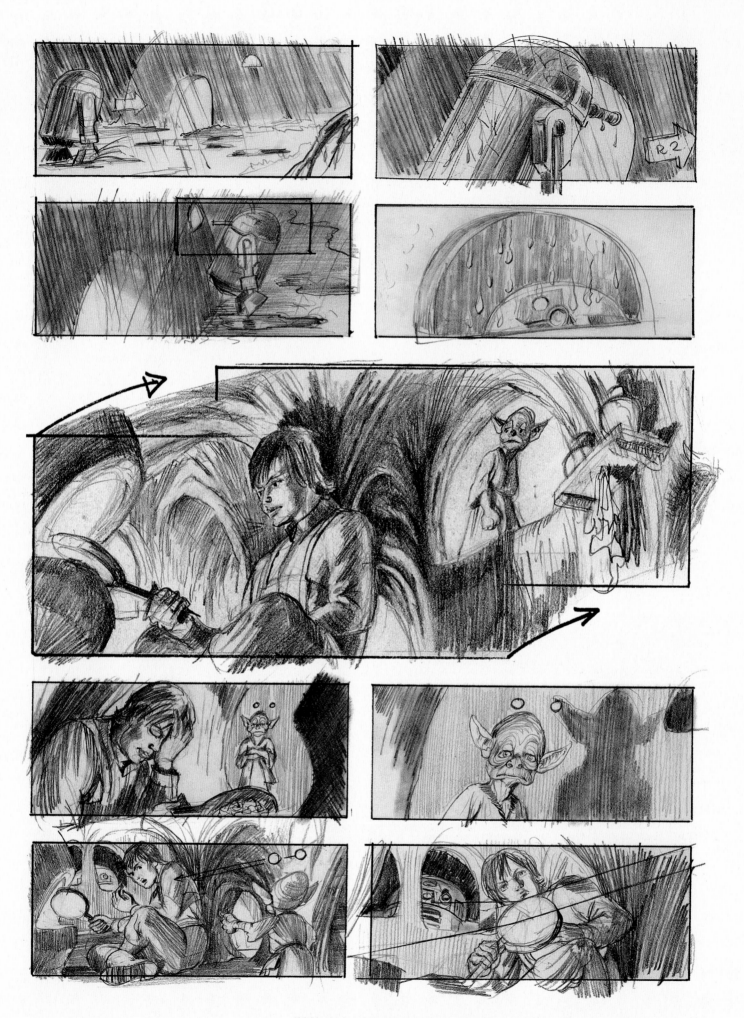

Within the hovel, Yoda is not through testing Luke—and launches two "stun globes" at him, one of which Luke deflects accidentally into R2 at the window. » Beddoes

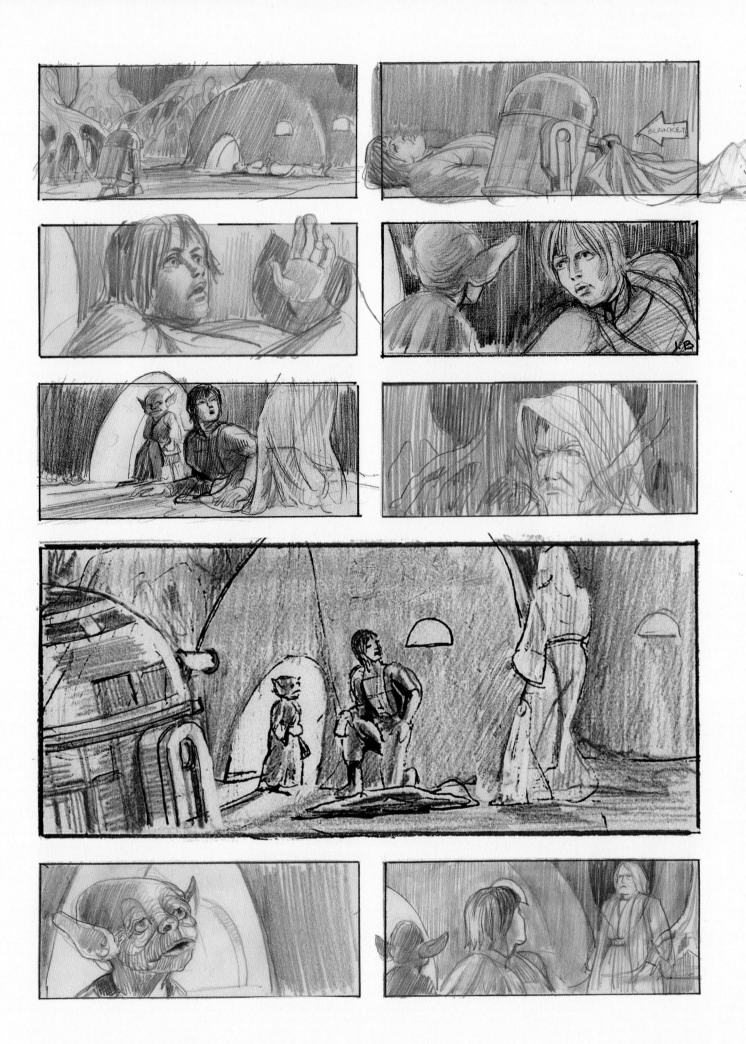

Faithful R2 pulls a blanket over a shivering Luke, who is sleeping outside when Ben appears to him. » Beddoes

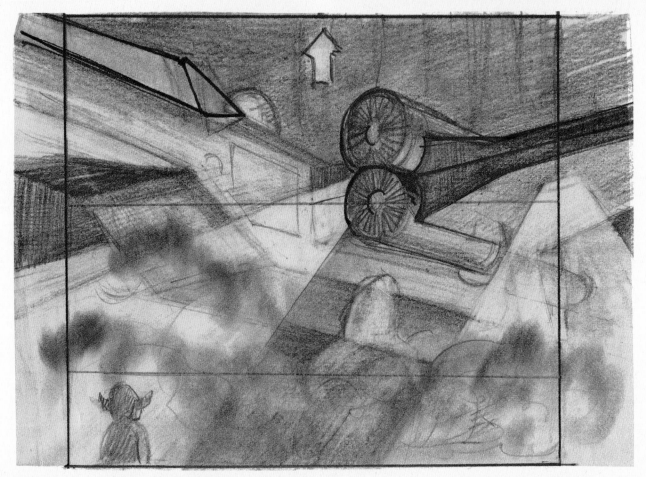
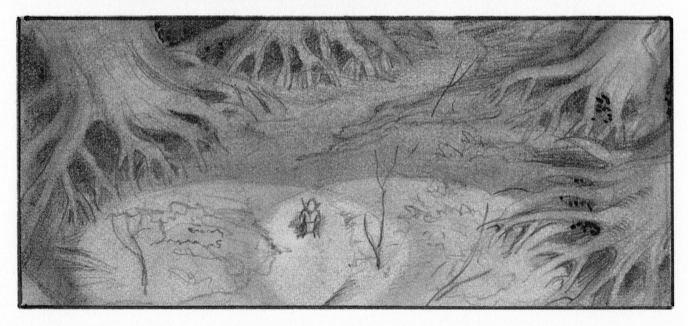

After Yoda and Ben advise against it, Luke takes off in his X-wing to rescue his friends. » Beddoes

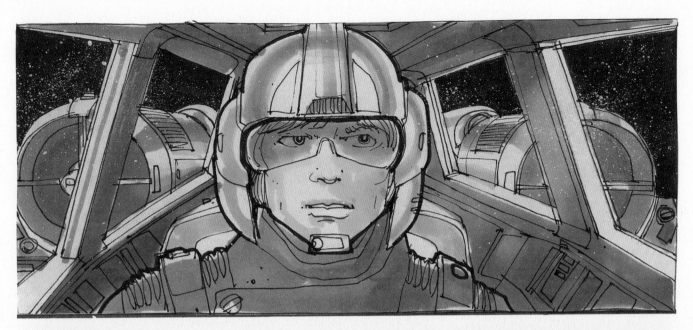

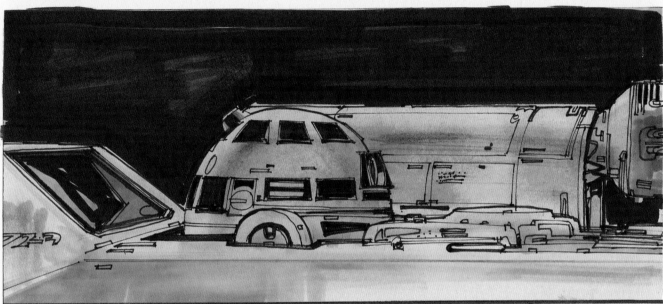

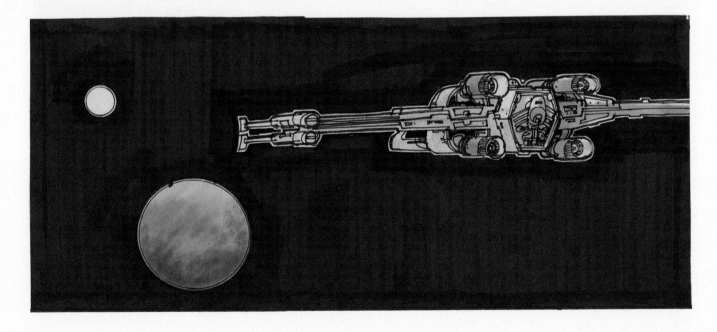

Luke communicates with R2 and heads toward Cloud City. » Johnston, **R1**; Rodis-Jamero, **R2:3**

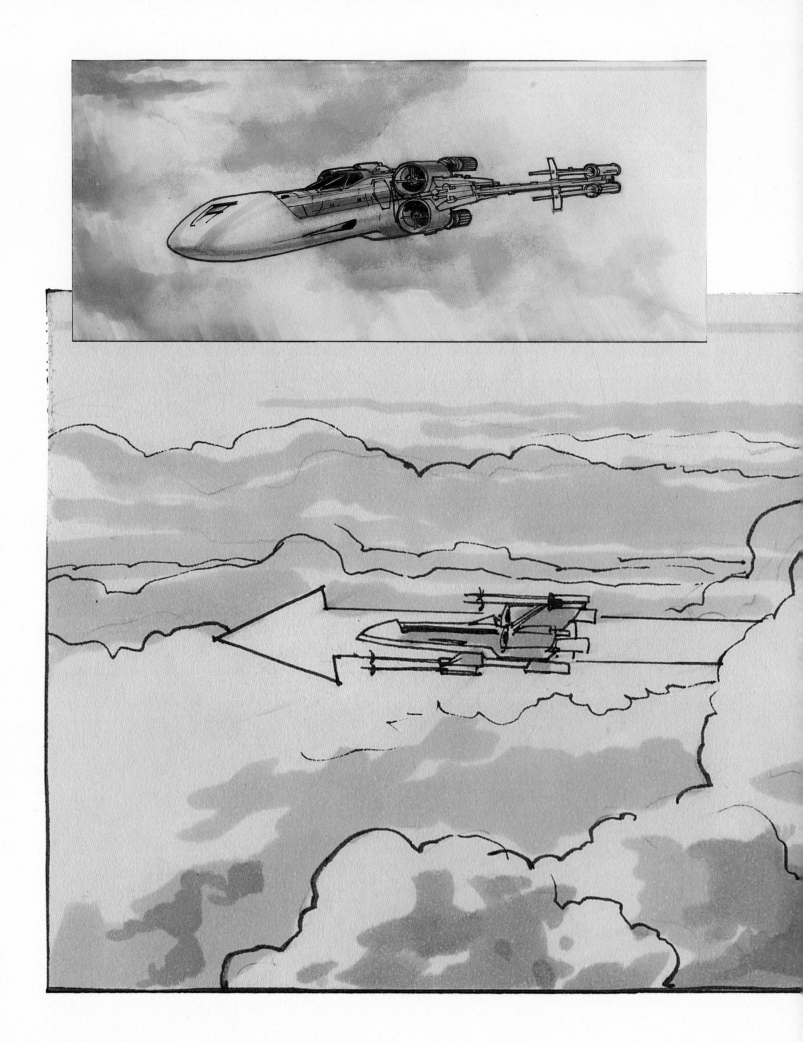

Luke approaches his destination, passing between clouds. » Johnston

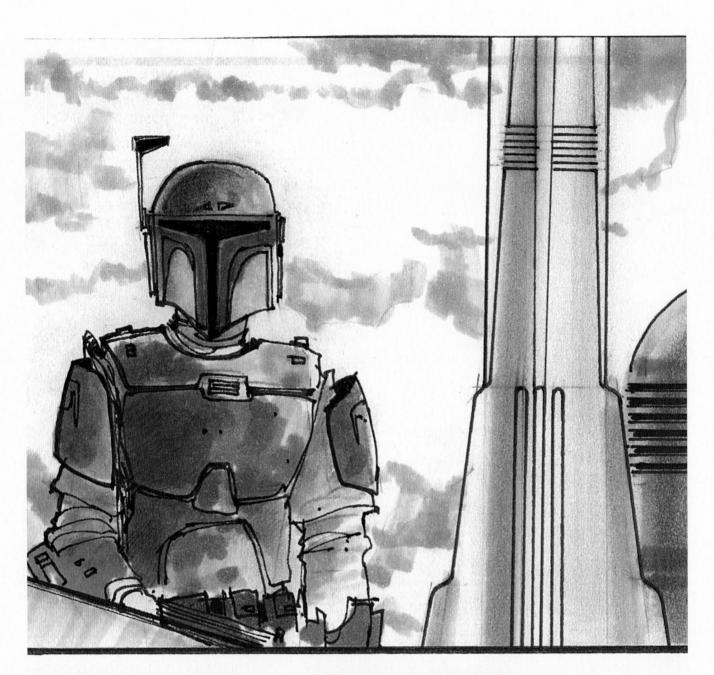

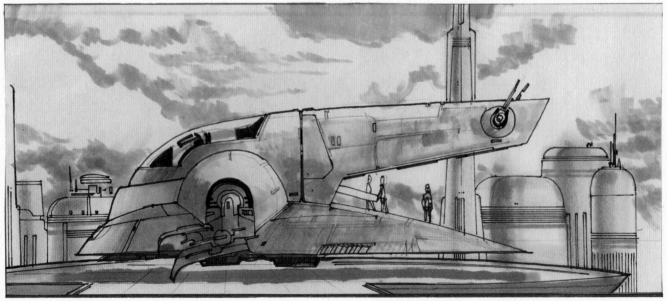

Boba Fett loads Han Solo, his bounty, into his ship. Solo has been frozen in a block of carbonite. » Rodis-Jamero

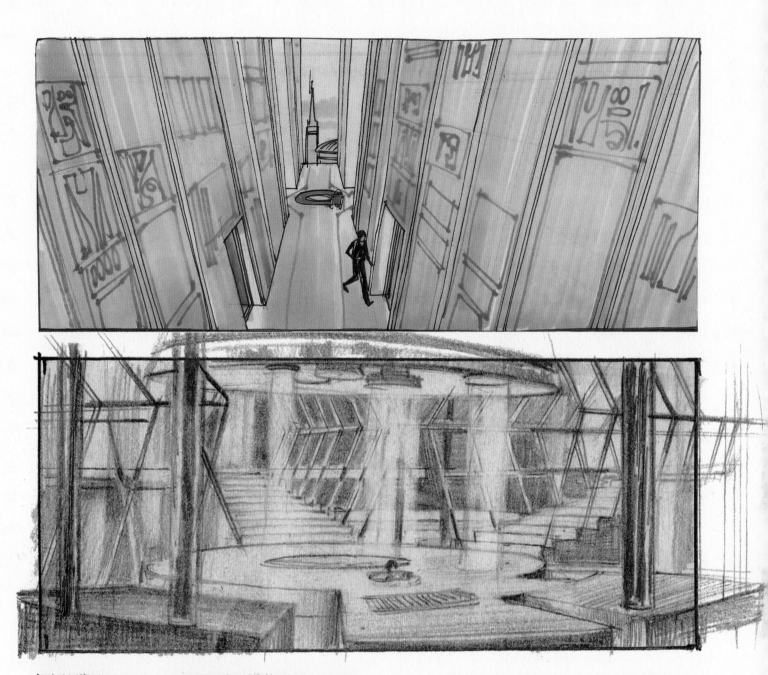

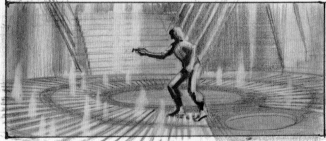

"Owing to script changes and deletions and action changes—set alterations—sketches are cut out and stuck onto new sheets with further eliminations and additions, which accounts for odd sketches alone on a page. This order is as Kersh agreed with me the night before the unit flew to Norway [for location shooting]."

Ivor Beddoes, March 12, 1979

Luke arrives on Cloud City and finds the carbon-freezing chamber—too late. Darth Vader is already waiting . . . » McQuarrie, **R1**; Beddoes, **R2:4**

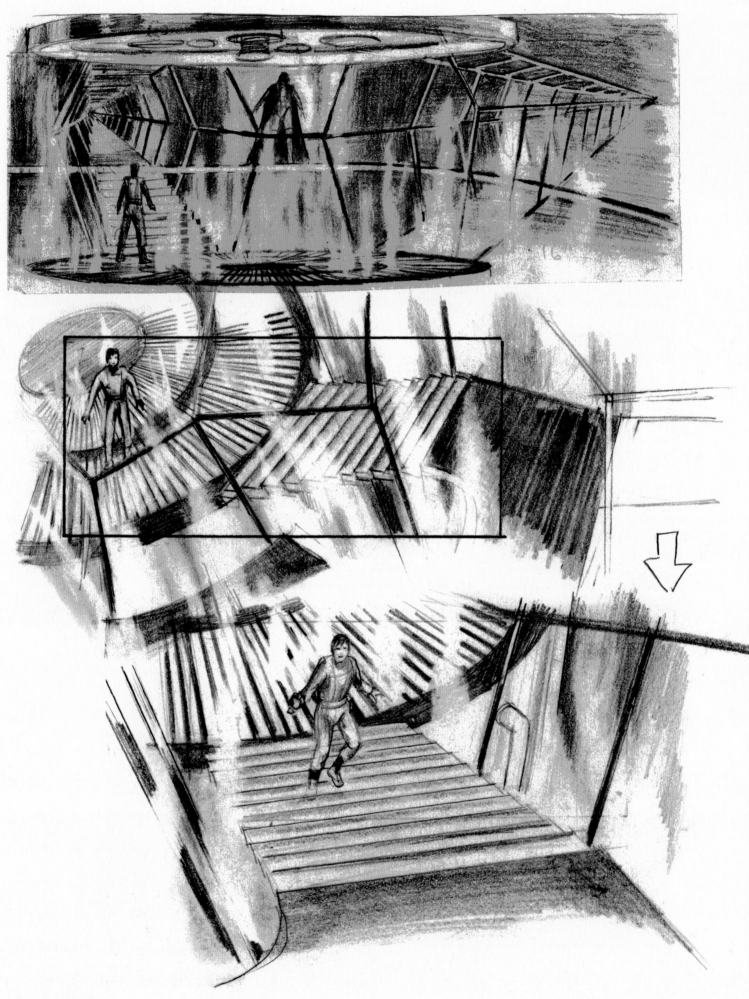

Luke confronts Vader. » Beddoes

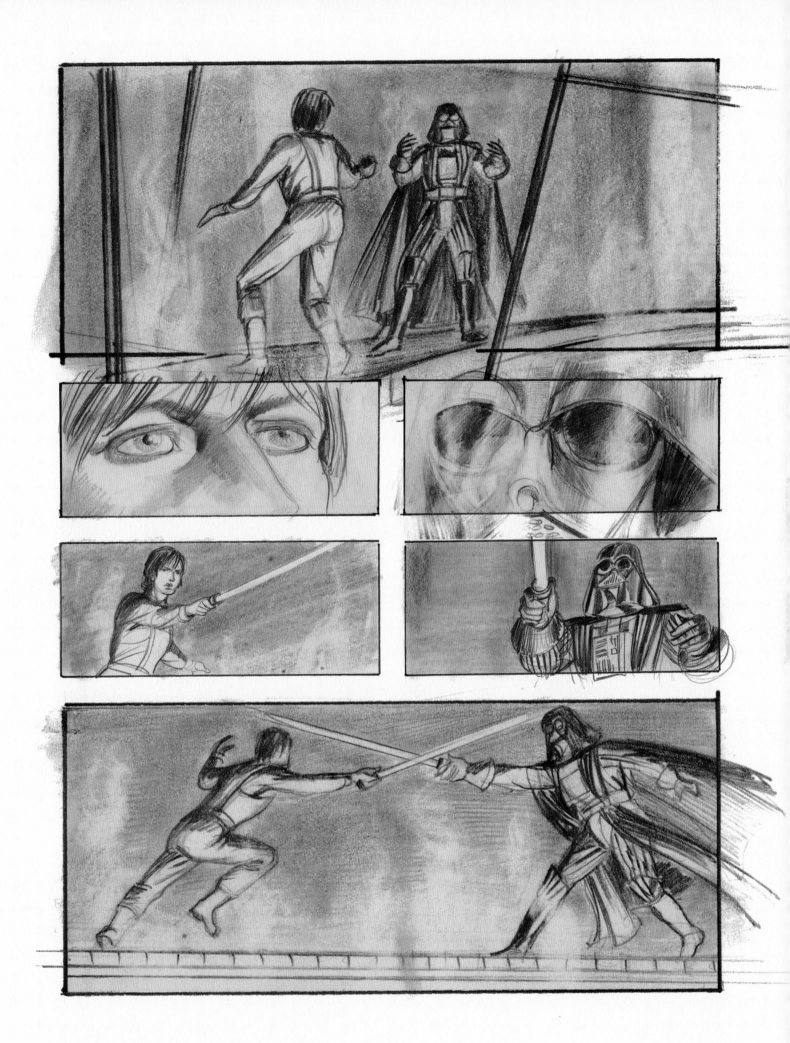

They ignite their lightsabers and the duel begins, with Luke attacking aggressively. » Beddoes

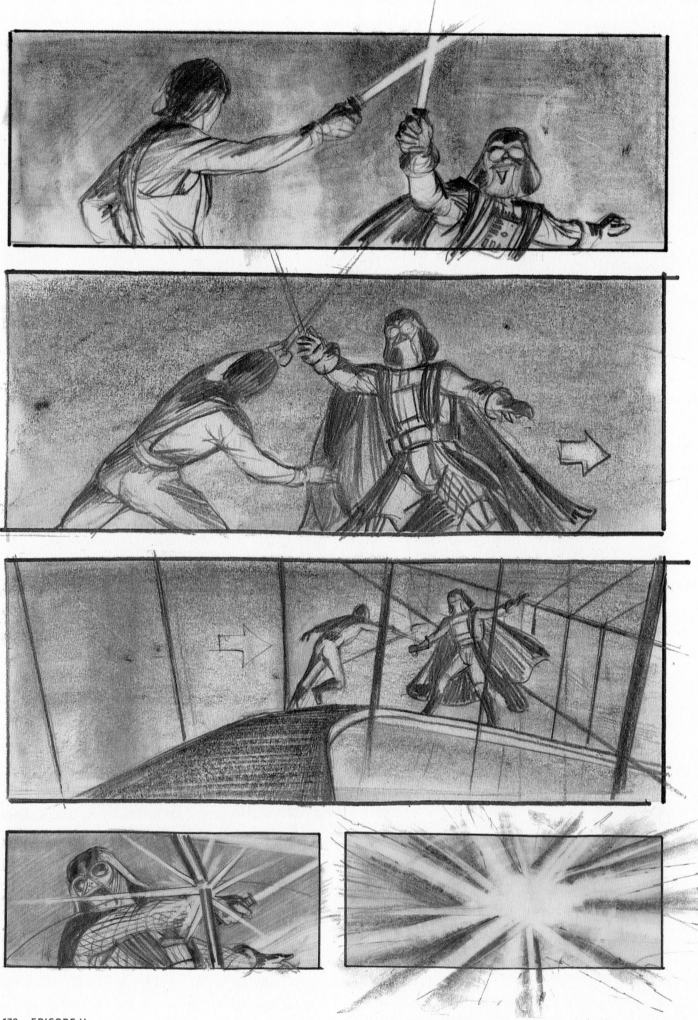

As they fight, Vader slashes through a support beam. » Beddoes

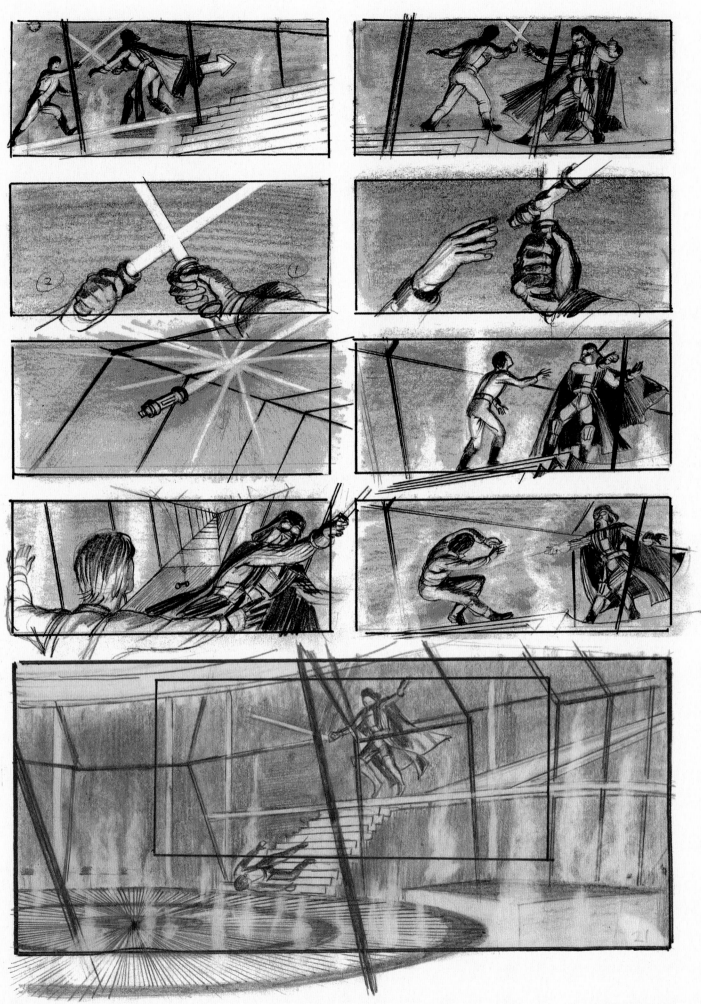

Vader knocks away Luke's lightsaber, which cuts one of the stay wires, and Luke tumbles down the stairs. » Beddoes

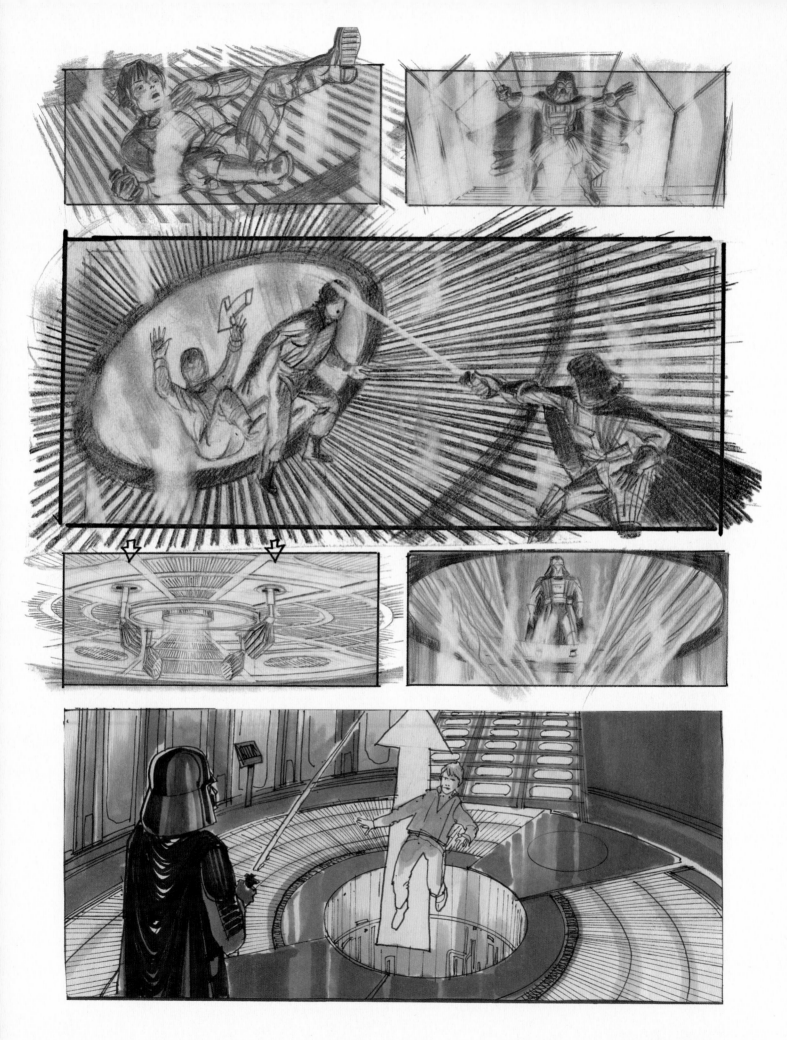

Luke steps backward and drops into the carbon-freeze hole, which is quickly filled with molten
liquid pouring in from above—but Luke jumps out in time. » Beddoes, **R1:3**; Johnston, **R4**

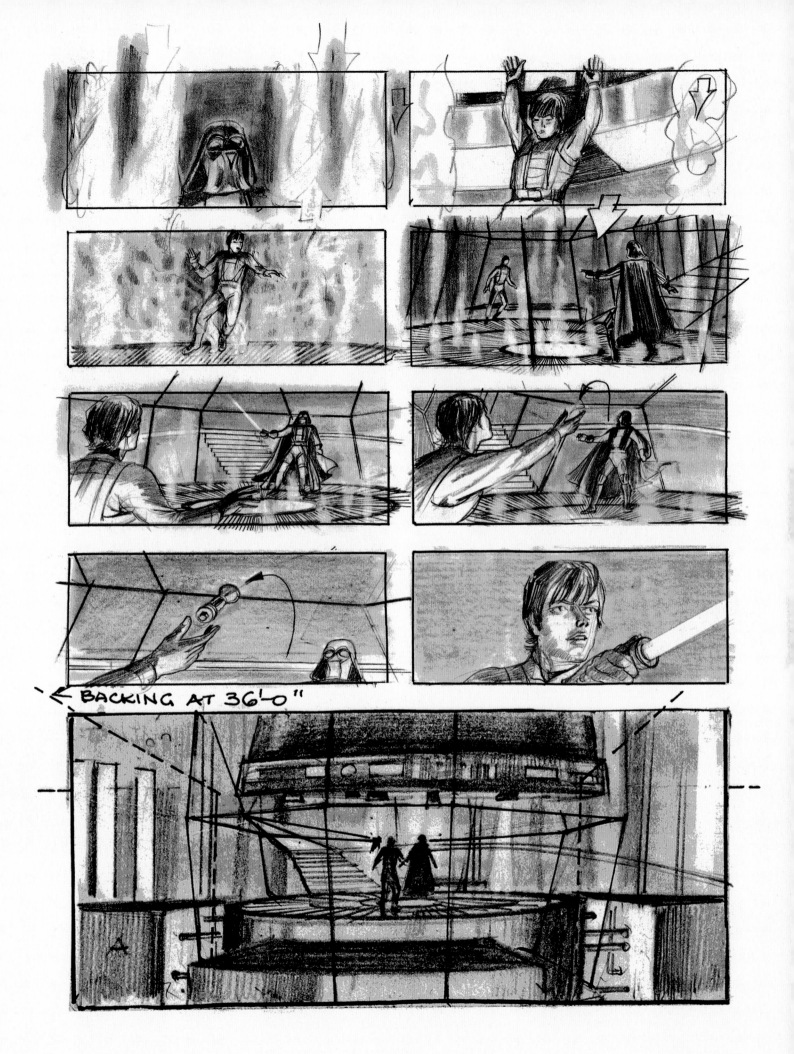

BACKING AT 36'-0"

Amid the metal and steam, Luke summons his lightsaber and is ready for round two. » Beddoes

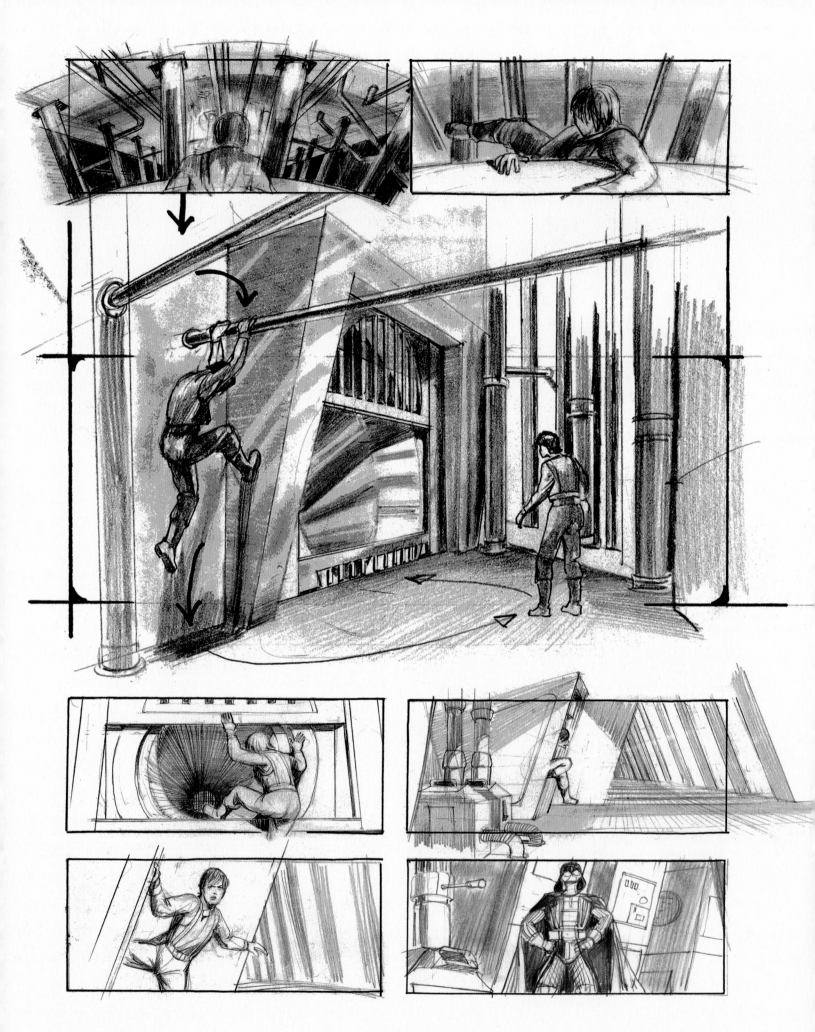

Realizing he's outmatched, Luke tries to escape Vader, climbing down from the chamber to another room—but Vader is waiting once again. » Beddoes

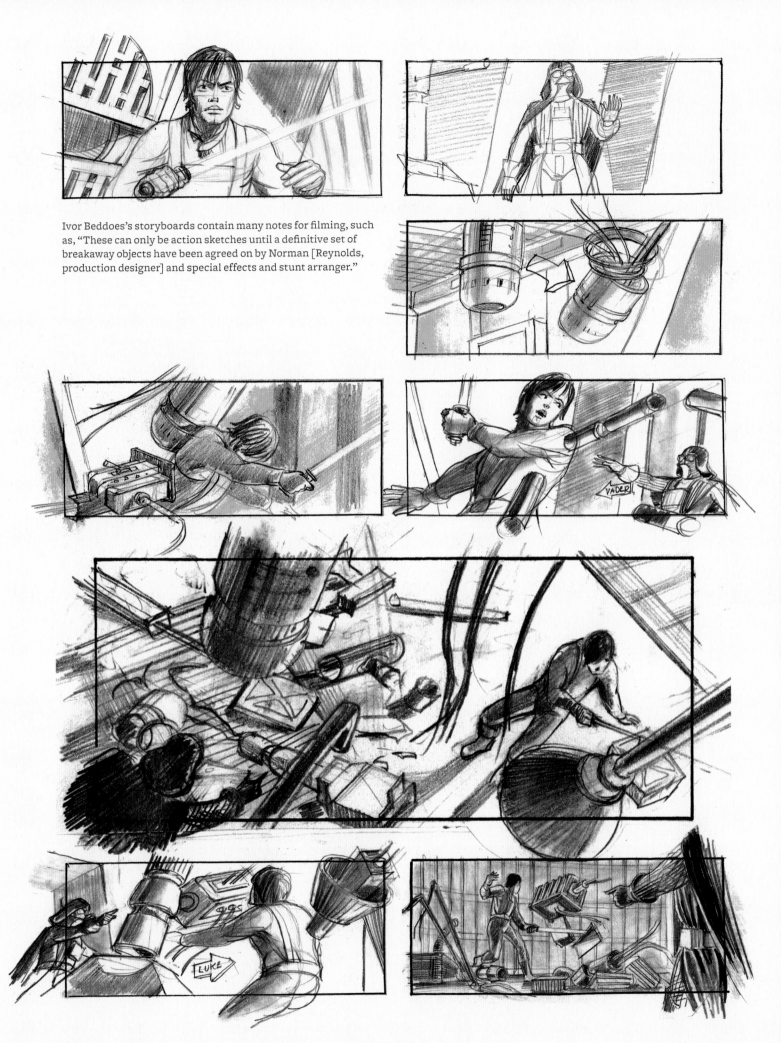

Ivor Beddoes's storyboards contain many notes for filming, such as, "These can only be action sketches until a definitive set of breakaway objects have been agreed on by Norman [Reynolds, production designer] and special effects and stunt arranger."

Using the dark side of the Force, Vader hurls objects at Luke, who is bruised and bloodied. » Beddoes

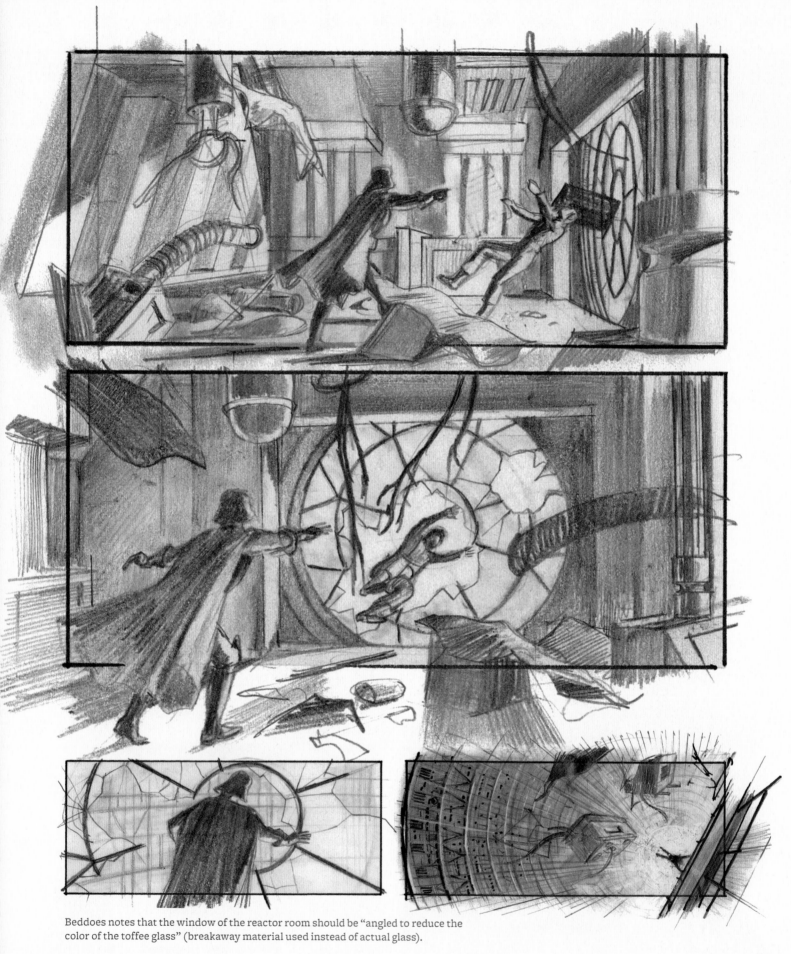

Beddoes notes that the window of the reactor room should be "angled to reduce the color of the toffee glass" (breakaway material used instead of actual glass).

When the window is broken, Luke is pulled out by powerful suction and hangs over "the nuclear reactor furnace a mile below." » Beddoes

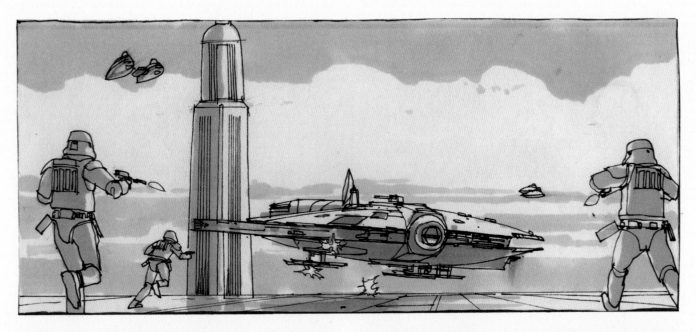

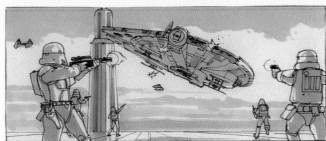

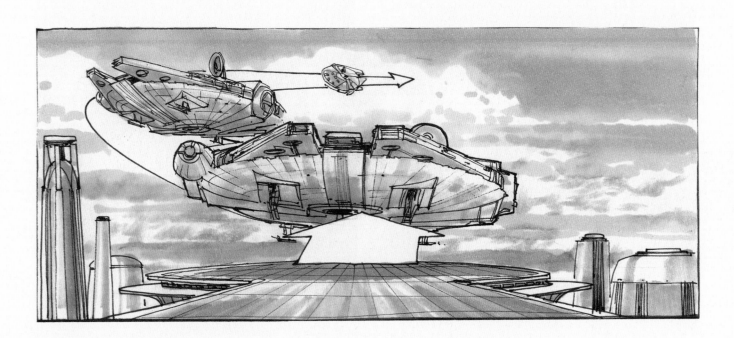

Leia, Chewbacca, the droids, and Lando escape the stormtroopers, blasting off from Cloud City
into a twilight sky (with two variations on the *Falcon*'s departure). » Johnston, **R1:2**; Rodis-Jamero, **R3**

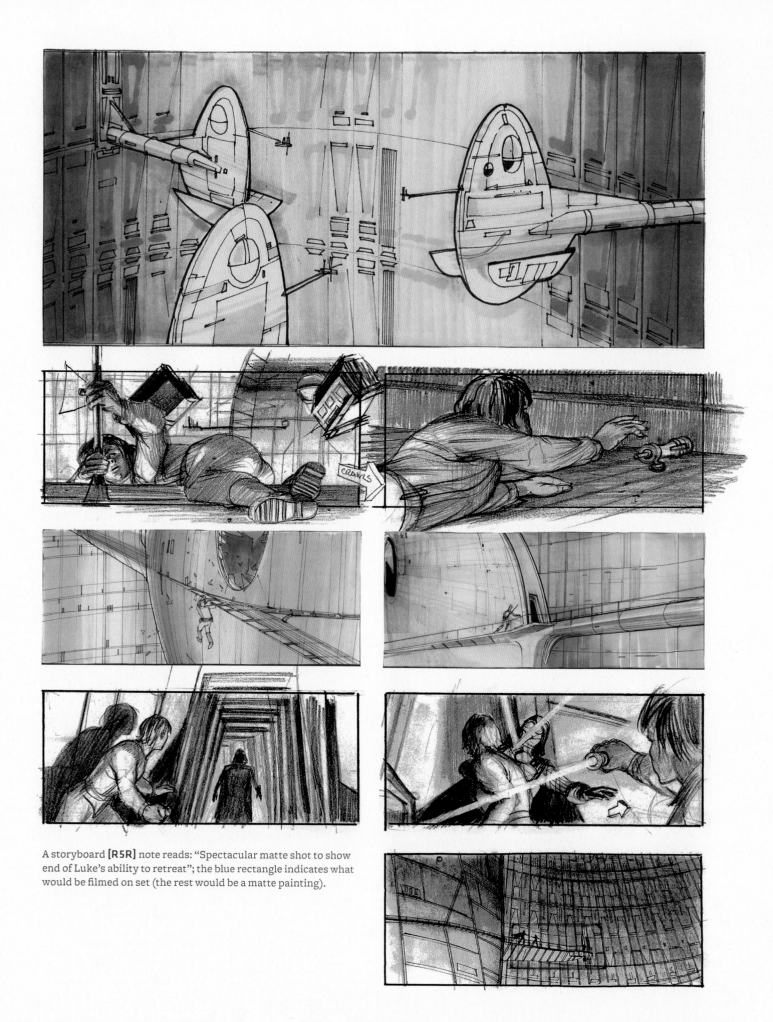

A storyboard [R5R] note reads: "Spectacular matte shot to show end of Luke's ability to retreat"; the blue rectangle indicates what would be filmed on set (the rest would be a matte painting).

Luke recovers his lightsaber, and his duel with Vader continues atop, originally, one of three gantries perched over a reactor core. » McQuarrie, **R1**, **R3**; Beddoes, **R2**, **R4:5**

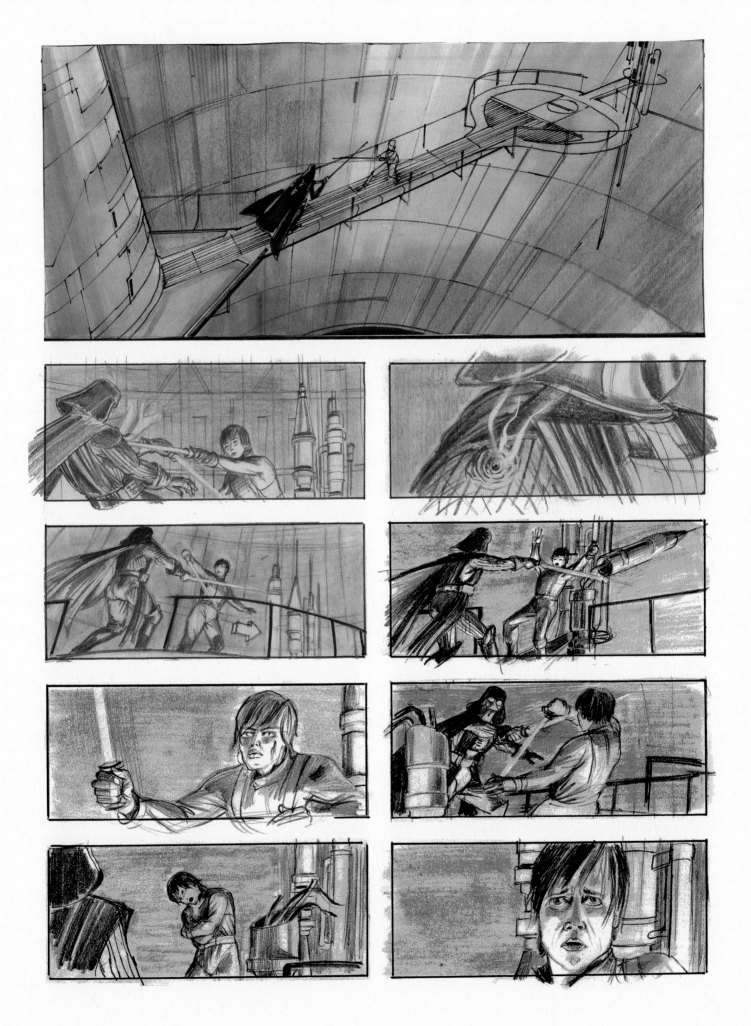

Luke wounds Darth Vader, who, in turn, cuts Luke. Luke "reels back in shock and pain." » McQuarrie, **R1**; Beddoes, **R2:5**

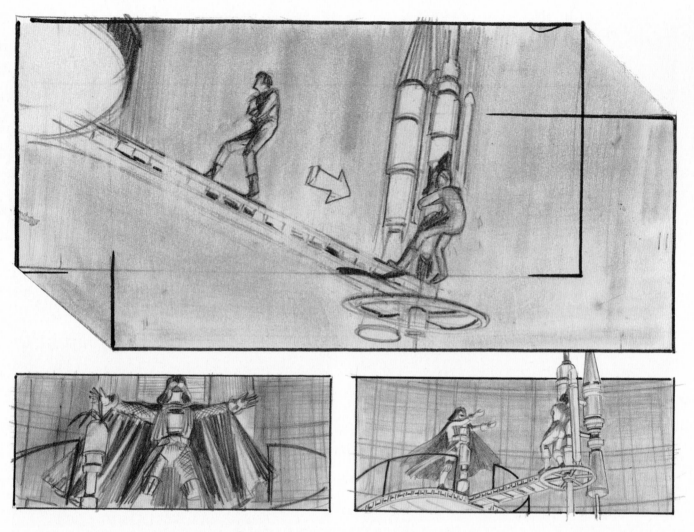

Beddoes did not know exactly what Vader would say at this point in the film, as this part of the script was top secret. His note reads "Beelzebub offering the world . . . end of dialogue."

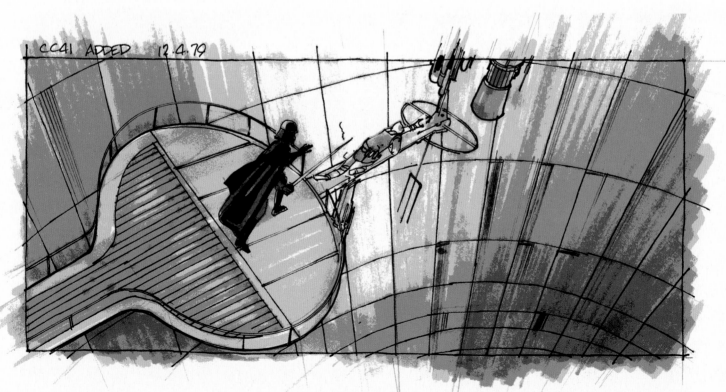

CC41 ADDED 12.4.79

Luke retreats to the end of the gantry, where Vader tempts him, revealing that he is Luke's father and that together the two of them could rule the galaxy. » Beddoes, **R1:2**; McQuarrie, **R3**

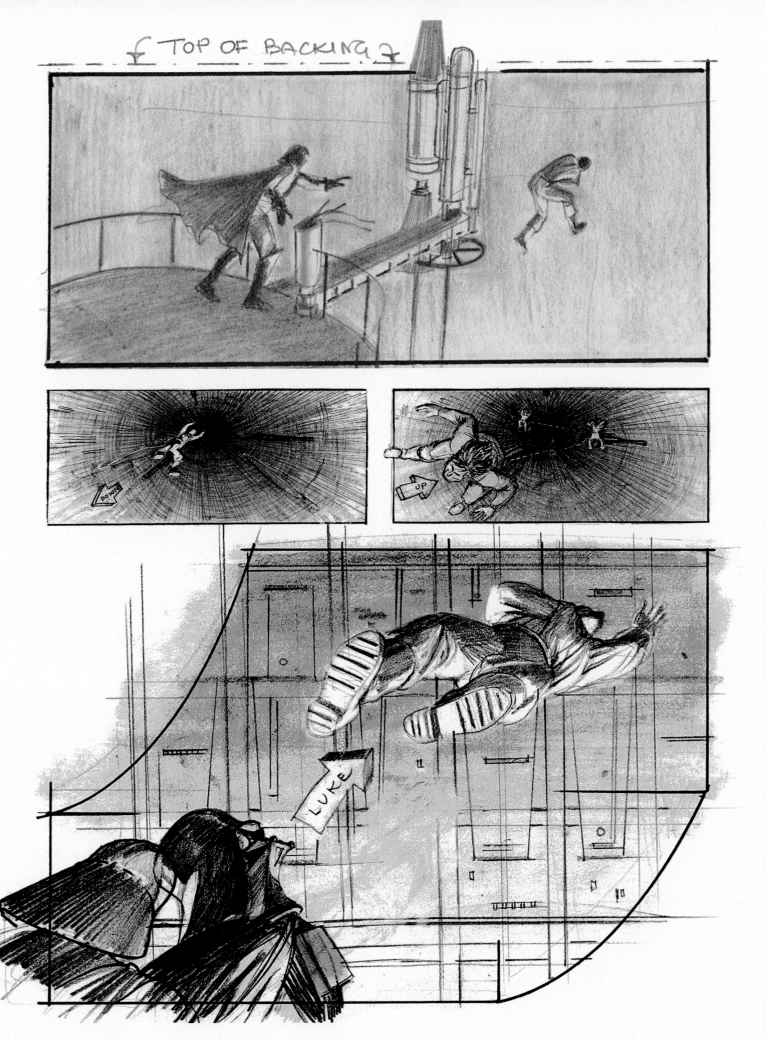

Rather than join Vader, Luke lets himself fall into the void—only to be blown back up over Vader's head by "the reactor gale." » Beddoes

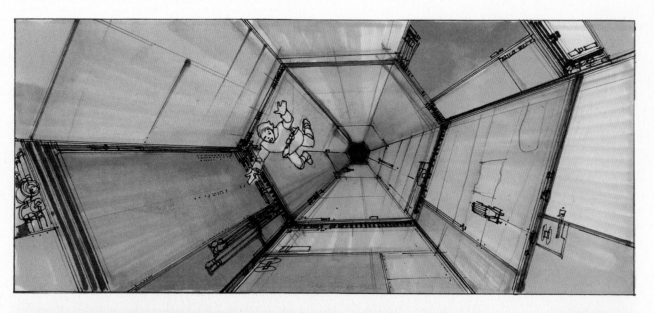

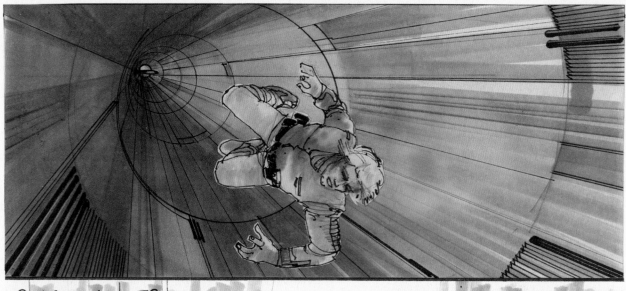

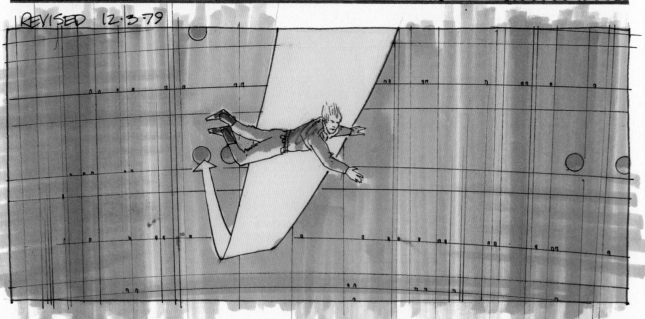

REVISED 12·3·79

Knowing that the boards were going to be cut out and mounted, artists didn't worry about going over the 2.35 format borders with their markers. This board **[R3]** was either redrawn or the angle was changed before the board had a chance to be mounted and numbered.

Luke falls through the shaft (in several iterations), where a current takes him into an exhaust port. » Rodis-Jamero, **R1:2**; Johnston, **R3**

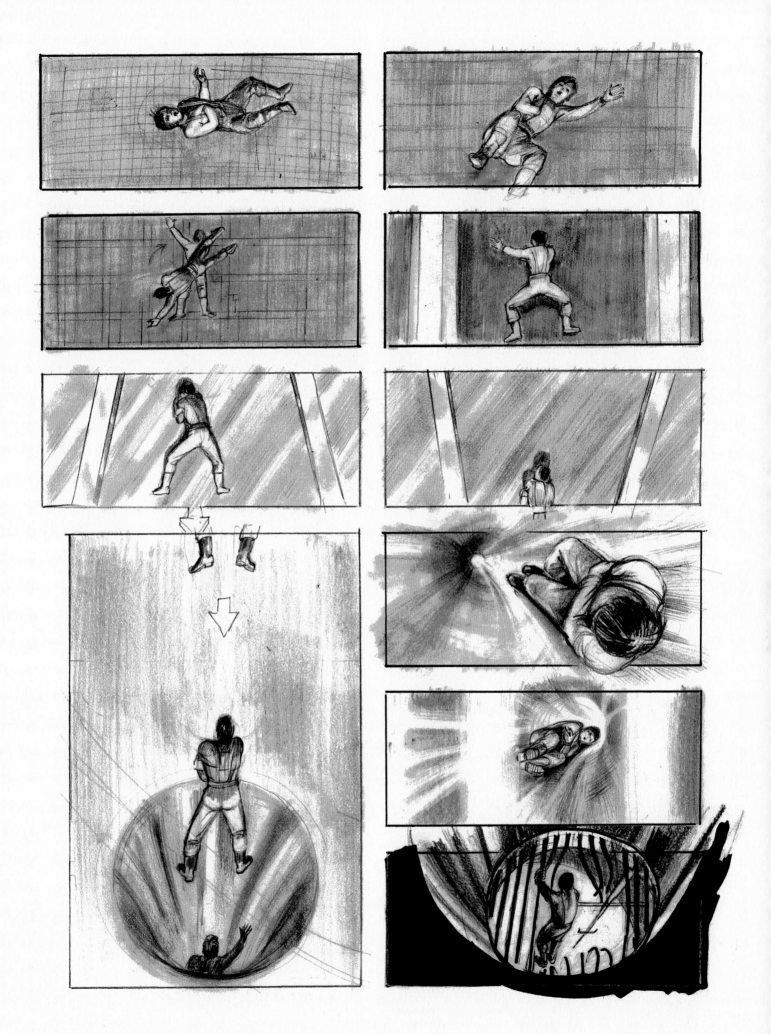

Another variation had Luke sliding down a glass wall (which would tilt on set), through a grille, into another shaft. » Beddoes

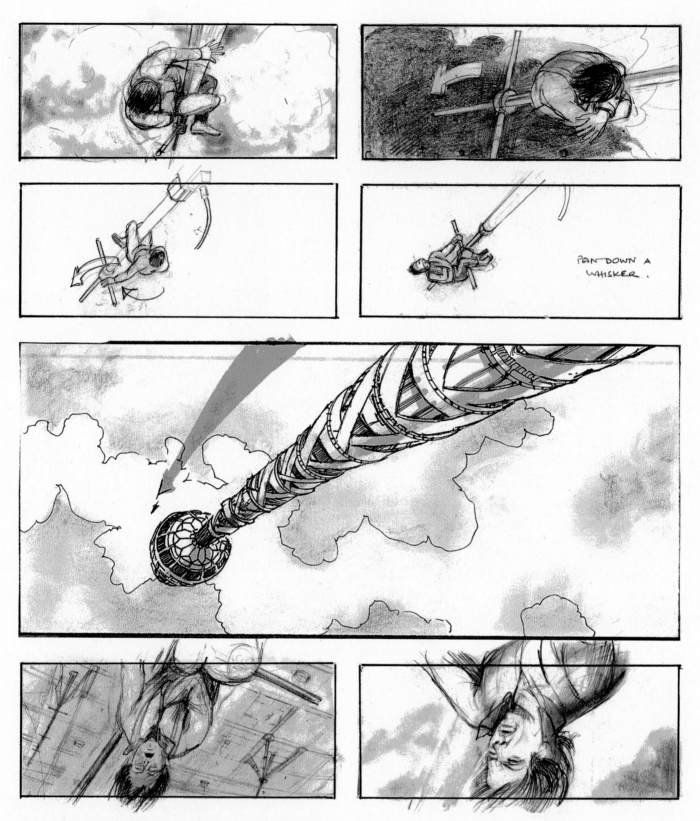

Beddoes wrote Kershner's instructions on the storyboards, for example **[R4]**: "Shoot this upside down (gum his hair upright); dry ice on painted backing with other mast upside down poking through."

The handwritten note on the storyboard reads: "PAN DOWN A WHISKER."

Luke falls onto an antenna jutting out below Cloud City and is left hanging upside down; "His position must seem utterly hopeless," a storyboard note reads. » Beddoes, **R1:2**, **R4**; McQuarrie, **R3**

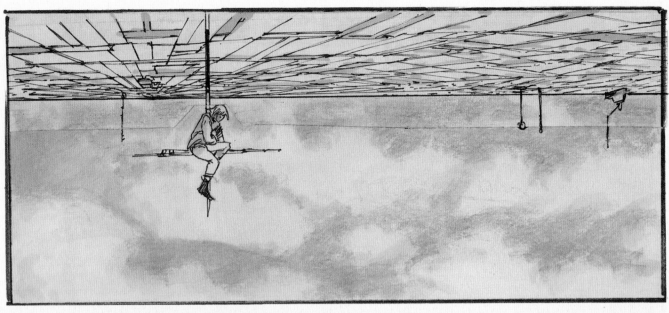

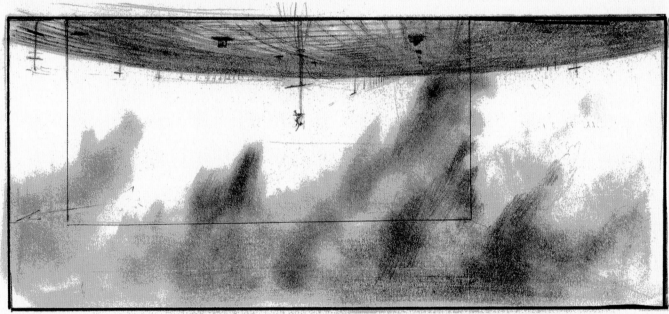

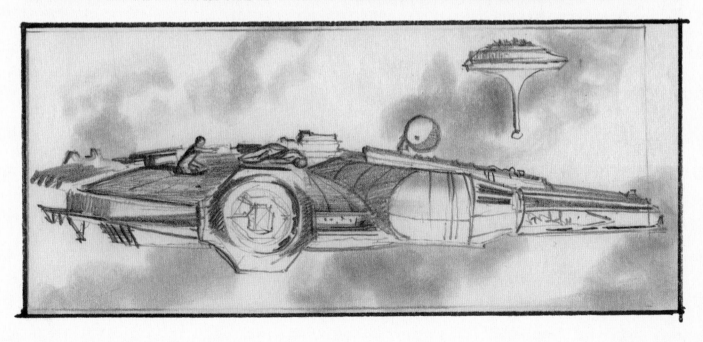

Another series of boards has Luke sitting on the antenna. The *Falcon* responds to his telepathic call to Leia. » Rodis-Jamero, **R1**; Beddoes, **R2:3**

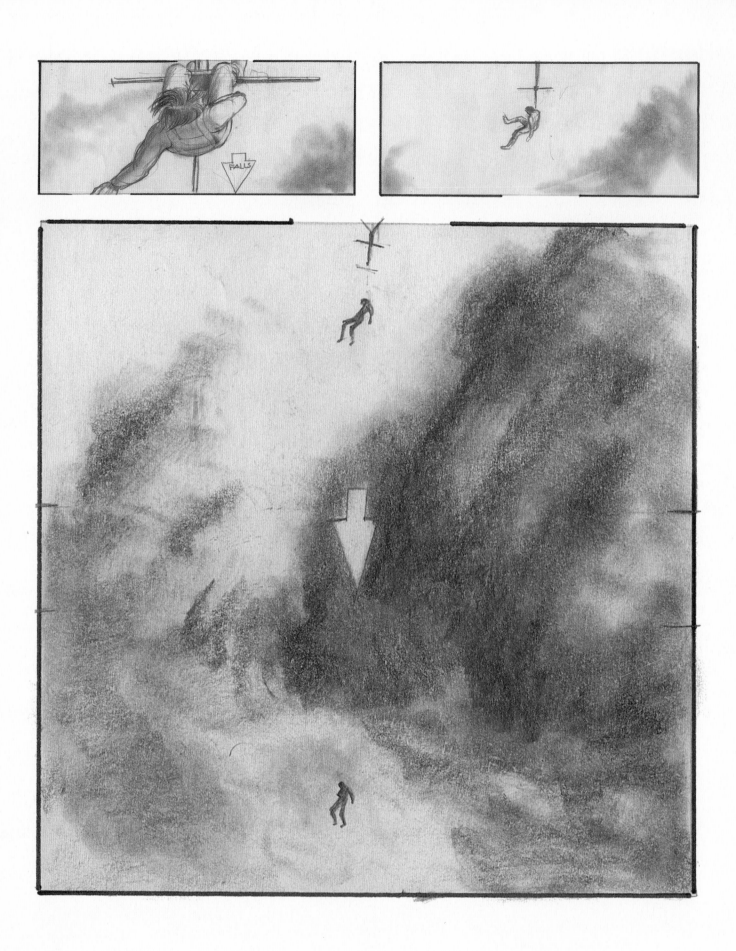

Luke faints and falls from the antenna (the camera would be over-cranked, so his fall would move more slowly when played back at twenty-four frames per second). » Beddoes

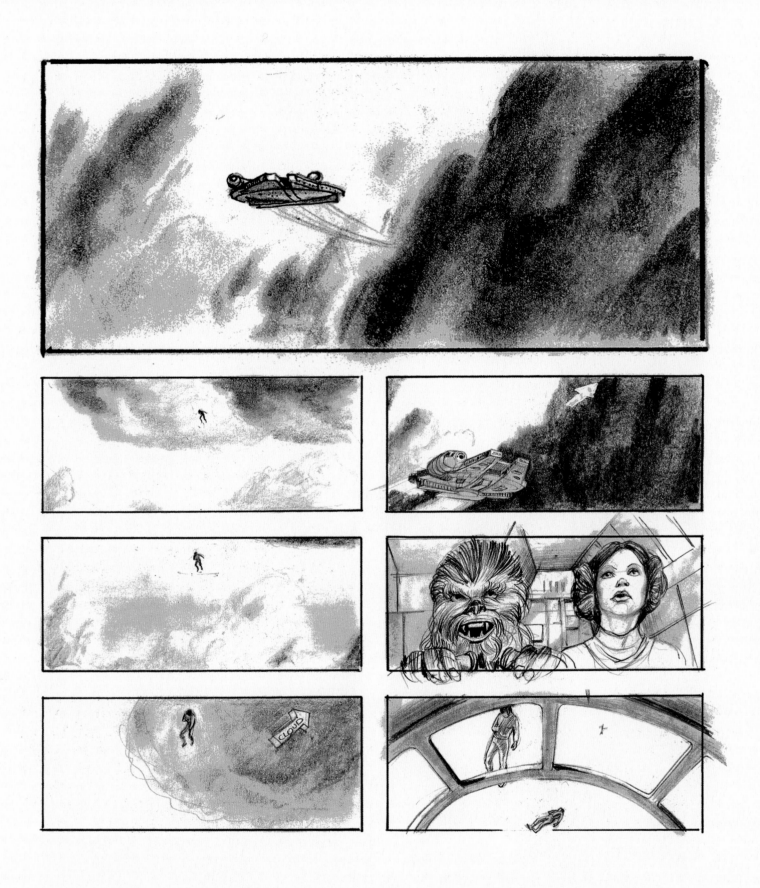

Responding to his call, Leia and Chewbacca spot the falling Luke and maneuver
the *Falcon* to catch him: "They hear a plop—he is on top!" a note reads. » Beddoes

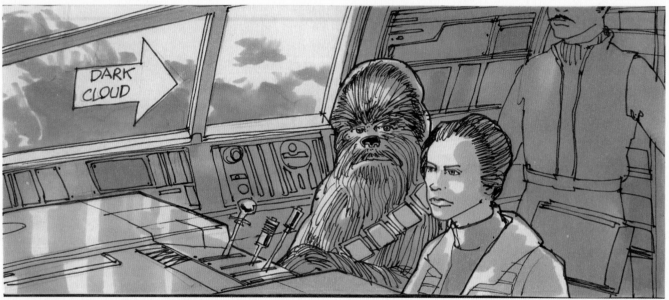

A storyboarded variation has the *Falcon* trio spot Luke (drawn from a VistaVision reference plate) before he falls from the antenna. » Rodis-Jamero, **R1**; Johnston, **R2**; Carson, **R3**

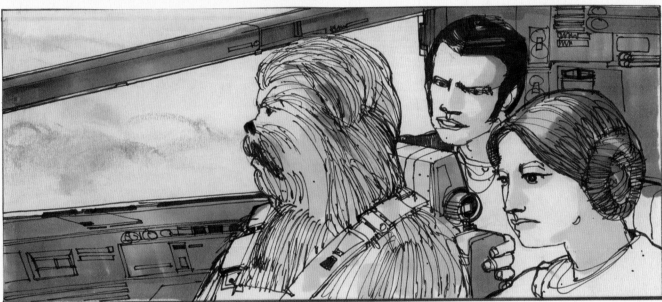

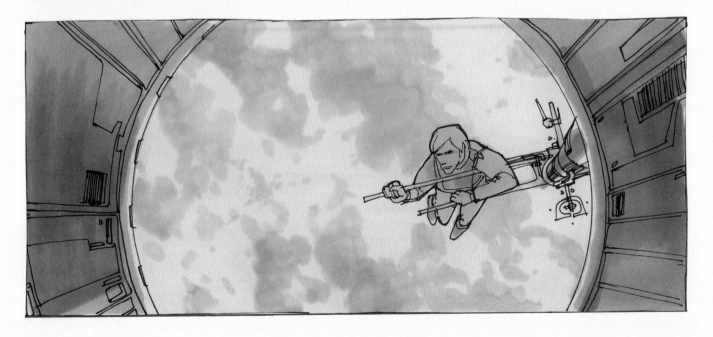

Leia, Lando, and Chewbacca hurry to catch Luke before it's too late. » Carson, **R1**; Rodis-Jamero, **R2**; Johnston, **R3**

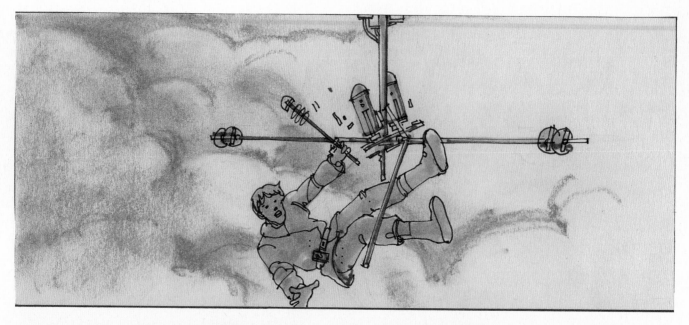

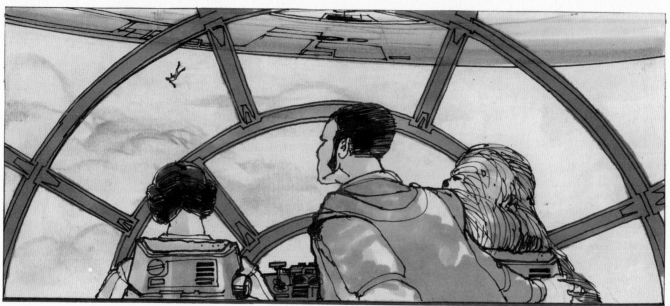

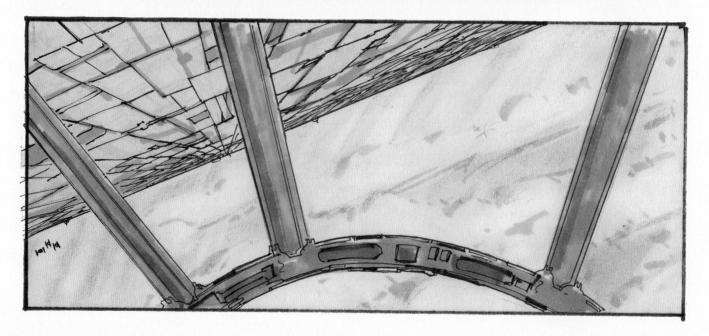

The antenna snaps and Luke falls while three TIE fighters approach. » Rodis-Jamero

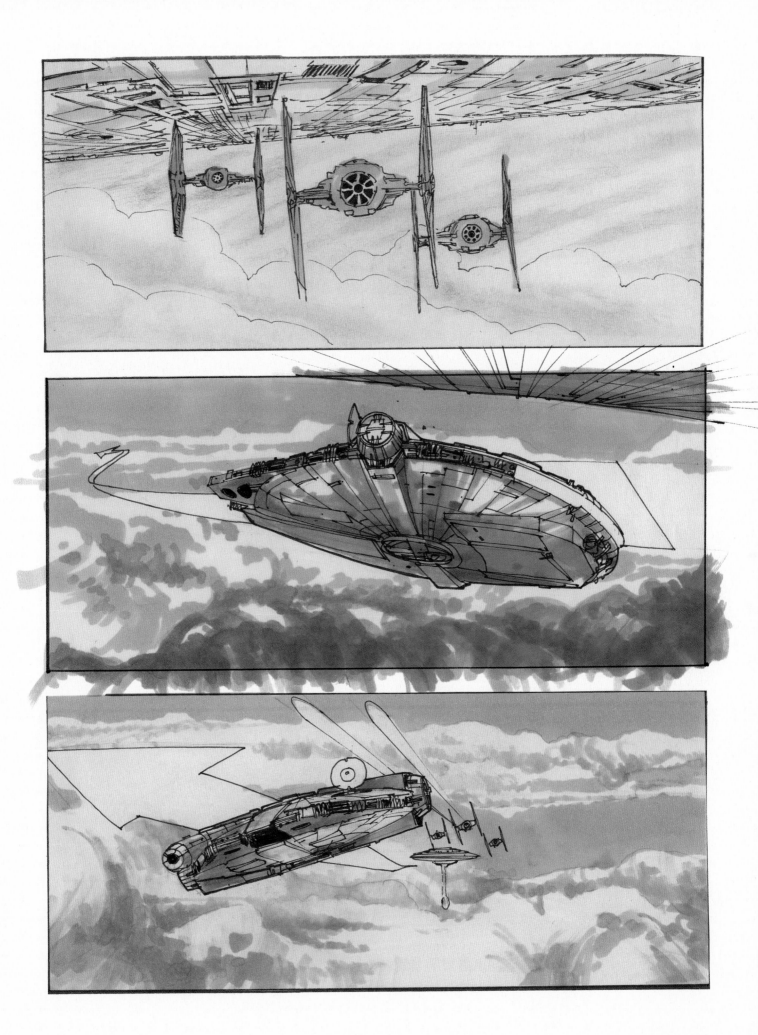

After recuperating Luke, the *Falcon* is pursued by TIE fighters. » McQuarrie, **R1**; Rodis-Jamero, **R2:3**

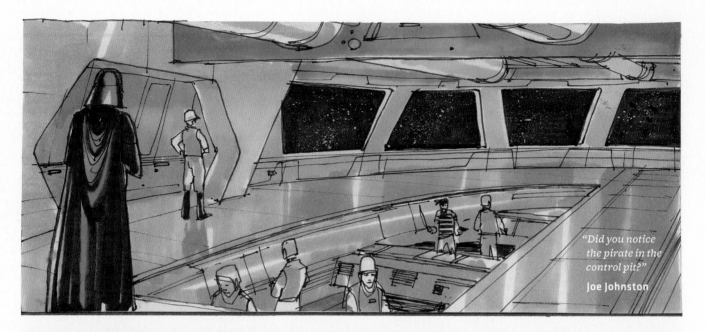

"Did you notice the pirate in the control pit?"
Joe Johnston

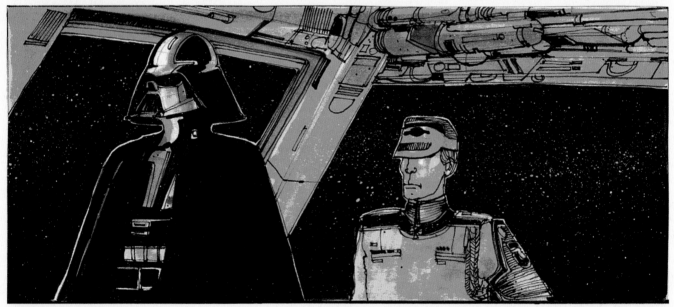

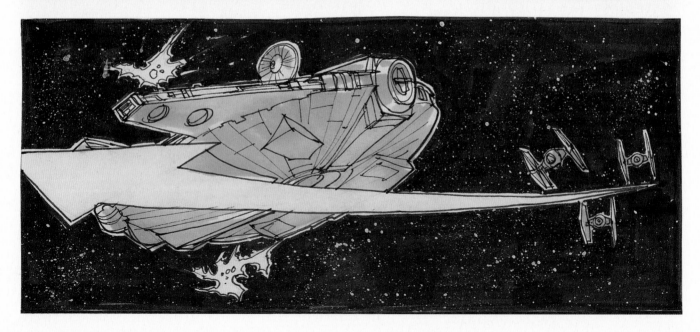

Vader is confident the *Falcon* will be captured, as its hyperdrive has been deactivated by his sinister agents. » Johnston, **R1**, **R3**; Rodis-Jamero, **R2**

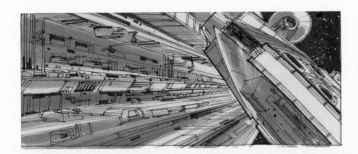
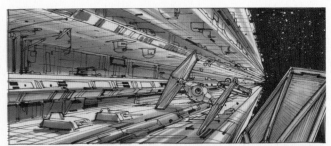

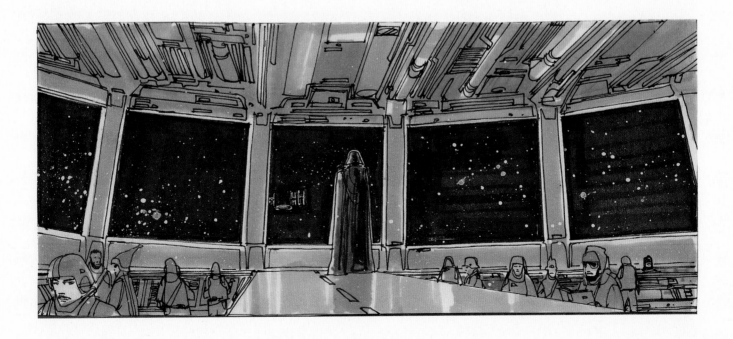

The *Falcon* is in great danger, pummeled by laser fire, as Vader watches. » Johnston, **R1**, **R3**; Rodis-Jamero, **R2**

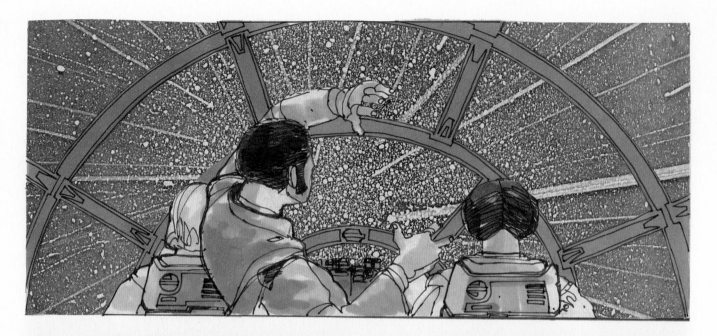

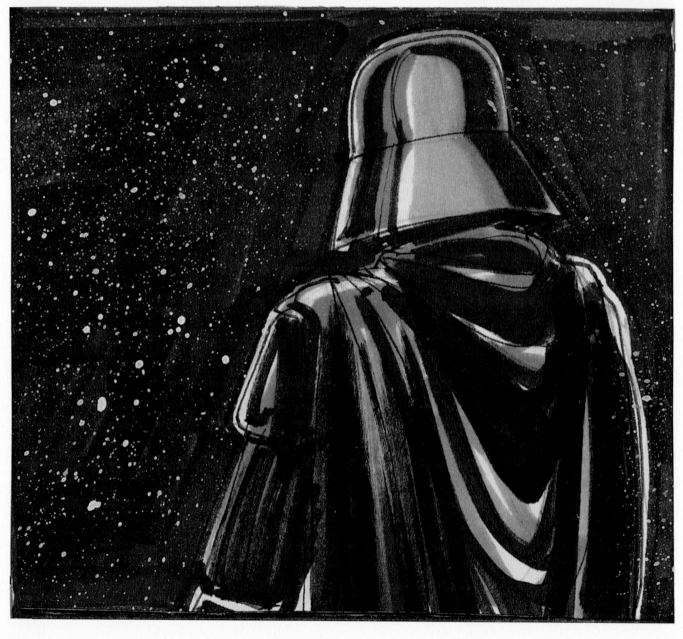

But after R2 repairs the hyperdrive the *Falcon* makes the jump to hyperspace. Vader stands alone. » Rodis-Jamero, **R1**; Johnston, **R2**

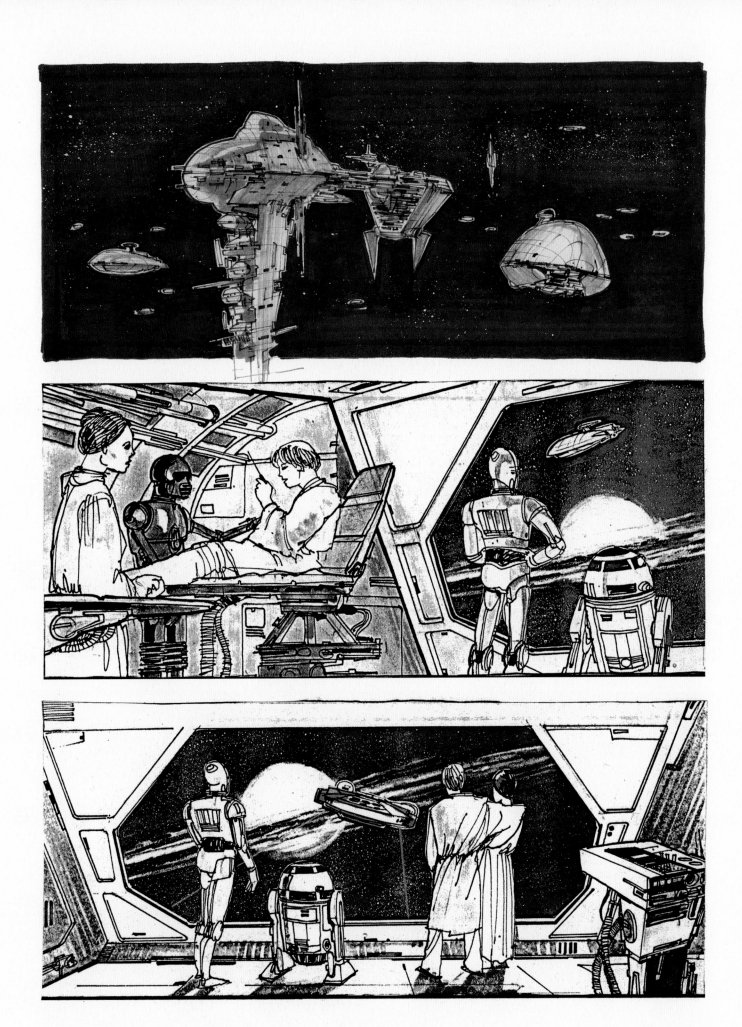

Aboard a medical frigate, back among the rebel fleet, a medical droid tends to Luke.
He and Leia then watch the *Falcon* leave in search of Han Solo. » Rodis-Jamero

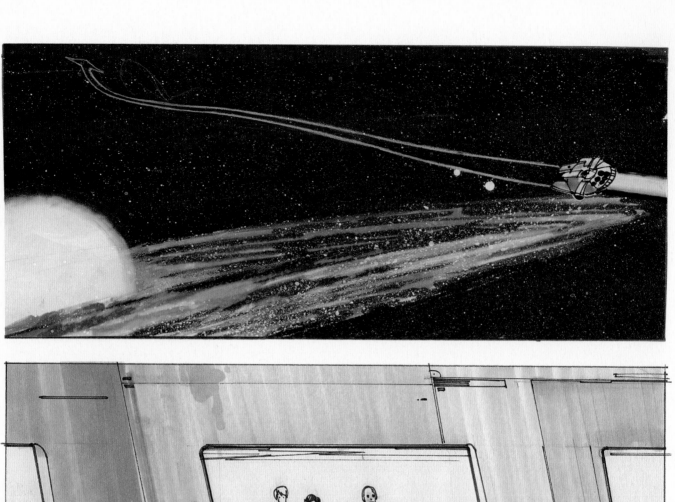

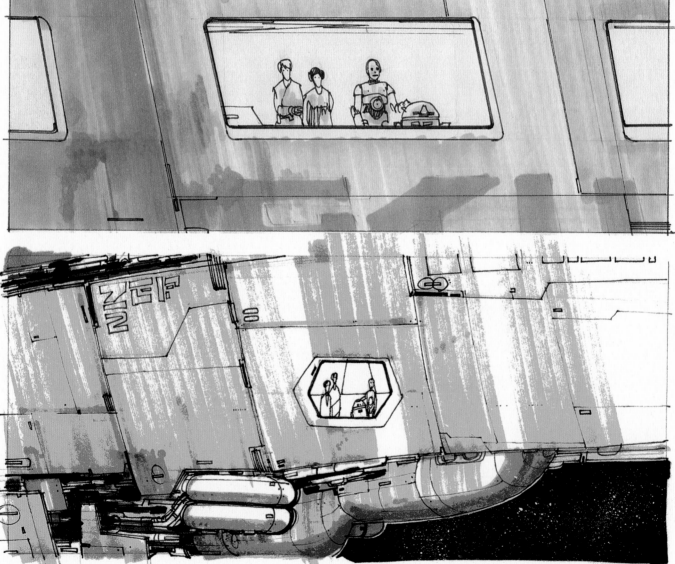

Luke, Leia, and the droids are seen from the exterior as
their rebel ship turns from camera. » Rodis-Jamero

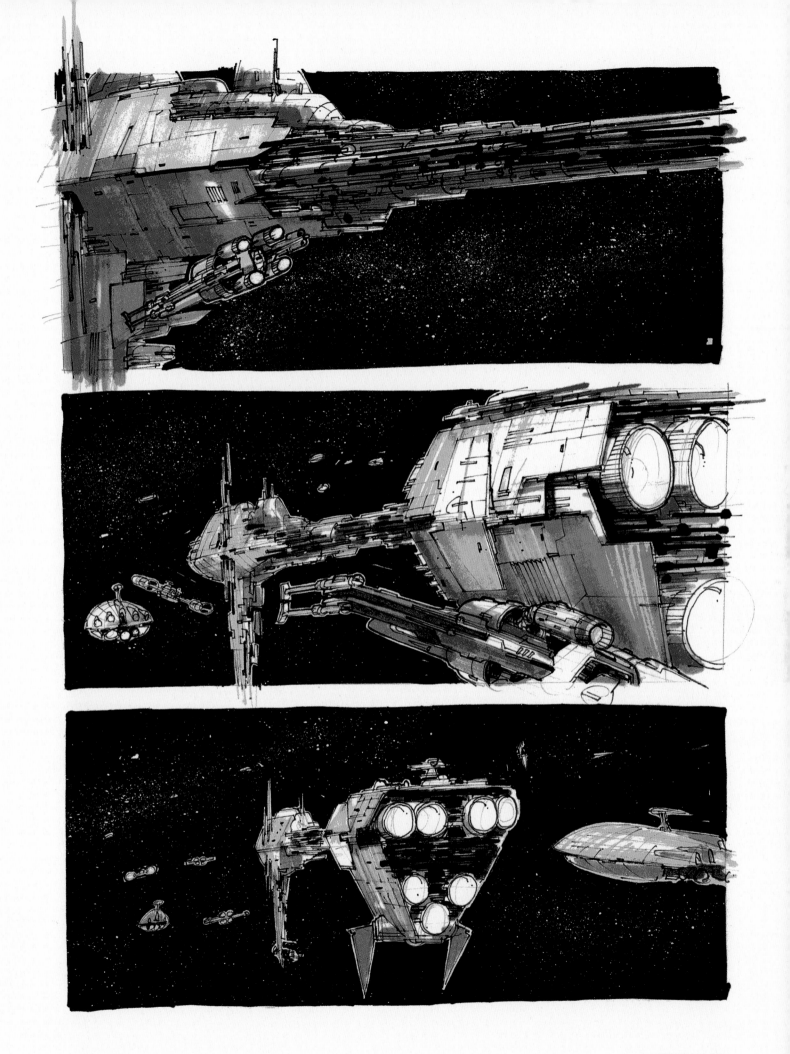

The Rebel Alliance fleet flies away to fight another day. » Rodis-Jamero

STAR WARS: EPISODE VI

RETURN OF THE JEDI

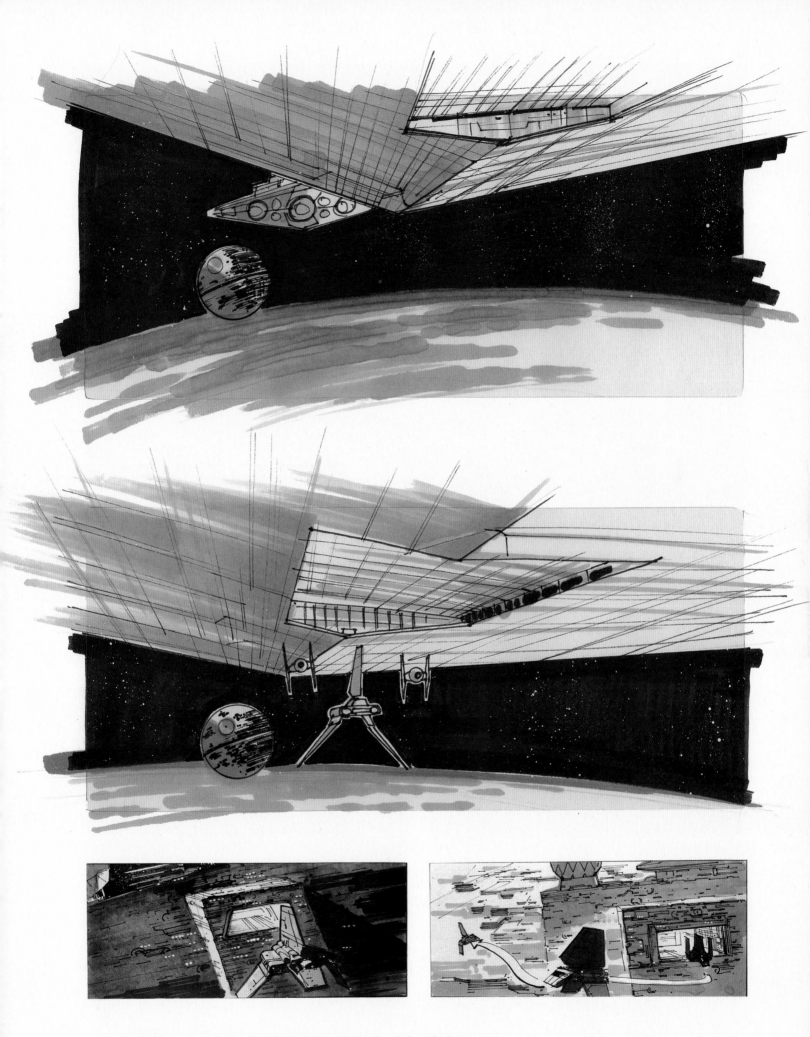

Variations on the opening sequence of the flight of Darth Vader's shuttle from the Super Star Destroyer to the half-completed Death Star. » Johnston, **R1:2**; George Jenson, **R3**

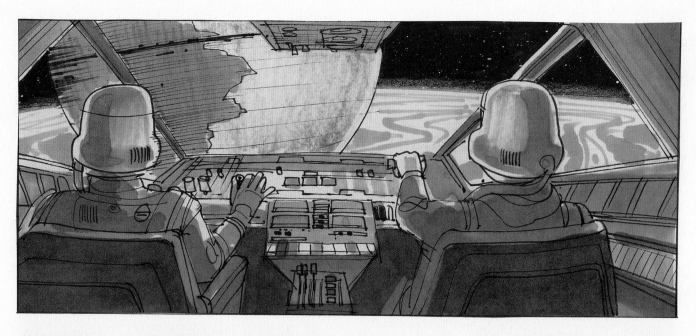

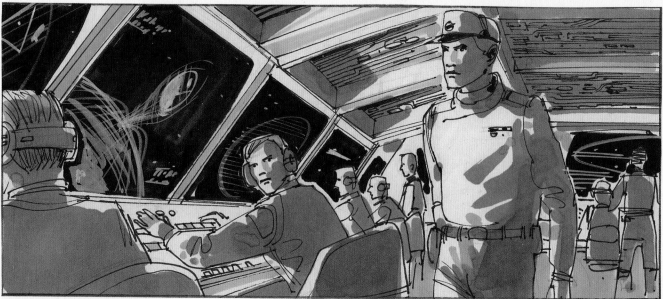

Imperial shield operators open a hole through which Vader—who's in no mood to wait—may enter. » Johnston, **R1:2**, **R3L**; Rodis-Jamero, **R3R**, **R4**

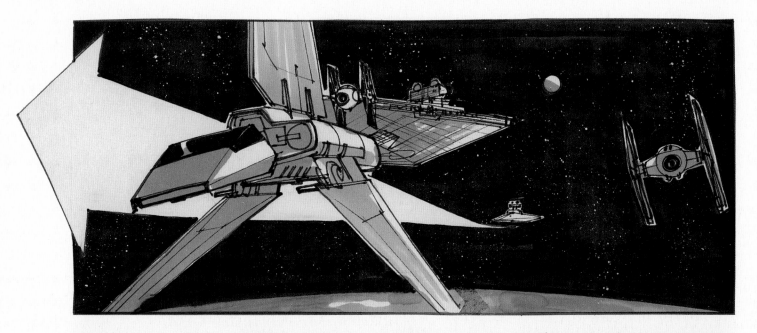

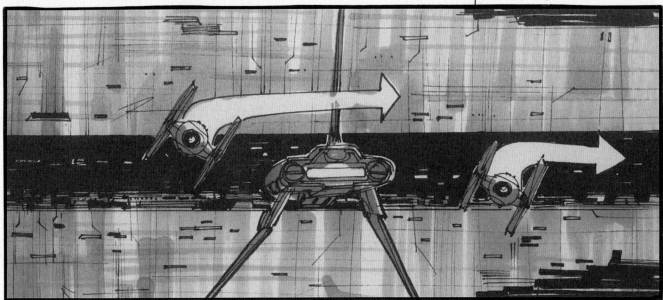

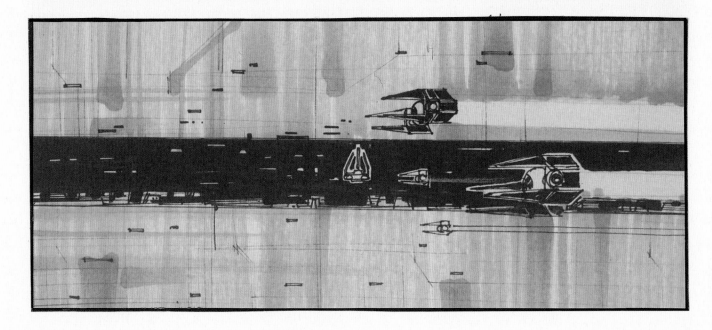

The shuttle's wings fold up into landing position as it approaches the Death Star "waistband." » Rodis-Jamero

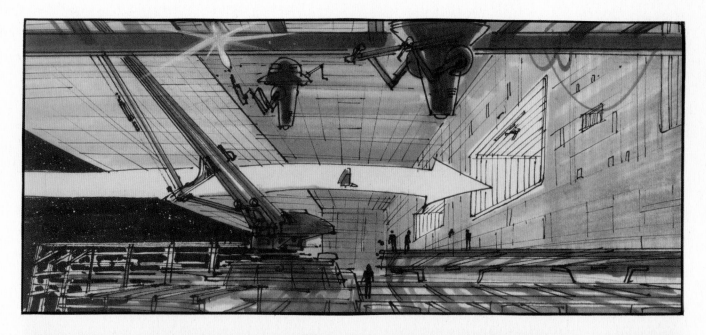

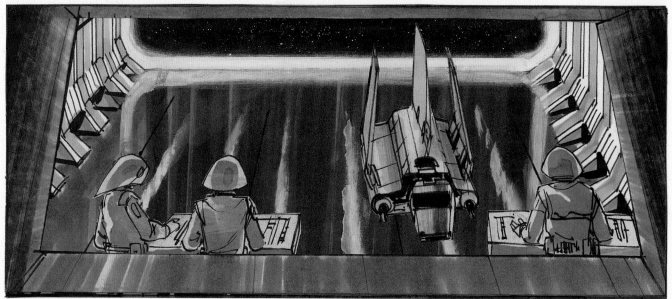

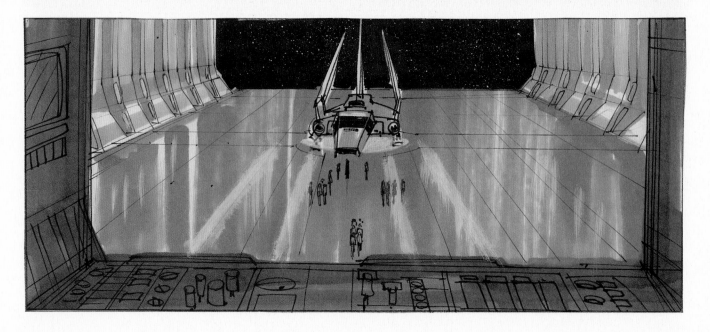

Vader's craft lands in a docking bay. » Johnston, **R1**, **R3**; Rodis-Jamero, **R2**

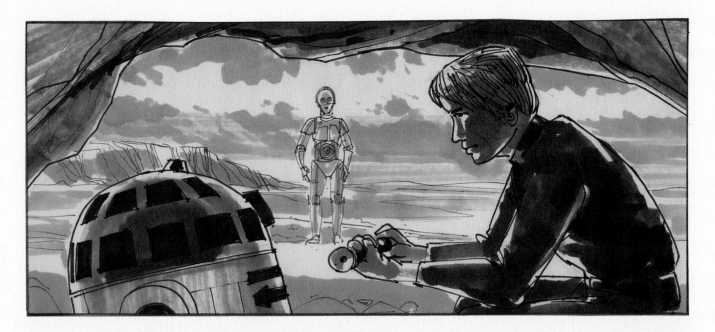

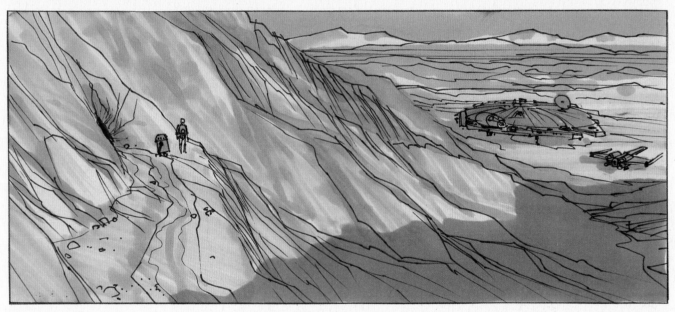

Hidden in a cave on Tatooine, Luke builds his new lightsaber; outside, his X-wing and the *Falcon* are parked on the desert sand. » Johnston

"Everyone in the art department was a worker. We didn't have time, especially on Return of the Jedi, *for anyone who wasn't willing to give it one hundred percent. We hired and fired a few who couldn't keep up with the pace or who just didn't fit in. It was hard work, very intense but very rewarding, and I wanted everyone to enjoy being there."*

Joe Johnston

A veteran of *2001: A Space Odyssey* (1968) and a well-known illustrator, Roy Carnon storyboarded a number of scenes while working directly with *Jedi* director Richard Marquand at Elstree Studios in England.

R2-D2 and C-3PO discuss their situation as they approach Jabba the Hutt's palace. » Roy Carnon

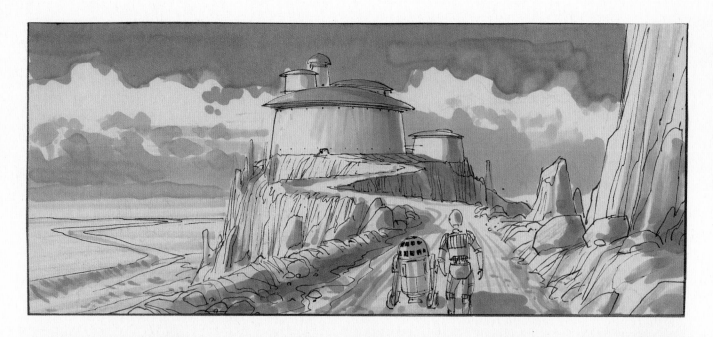

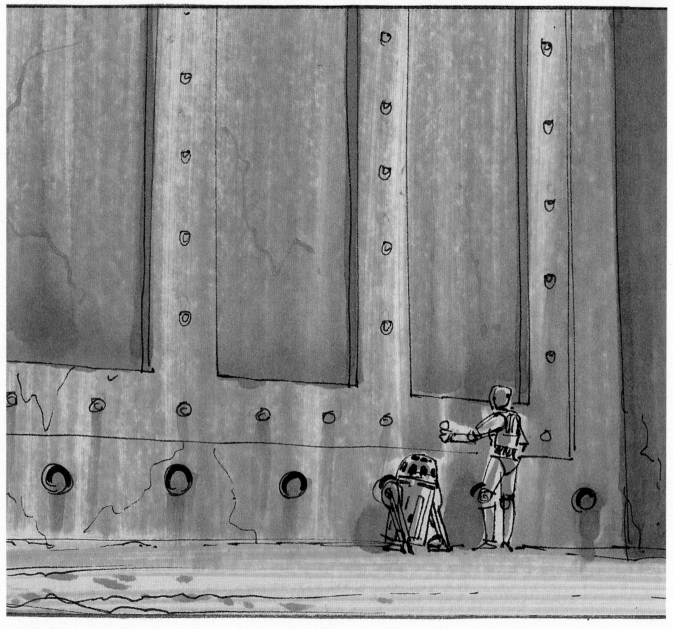

C-3PO knocks on the massive iron door. » Johnston

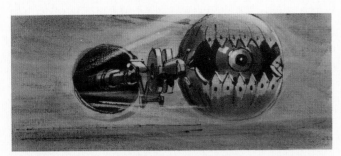

CLOSE ON GATE AS EYE SHOOTS
OUT INTO CAMERA

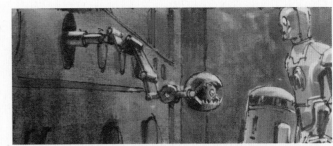

ANGLE ON EYE AS IT DROPS DOWN
TO LOOK AT 'R2.

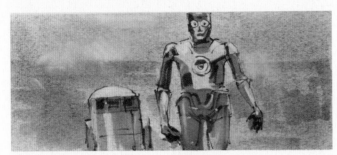

ON R2 + 3PO — REACTION

THEIR POV AS EYE RETRACTS
+ GATE STARTS TO RISE

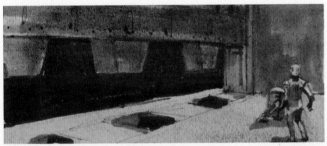

GATE RISES - R2 STARTS FORWARD

R2 WALKS IN — 3PO «COME BACK»

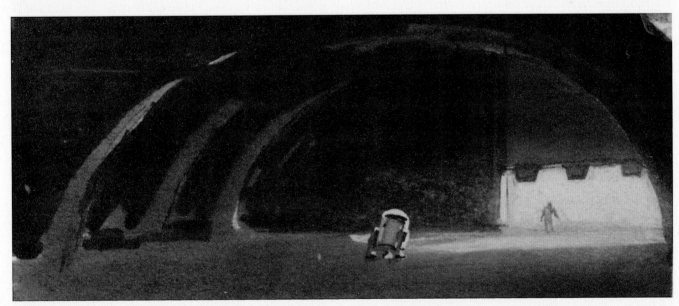

REVERSE ON R2 FROM INSIDE — 3PO STARTS TO FOLLOW

The two droids gain entry into the foreboding palace of Jabba the Hutt. » Carnon

PIG GUARDS ENTER FROM BOTH SIDES

THEIR POV. BIBA 'APPEARS'

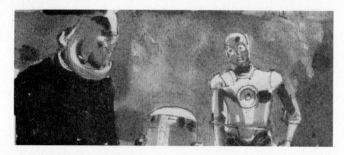

CLOSER FOR DIALOGUE

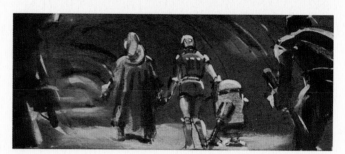

PAN-TRACK THEM — THEY WALK AWAY DOWN TUNNEL

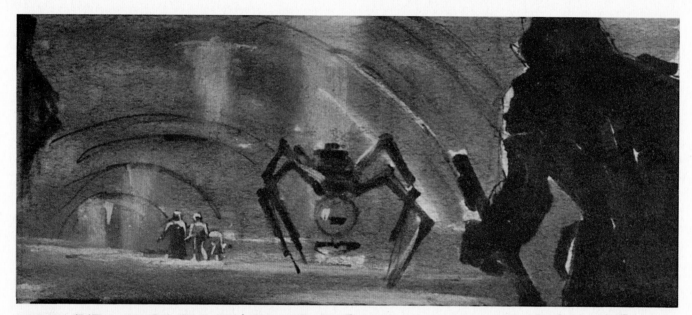

HOLD THEM PAST PIG GUARD AS THEY WALK AWAY INTO DISTANCE — M. SPIDER ALIEN WALKS ACROSS TUNNEL.

BIB, 3PO + R2 ENTER PAST WINDOW + TURN

TRACK IN FAVOURING 3PO + R2 — THEY 'LOOK'

As they enter deeper into the bowels of the palace, the two droids are confronted by a variety of strange creatures, including Bib Fortuna, Jabba's majordomo. » Carnon

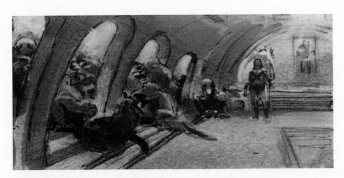

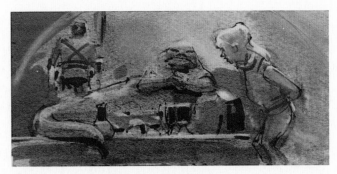

THEIR POV. REVELRY — MONSTERS +
CREATURES IN ALCOVES — PAN L — R ...

BIB WHISPERS TO JABBA

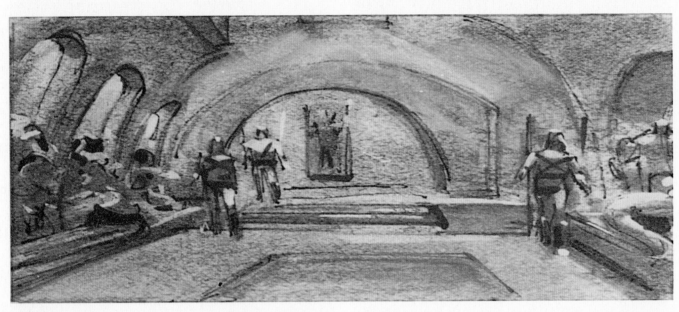

3PO's POV. — THE FROZEN HAN .

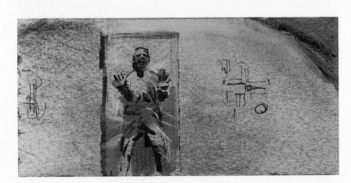

ZOOM IN TO SHOW FROZEN HAN .

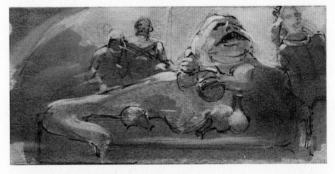

CLOSE ON JABBA — HE SHOUTS TO DROIDS

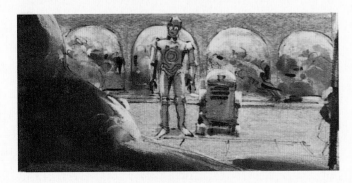

PAN THEM TO STAND BEHIND GRILL
IN FRONT OF JABBA

R2 SWIVELS HEAD ROUND TO 'LOOK'
AT CREATURES

Within the main hall, C-3PO and R2-D2 glimpse scary creatures half-hidden in alcoves—as well as Han Solo
in his carbonite block, decorating a wall. They then meet the infamous gangster Jabba the Hutt. » Carnon

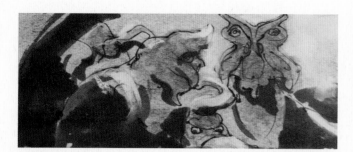

R2'S P.O.V.

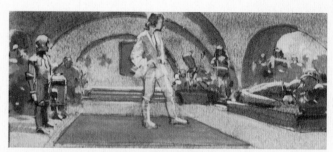

R.2. PROJECTS HOLOGRAM OF LUKE
(STARTS SMALL + GROWS ??)

C.U. 3PO'S REACTION

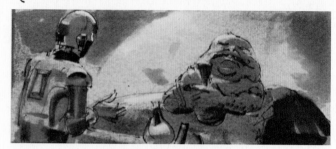

ON JABBA + TRANSLATOR — LUKES VOICE
STOPS — JABBA BARKS REPLY

C.U. JABBA — LIVID

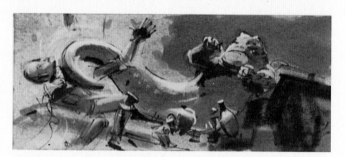

JABBA SMASHES INTERPRETOR WITH
TAIL

PAST 3PO — PIG GUARDS COME IN +
CHOP UP INTERPRETOR

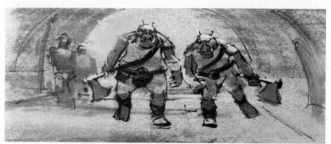

3PO'S P.O.V. —PIG GUARDS APPROACH
-ING

3PO FLEES FOLLOWED BY R2 +
PURSUED BY GUARDS

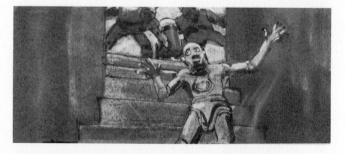

CAMERA AT BOTTOM OF STEPS.
3PO IS PUSHED + SLITHERS DOWN
OUT OF FRAME

R2 projects a hologram of Luke's recorded message, in which he gives the droids as a gift to Jabba. When the translator droid delivers an "offensive" part of the message, however, he is destroyed by Jabba and his pig guards. » Carnon

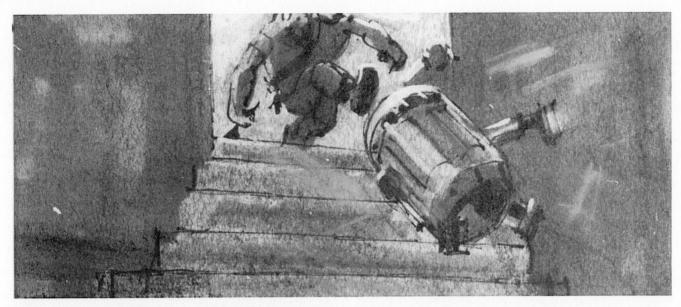

R2 IS BOOTED + CLATTERS DOWN.

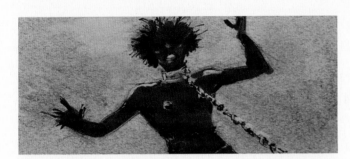

TO HEAD - SHOWING COLLAR + CHAIN

PULL BACK ALONG CHAIN..

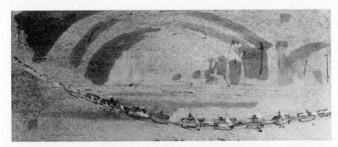

+ PAN L—R ALONG CHAIN

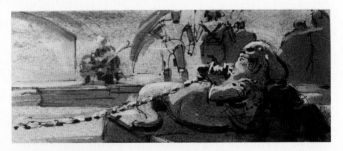

TO JABBA

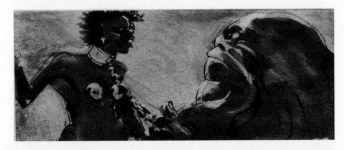

ON JABBA AS HE PULLS BIRD LADY
CLOSE — "GIVE ME....."
SHE REPULSES HIM.

HE LETS OUT CHAIN — BIRD LADY
DANCES BACK.

The droids are chased downstairs. Later, a "bird lady" dances for Jabba and his monstrous cohorts. » Carnon

ON JABBA - HE SMIRKS

ON BIRD LADY AS TRAP OPENS + SHE FALLS — ROARS + SCREAMS

CLOSE PIG GUARD ROARING WITH LAUGHTER

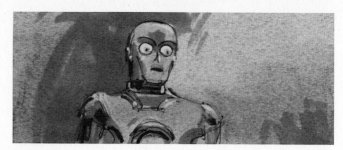

CLOSE 3PO — REACTION

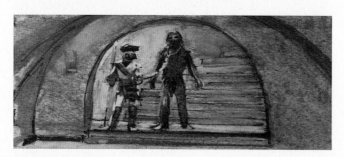

THEIR P.O.V. BOUNTY HUNTER + CHEWIE ON CHAIN.

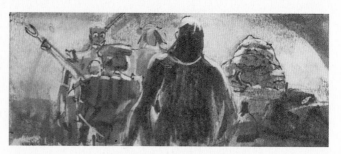

..STAND IN FRONT OF JABBA. (3PO IS NOW STANDING IN TRANSLATOR'S POSITION

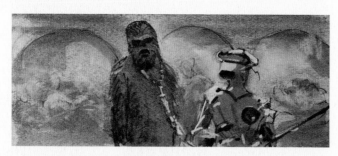

ON CHEWIE + BOUNTY HUNTER

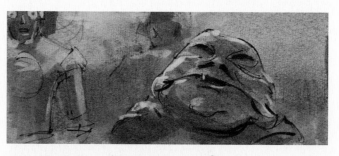

ON JABBA (BARGAINING)

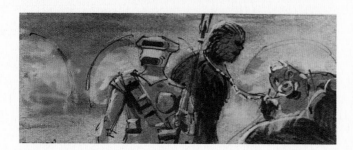

CHEWIE IS LED AWAY BY PIG GUARDS —HOLD ON BOUNTY HUNTER

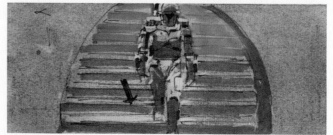

BOBA FETT ENTERS DOWN STEPS

Jabba opens a trapdoor beneath the "bird lady"—just before a masked bounty hunter appears leading Chewbacca in chains. » Carnon

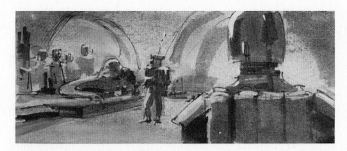

CAMERA DOLLIES ROUND BEHIND BOBA TO SHOW JABBA + BOUNTY HUNTER,

ON BOUNTY HUNTER WHO TURNS + LOOKS RIGHT

BOUNTY HUNTER'S P.O.V.

ZOOM IN ON BOBA FOR REACTION.

Boba Fett enters. The Wookiee is led away to prison. » Carnon

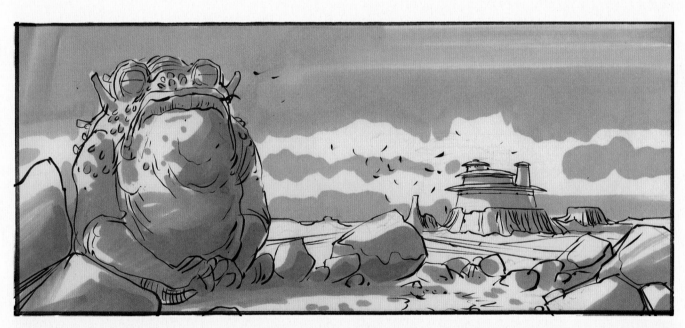

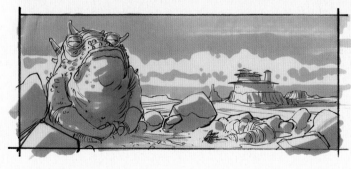

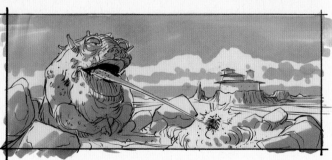

Outside Jabba's palace a monster slurps up a meal. » Johnston

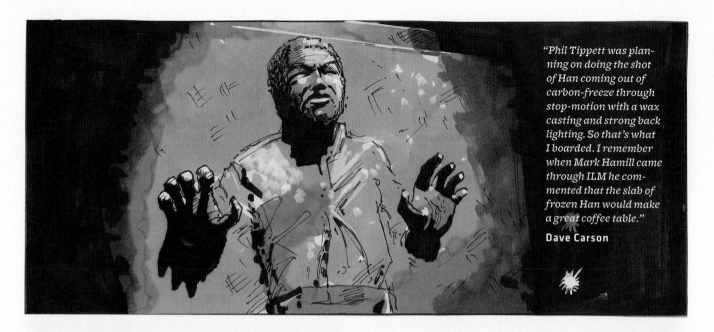

"*Phil Tippett was planning on doing the shot of Han coming out of carbon-freeze through stop-motion with a wax casting and strong back lighting. So that's what I boarded. I remember when Mark Hamill came through ILM he commented that the slab of frozen Han would make a great coffee table.*"
Dave Carson

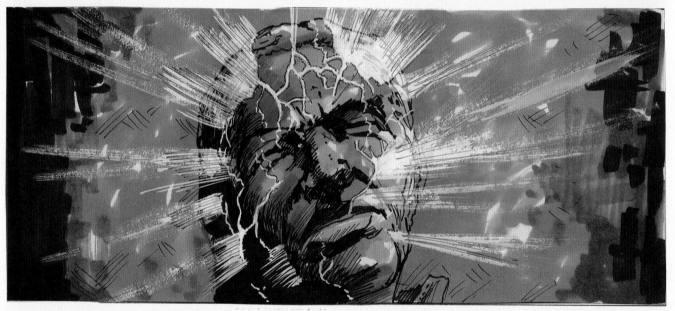

Han Solo emerges from carbon-freeze. » Carson

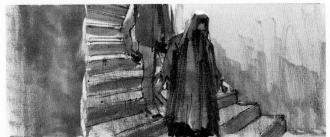

PAN LUKE DOWN STEPS FOLLOWED BY
BIB

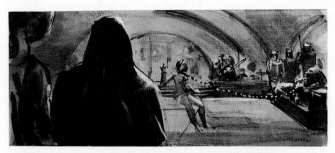

TO SHOT OVER LUKES SHOULDER.
SHOWING LEIA ON CHAIN + JABBA.

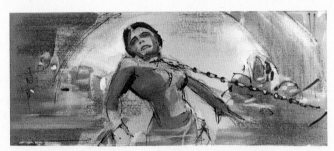

CLOSE ON LEIA — SHE GLANCES
TOWARDS LUKE

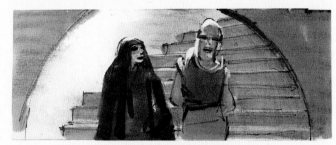

ON LUKE « INTRODUCE ME »

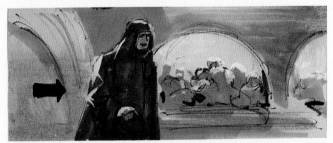

PAN LUKE ACROSS FLOOR.....

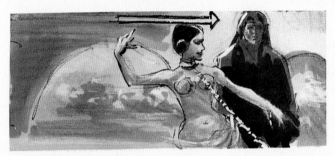

HE STANDS BEHIND LEIA

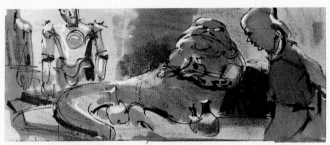

BIB WHISPERS TO JABBA
« THROW HIM OUT »

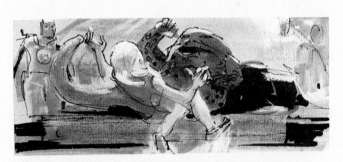

ON JABBA — HE SMASHES BIB

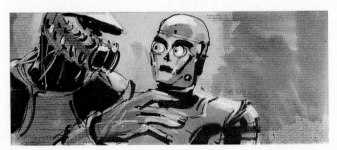

« WHY IT'S L... » — LANDO LIFTS
HAND TO GAG 3PO ...

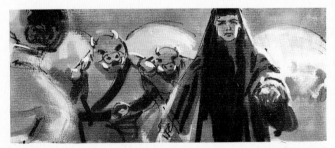

ON LUKE — HE LIFTS HAND + POINTS
AT 3.P.O.

Leia is made into a dancing slave girl for Jabba after she's revealed beneath her bounty hunter disguise.
Luke sneaks in and C-3PO notices that Lando is also there disguised. » Carnon

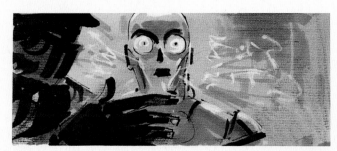

3PO IS STOPPED + EMITS STRANGE ELECTRONIC SOUNDS.

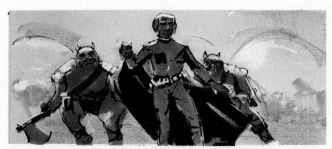

LUKE STEPS FORWARD THROWING OFF CLOAK « I MUST BE ALLOWED TO SPEAK »

CLOSE ON LUKE

ON JABBA

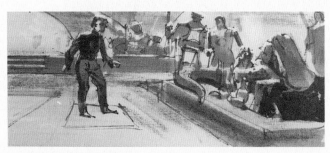

LUKE & JABBA
LUKE STEPS ON TRAPDOOR

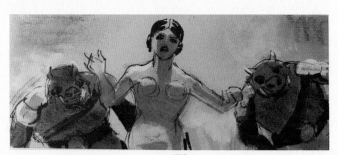

LEIA - REACTION SHE PUSHES BETWEEN GUARDS

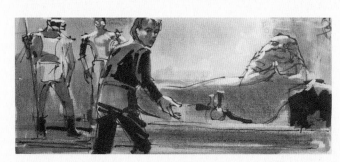

LUKE TURNS + PUTS OUT HAND

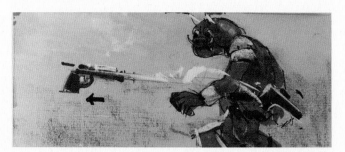

ON GUARD — GUN LEAVES HOLSTER

Using the Force, Luke "silences" C-3PO and "calls" a blaster to deal with Jabba . . . » Carnon

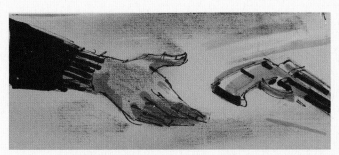

ON LUKE'S HAND AS HE RECIEVES GUN

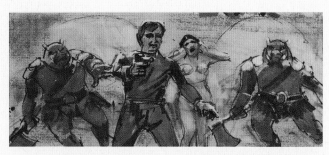

LUKE POINTS GUN — GUARDS RUSH IN — LEIA TRANSFIXED

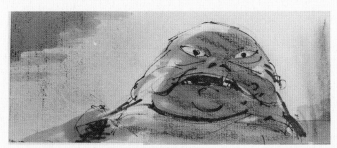

JABBA « OPEN IT »

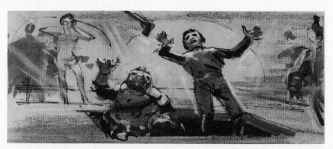

LUKE FALLS THROUGH TRAP — GUN FLYS AWAY — GUARD FALLS THROUGH AS WELL.

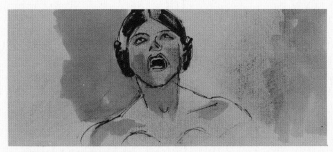

LEIA SCREAMS

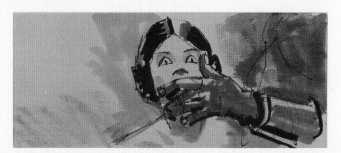

GUARDS HAND STIFLES LEIA

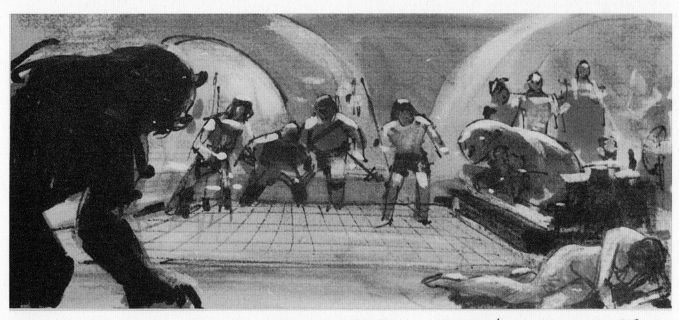

JABBA PULLS LEIA TO HIM — SHE COLLAPSES — JABBA'S THRONE MOVES FORWARD — CREATURES GATHER — THEY ALL LOOK THROUGH GRILL.

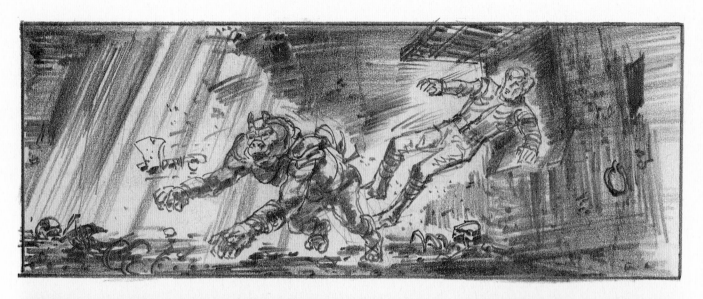

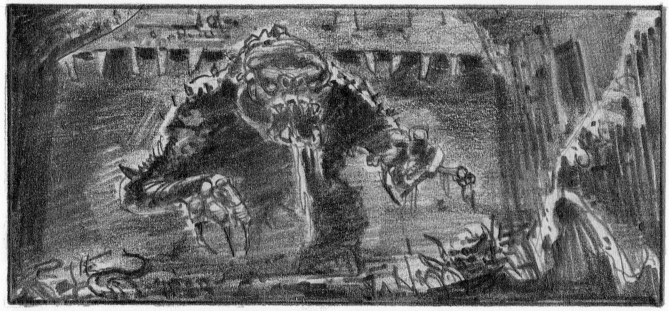

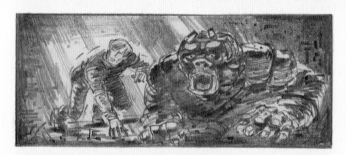
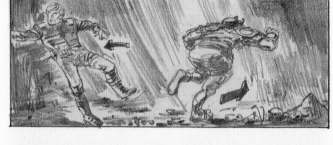
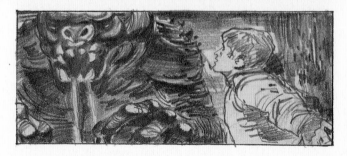
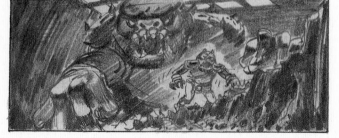

Veteran artist George Jenson storyboarded an early version of the rancor sequence.

In the pit, a rancor emerges, eating a pig guard and then attacking Luke. » Jenson

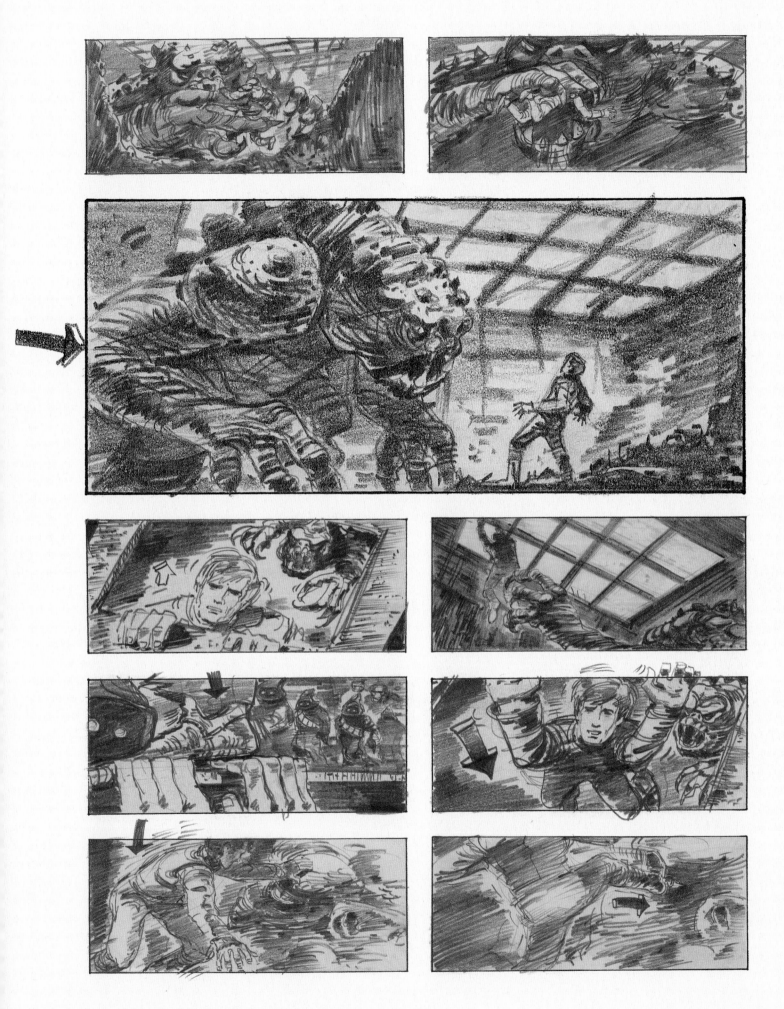

Luke jumps up and holds on to a grate, but Jawas savagely kick at his fingers; he lets go and lands on the monster, kicking it in the eye. » Jenson

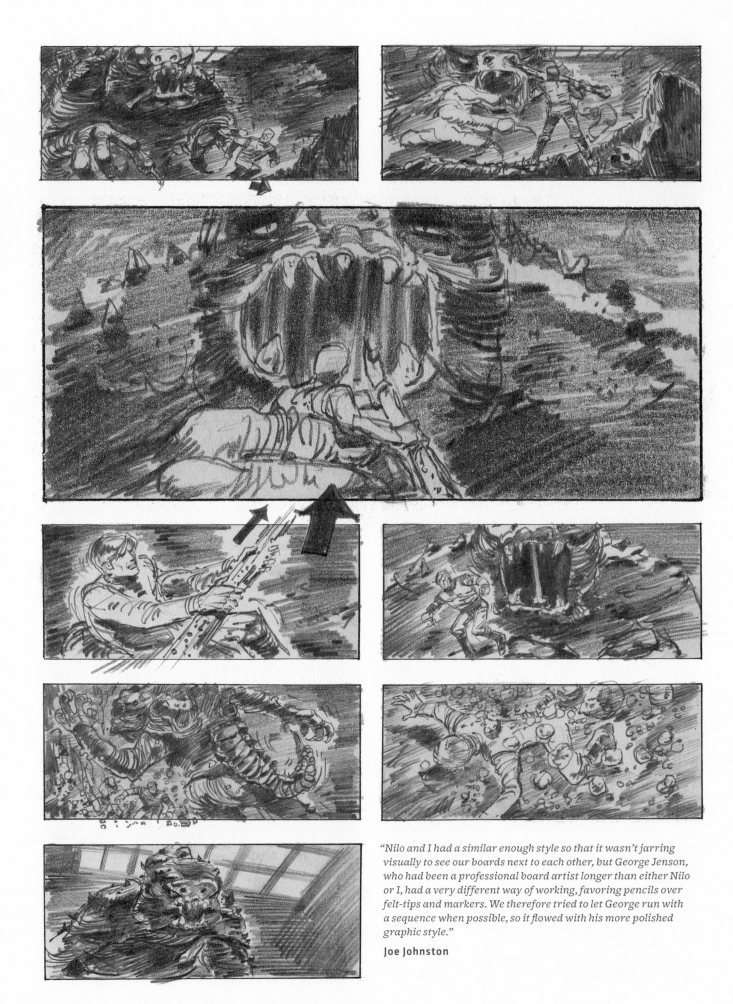

"Nilo and I had a similar enough style so that it wasn't jarring visually to see our boards next to each other, but George Jenson, who had been a professional board artist longer than either Nilo or I, had a very different way of working, favoring pencils over felt-tips and markers. We therefore tried to let George run with a sequence when possible, so it flowed with his more polished graphic style."

Joe Johnston

Luke jams a bone into the rancor's mouth, but is knocked unconscious by rocks felled by the rampaging monster. » Jenson

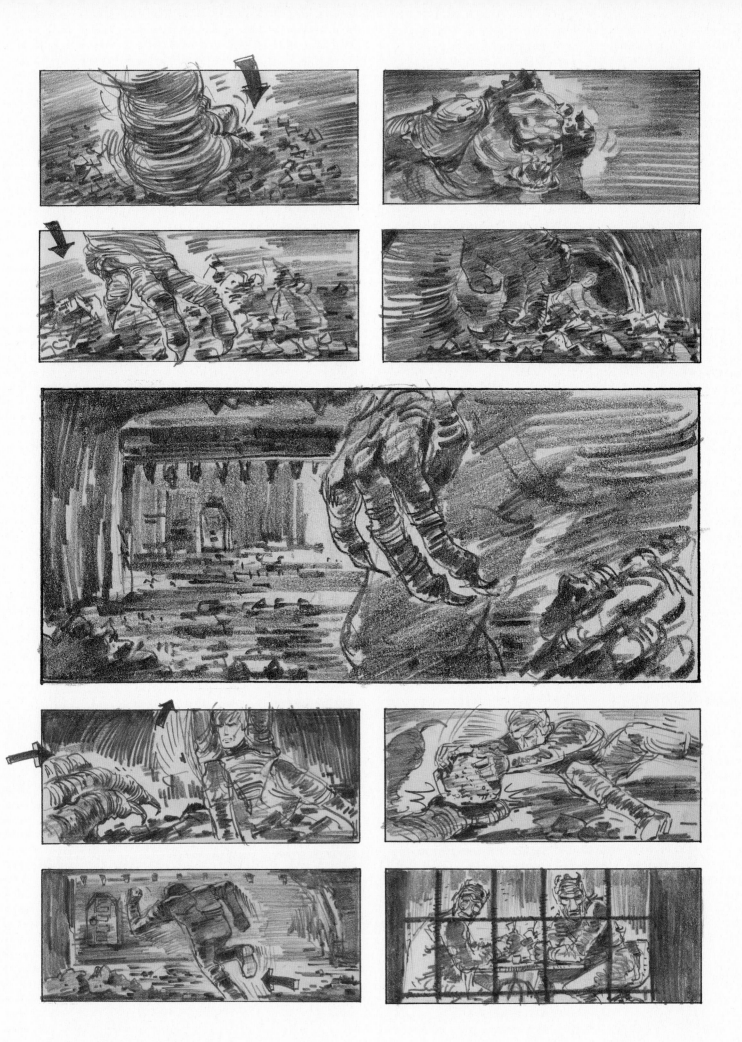

The rancor stomps on the rocks, but Luke, who has sneaked away, slams a stone on the rancor's hand and makes a run for it. » Jenson

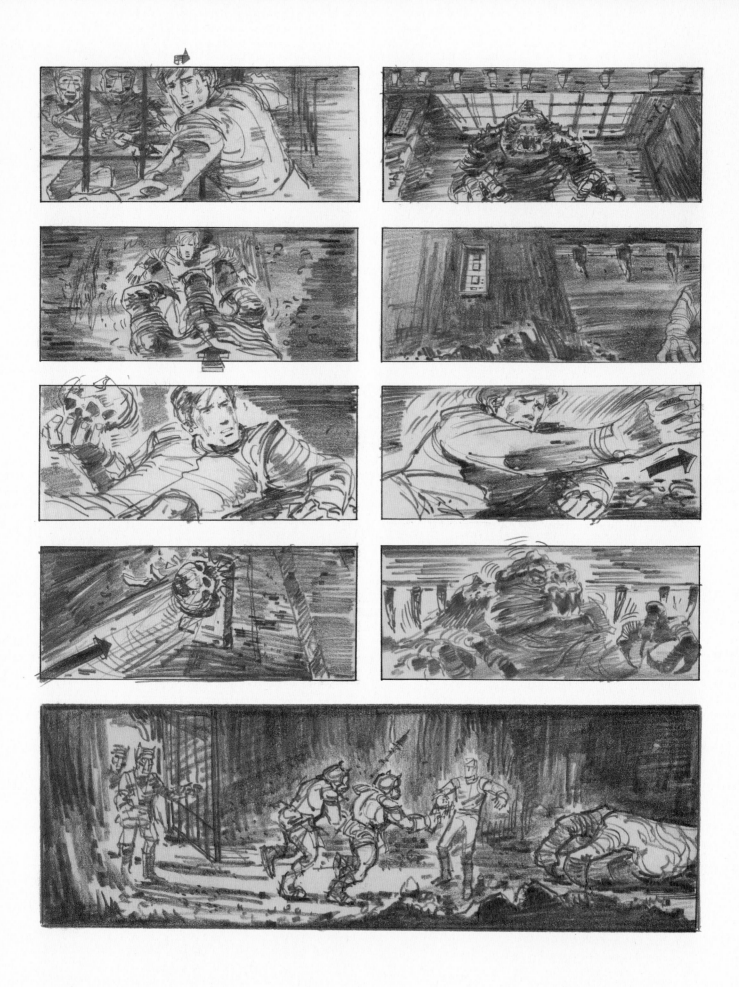

Luke triggers the serrated gate with a thrown skull—and the rancor is crushed. » Jenson

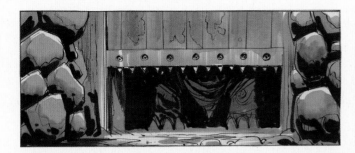

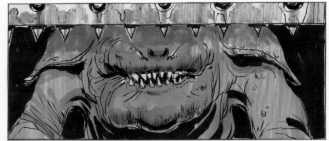

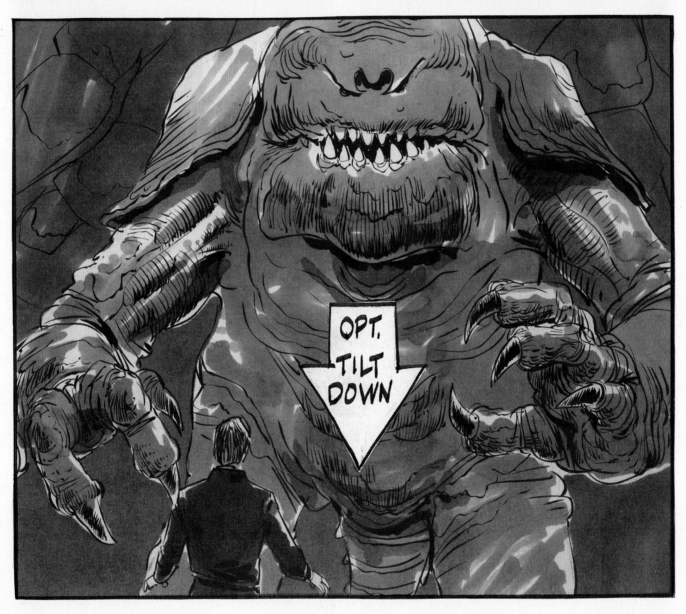

In the final version of boards, complete shot descriptions are listed as the rancor emerges into frame, for example: "Tilt up slightly as he approaches" **[R1L]**, or "Optical: Tilt down" **[R2]**.

"George Jenson came up with 'The Big Dump.' We had buckets of the little round pieces of paper left over from using a three-hole punch on the storyboards. George's idea was to fill a paper bucket about half full of the 'confetti' and mount it above the art department door with a string attached that would trip the bucket when someone opened it—dumping the confetti squarely on their head. We even got George Lucas once. He laughed. It was great fun (unless it was your turn to sweep up the debris)."

Joe Johnston

In a later iteration, Johnston storyboarded the rancor's entrance. » Johnston

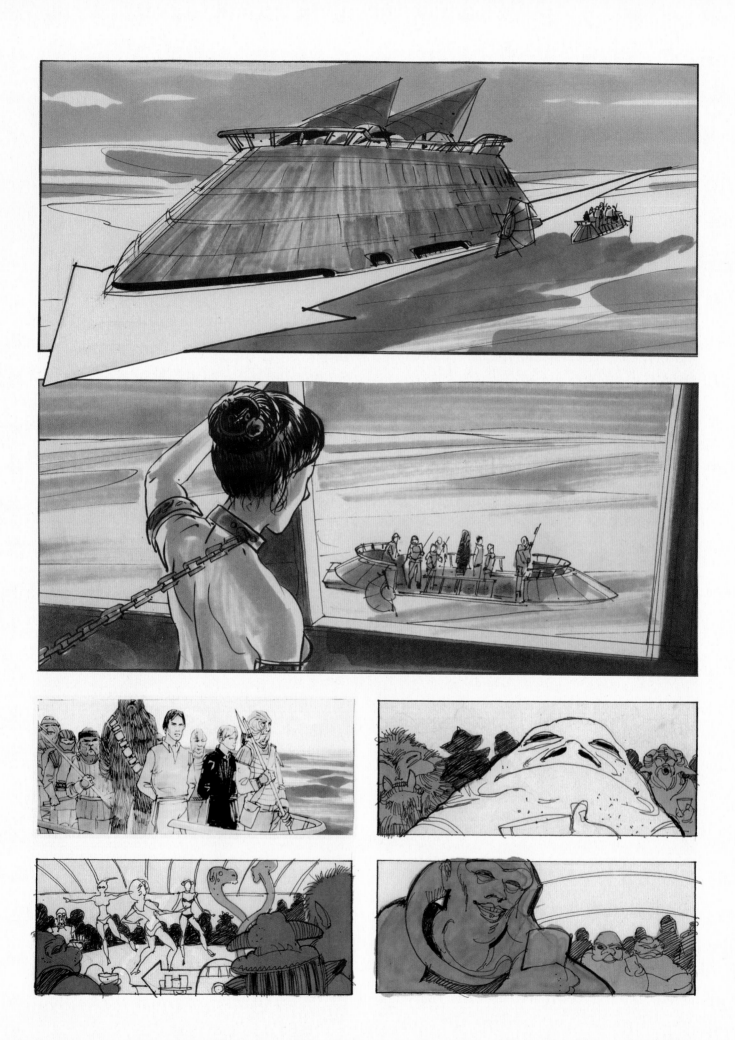

With Leia as prisoner, Jabba's barge and the prison skiff sail across the desert. » Johnston, **R1:2**, **R3L**; Artist unknown, **R3R**, **R4**

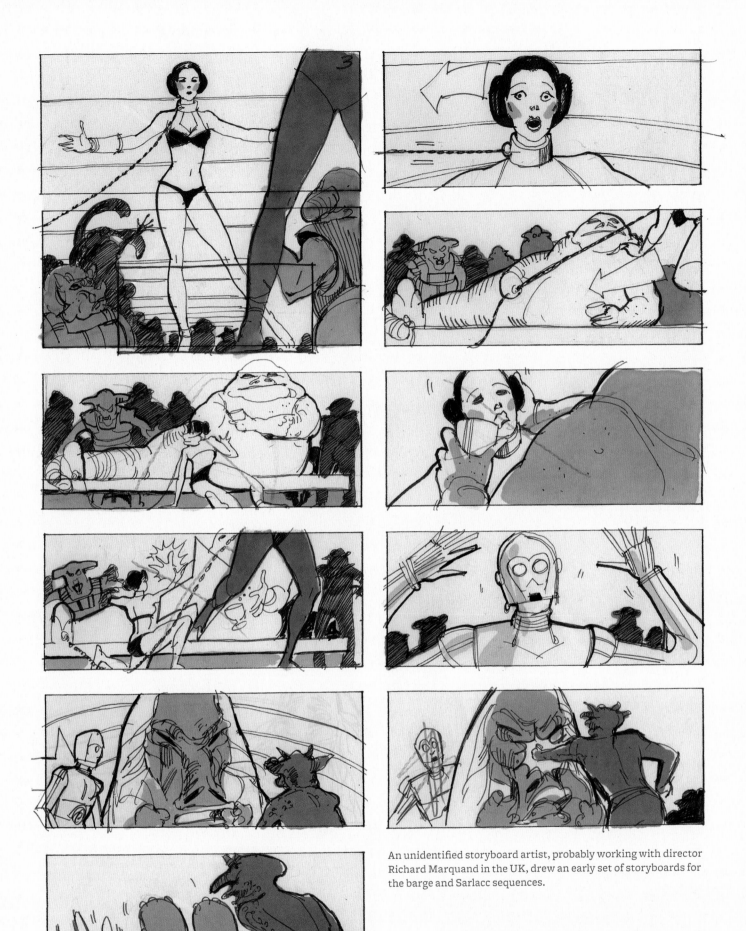

An unidentified storyboard artist, probably working with director Richard Marquand in the UK, drew an early set of storyboards for the barge and Sarlacc sequences.

Leia avoids Jabba, while C-3PO winds up in the middle of squabbling monsters—one of whom punches the other. » Artist unknown

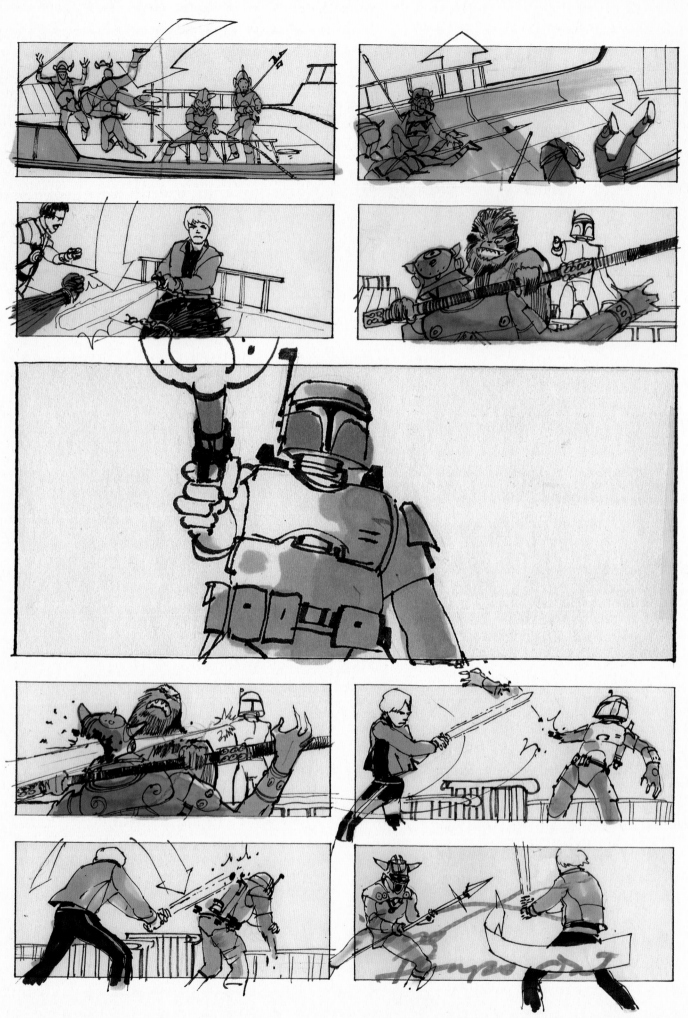

After Luke springs into action, two guards are thrown out of frame.
Boba Fett wounds Chewie, but Luke cuts off Fett's hand and axes his backpack. » Artist unknown

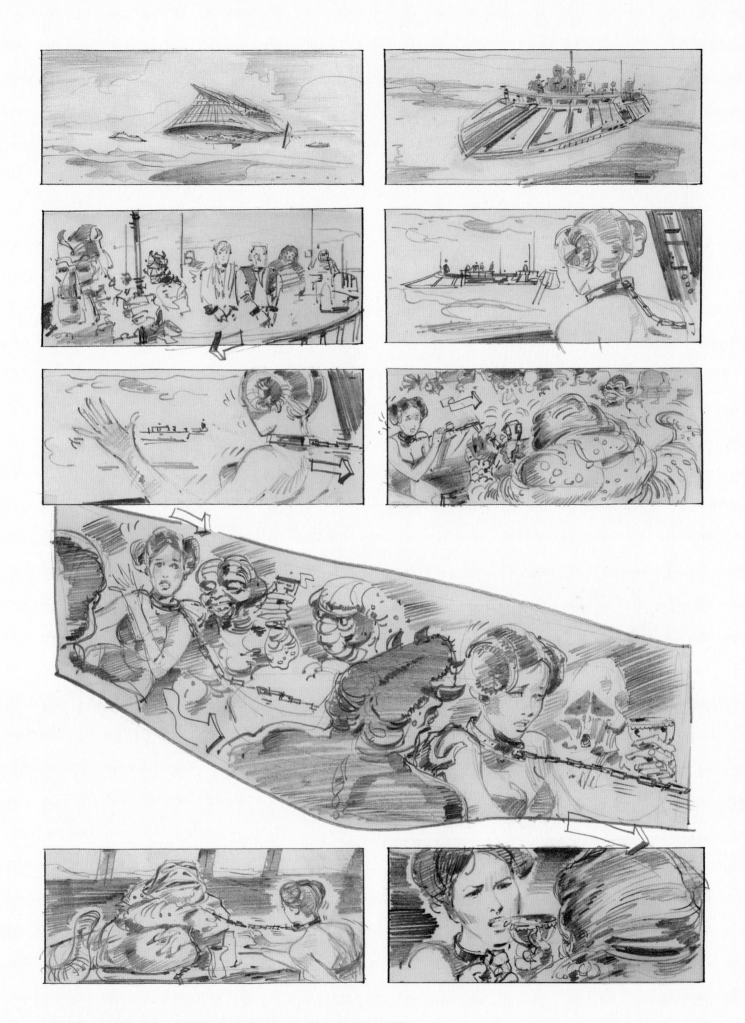

A later iteration of the Sarlacc sequence begins identically, with the barge and skiff skimming the desert floor. Inside, Jabba tries to force a drink on Leia. » Jenson

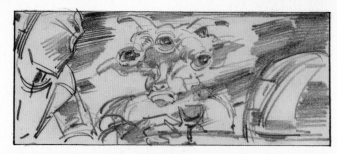

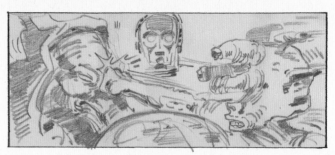

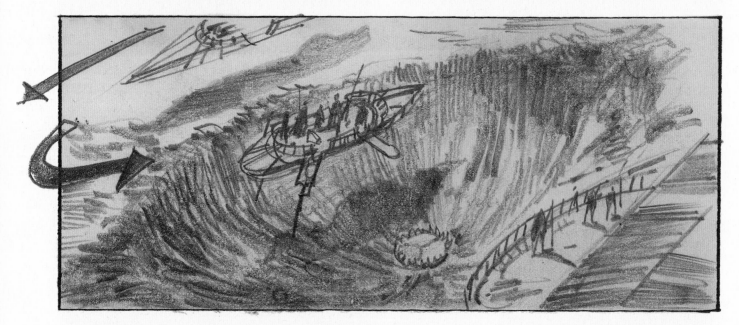

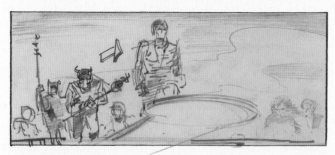

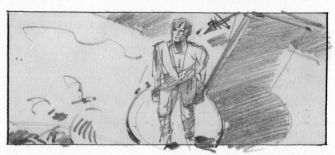

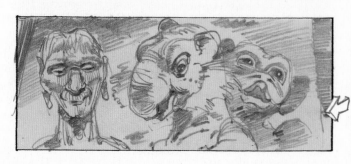

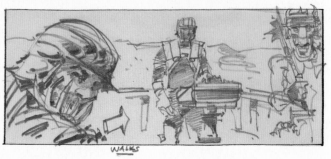

A three-eyed monster is insulted and socks another monster. Once arrived, the craft hover over the awful Sarlacc pit and Luke is made to walk the plank. » Jenson

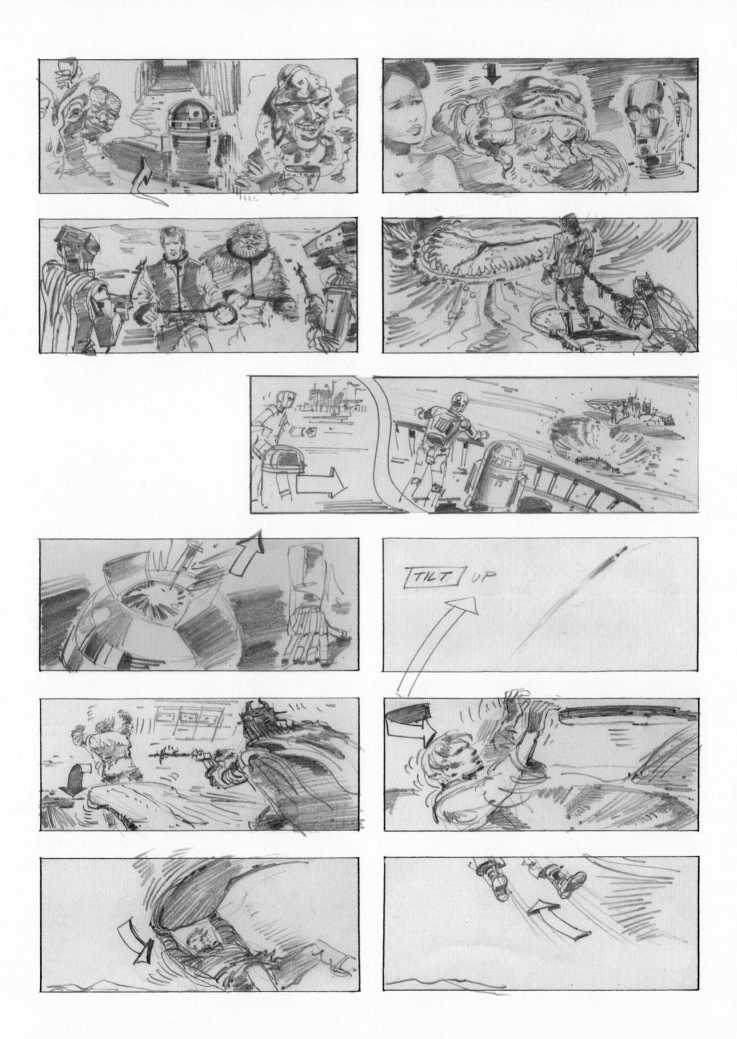

R2 launches a lightsaber to Luke, who uses the plank as a springboard, catapulting himself out of frame. » Jenson

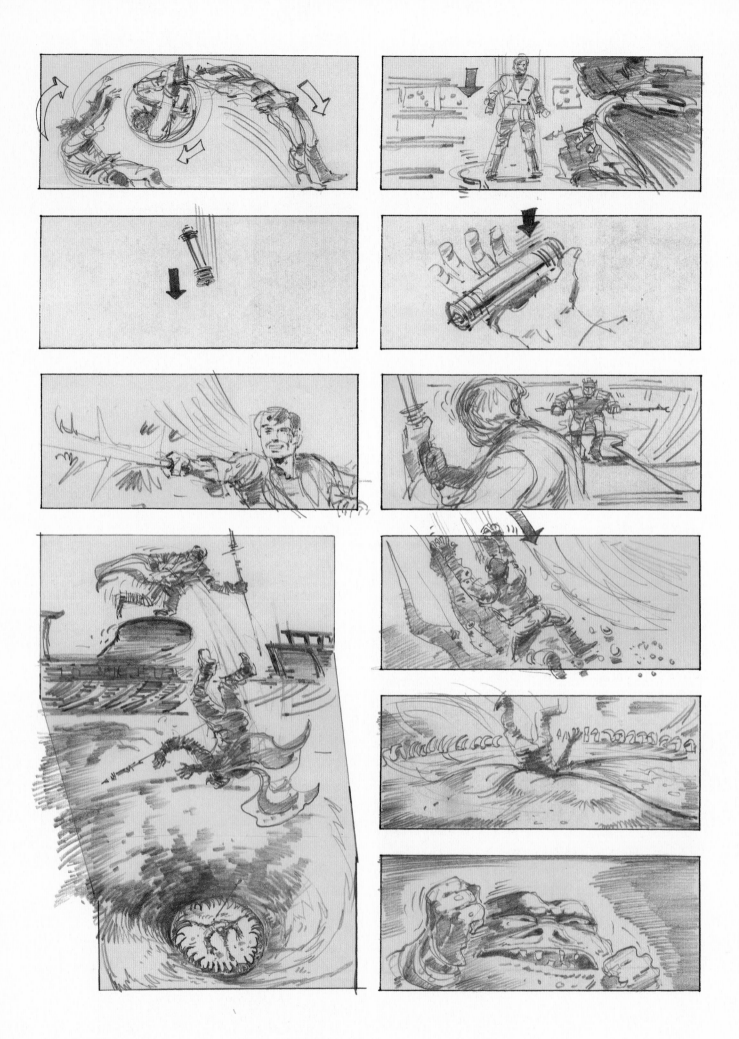

Luke catches his laser sword, while a monster guard tumbles off the plank into the pit.　» Jenson

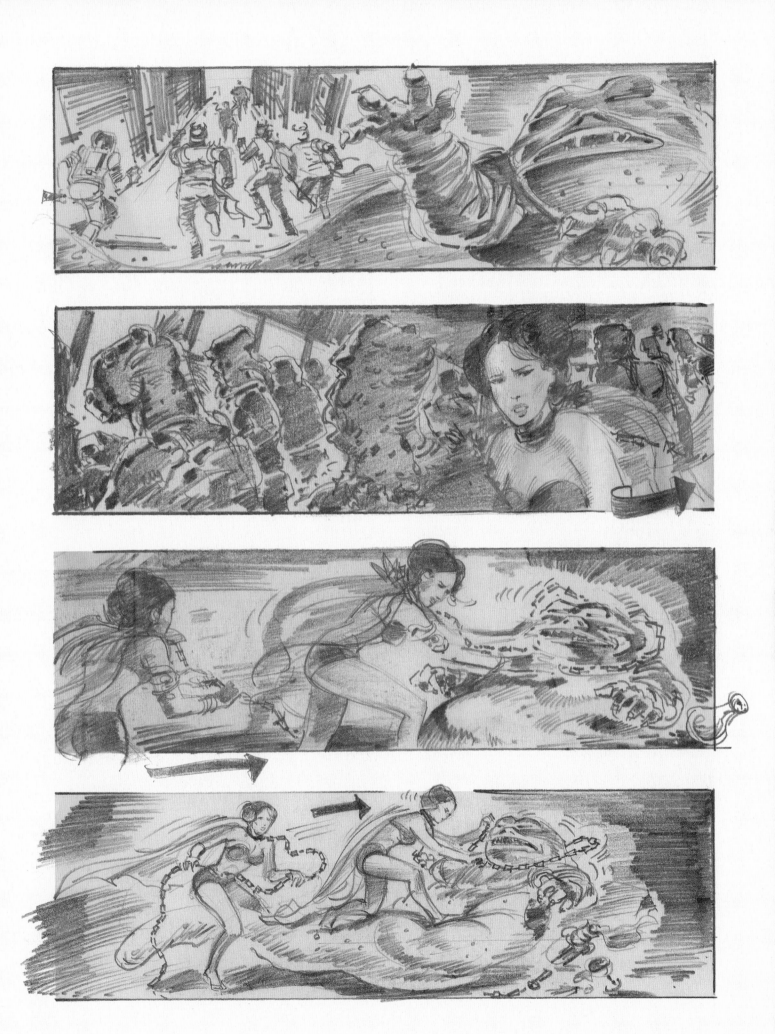

Jabba orders his minions into action, but Leia seizes the opportunity and strangles the crime lord. » Jenson

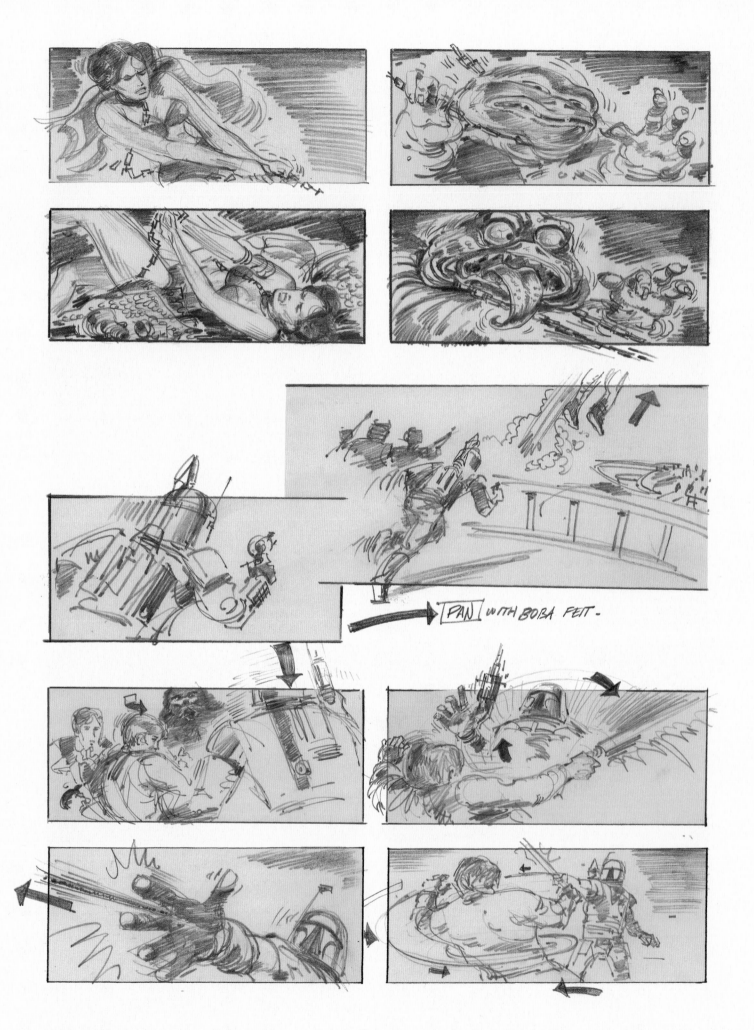

PAN WITH BOBA FETT.

Fett blasts into the fray. Luke disarms him, but Fett fires a cable at Luke. » Jenson

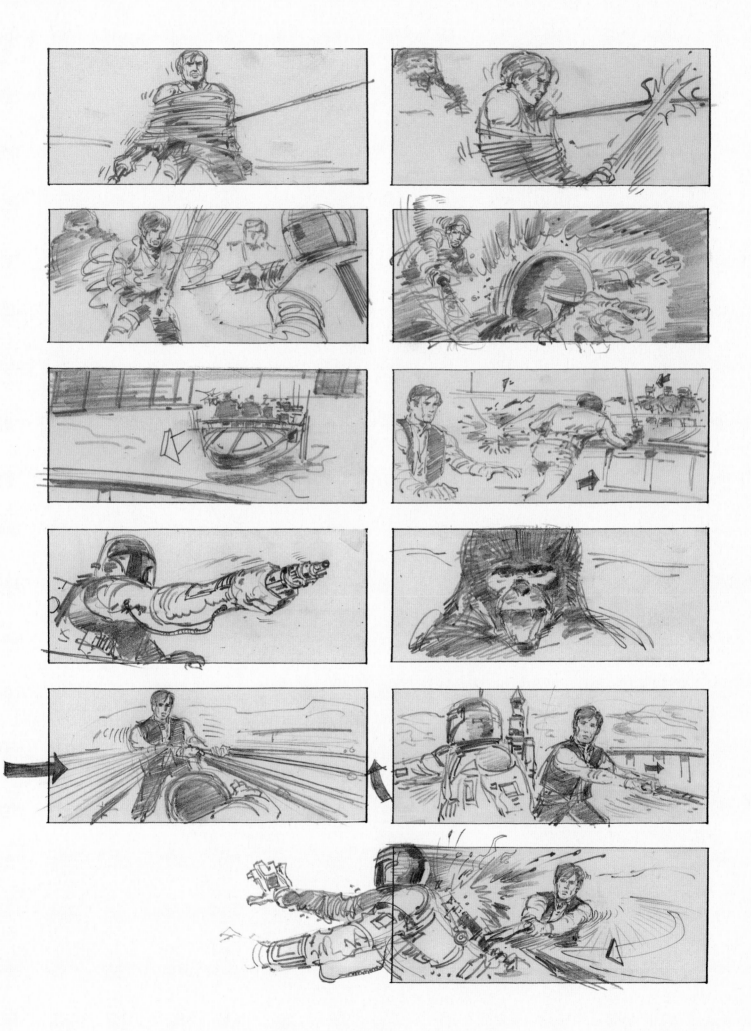

Luke cuts himself free; Chewie alerts Han, who swings at Fett, whacking his jetpack. » Jenson

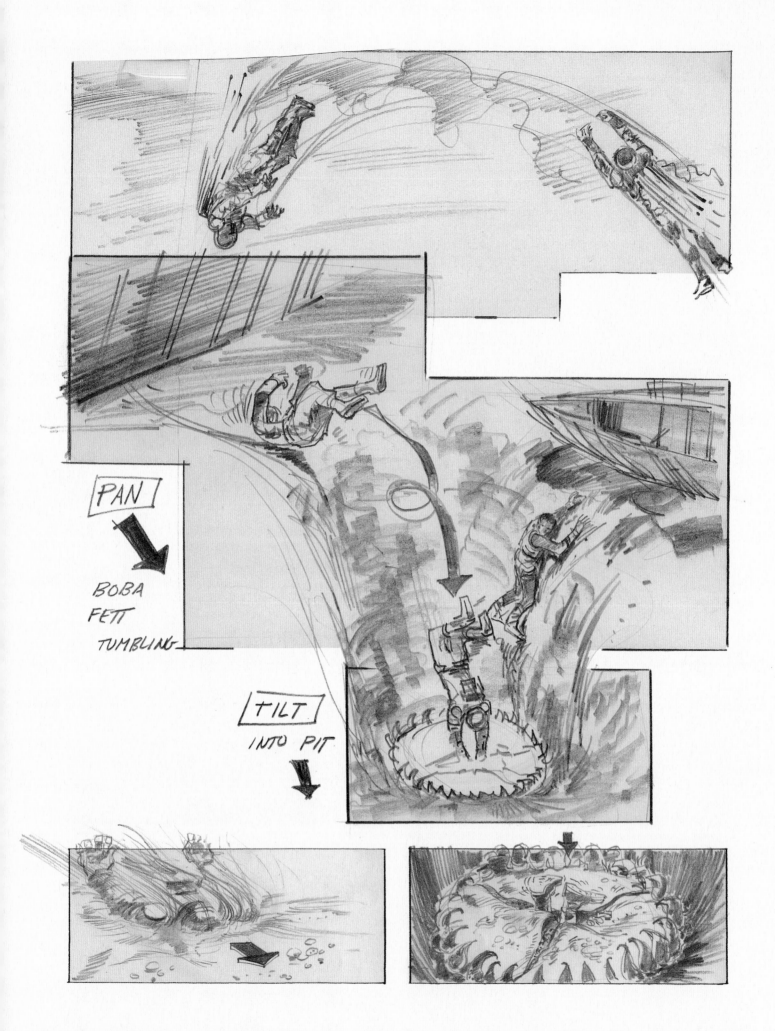

PAN

BOBA
FETT
TUMBLING

TILT

INTO PIT

Fett is launched into the gaping maw of the Sarlacc. » Jenson

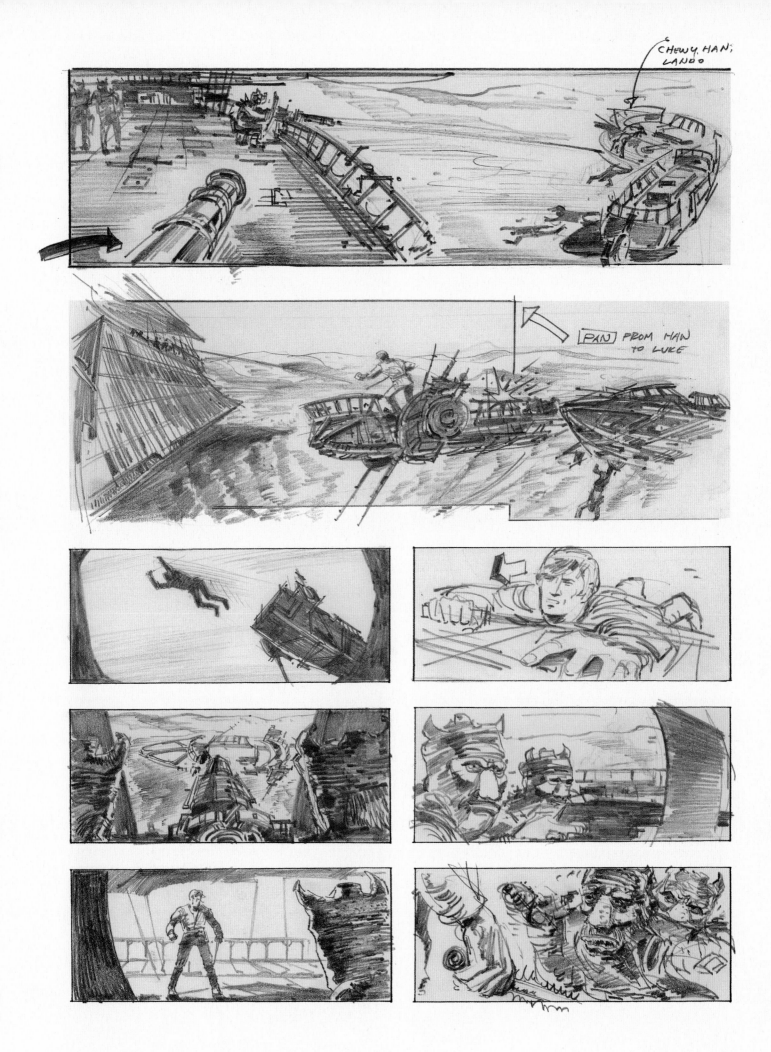

Luke leaps onto the barge and takes on the regrouped guards. » Jenson

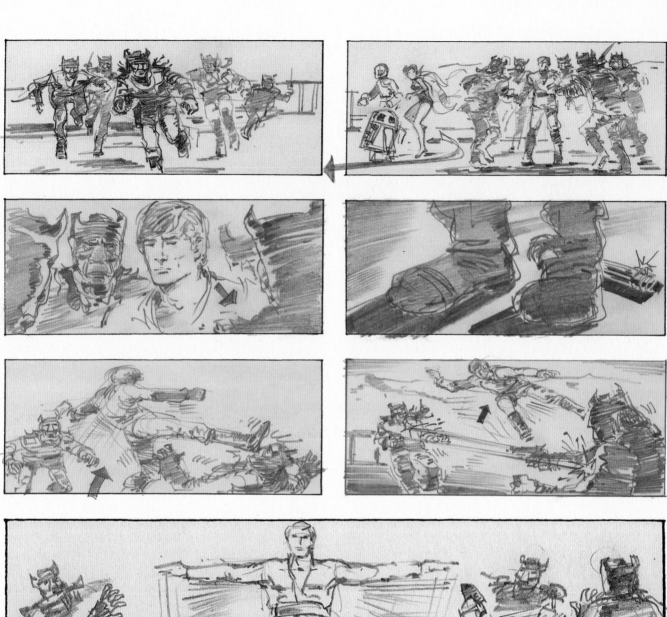

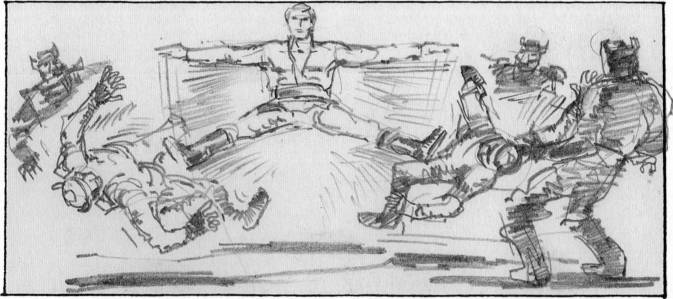

Having lost his lightsaber, Luke leaps into action, using his hands and feet, and then, using the Force, recalls his laser sword. » Jenson

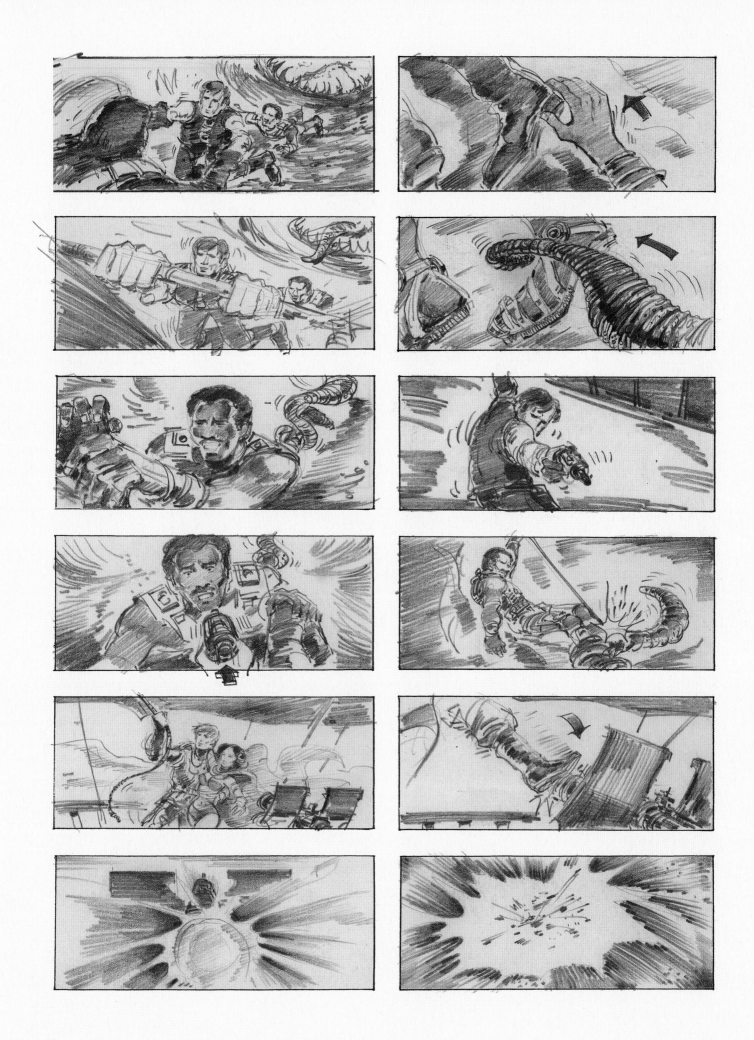

Han helps Lando escape the Sarlacc; Luke and Leia blast the barge . . . » Jenson

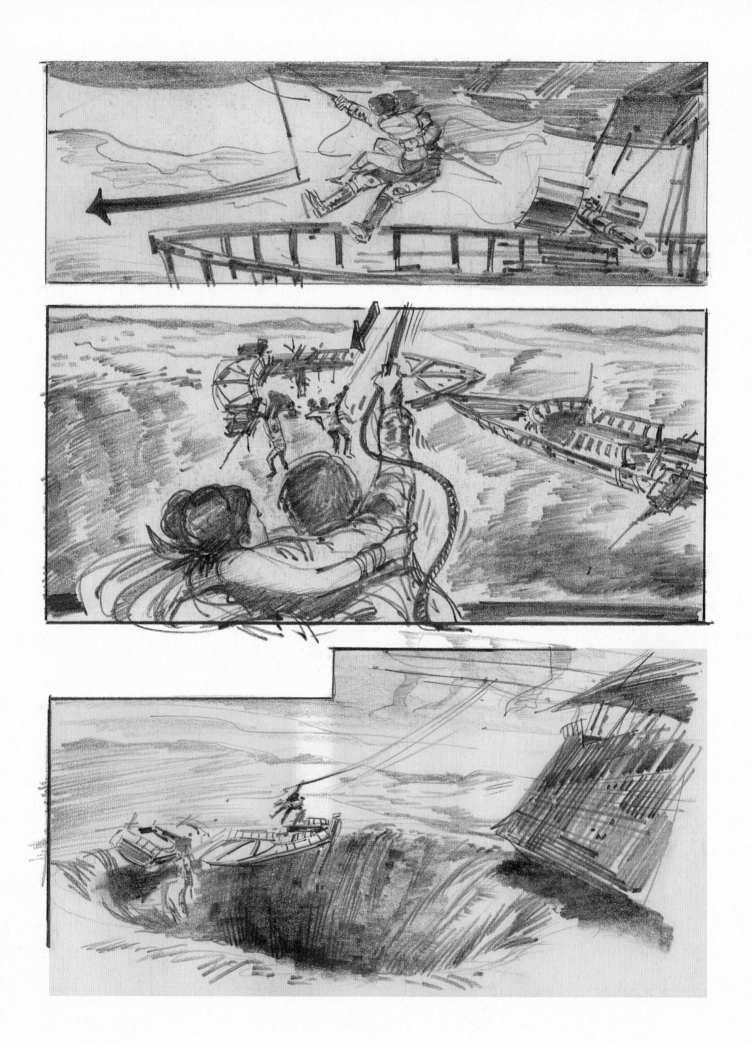

. . . and swing to the skiff. » Jenson

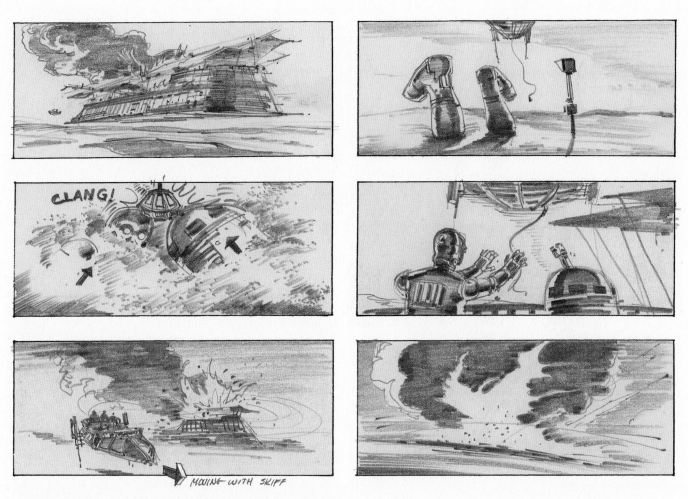

C-3PO and R2-D2 are rescued from the desert and the barge explodes. » Jenson

In a moment that wouldn't make the final cut, Luke's severed hand crawls of its own volition toward his lightsaber. » Johnston

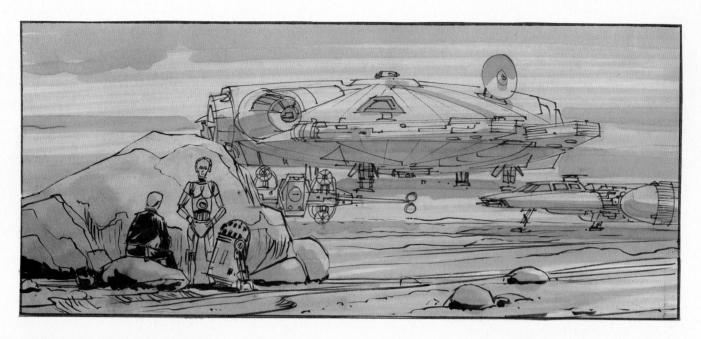

A single storyboard illustrates a moment with Luke, the droids, and all three vehicles (the Y-wing was Leia's), which wouldn't make the final cut.

After rescuing Han, Luke and the droids take shelter behind some rocks. » Johnston

Storyboard notes indicate that ILM planned to take elements from *Empire* for shots of the X-wing.

In his X-wing, Luke heads for Dagobah; meanwhile Leia and Han head for a rendezvous with the Rebel Alliance fleet. » Johnston, **R1:2**; Rodis-Jamero, **R3**

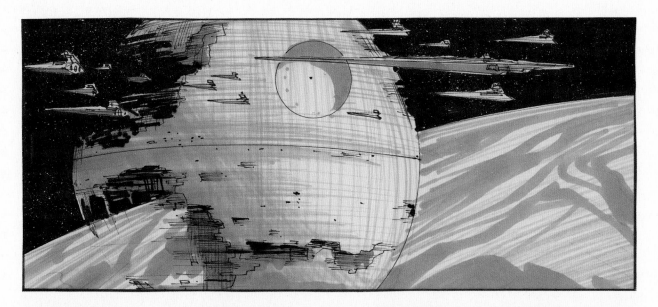

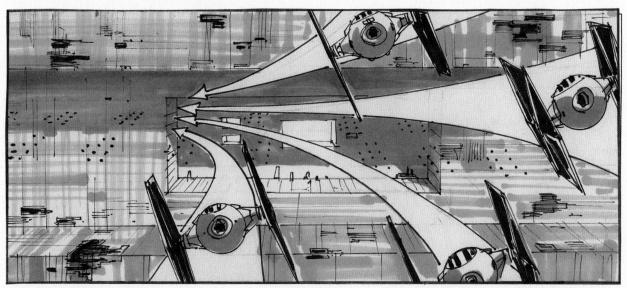

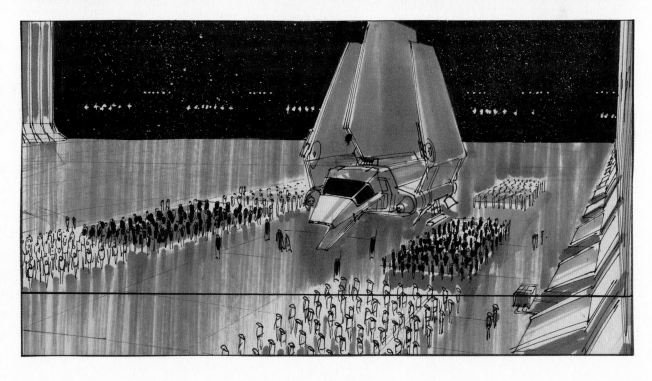

TIE fighters parade in space as the Emperor disembarks on the second Death
Star amid hundreds of stormtroopers standing in formation. » Johnston

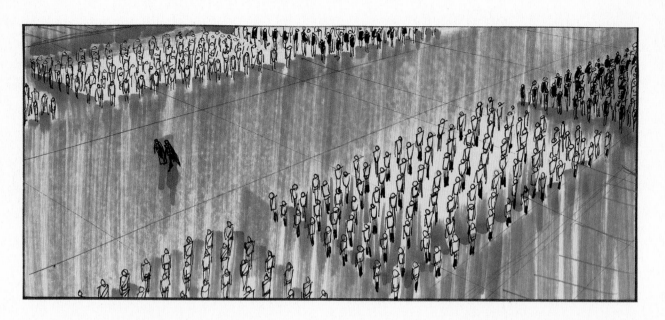

The Emperor and Darth Vader plot against Luke Skywalker. » Johnston

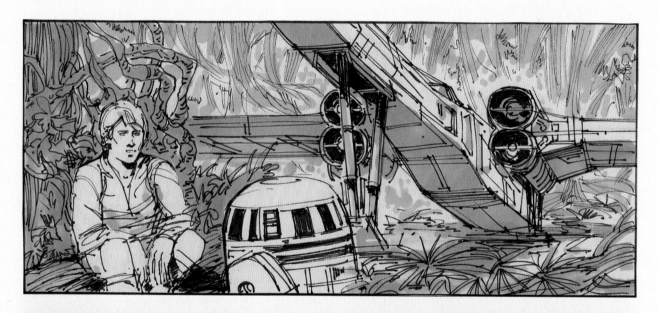

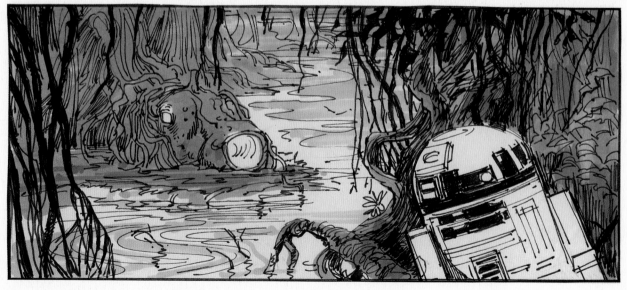

On Dagobah, Luke learns secrets from a dying Yoda in the latter's hovel; R2, as usual, waits outside. » Jenson

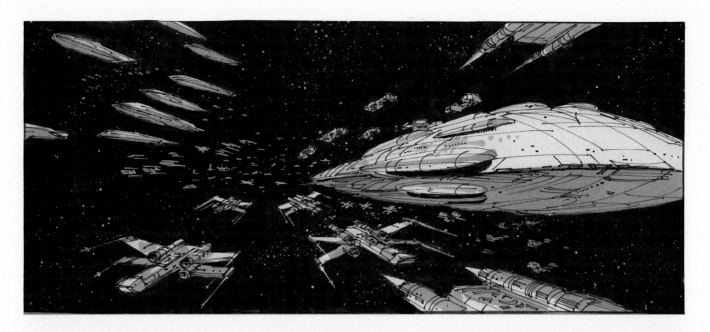

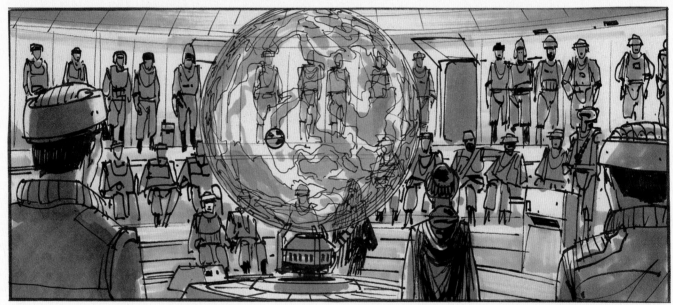

"There were dart games at lunch and after hours. Five or six players would all put in a dollar, winner take all. We had a good sound system and took turns picking the music; we had a mini fridge with beer for the dart games. We had no windows to distract us, only a skylight; and for inspiration we had gigantic enlargements of pages from Heavy Metal *magazine, featuring Moebius's work."*

Joe Johnston

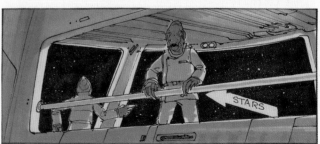

Aboard the rebel "headquarters frigate," Mon Mothma, General Nadine, and Admiral Ackbar explain their strategy for destroying the second Death Star. » Jenson, **R1**, **R4L**; Johnston, **R2:3**, **R4R**

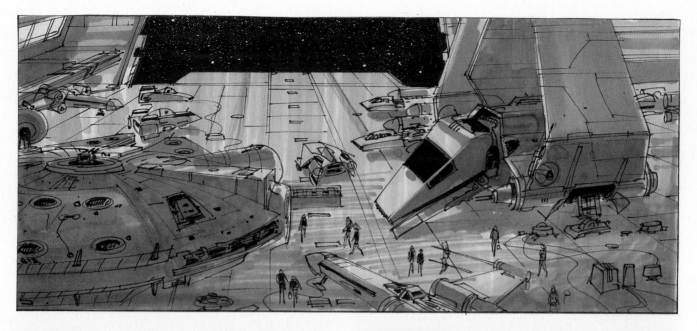

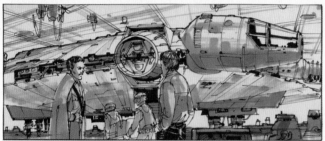

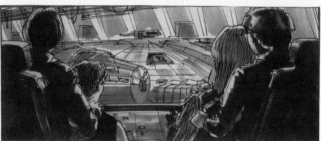

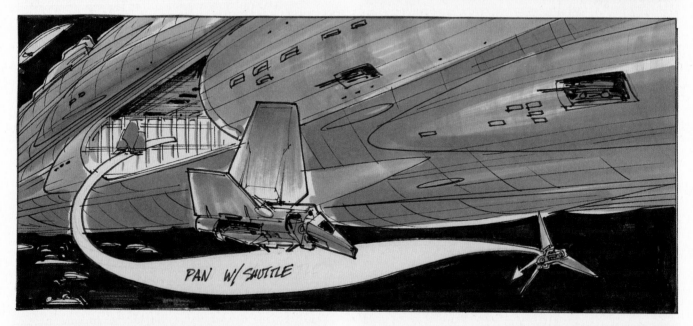

PAN W/ SHUTTLE

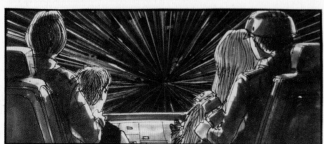

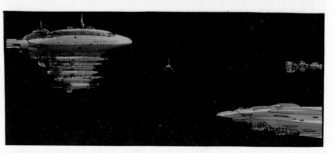

After saying good-bye to Lando, who will pilot the *Falcon*, Han, Luke, Leia, and company make the jump to hyperspace in a stolen Imperial shuttle. » Johnston, **R1**, **R2R**; **R3:4**; Rodis-Jamero, **R2L**

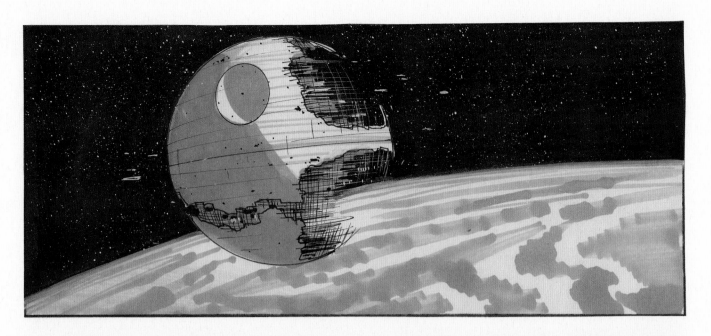

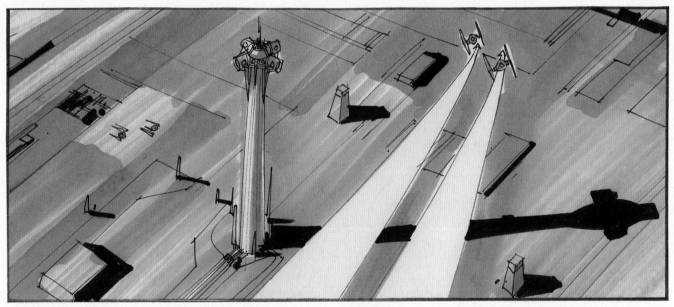

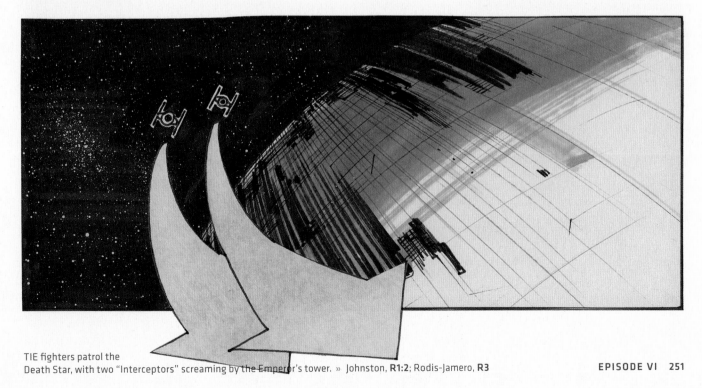

TIE fighters patrol the
Death Star, with two "Interceptors" screaming by the Emperor's tower. » Johnston, **R1:2**; Rodis-Jamero, **R3**

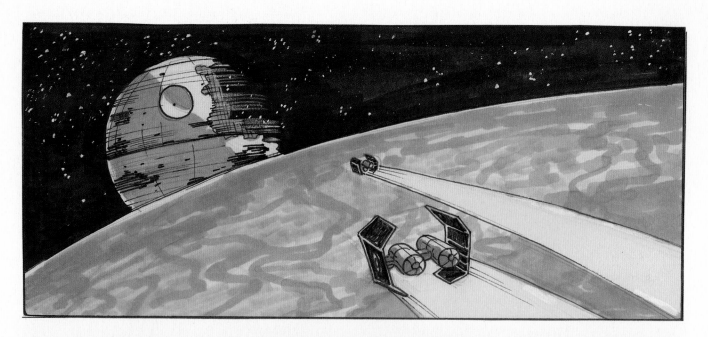

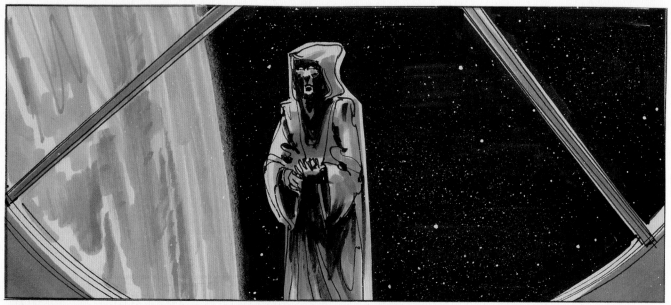

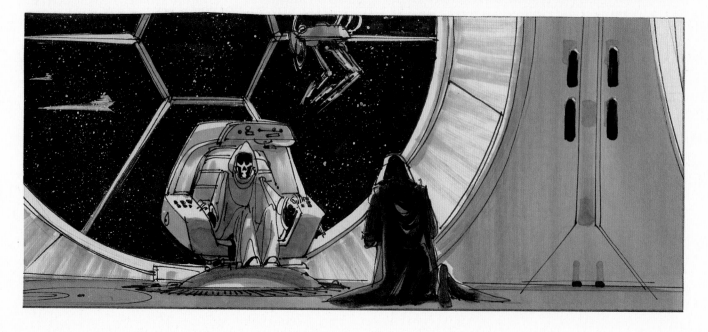

Two "Chili Bombers" also patrol, while, inside the tower, Vader and the
Emperor make their insidious plans. » David Russell, **R1**; Johnston, **R2:3**

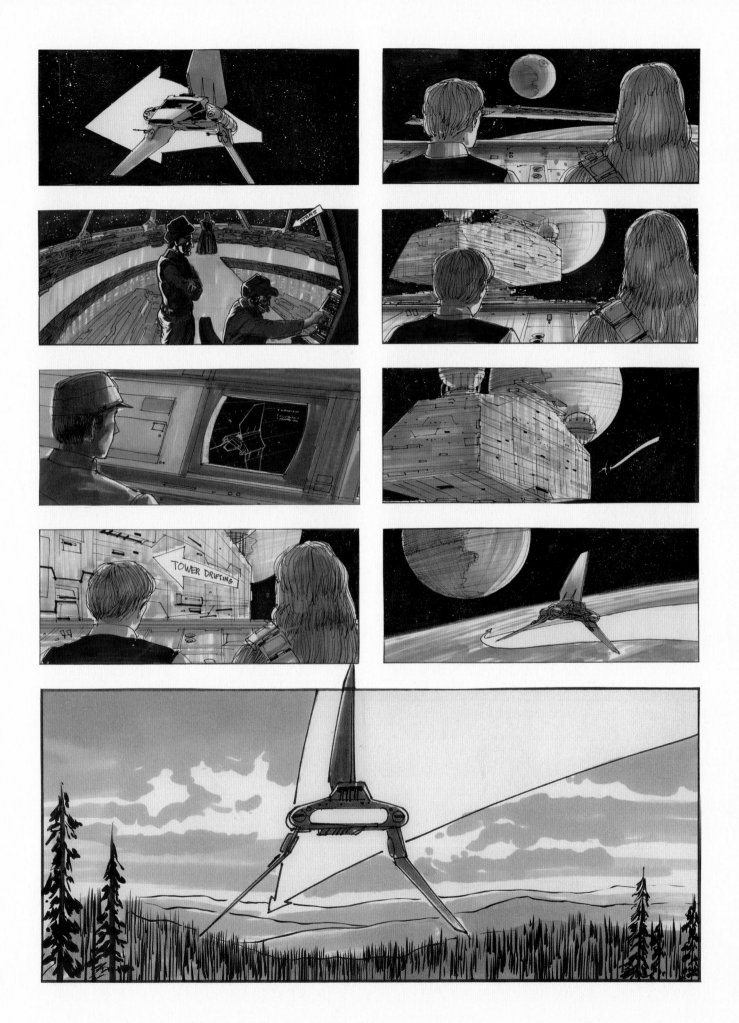

After transmitting their stolen Imperial code, Han, Chewbacca, and the others are
allowed to land on the forest moon of Endor. » Johnston, **R1**, **R2R**, **R3:5**; Russell, **R2L**

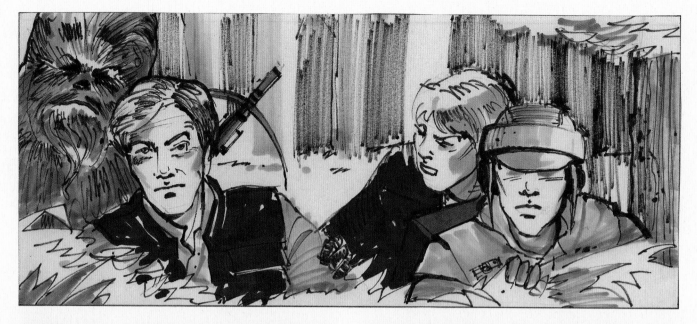

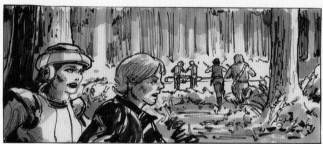

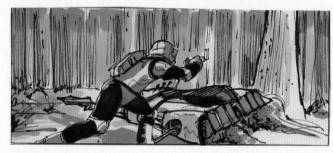

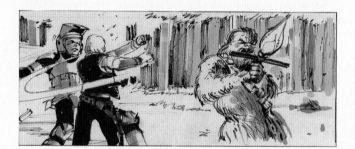

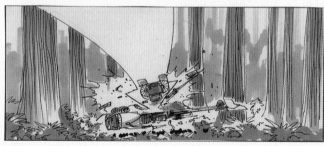

"Similar to the way the snow battle on Hoth evolved, there were several drafts of the speeder-bike sequence. We kept revising, either because the script kept changing or because we had to cut it down to a certain number of shots for budget reasons. There was an initial version done before the videomatic was shot, and several versions afterward."

Joe Johnston

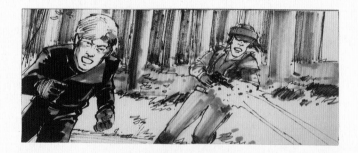

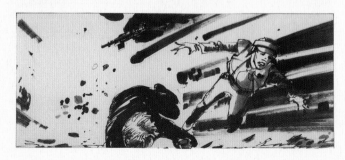

An early iteration of a tussle between our heroes and numerous biker scouts had the latter blasting away at Luke and Leia, who loses her blaster as a result. » Rodis-Jamero, **R1**, **R3L**, **R4:5**; Carson, **R2**; Johnston, **R3R**

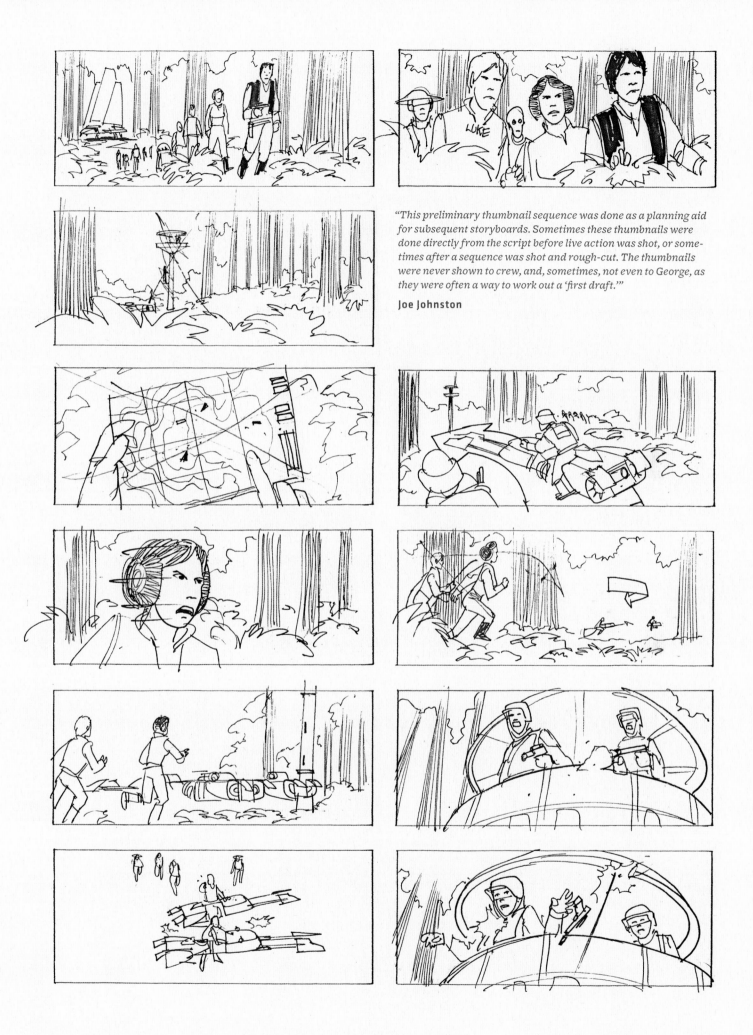

"This preliminary thumbnail sequence was done as a planning aid for subsequent storyboards. Sometimes these thumbnails were done directly from the script before live action was shot, or sometimes after a sequence was shot and rough-cut. The thumbnails were never shown to crew, and, sometimes, not even to George, as they were often a way to work out a 'first draft.'"

Joe Johnston

In this iteration, Imperials in a lookout tower take potshots at Luke and company. » Johnston

① TWO IMPERIAL BIKERS PULL INTO FRAME...STOP... & SEE FIGHT IN DISTANCE...

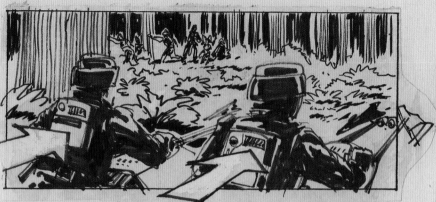

② LEIA HEARS SOMETHING, TURNS AND SEES.....

③ (LEIA'S POV)

...IMPERIAL BIKERS RACING AWAY INTO WOODS.

LUKE & LEIA RUN TO THE BIKE (MOVE IN DURING SHOT.)

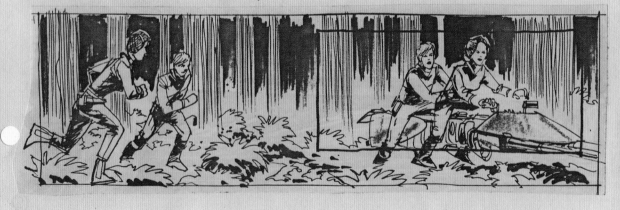

In a more finished version of the sequence Luke and Leia hop on speeder bikes to prevent the scouts from revealing the rebels' presence. » Johnston

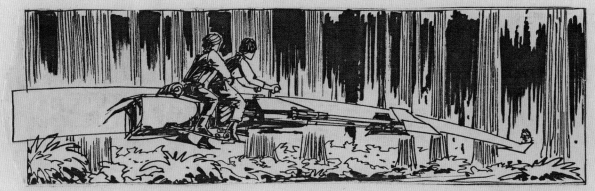

IMPERIAL BIKERS RACE THRU FRAME, FOLLOWED BY LUKE & LEIA. (PAN W/ LUKE & LEIA)

⑥ LUKE & LEIA'S POV OF DISTANT BIKERS.

"This entire biker chase series was a more elaborate form of a 'thumbnail' sequence even though the drawings were more finished. The fact that the drawings were various sizes means that this sequence was a preliminary plan (probably after the videomatic was shot) to lay out ideas and action for the first of the 'published' boards. These boards were never cut from the page and mounted on backing sheets."

Joe Johnston

C.U. GUN FIRING

⑧ TRUCKING W/ BIKERS AS LASER HITS TREE

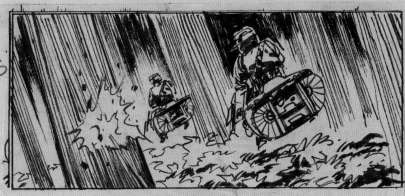

Luke and Leia fire their bike's belly gun at the fast-moving scouts—but miss. » Johnston

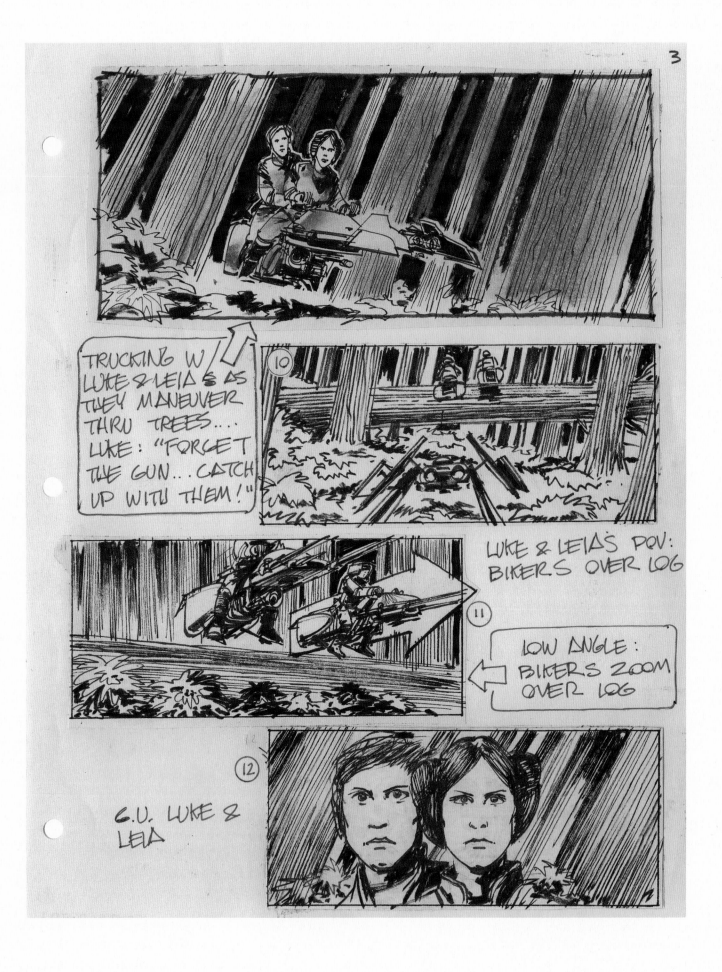

A giant log bars Luke and Leia's path. » Johnston

⑬

LUKE & LEIA'S
POV AS THEY
DIVE UNDER
LOG.

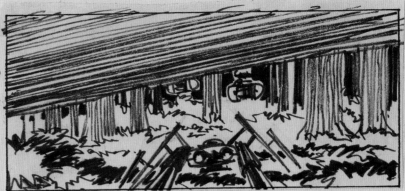

BIKERS BETWEEN
NARROW TREES,
SECOND BIKER
HITS TREE

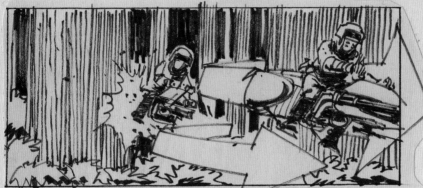

⑭

SAME SHOT...
LUKE & LEIA
COME THRU
O.K.

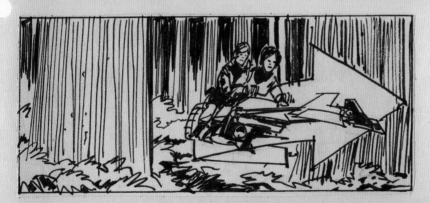

⑮

C.U. LUKE &
LEIA.

LUKE: "PULL
UP NEXT TO
THAT GUY"

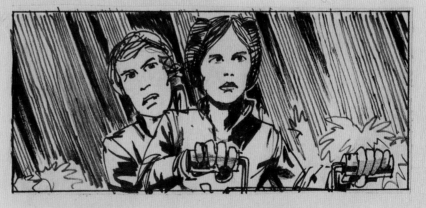

The couple duck under the log and attempt to pull even with the scouts. » Johnston

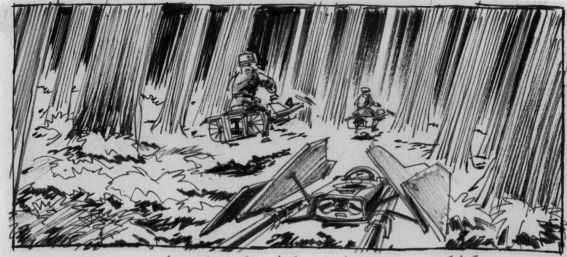

(16) TRUCKING W/ BIKERS AS LUKE & LEIAS BIKE PULLS INTO FRAME... GAIN ON CLOSEST BIKER.

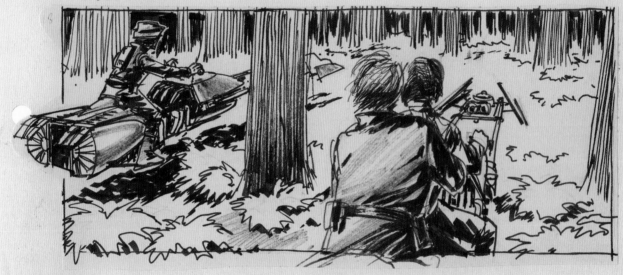

(17) BIKER PULLS INTO FRAME... LOOKS, MOVES CLOSER.

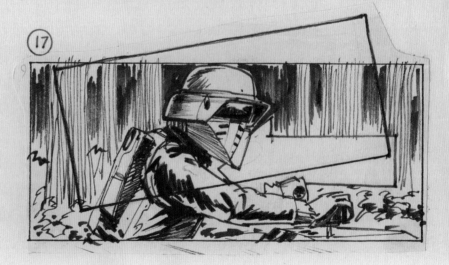

They get closer to the trailing Imperial. » Johnston

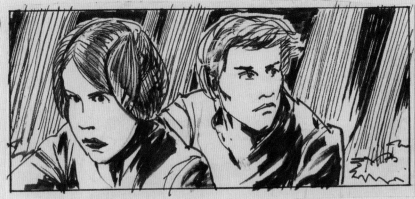

18 C.U. LUKE & LEIA.

LUKE LOOKS

19 BIKES CRASH TOGETHER.... SMALL PIECES FLY.

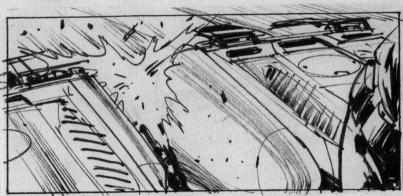

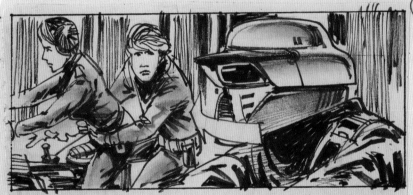

20 C.U. BIKER, LUKE & LEIA IN B.G.

BIKER LOOKS

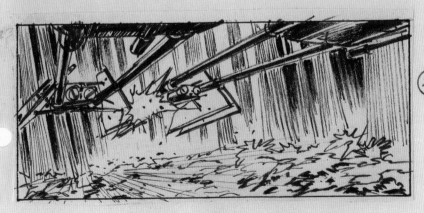

STEERING VANES SCRAPE

21

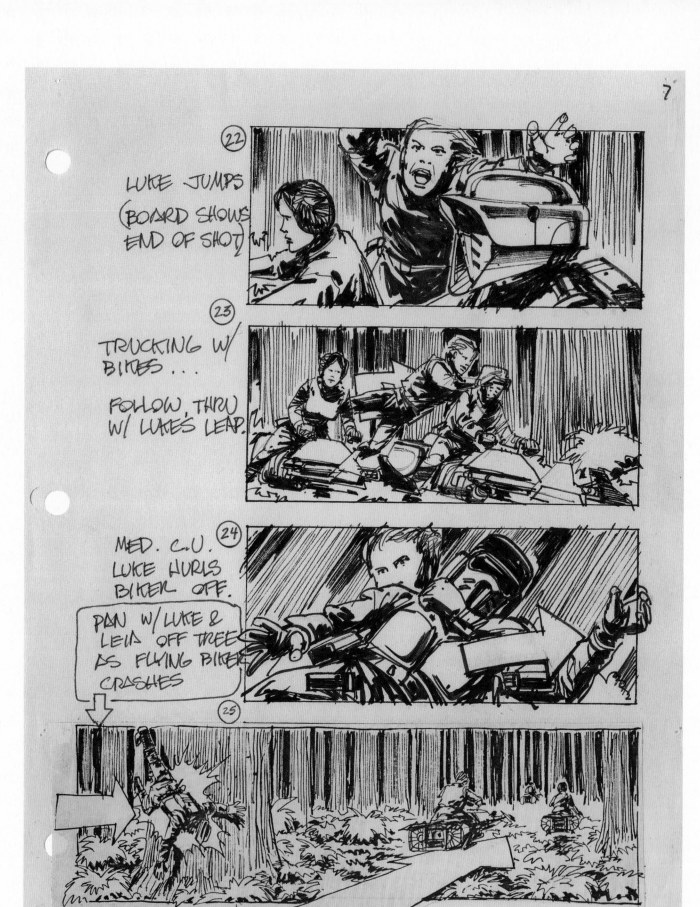

(22) LUKE JUMPS (BOARD SHOWS END OF SHOT)

(23) TRUCKING W/ BIKES...

FOLLOW. THRU W/ LUKE'S LEAP.

(24) MED. C.U. LUKE HURLS BIKER OFF.

PAN W/ LUKE & LEIA OFF TREE AS FLYING BIKER CRASHES

(25)

...leaps onto the other bike and throws that rider headlong into a tree. » Johnston

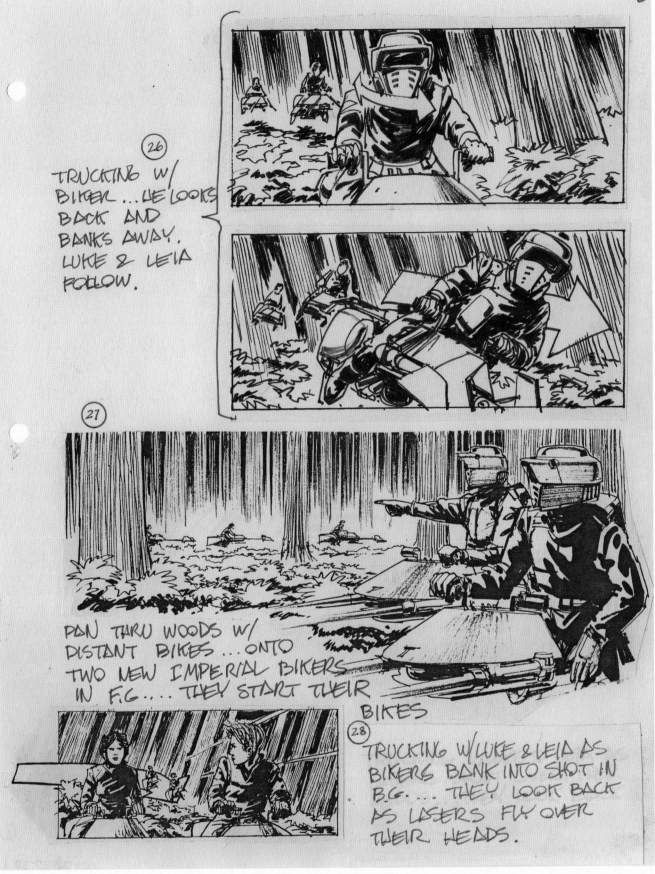

26 TRUCKING W/ BIKER...HE LOOKS BACK AND BANKS AWAY. LUKE & LEIA FOLLOW.

27 PAN THRU WOODS W/ DISTANT BIKES...ONTO TWO NEW IMPERIAL BIKERS IN F.G.... THEY START THEIR BIKES

28 TRUCKING W/LUKE & LEIA AS BIKERS BANK INTO SHOT IN B.G.... THEY LOOK BACK AS LASERS FLY OVER THEIR HEADS.

Two additional biker scouts espy Luke and Leia and get into the act. » Johnston

LUKE & LEIA'S POV
BIKERS GAINING
FAST & FIRING

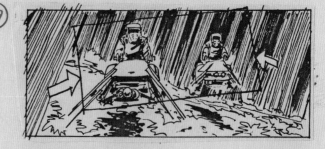

A LASER ZAPS
LUKE'S BIKE
(MINOR DAMAGE)

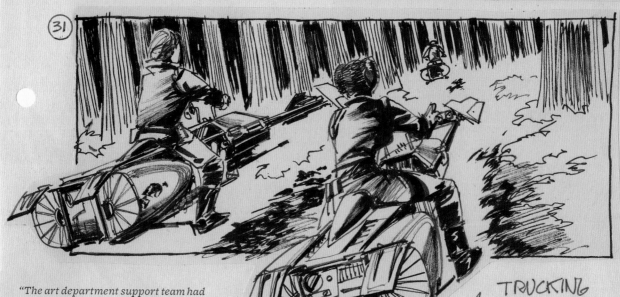

*"The art department support team had
to cut the boards out and mount them on
backing sheets that had all the pertinent
data. So they always groused when I had
a piece of the image breaking the border
of the anamorphic frame, because they
had to either slice it off or cut around it.
Great fun!"*

Joe Johnston

TRUCKING
W/ LUKE & LEIA
SINGLE BIKER IN
DISTANCE.
(LASERS)

LUKE YELLS: "YOU TAKE
THE ONE UP AHEAD, I'LL
TAKE THE OTHER TWO!"

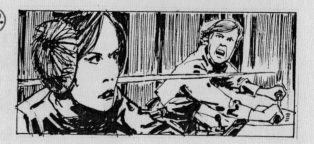

Luke decides to take care of the two pursuers, telling Leia to concentrate on the Imperial still out front. » Johnston

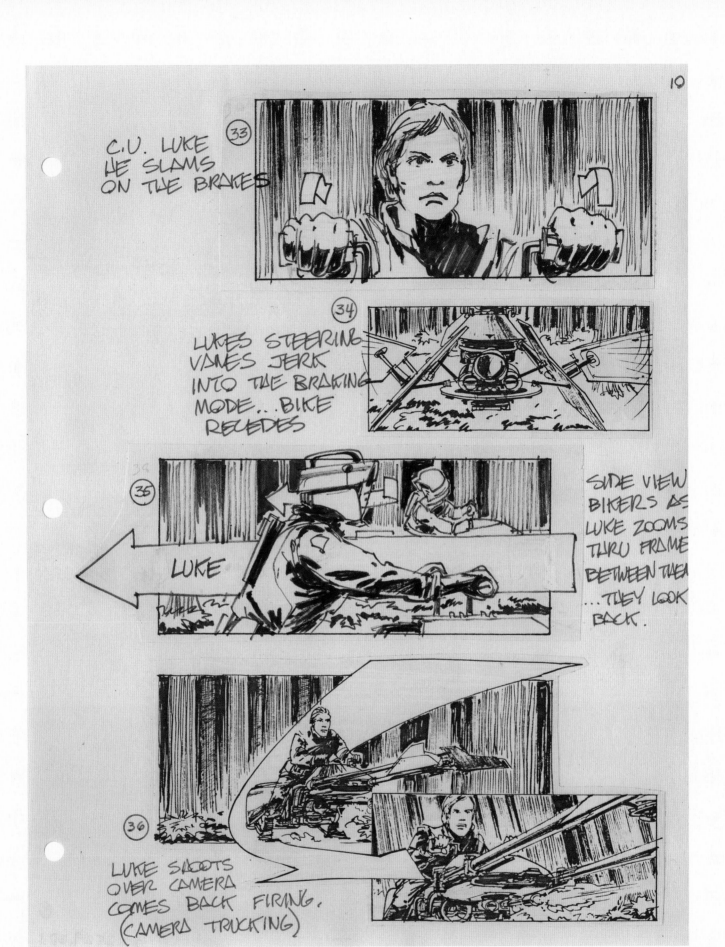

C.U. LUKE ③③
HE SLAMS
ON THE BRAKES

LUKES STEERING ③④
VANES JERK
INTO THE BRAKING
MODE...BIKE
RECEDES

③⑤ LUKE

SIDE VIEW
BIKERS AS
LUKE ZOOMS
THRU FRAME
BETWEEN THEM
...THEY LOOK
BACK.

③⑥ LUKE SHOOTS
OVER CAMERA
COMES BACK FIRING.
(CAMERA TRUCKING)

Luke slams on the bike's brakes, falls behind the two, and then blasts away. » Johnston

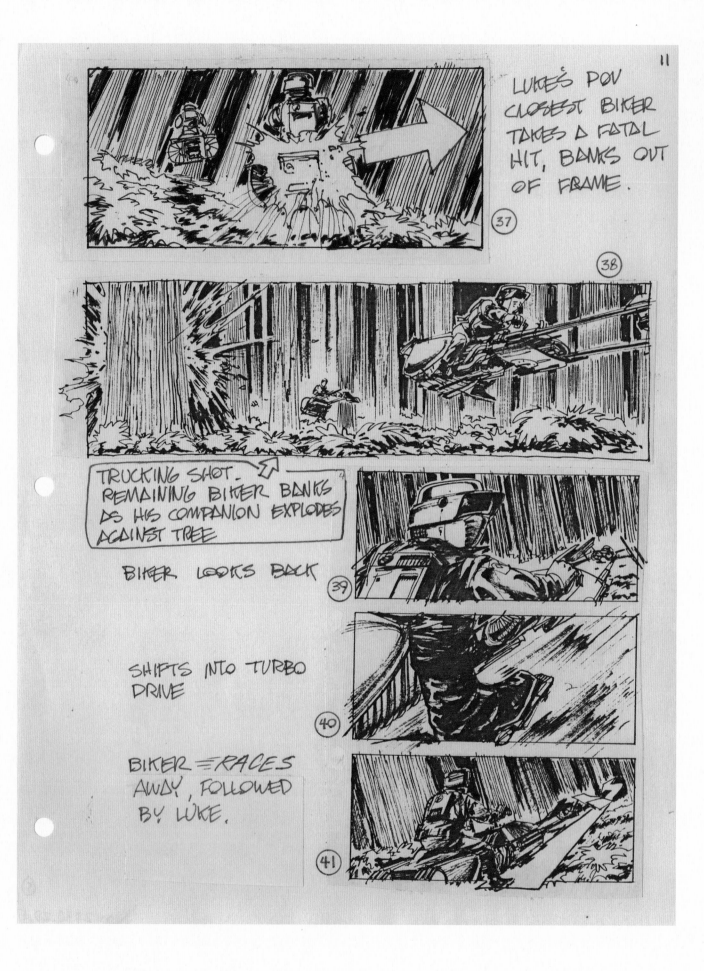

11

LUKE'S POV
CLOSEST BIKER
TAKES A FATAL
HIT, BANKS OUT
OF FRAME.

37

38

TRUCKING SHOT.
REMAINING BIKER BANKS
AS HIS COMPANION EXPLODES
AGAINST TREE

BIKER LOOKS BACK

39

SHIFTS INTO TURBO
DRIVE

40

BIKER RACES
AWAY, FOLLOWED
BY LUKE.

41

One of the bikers is hit and veers off into a tree. » Johnston

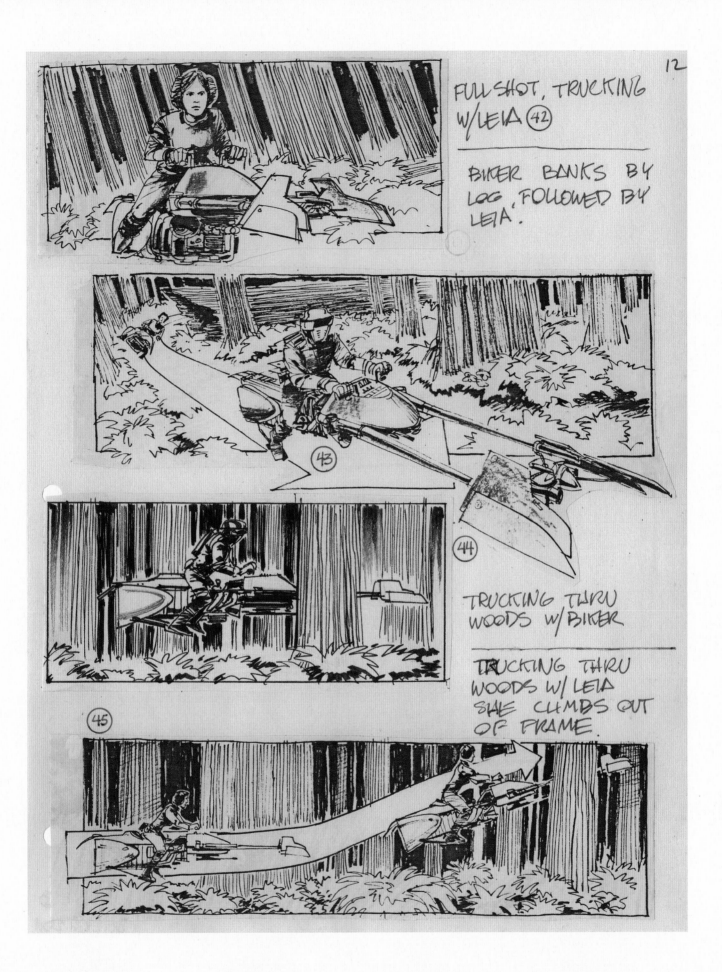

FULL SHOT, TRUCKING
W/ LEIA ㊷

BIKER BANKS BY
LOG, FOLLOWED BY
LEIA.

TRUCKING THRU
WOODS W/ BIKER

TRUCKING THRU
WOODS W/ LEIA
SHE CLIMBS OUT
OF FRAME.

Leia takes the high road, literally, while pursuing her Imperial . . . » Johnston

46 TRUCKING W/
BIKER

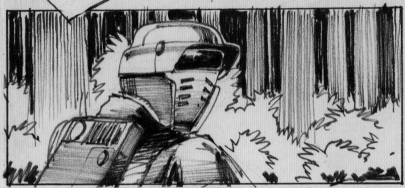

C.U. BIKER AS
HE LOOKS OVER
HIS SHOULDER.

47

48

BIKERS POV
...TREES

SIDE VIEW 49
TRUCKING W/BIKER
HE TURNS, LOOKS
ON BOTH SIDES.

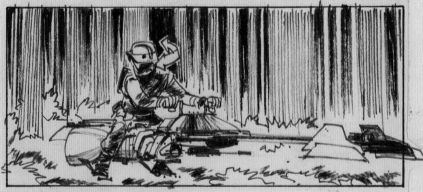

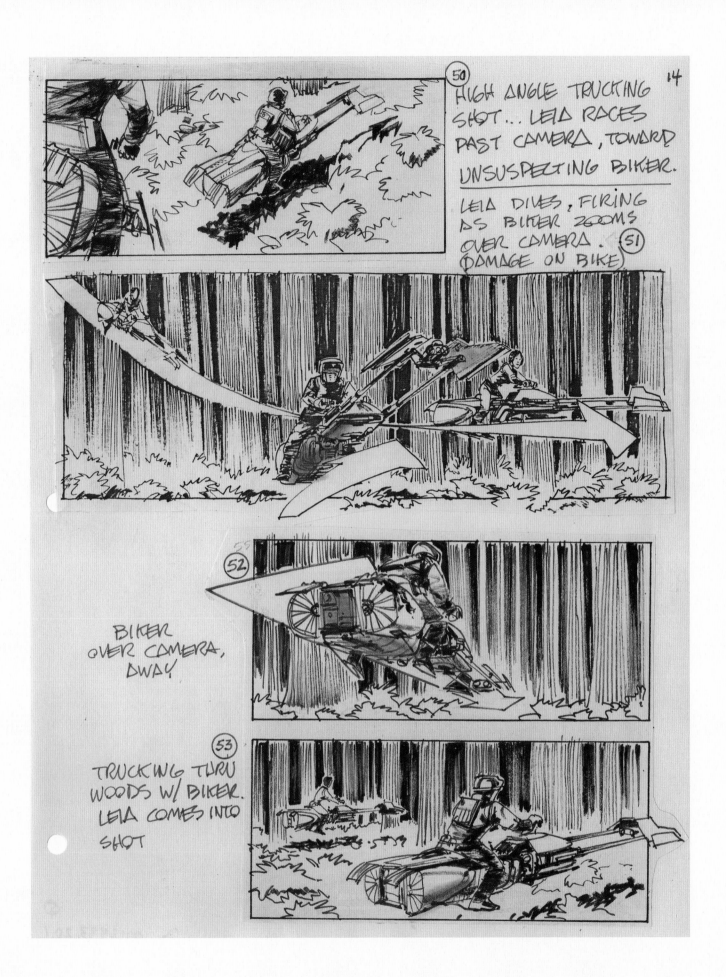

50 HIGH ANGLE TRUCKING SHOT... LEIA RACES PAST CAMERA, TOWARD UNSUSPECTING BIKER.

LEIA DIVES, FIRING AS BIKER ZOOMS OVER CAMERA. 51 (DAMAGE ON BIKE)

52 BIKER OVER CAMERA, AWAY

53 TRUCKING THRU WOODS W/ BIKER. LEIA COMES INTO SHOT

14

Leia zooms down and is now side by side with her foe. » Johnston

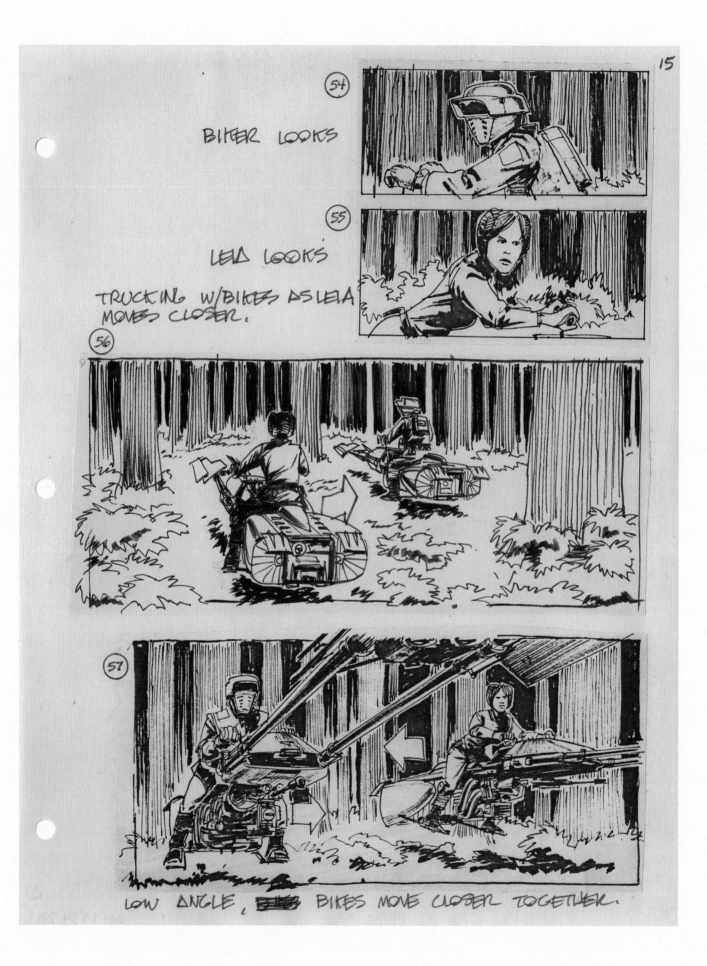

54 BIKER LOOKS

55 LEIA LOOKS

TRUCKING W/BIKES AS LEIA
MOVES CLOSER.

56

57 LOW ANGLE, ~~BIKES~~ BIKES MOVE CLOSER TOGETHER.

 A game of nerves as the two ride at breakneck speed. » Johnston

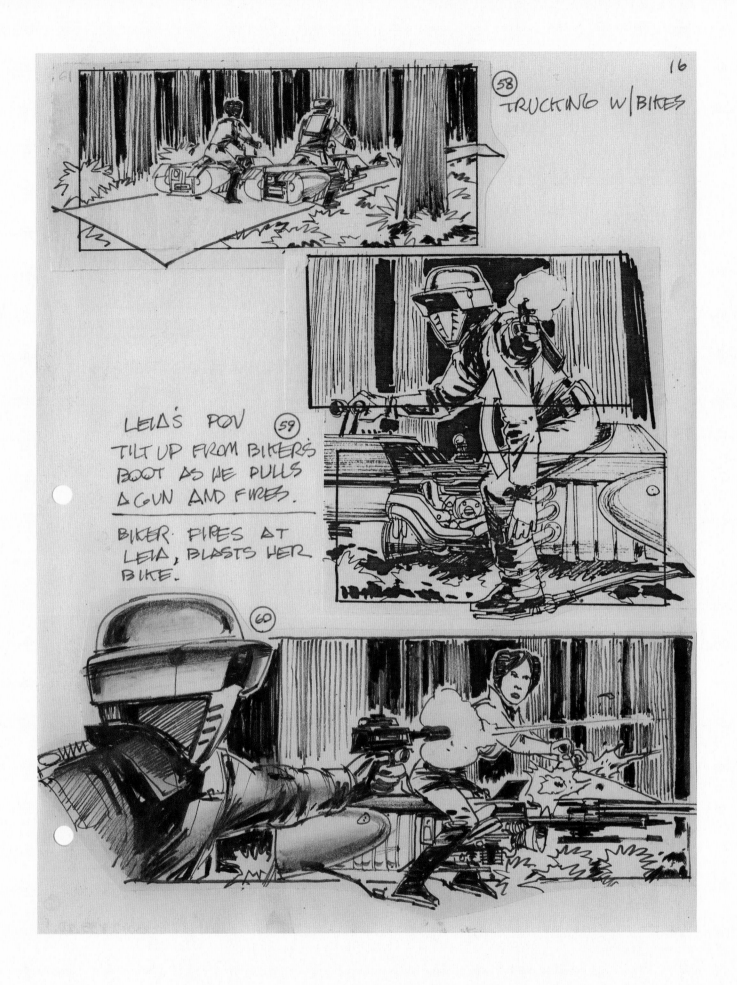

58 TRUCKING W/ BIKES

LEIA'S POV 59
TILT UP FROM BIKER'S
BOOT AS HE PULLS
A GUN AND FIRES.

BIKER FIRES AT
LEIA, BLASTS HER
BIKE.

60

The biker scout pulls out his blaster and fires at Leia. » Johnston

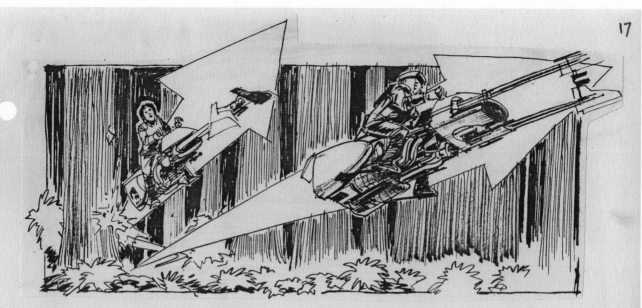

(61) LEIA LOSES CONTROL ... CROSSES BIKERS PATH.
HITS A TREE, GOES SHOOTING OVER CAMERA.

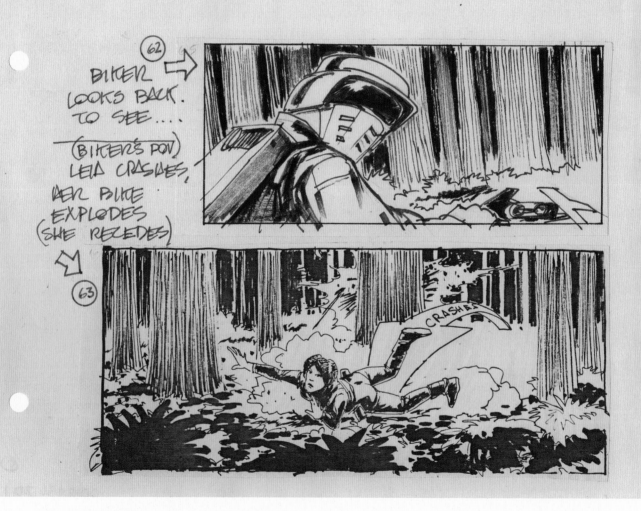

(62) BIKER LOOKS BACK. TO SEE

(BIKER'S POV) LEIA CRASHES, HER BIKE EXPLODES (SHE RECEDES)

(63)

CRASHES

Leia bounces off a tree, which knocks her from her bike, which smashes into another tree. » Johnston

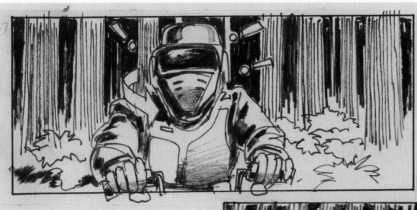

MEDIUM C.U. — BIKER
TURNS BACK, HITS
BRAKES.
64

BIKERS POV OF
APPROACHING LOG.
65

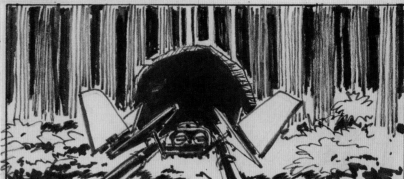

PAN W/ BIKER
INTO LOG

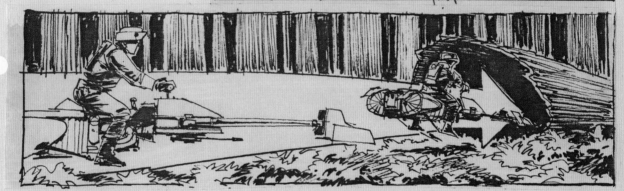

(SAME SHOT). GIANT EXPLOSION, BIKE PARTS FLY OUT.
66

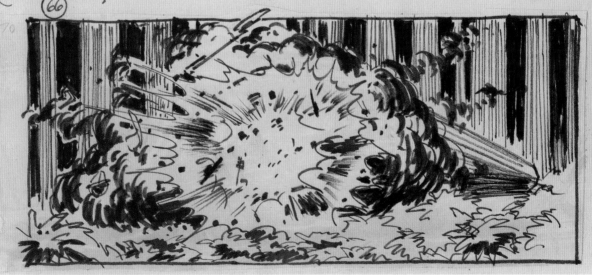

The biker looks back—fatally—as he then flies smack into a fallen tree and is killed. » Johnston

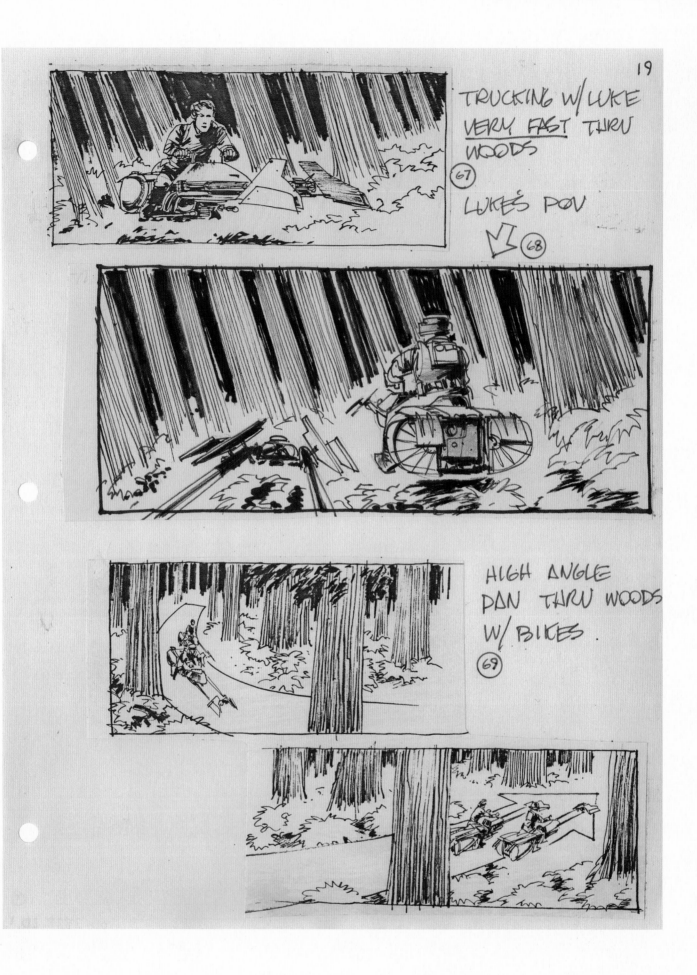

TRUCKING W/ LUKE
VERY FAST THRU
WOODS
67

LUKE'S POV
68

HIGH ANGLE
PAN THRU WOODS
W/ BIKES.
69

Meanwhile, Luke is still trailing the last Imperial scout. » Johnston

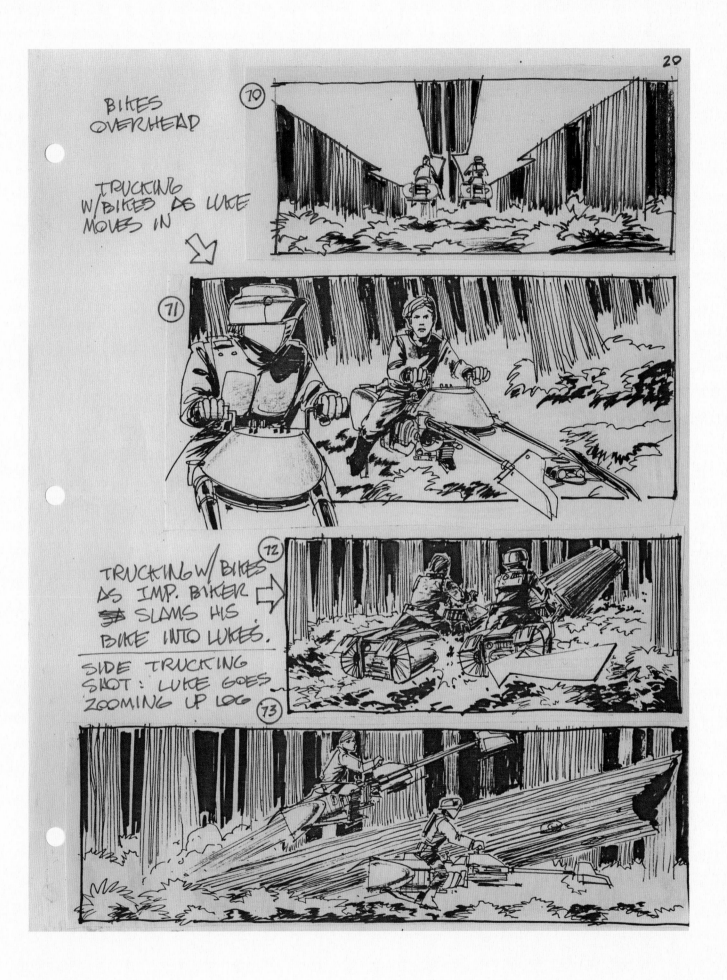

BIKES
OVERHEAD

TRUCKING
W/BIKES AS LUKE
MOVES IN

TRUCKING W/ BIKES
AS IMP. BIKER
SLAMS HIS
BIKE INTO LUKES.

SIDE TRUCKING
SHOT: LUKE GOES
ZOOMING UP LOG

Luke is forced onto a log jutting upward . . . » Johnston

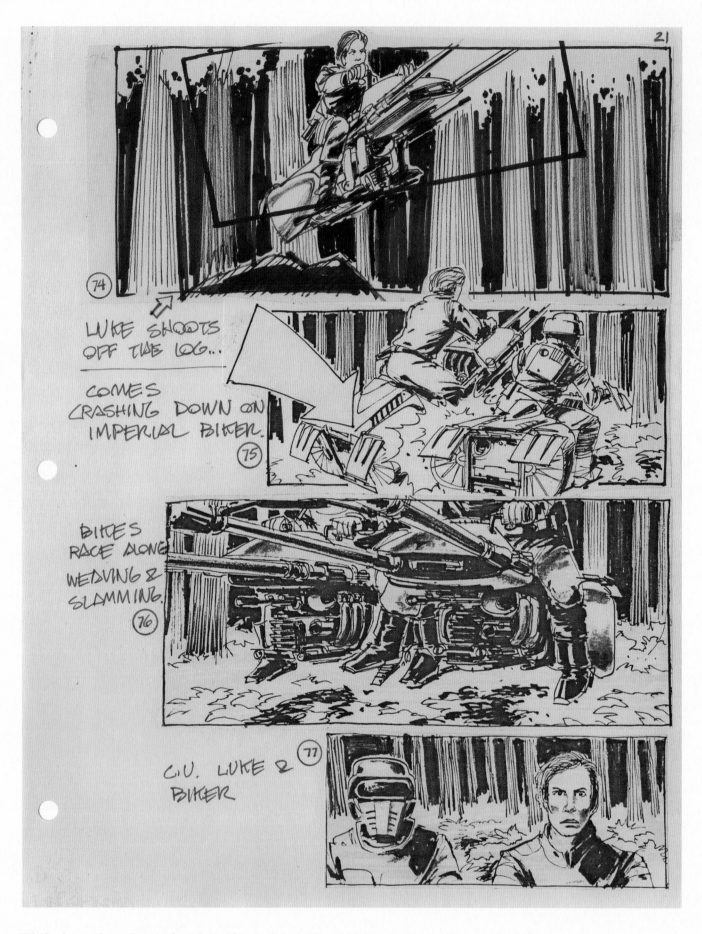

74

LUKE SHOOTS
OFF THE LOG...

COMES
CRASHING DOWN ON
IMPERIAL BIKER.
75

BIKES
RACE ALONG
WEAVING &
SLAMMING.
76

C.U. LUKE & 77
BIKER

"The background was always going to be moving, really just a blur, which meant we could get away with a lot."
Joe Johnston

. . . but soars off its end and comes crashing down on his opponent. » Johnston

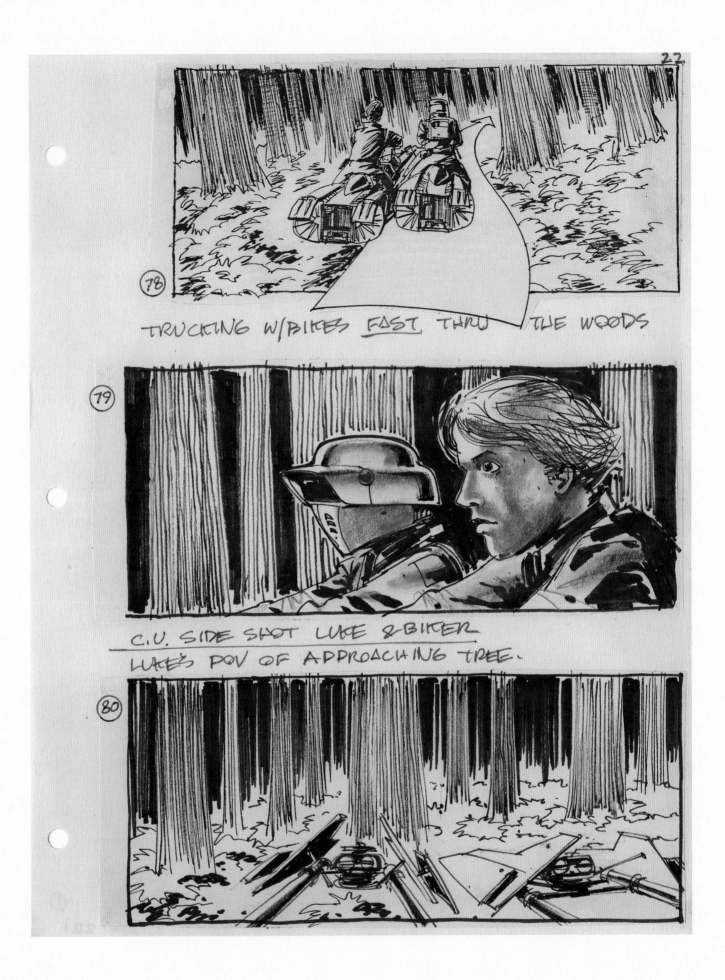

TRUCKING W/BIKES <u>FAST</u> THRU THE WOODS

<u>C.U. SIDE SHOT LUKE & BIKER</u>
LUKE'S POV OF APPROACHING TREE.

Luke is then heading straight toward a tree . . . » Johnston

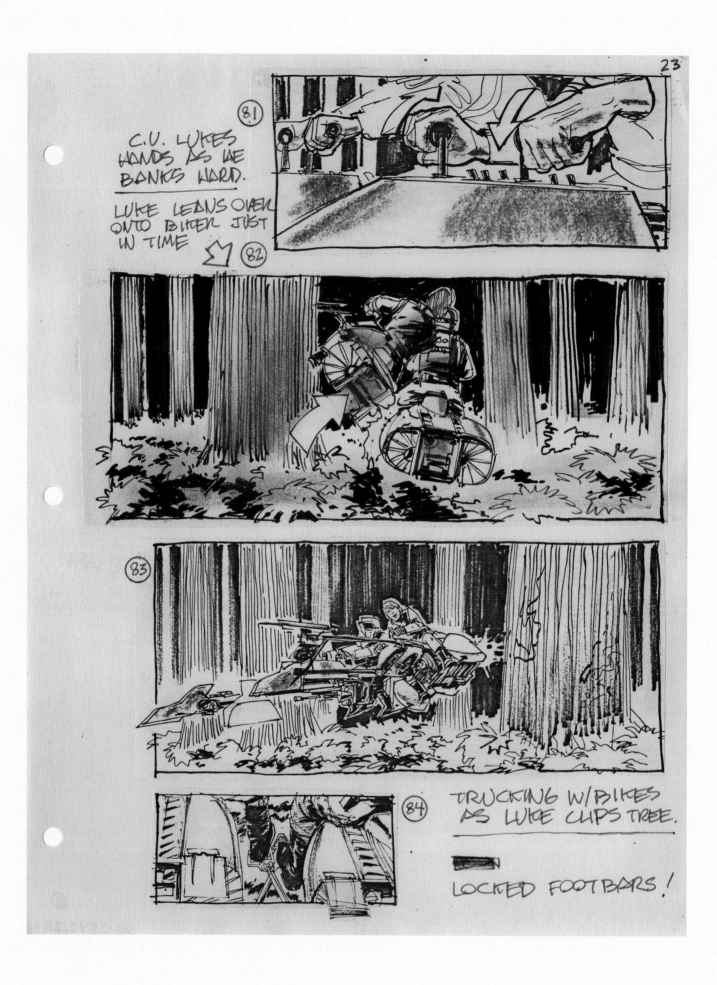

81

C.U. LUKES
HANDS AS HE
BANKS HARD.

LUKE LEANS OVER
ONTO BIKER JUST
IN TIME

82

83

84

TRUCKING W/BIKES
AS LUKE CLIPS TREE.

LOCKED FOOTBARS!

. . . but manages to lean out of the way in the nick of time. » Johnston

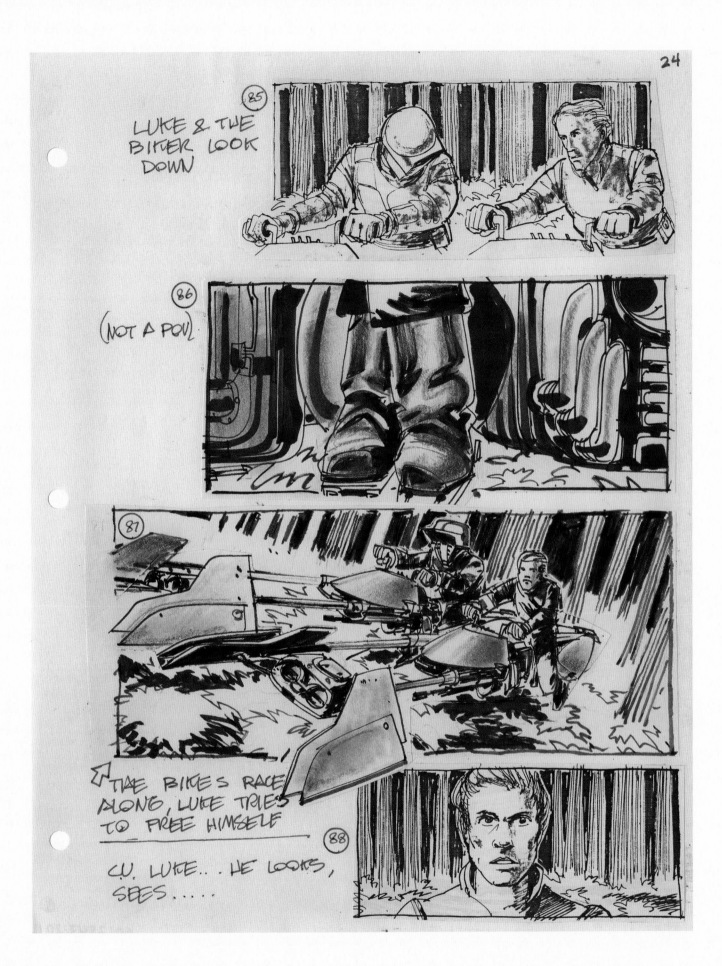

85 LUKE & THE BIKER LOOK DOWN

86 (NOT A POV)

87 THE BIKES RACE ALONG, LUKE TRIES TO FREE HIMSELF

88 C.U. LUKE... HE LOOKS, SEES.....

The two bikes become entangled . . . » Johnston

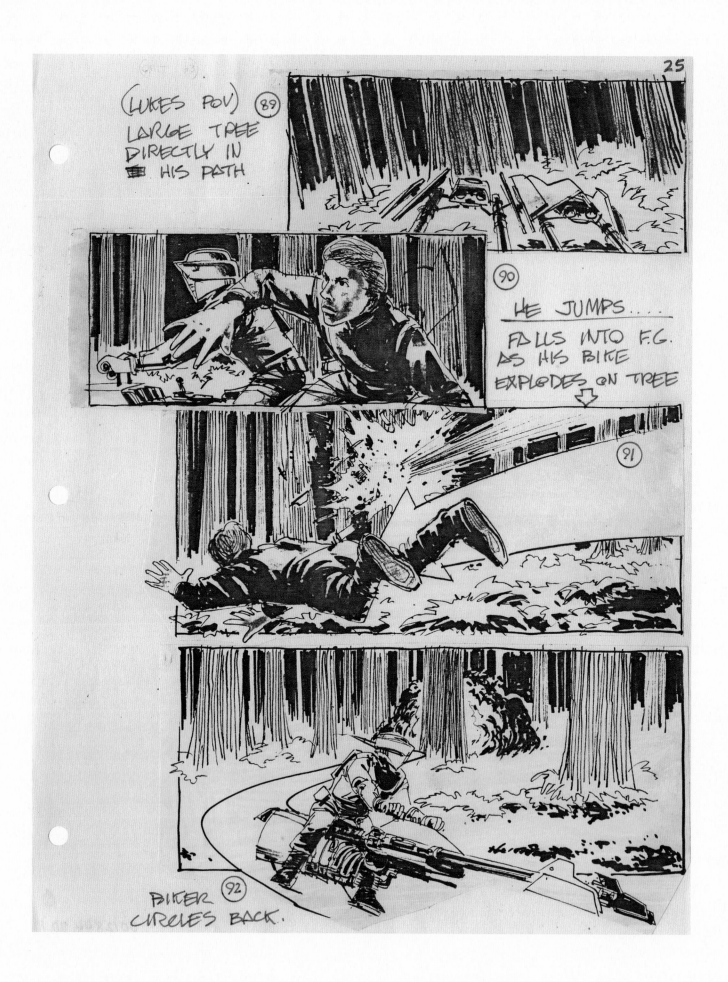

. . . and this time Luke must abandon his ride to avoid hitting yet another tree. » Johnston

BIKER CONTINUES
HIS LOOP (93)

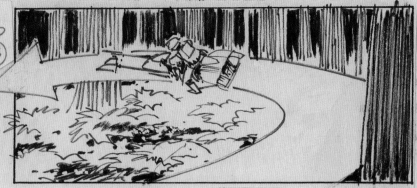

LUKE RISES
UP OUT OF
UNDERBRUSH (94)

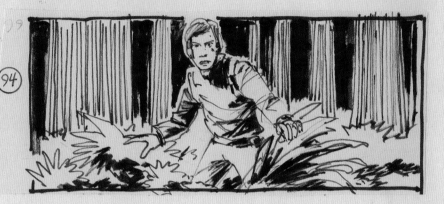

TRUCKING W/BIKER AS HE STRAIGHTENS OUT, HEADS
DIRECTLY FOR LUKE. (95)

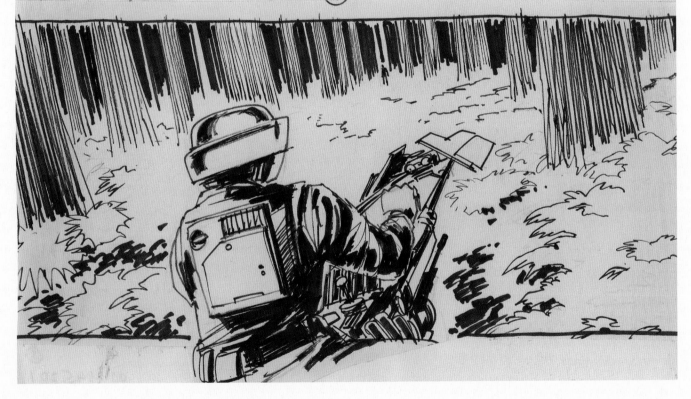

Circling back for the kill, the biker scout zeroes in . . . » Johnston

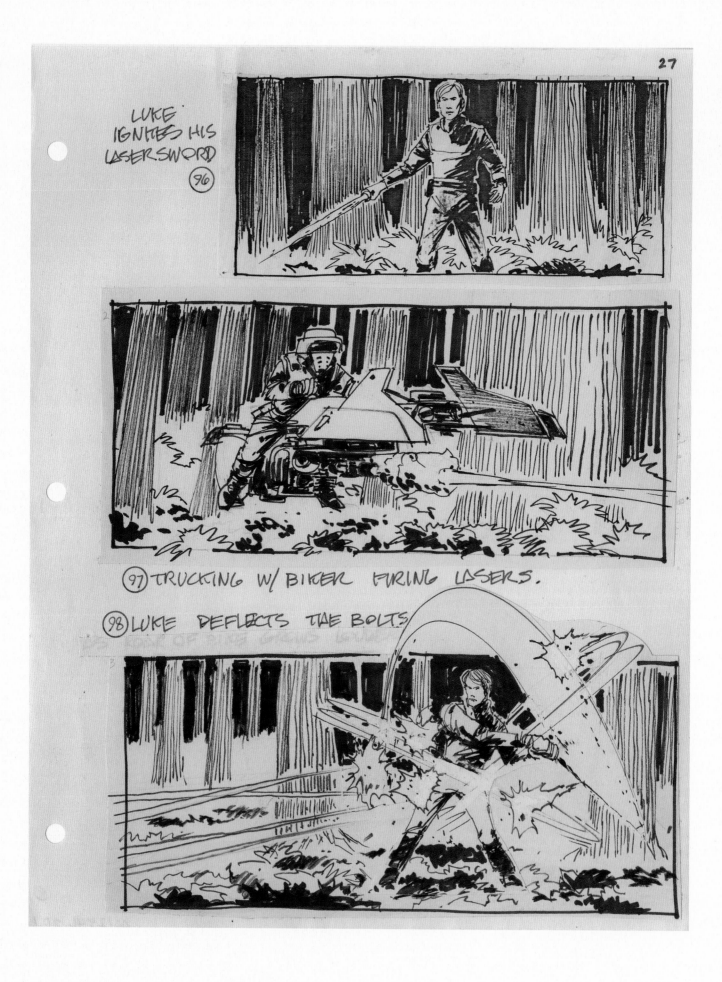

LUKE IGNITES HIS LASERSWORD
96

97 TRUCKING W/ BIKER FIRING LASERS.

98 LUKE DEFLECTS THE BOLTS

. . . but Luke deflects the blaster bolts with his lightsaber. » Johnston

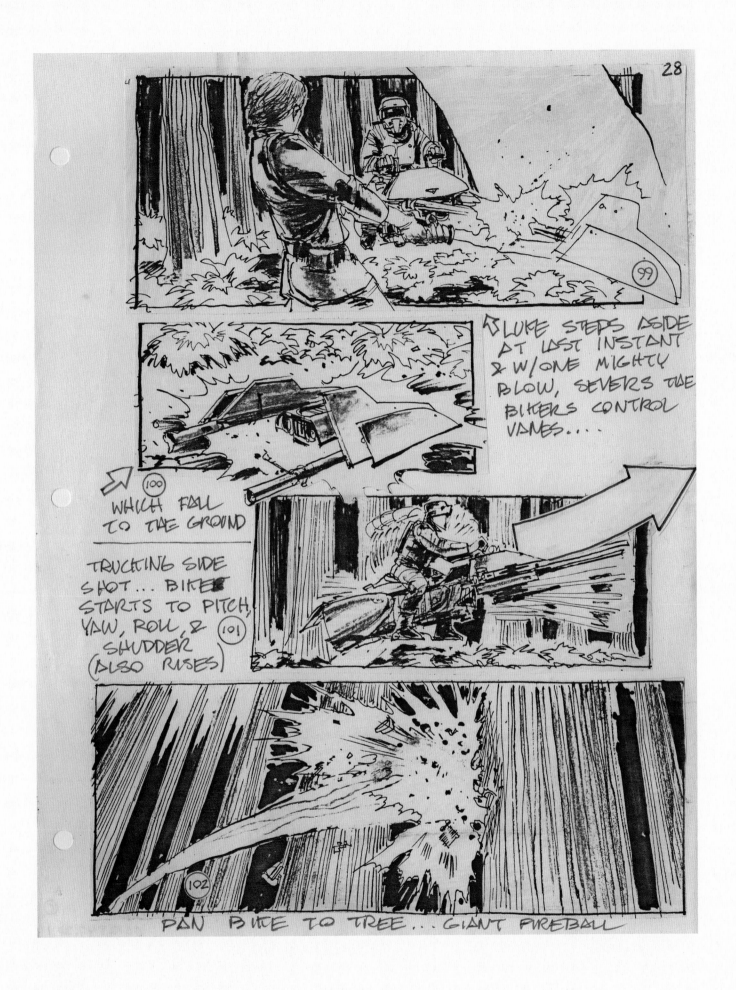

Luke then severs the bike's steering vane, causing the scout to crash—a fiery end. » Johnston

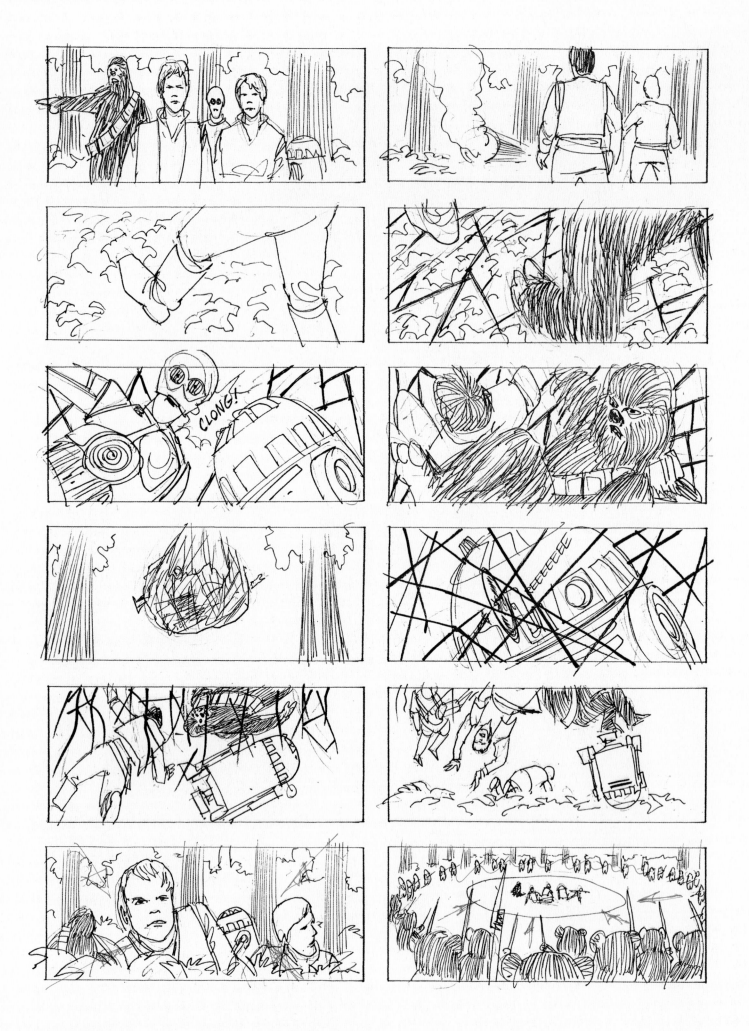

Early boards show the heroes triggering a trap and then being surrounded by Ewoks. » Johnston

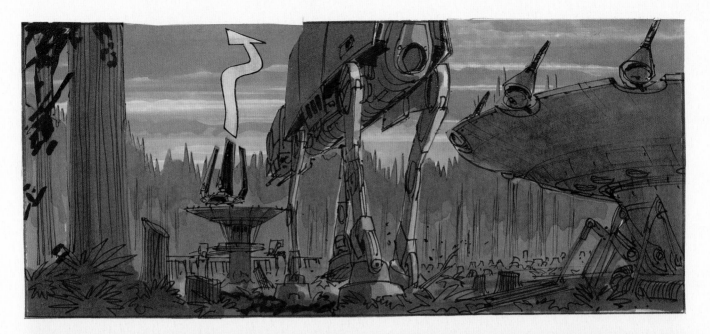

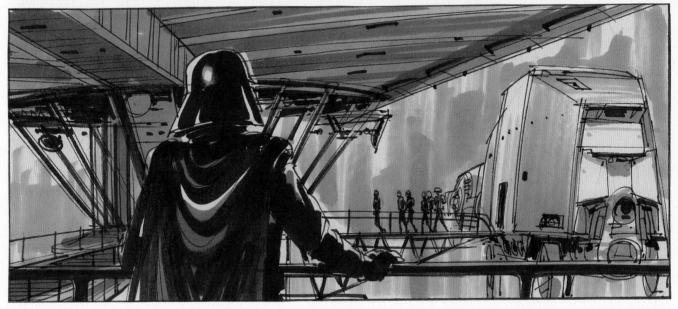

The two chicken walkers flanking the Imperial landing post **[R1]** wouldn't make the final shot.

"One of things to remember is that storyboards are never used for design sketches. That's something I struggled with at ILM, trying to make people understand that they couldn't assume a costume in a storyboard was an actual design sketch. Just because it's on paper doesn't mean that's the design. The storyboard is just telling you what's happening in the shot—so don't send it to somebody and say, 'Build this.'"

Joe Johnston

In order to save his friends, Luke gives himself up to Darth Vader. » Johnston

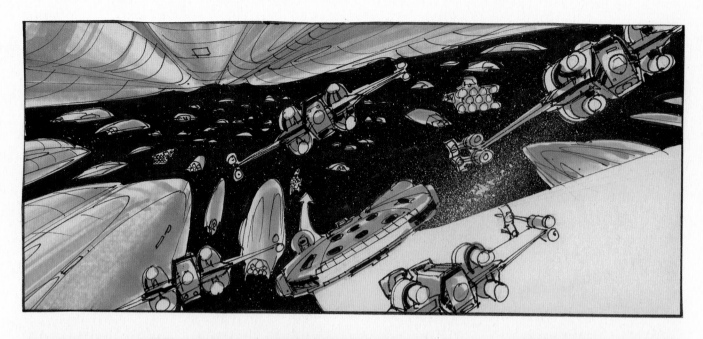

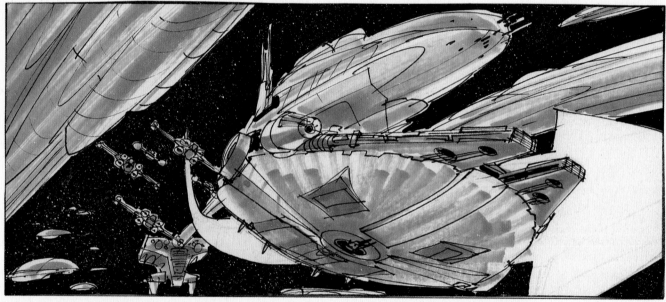

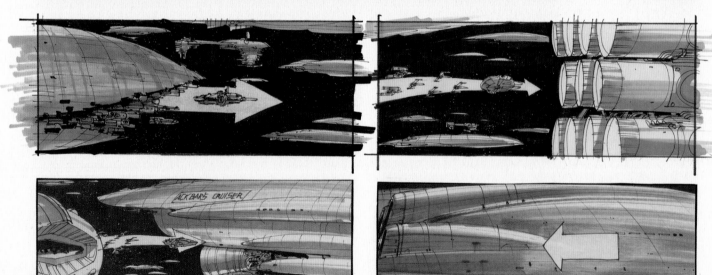

The *Falcon* snakes among the other ships in the Rebel Alliance fleet. » Johnston

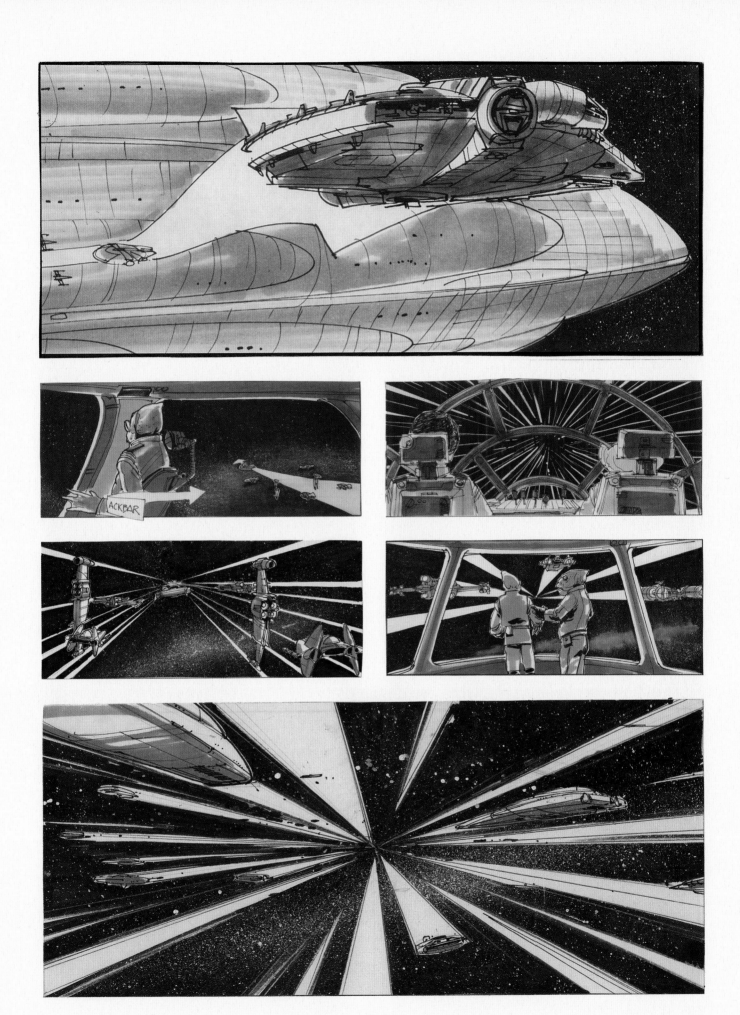

The fleet makes a collective jump to hyperspace. » Johnston **R1**, **R3R**;
Rodis-Jamero/Carson **R2L**, **R3L**; Carson **R2R**; Rodis-Jamero **R4**

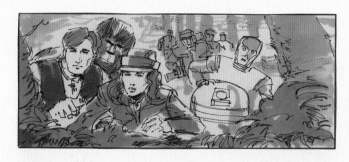
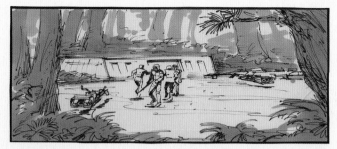

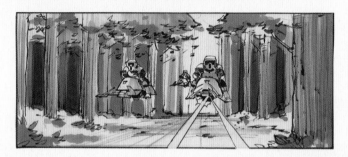
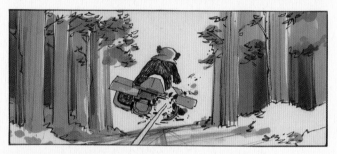
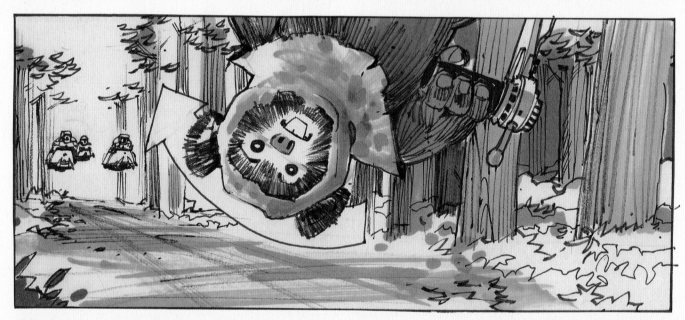
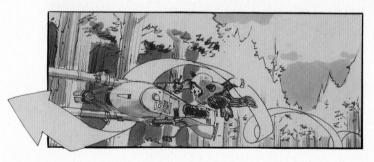
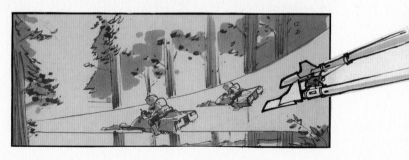

To the surprise of Han and Leia, a wily Ewok named Paploo decides to steal an Imperial speeder bike to create a diversion. » Jenson, **R1**, **R2L**; Rodis-Jamero, **R2R**, **R3:5**

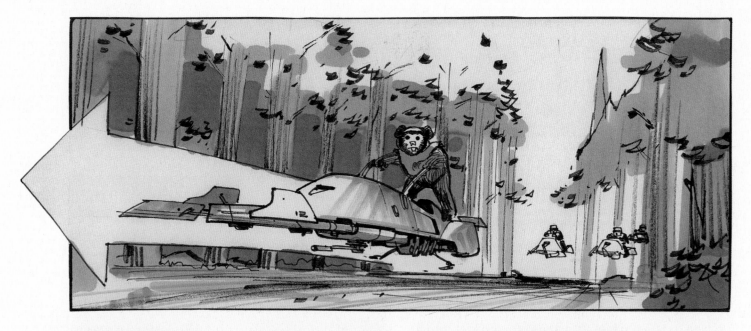

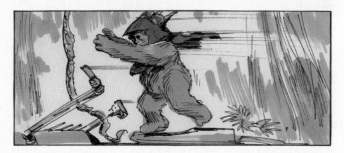

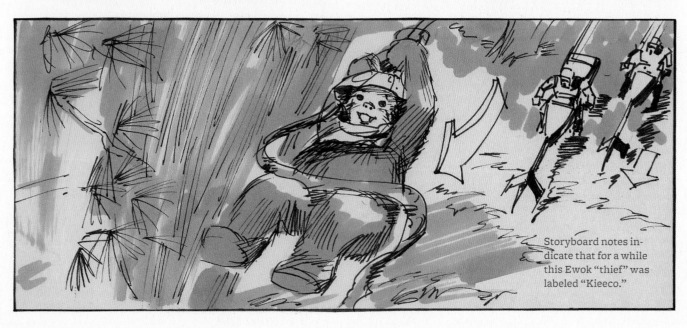

Storyboard notes indicate that for a while this Ewok "thief" was labeled "Kieeco."

Spotting a vine, Paploo swings to safety while the biker scouts continue their hapless pursuit. »
Rodis-Jamero, **R1:2**, **R3L**; Jenson, **R3R**, **R4**

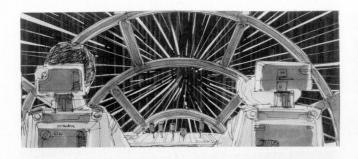

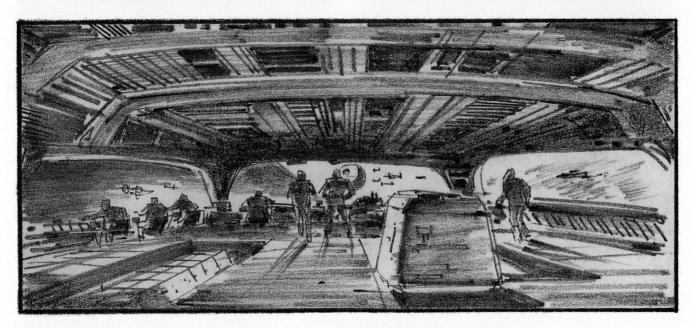
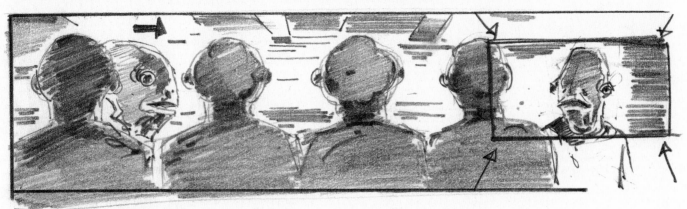

"We had cardboard templates that we used to draw the boards' frames. We sketched the shots in pencil and then inked them using a fine-point marker. For a while, we used calligraphy markers with a chisel point. Next, we shaded them using two or three shades of gray. Sometimes we used warm gray makers, sometimes cool, sometimes mixed."

Dave Carson

Lando, in the *Falcon*, and the rebel fleet emerge from hyperspace;
Admiral Ackbar says, "May the Force be with you." » Carson, **R1:2**; Jenson, **R3:4**

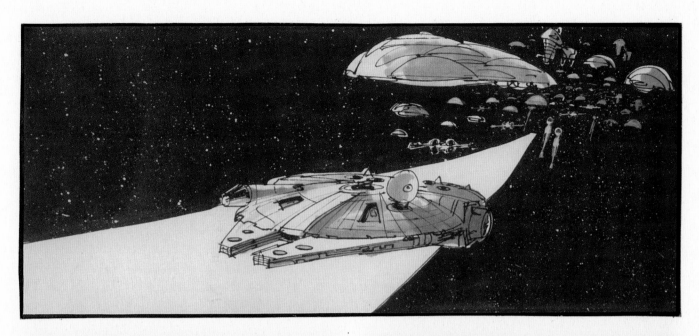

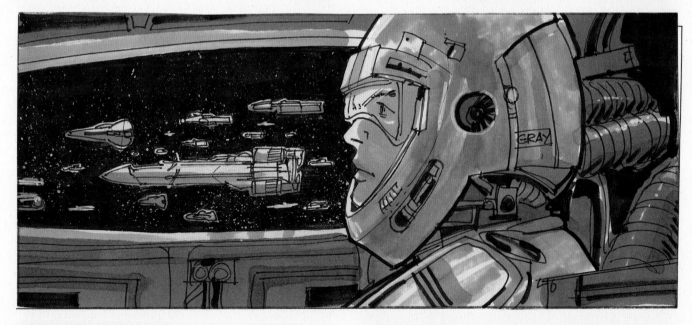

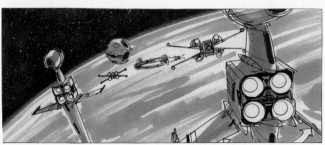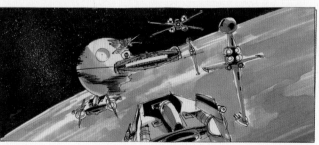

The *Falcon* leads the fleet, including B-wing pilot and Gray Leader **[R3]**, toward the Death Star;
ships lock their S-foils in attack position. » Johnston/Rodis-Jamero, **R1:2**; Rodis-Jamero/Carson, **R3**; Johnston, **R4**

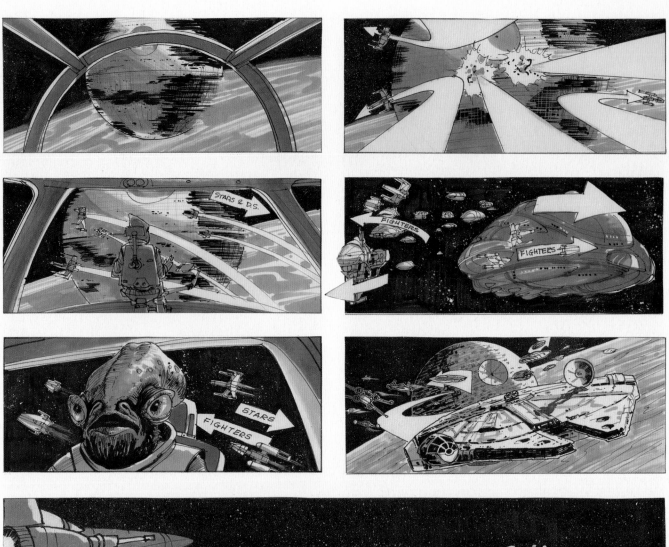

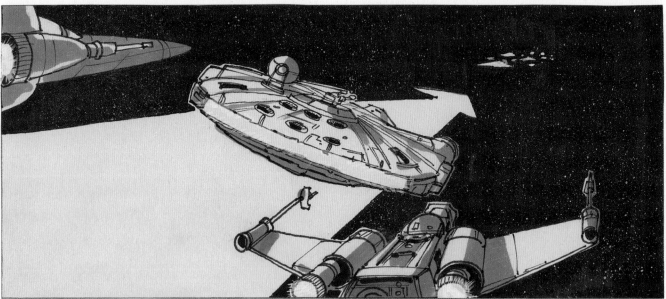

"My number one pet peeve about motion-control camera personnel involved the concept of flight. The spaceships in the Star Wars films should always move like aircraft in earth's atmosphere because that's what we as earthlings understand as flight. I had too many discussions with camera-move programmers (usually the new guys) about this issue. The argument always went something like, 'But there's no air in space so an X-wing doesn't have to move like an airplane.' But flight is a very visceral, familiar, universal feeling. We all have a sense of what it feels like. When it looks wrong, any audience member immediately knows it."

Joe Johnston

"It's a trap!" The Death Star's shield is up. The fleet turns to avoid it, though two rebel craft explode on impact. » Johnston, **R1**, **R2L**; Carson, **R2R**, **R3:4**

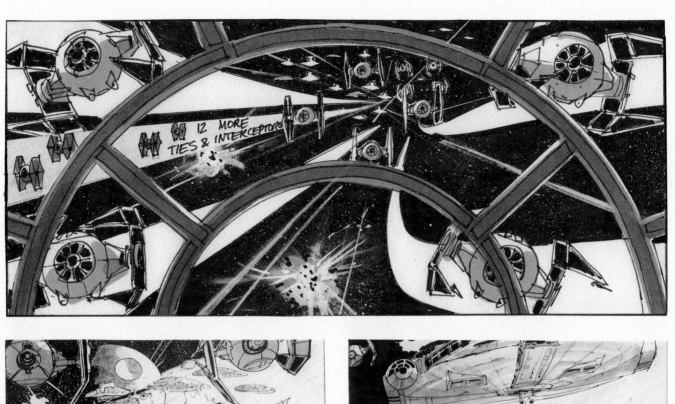

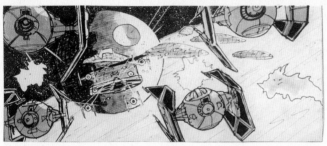

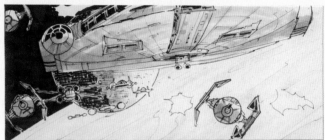

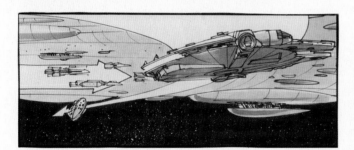

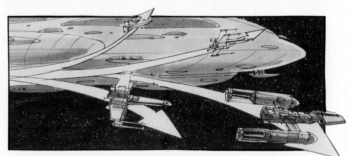

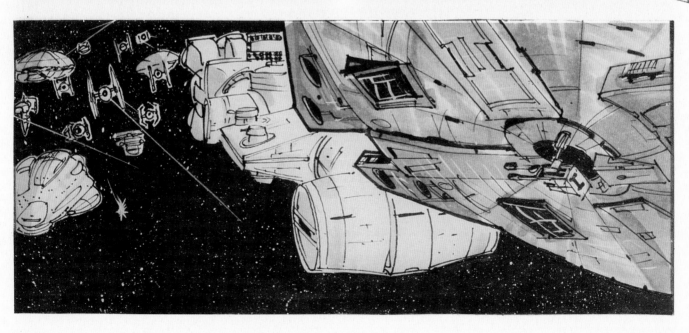

The fleet turns—only to run straight into the Imperial fleet. » Johnston
OVERLEAF: The *Falcon* passes by a blockade runner as each rebel pilot struggles to stay alive. » Johnston

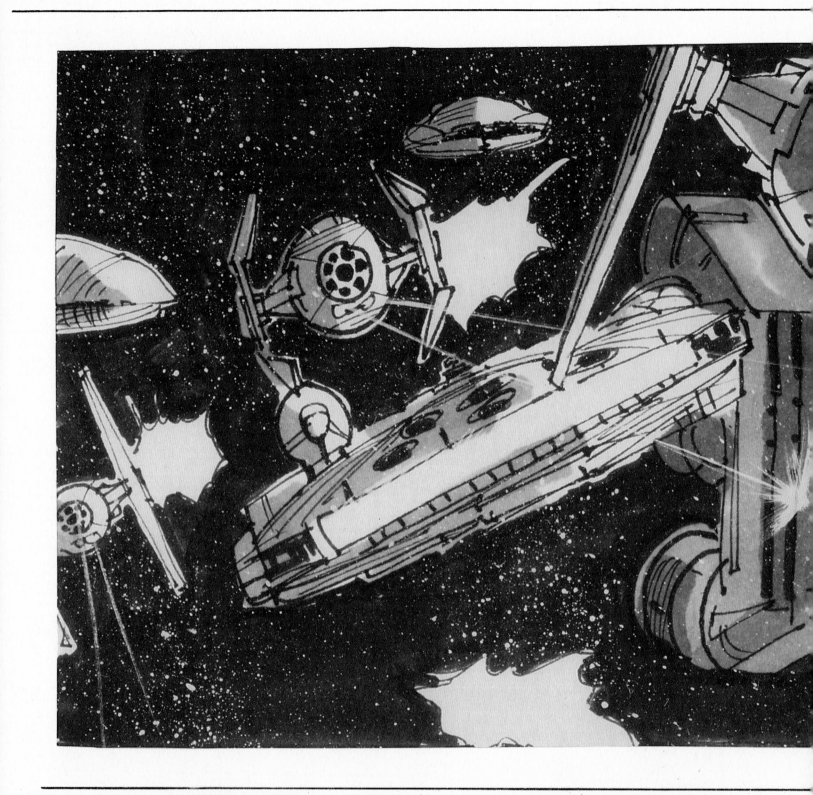

2 **DESCRIPTION: EXT. SPACE - DOGFIGHT - TRUCKING**

TRUCKING with Falcon toward a group of T
Rebel Fleet is in background; Falcon pass
Blockade Runner on right. Imperial fight
firing at each other.

ELEMENTS:	STAGE	ANIM	PLATE	MATTE	NON-ILM		ELEM
Falcon	x						Rebel (
Blockade Runner	x						Rebel (

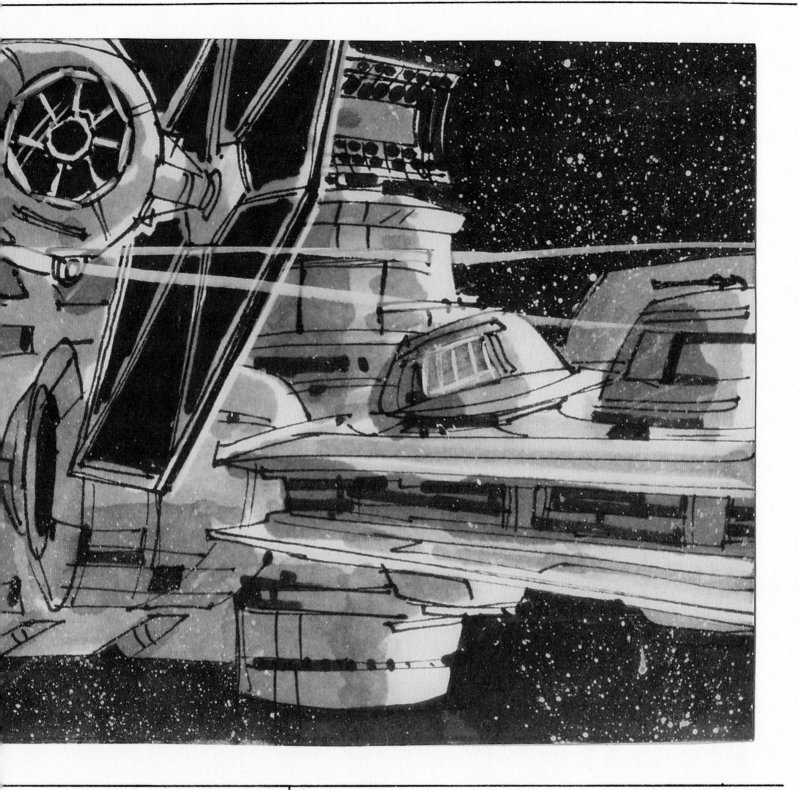

s and Interceptors.
s close to a
rs and Falcon are

NOTES:

NTS:	STAGE	ANIM	PLATE	MATTE	NON-ILM
uiser #1	x				
uiser #2	x				

SHOT # / SEQUENCE

102-32

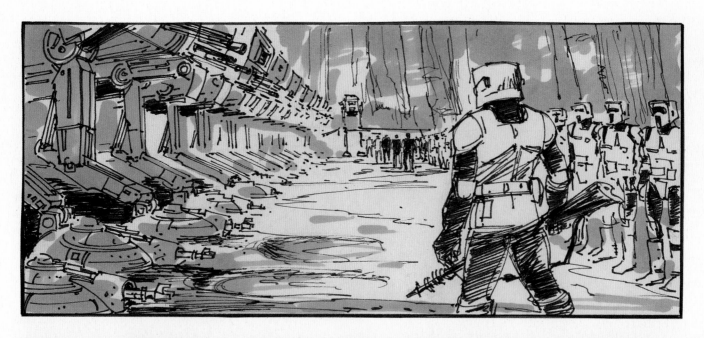

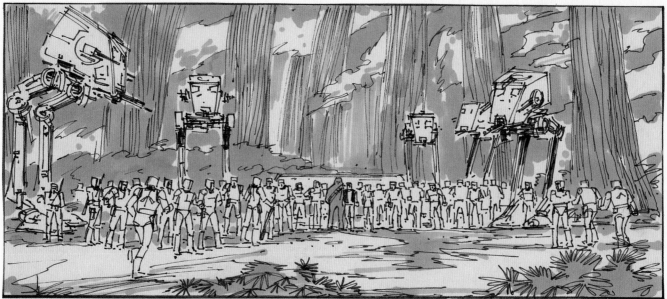

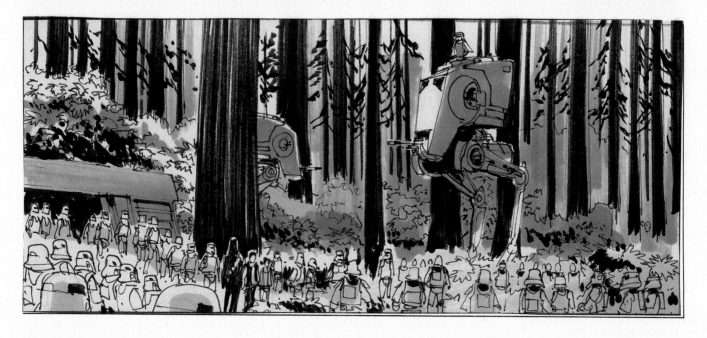

Han, Leia, Chewbacca, and the droids have walked into a trap as well: They are surrounded
on all sides by hundreds of stormtroopers and several chicken walkers. » Jenson, **R1:2**; Johnston, **R3**

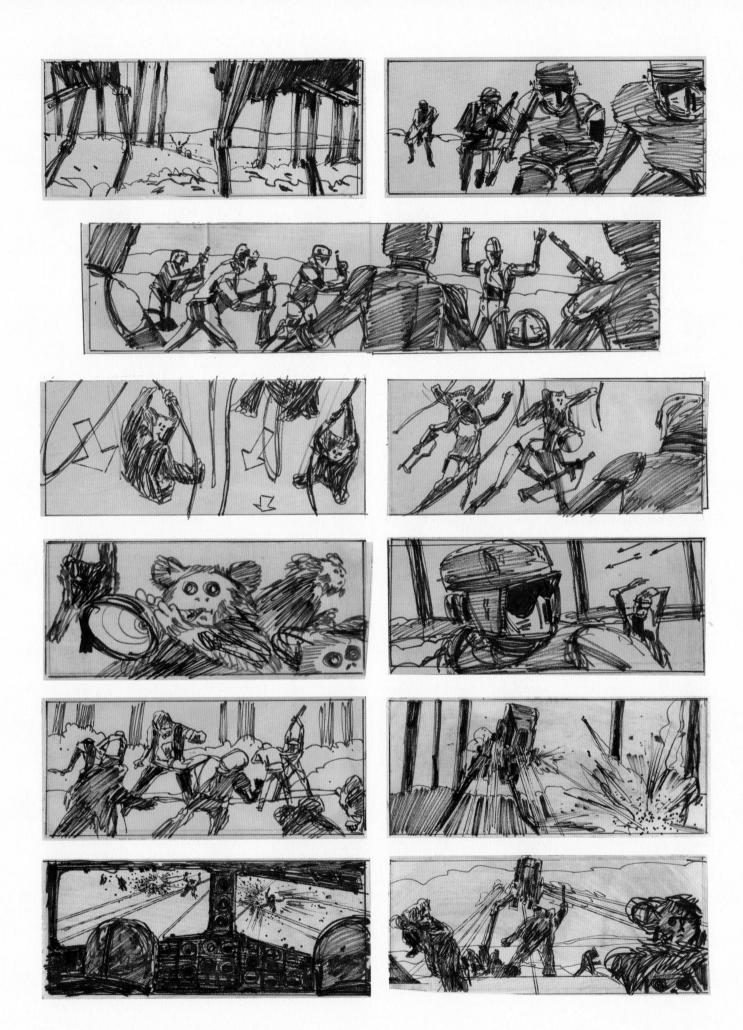

In very early storyboard sketches the Ewoks come to the rescue, sounding the alarm. » Brook Temple

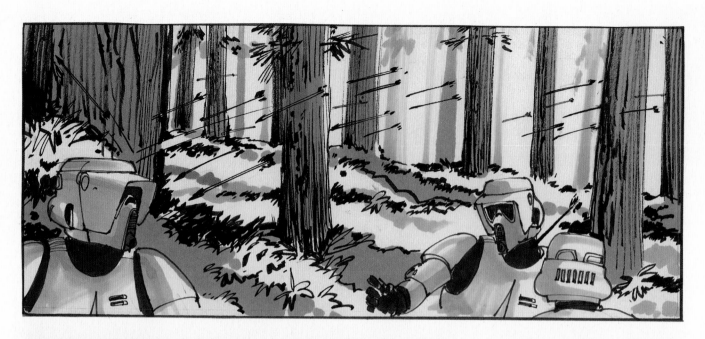

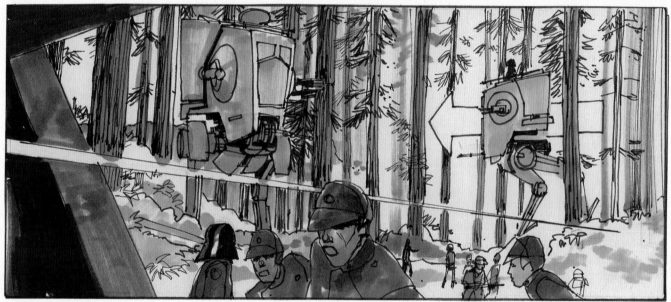

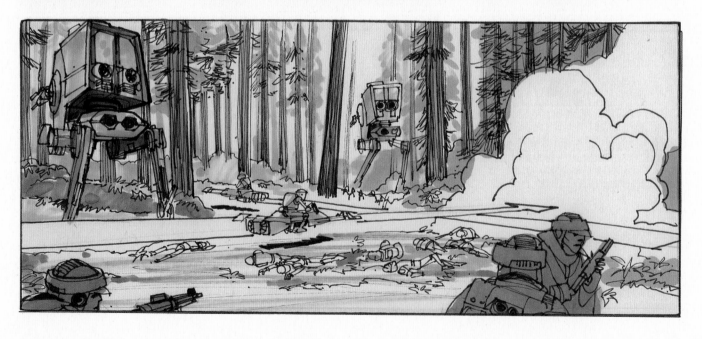

A biker scout is felled by an arrow [R1] as the battle rages between furry forest denizens and armored Imperials. » Rodis-Jamero

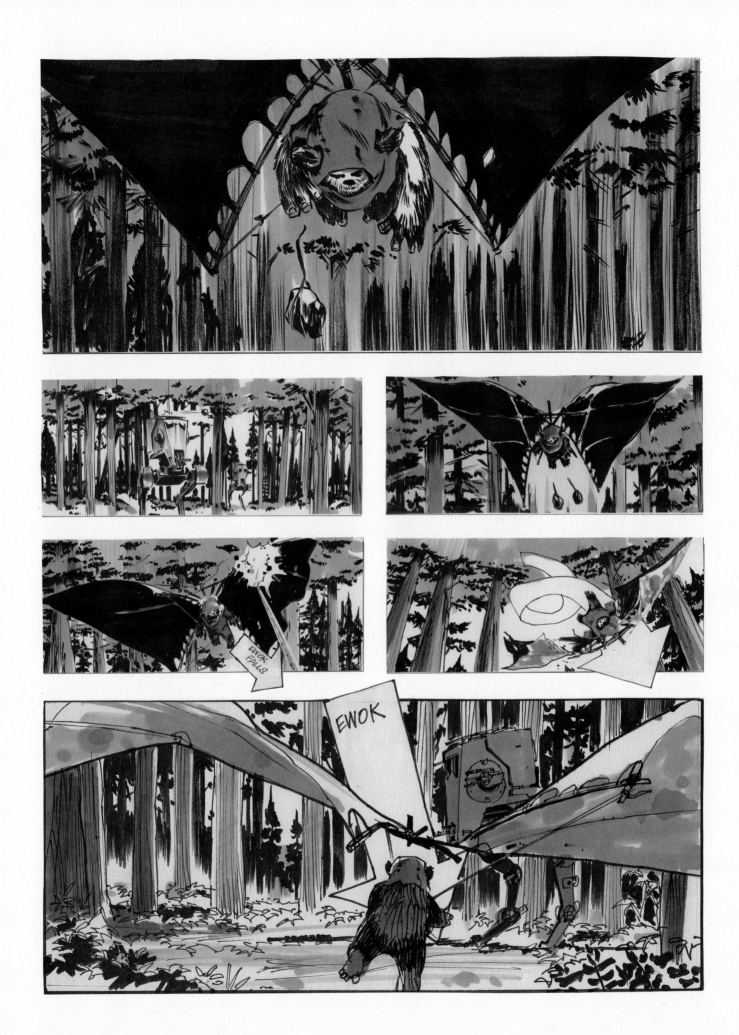

In an Ewok glider, Teebo drops rocks on a chicken walker but is shot down and has to make a crash landing. » Rodis-Jamero

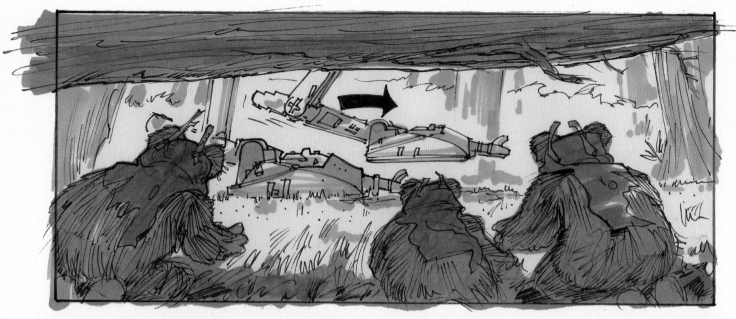

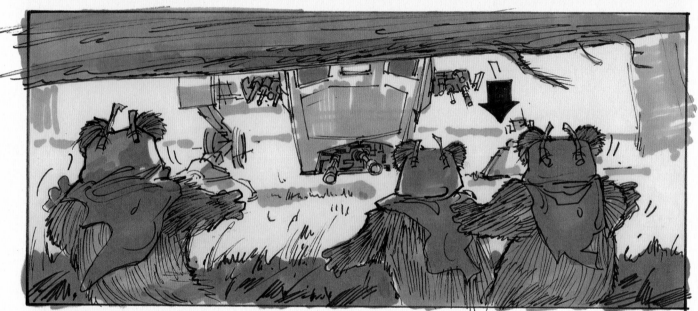

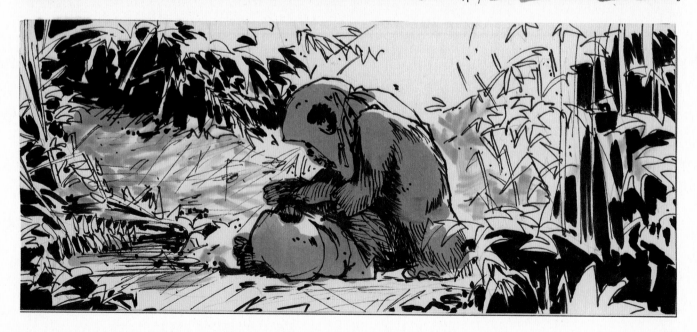

Ewoks in hiding are discovered by a chicken walker; one Ewok has been killed. » Jenson, **R1:2**; Rodis-Jamero, **R3**

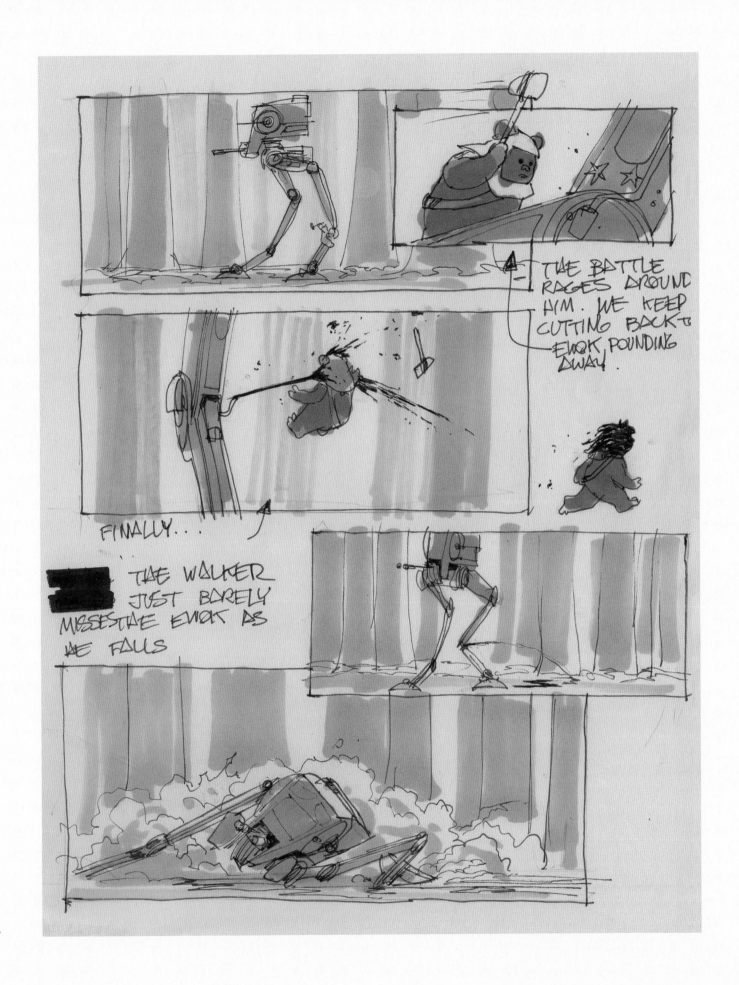

A lone Ewok succeeds in crippling a chicken walker—and then barely escapes being crushed. » Johnston

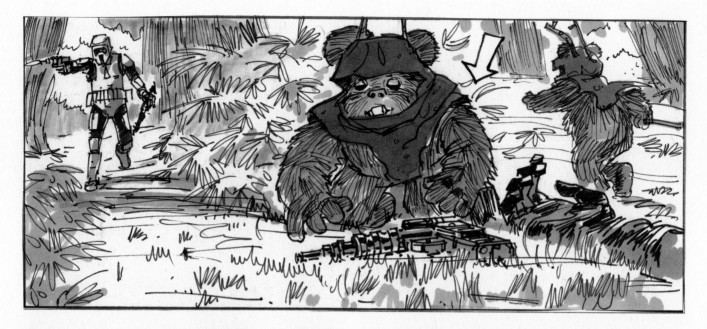

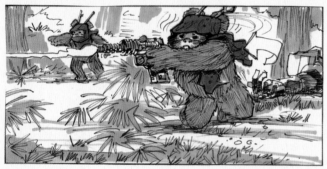

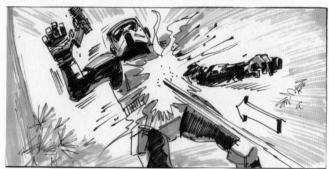

An Ewok uses a found blaster
to deadly effect. » Jenson

"*Everyone in the art department drew up various ideas about how Ewoks could combat
the Imperial troops. I think George Jenson held the record for page count.*"

Joe Johnston

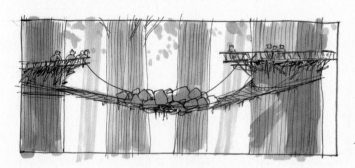

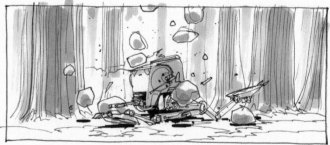

The storyboard artists pitched dozens and dozens of ground battle gags that weren't
ever filmed (only a few could be picked). Many are shown here, often for the first time.

Boulders are released onto a
chicken walker. » Johnston

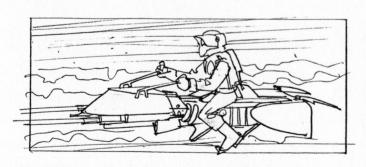

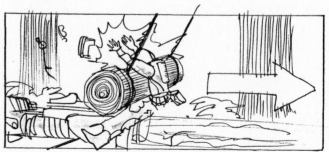

In a gag called "The Swinger," a log smacks a trooper off his bike. » Johnston

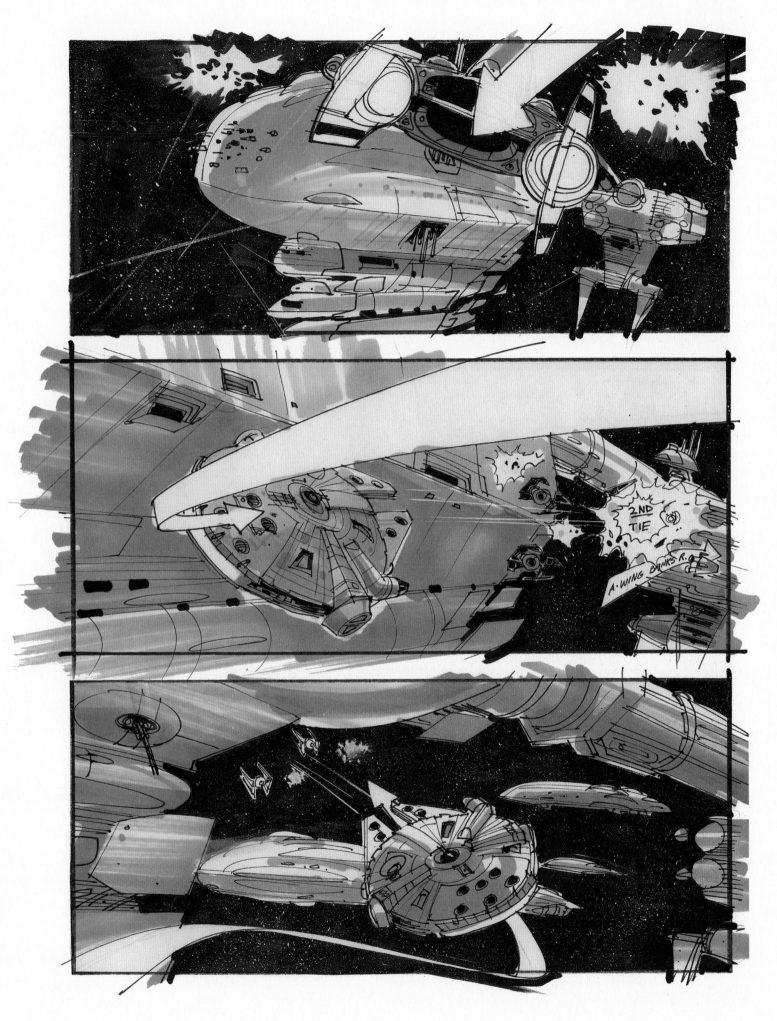

An A-wing and the *Falcon* take evasive action in the rebels' losing space battle. » Johnston

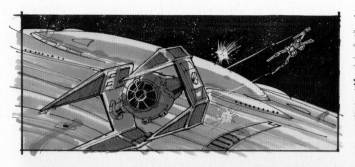
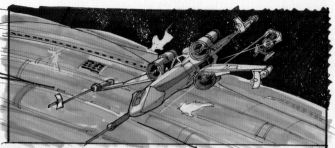
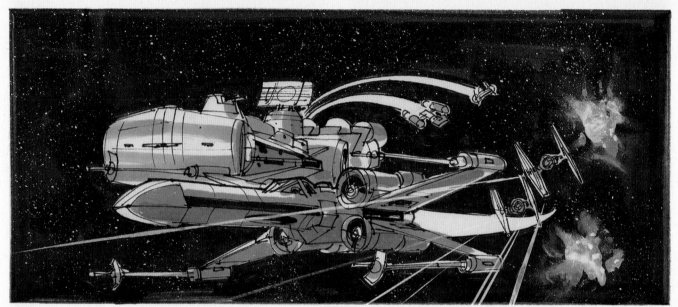
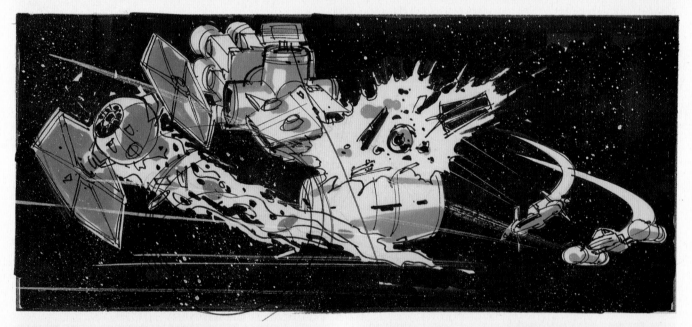
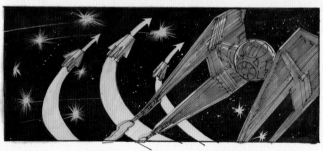
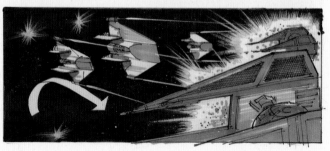

In ultra-fast-moving dogfights, A-wings and X-wings pick off
TIE fighters and Interceptors. » Johnston, **R1:3**; Artist unknown, **R4**

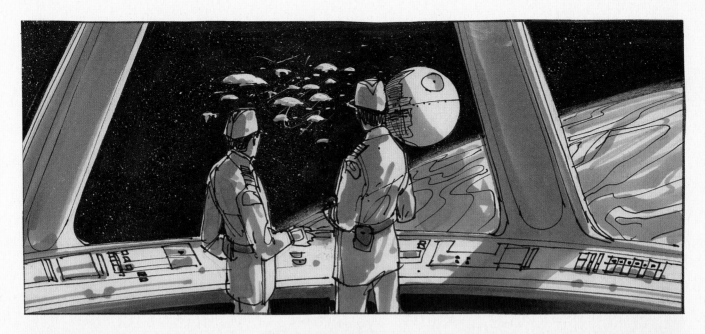

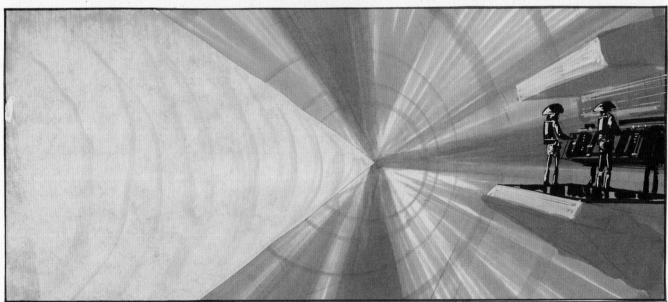

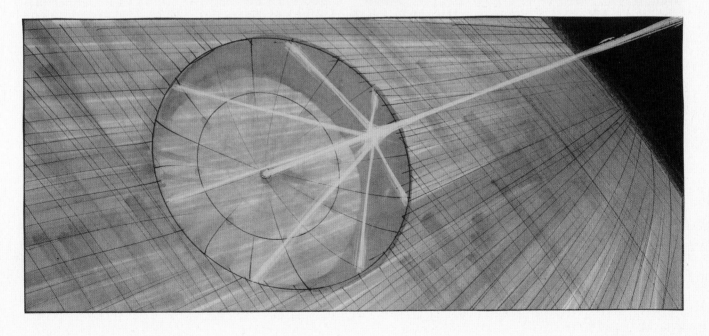

But, alas for the rebel fleet, this Death Star is . . . operational! And the order is given to fire. » Johnston

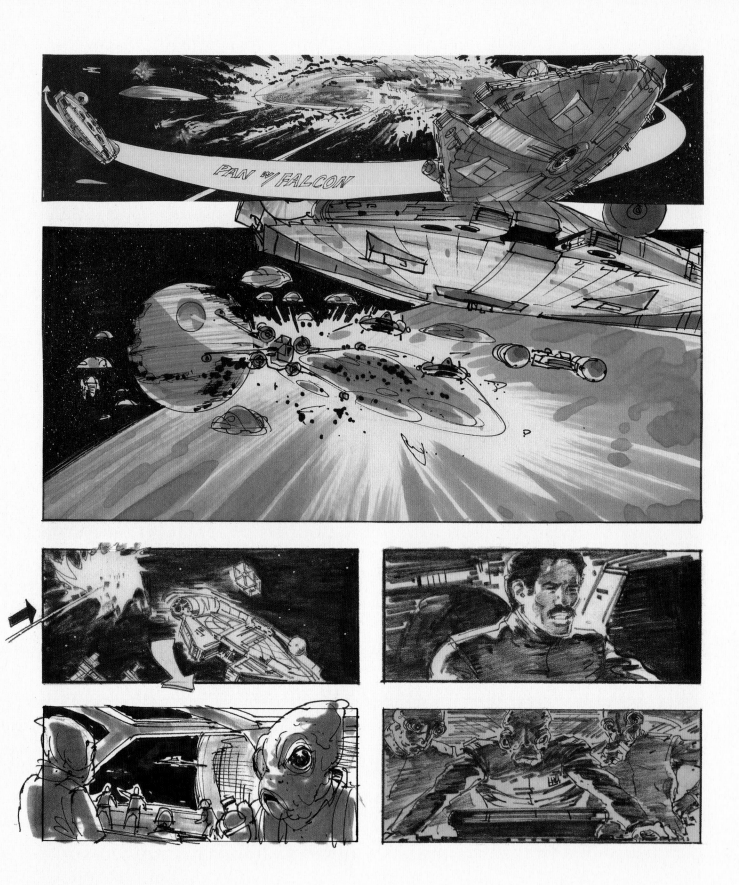

As a rebel cruiser is reduced to space dust, Ackbar orders a full retreat: "Code Red!" » Johnston, **R1:2**, **R4L**; Jenson, **R3**, **R4R**

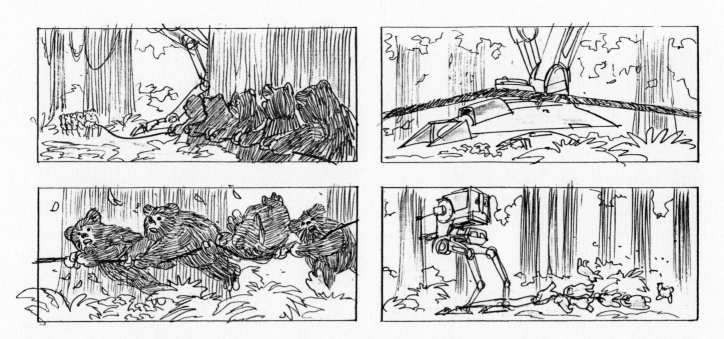

Several Ewoks are dragged along the ground when their attempt to trip up a walker doesn't go as planned. » Johnston

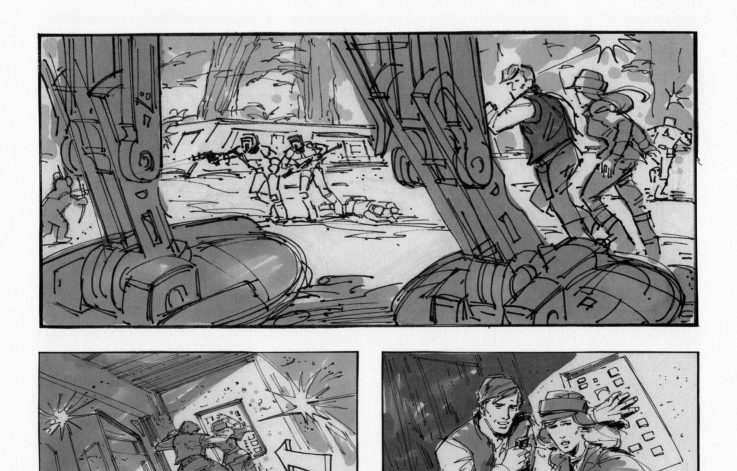

Under cover of the melee, Han and Leia run to the bunker door and call for their faithful astromech droid: R2-D2. » Jenson

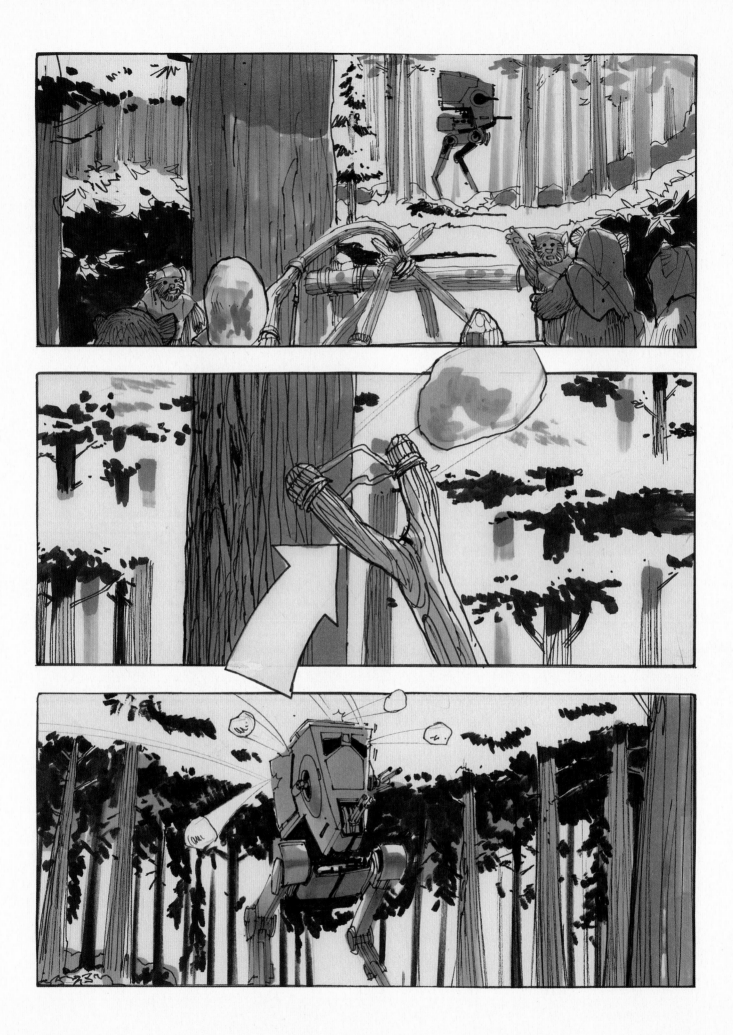

An Ewok catapult launches rocks, which bounce harmlessly off the chicken walker's armor. » Rodis-Jamero

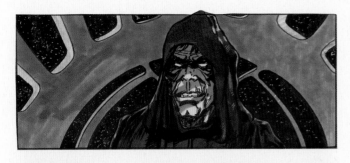
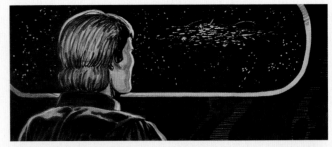
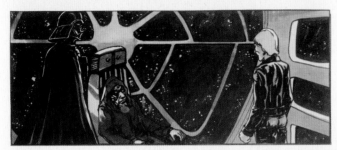
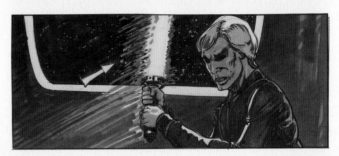
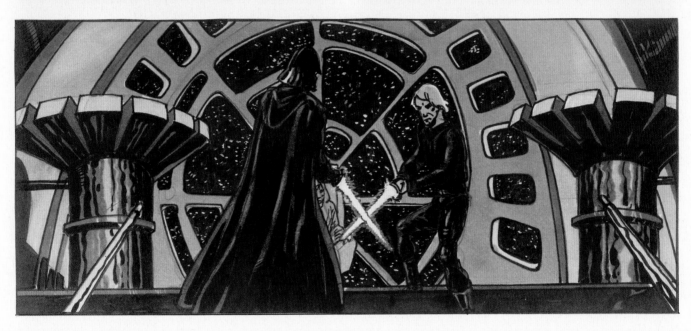

To help with the overload of storyboards Joe Johnston hired David Russell.

"It's hard to convey the joy I experienced on my first day of work. I felt like I'd just entered the Emerald City of Oz."

David Russell

In the Death Star's throne room, the Emperor taunts Luke—who then duels with his father, Darth Vader. » Russell

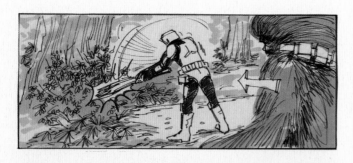
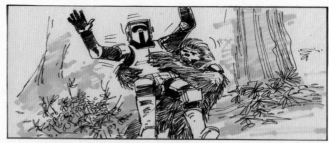
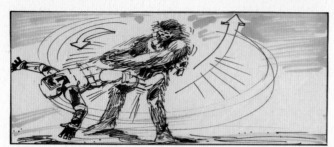
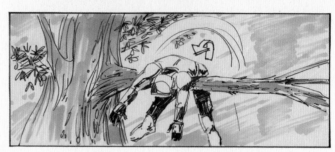
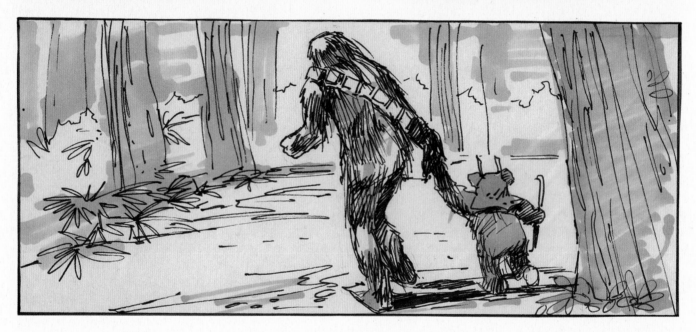

When a stormtrooper is terrorizing a lone Ewok, Chewbacca takes him by a leg, twirls him around, and tosses him into a tree. » Jenson

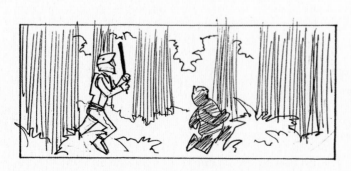
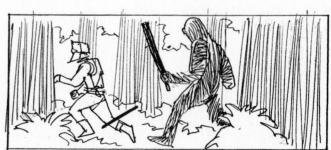

In a vaudeville-style gag, a stormtrooper runs after an Ewok, and then a Wookie runs after a stormtrooper. » Johnston

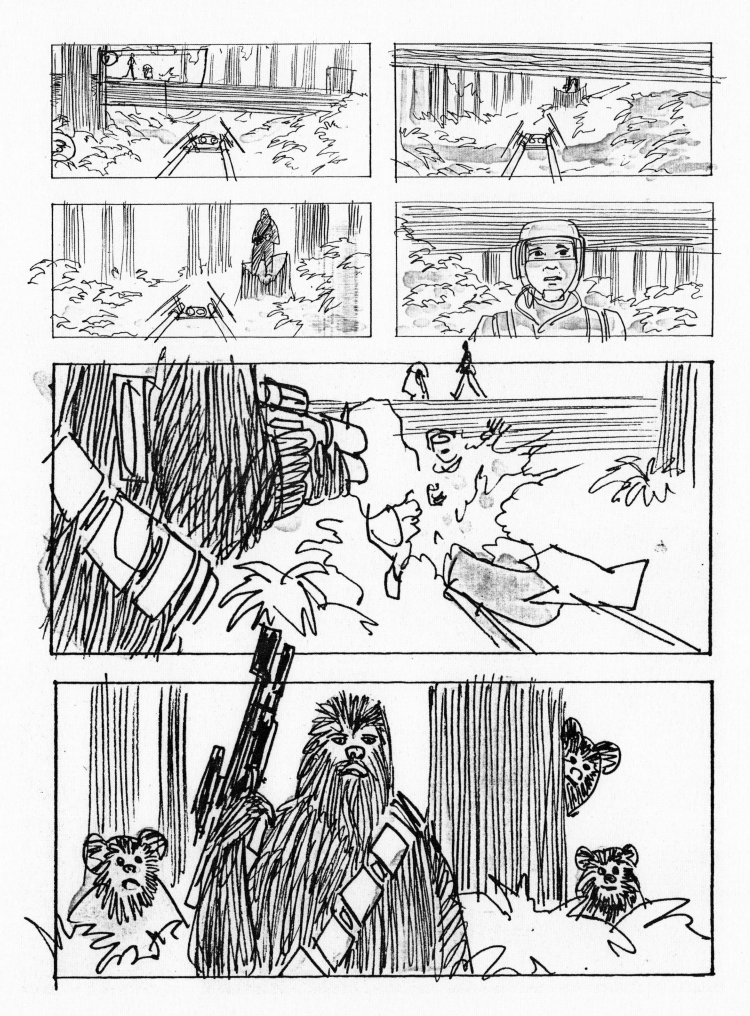

As the droids make their way to the bunker door, a biker scout is dispatched by Chewbacca. The scout's last words: "Now that's a big Ewok." » Johnston

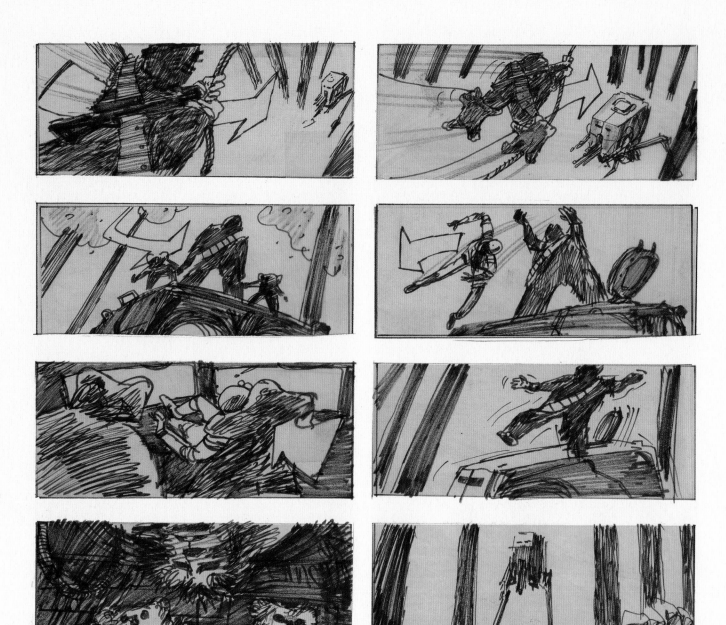

"The work itself was challenging, lots of pressure because I was hired in the middle of production. They needed speed and facility. I was under the gun because they were under the gun from the producer. I was forced at this point in production to get up to speed with technology, character, everything that was new to me. I was locked in a room with Joe and several other sketch artists, as the work we were doing was secret from everyone else. Every other day, Lucas would check, in person, on progress..."

Brook Temple

An early iteration of Chewbacca's swing to the top of a chicken walker. His companions take the controls . . . » Temple

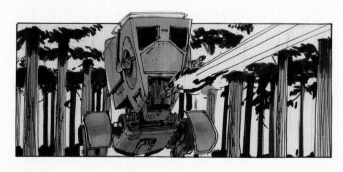

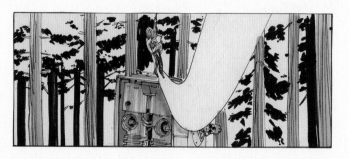

Later storyboards depict Chewbacca's Tarzan-like swing from a different angle. » Rodis-Jamero

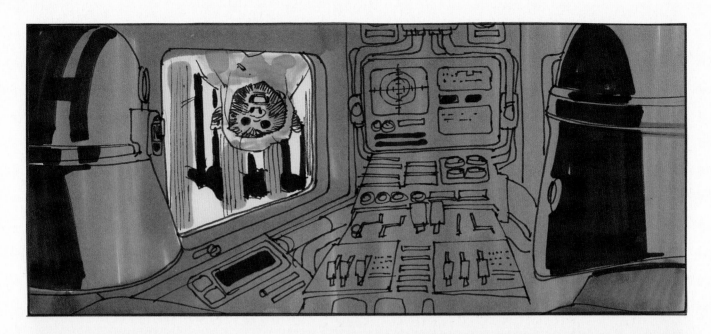

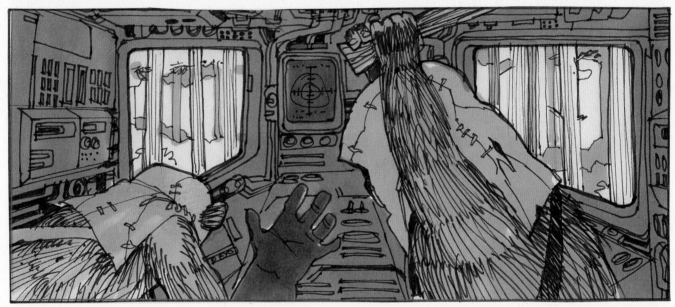

Wicket and Teebo knock the drivers senseless. » Rodis-Jamero

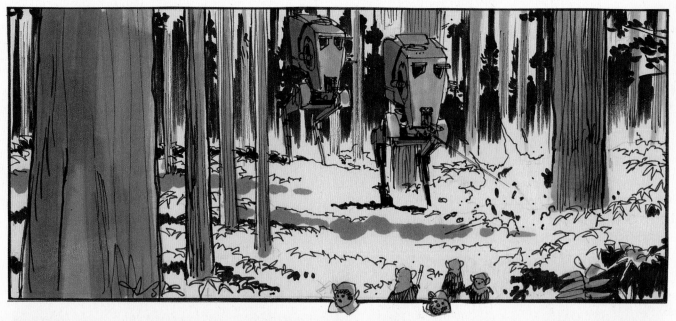

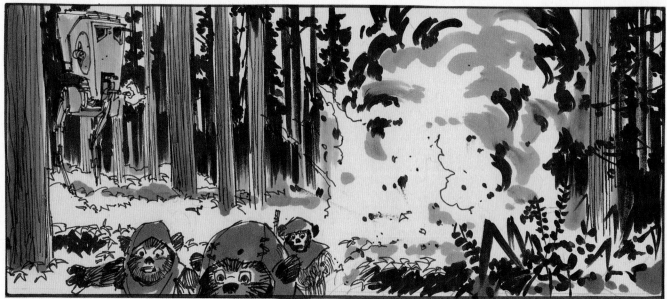

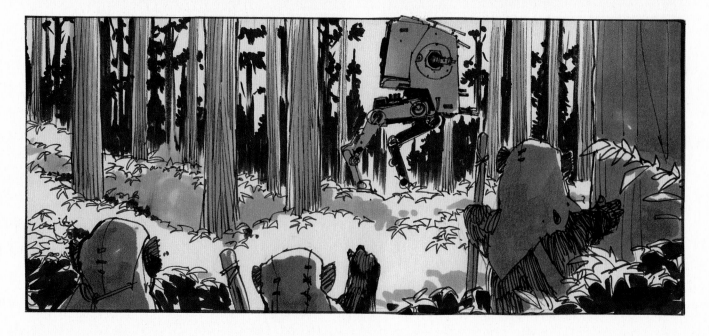

With Chewie at the controls, his chicken walker obliterates an enemy chicken walker. » Rodis-Jamero

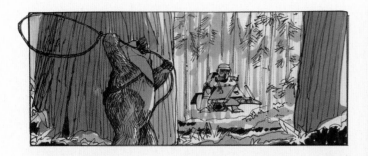

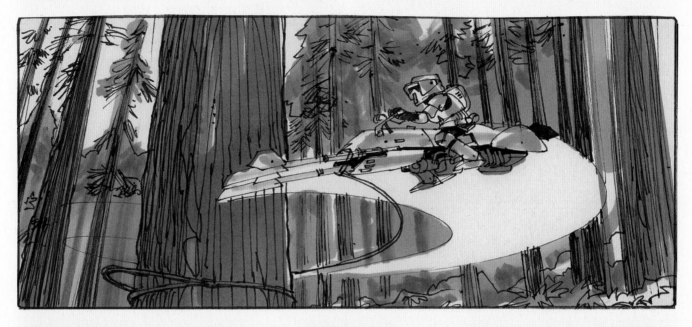
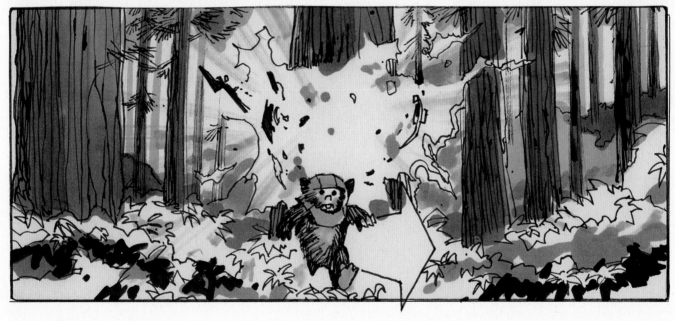

The tide of battle turns and the Ewoks ambush another biker scout. » Rodis-Jamero

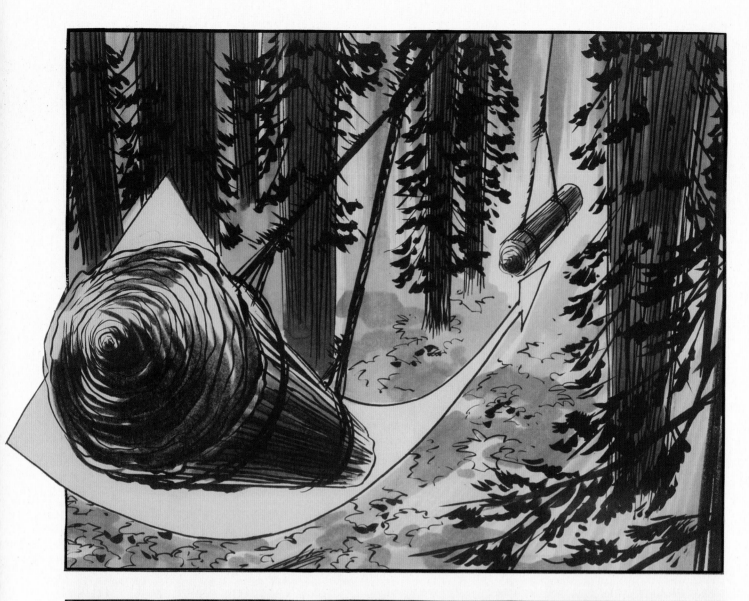

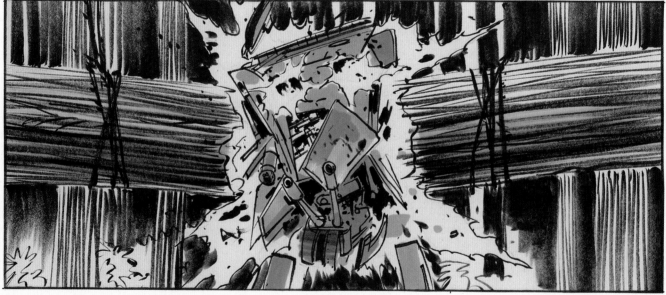

Another Ewok ploy utilizes two massive tree trunks to crushing effect. » Johnston

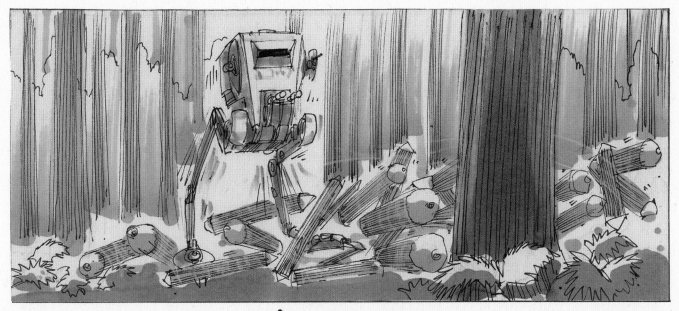

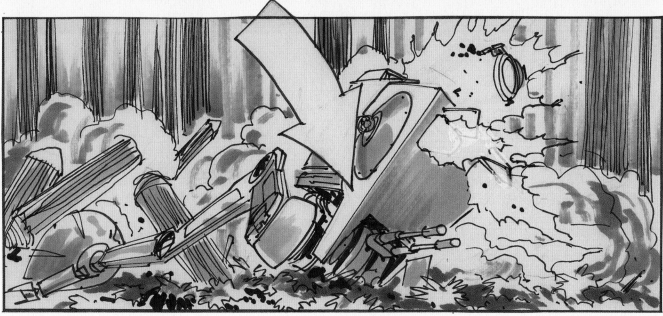

Tumbling logs trip up another walker. » Johnston

A note on a storyboard [R2] reads: "Explosion is not a nuke; should be gaseous explosion coming out of eyes and nose."

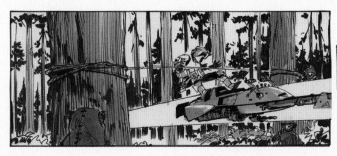

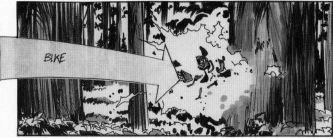

BIKE

A well-placed vine clotheslines another biker scout. » Rodis-Jamero

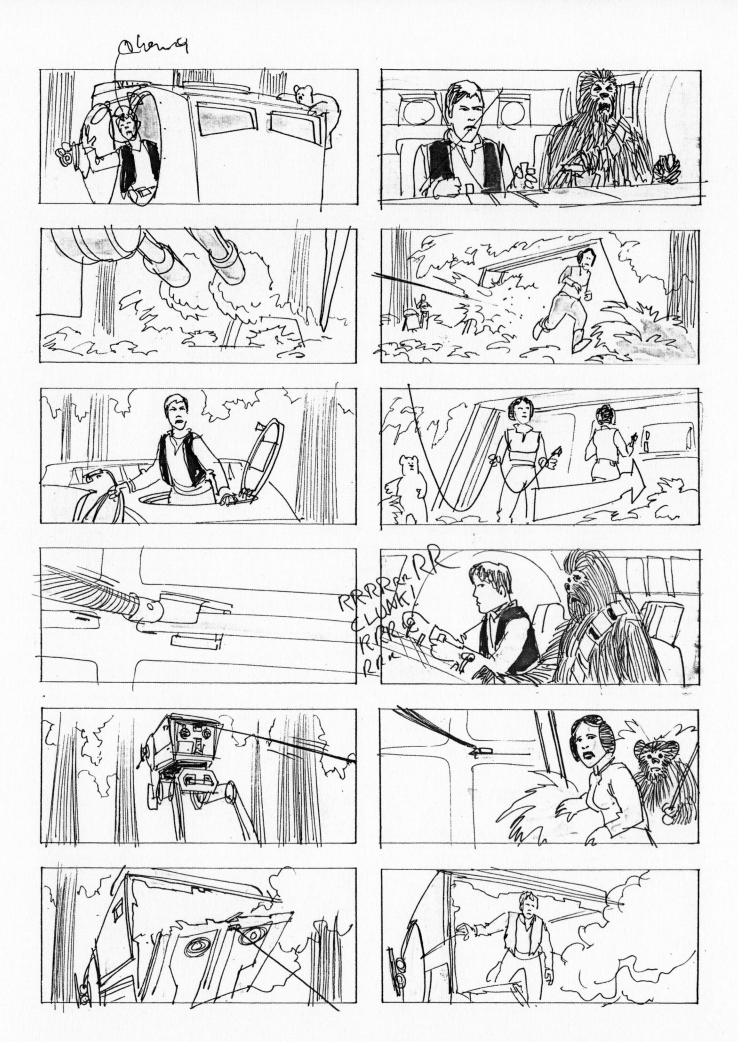

As in early script drafts, Solo takes the hijacked vehicle and attempts to use it to pull off the bunker door—instead ripping off the back of the chicken walker. » Johnston

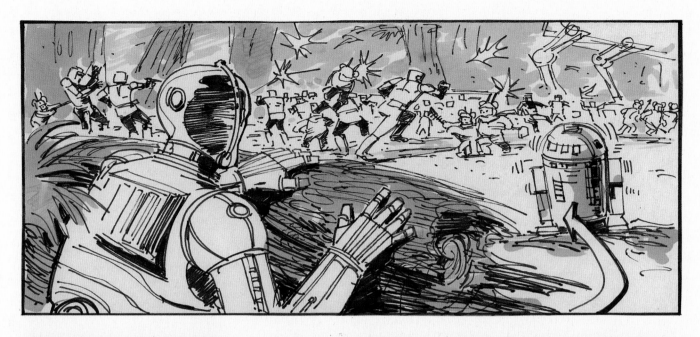

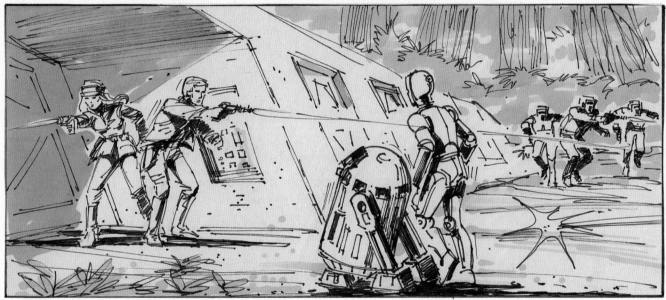

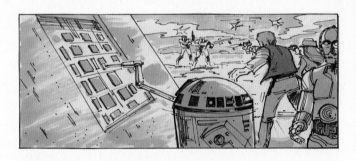

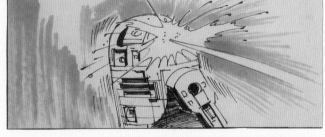

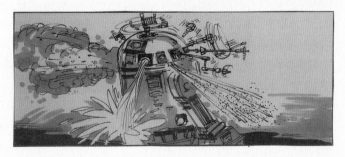

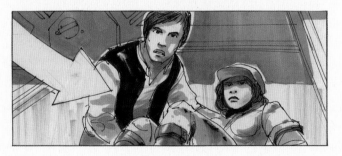

C-3PO and R2-D2 arrive at the bunker, but when the latter tries to open the bunker door, he is hit by a stray bolt—and so is Leia. » Jenson, **R1:3**, **R4L**; Johnston, **R4R**

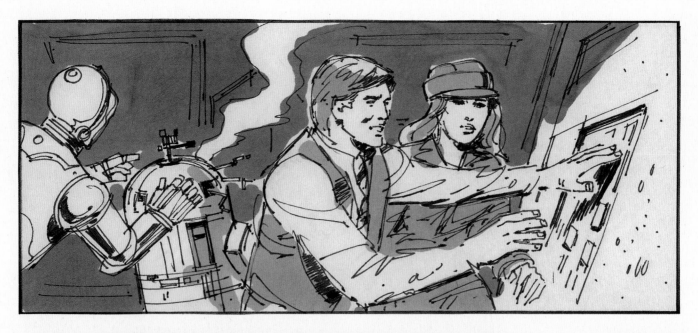

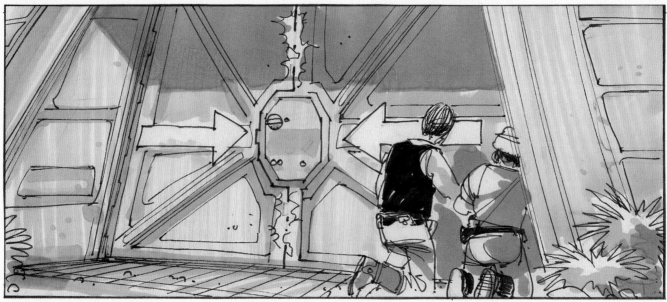

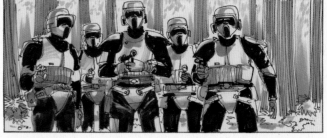

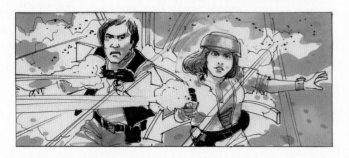

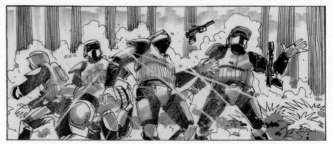

Han tries to hot-wire the door—instead closing a second door. However, when troopers arrive, he and Leia gun them down. » Jenson, **R1**; Johnston, **R2:4**

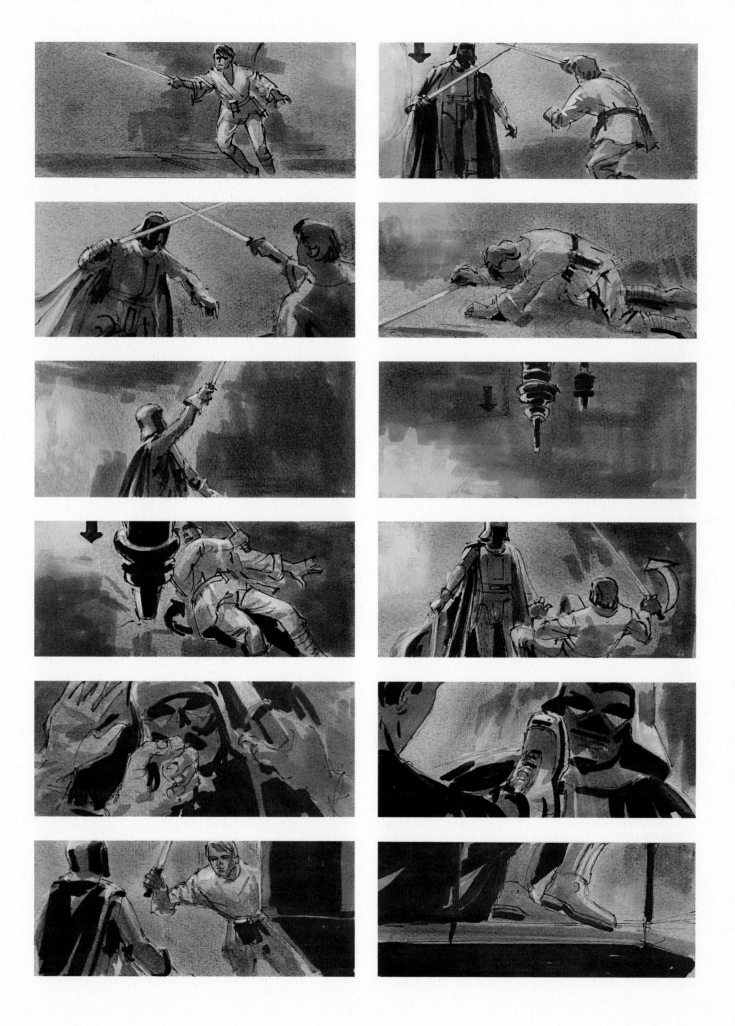

Meanwhile Luke and Darth Vader continue their duel, with a karate sequence. » Carnon

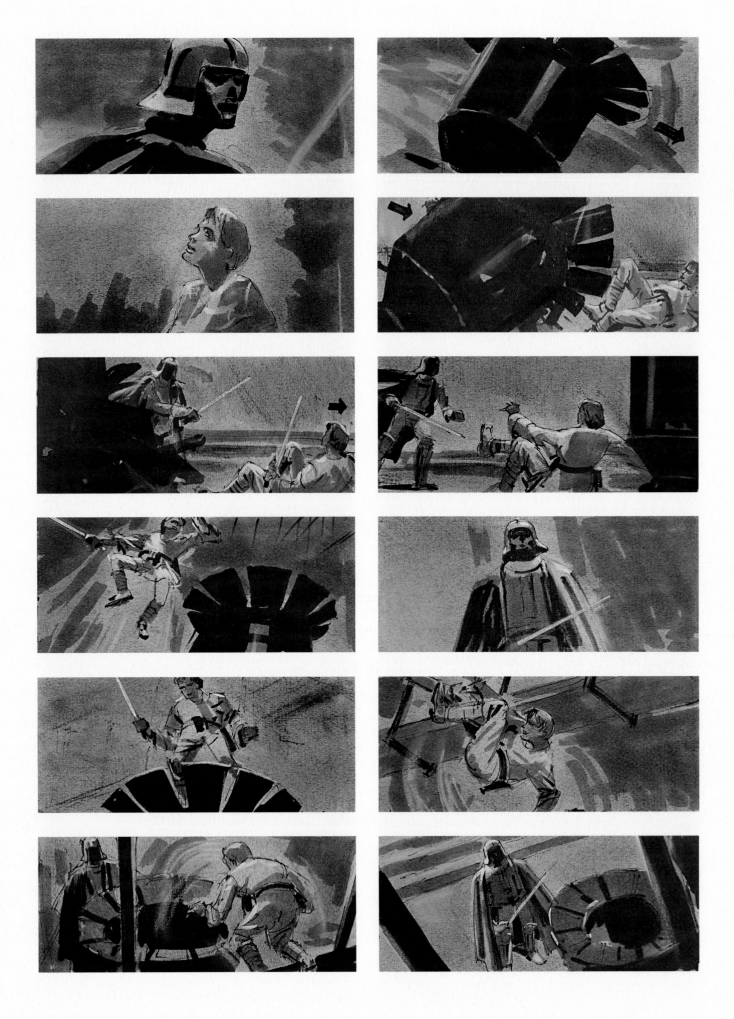

Avoiding one pod, Luke somersaults from another pod up to the gantry. » Carnon

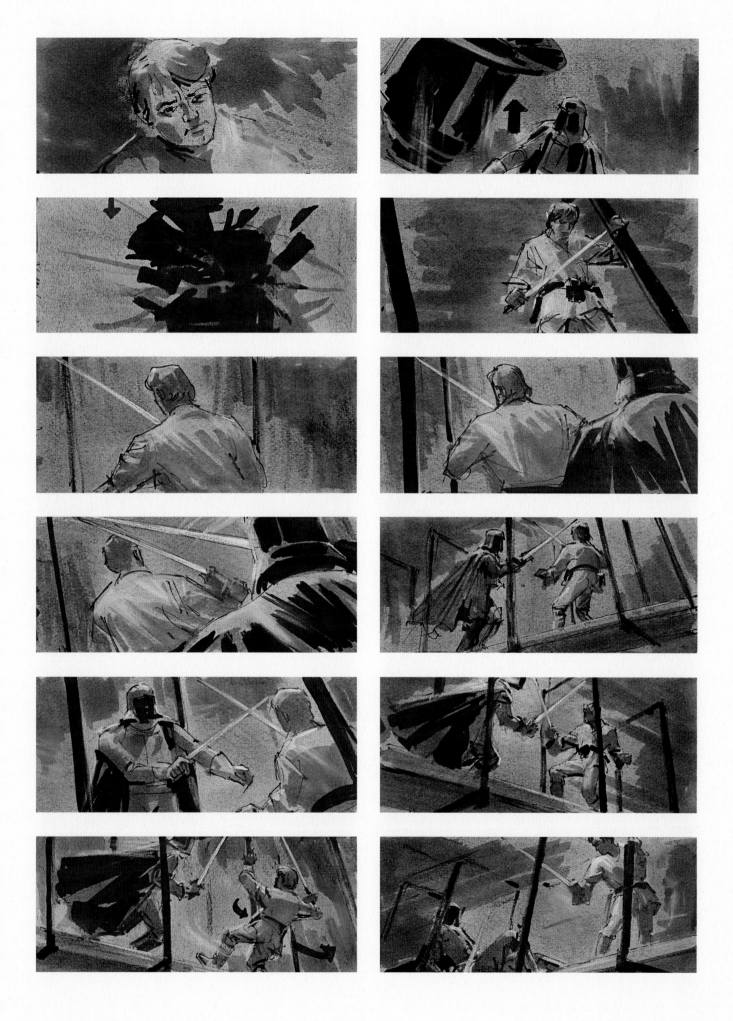

Luke parries a blow from behind and renews his attack on Vader. » Carnon

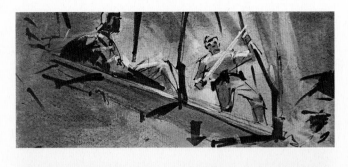
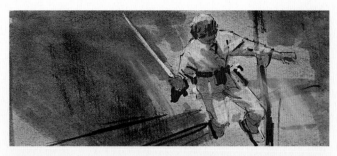
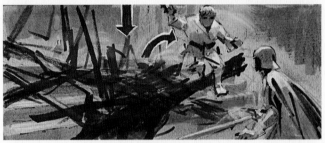
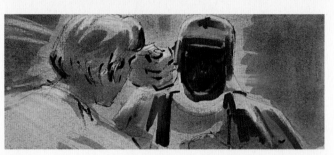
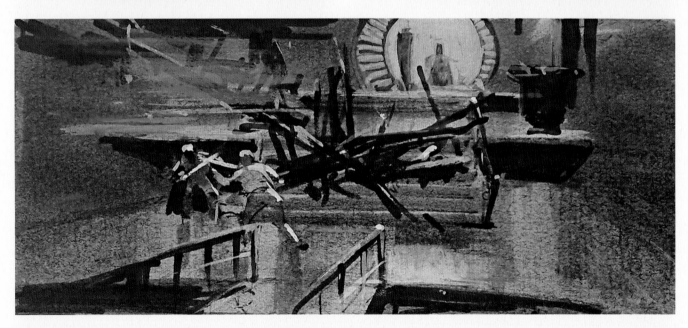
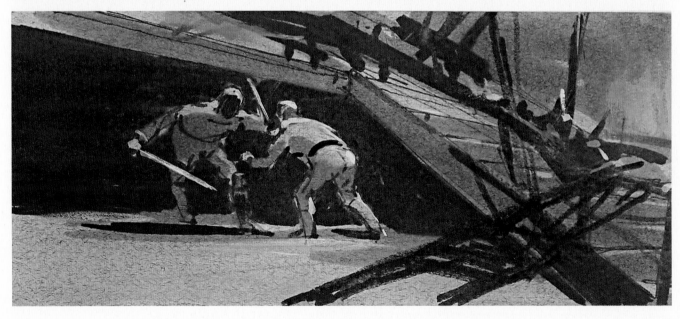

Luke cuts its "ties" and the gantry crashes to the ground. » Carnon

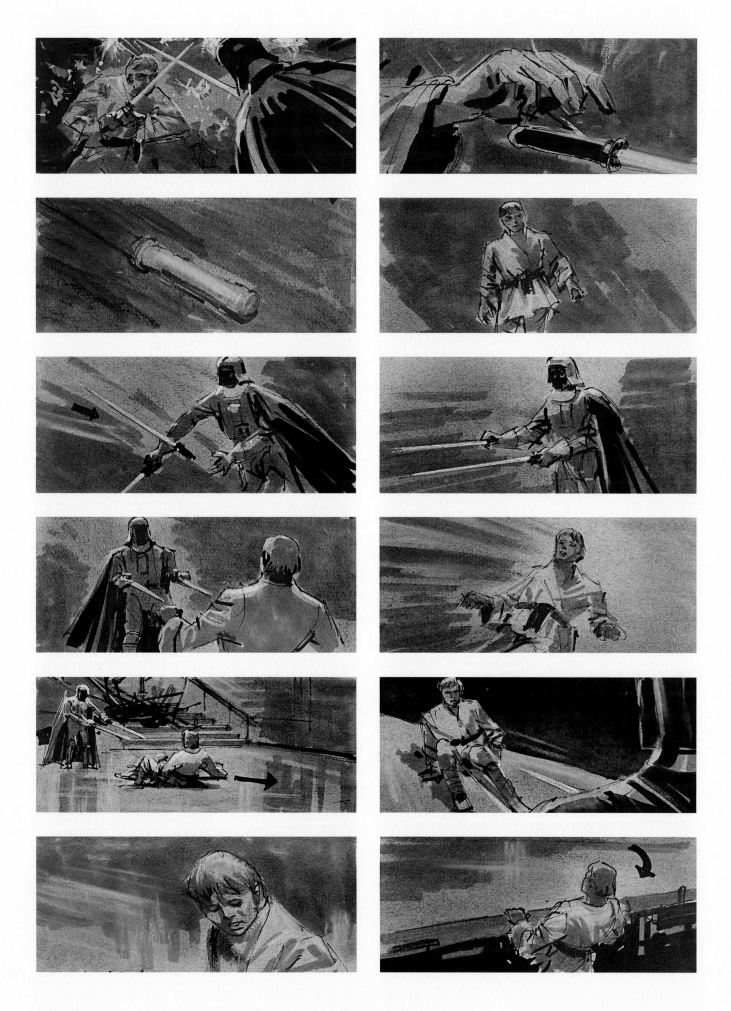

The lightsabers create painful sparks when they slash the walls in a restricted space; when a spark hits Luke's hand, he drops his saber—which Vader summons. » Carnon

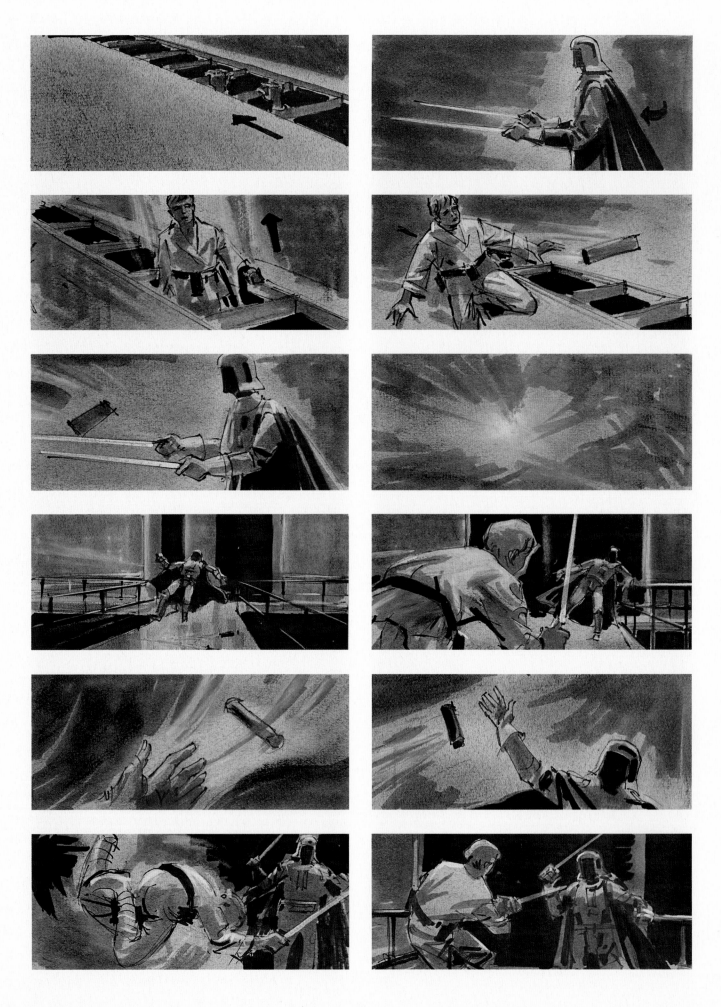

Luke throws a metal block that, when it hits the two sabers, temporarily short-circuits them; Luke recuperates his lightsaber. » Carnon

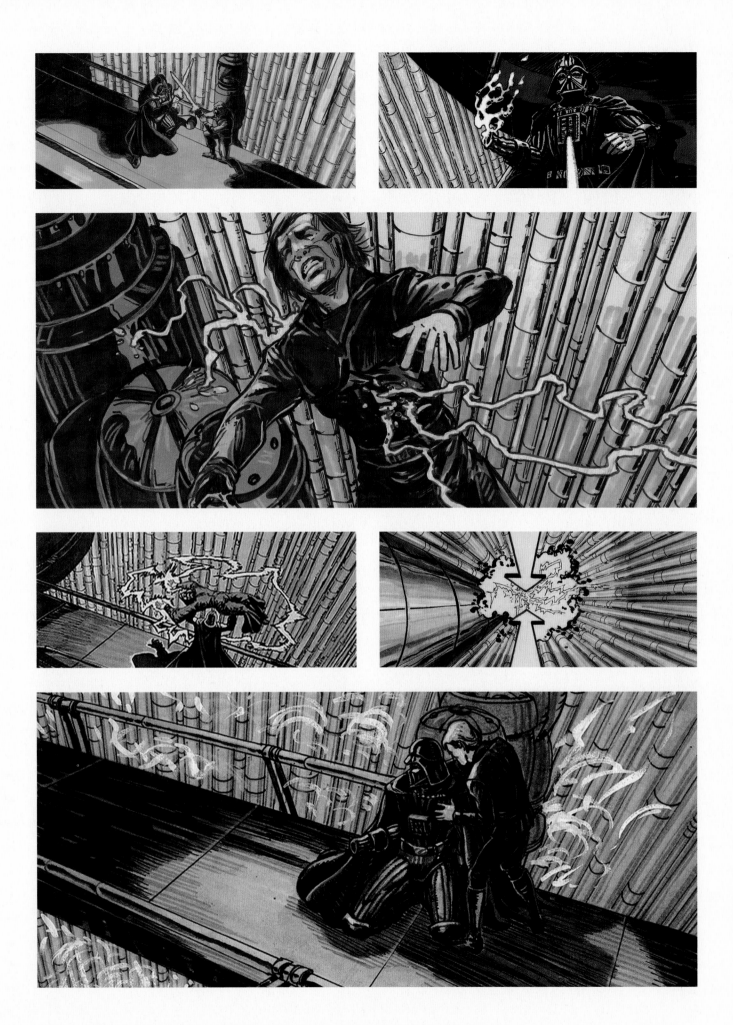

Luke cuts off his father's hand—but then the Emperor attacks with his vicious "bolts." Vader realizes
that his son will be killed—and hurls the Emperor in the "Pit of Death." » Russell

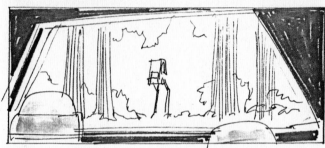

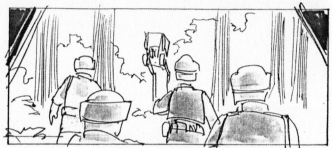

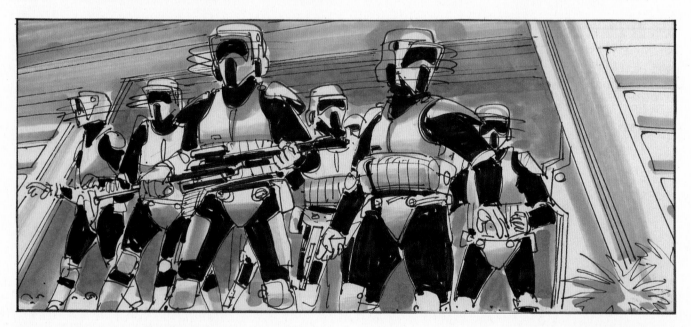

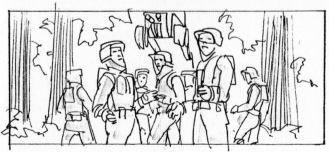

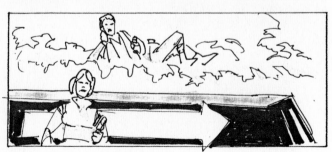

Han tricks the Imperials into opening the bunker door. » Johnston

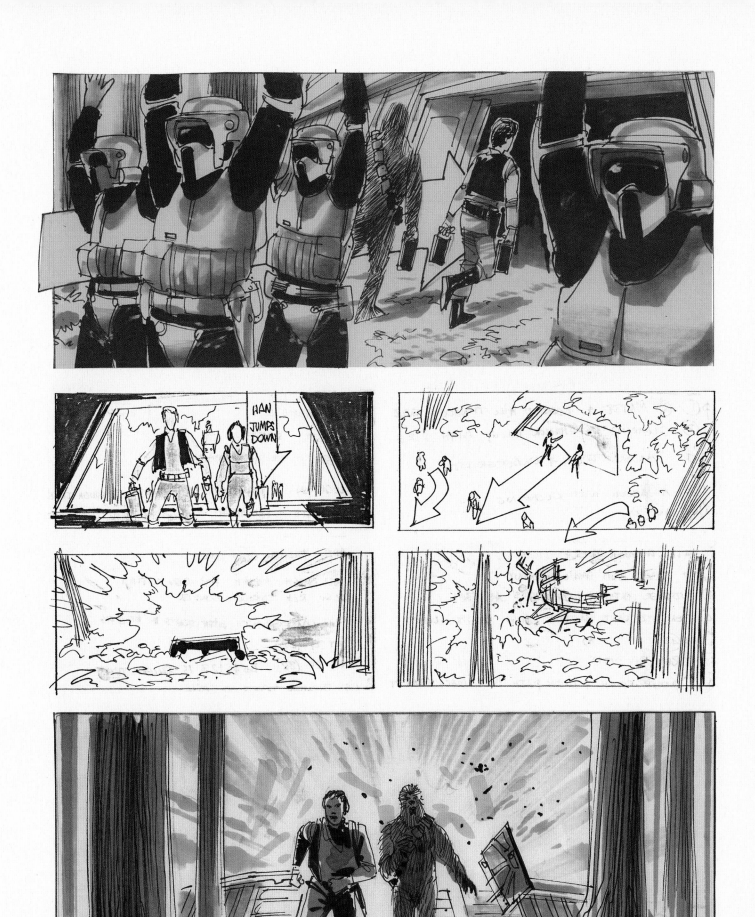

Han and Leia place explosives inside the bunker and then everyone runs for cover as it explodes. » Johnston

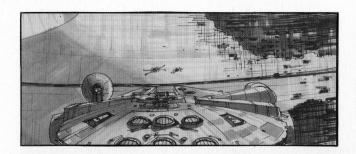

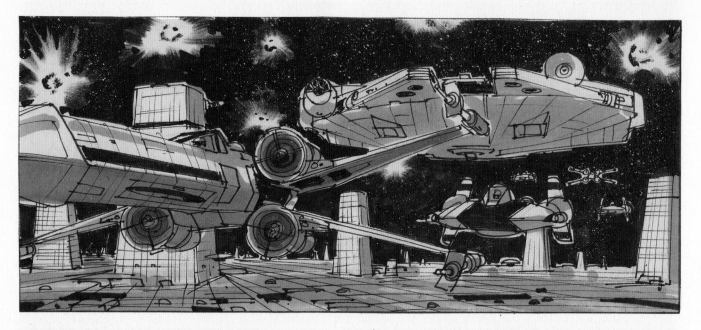
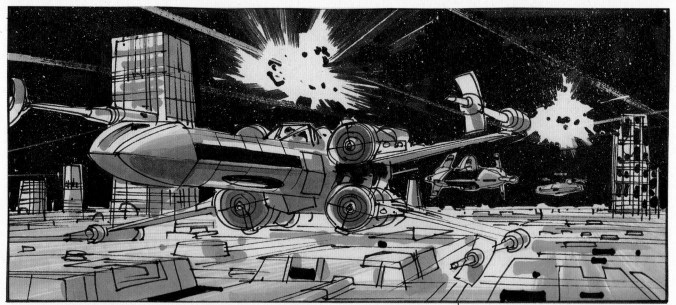
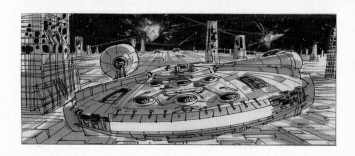
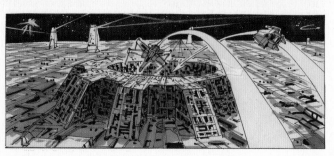

With the shield down, an X-wing and an A-wing lead the *Falcon* into the Death Star interior. » Johnston, **R1:3**, **R4L**; Carson, **R4R**

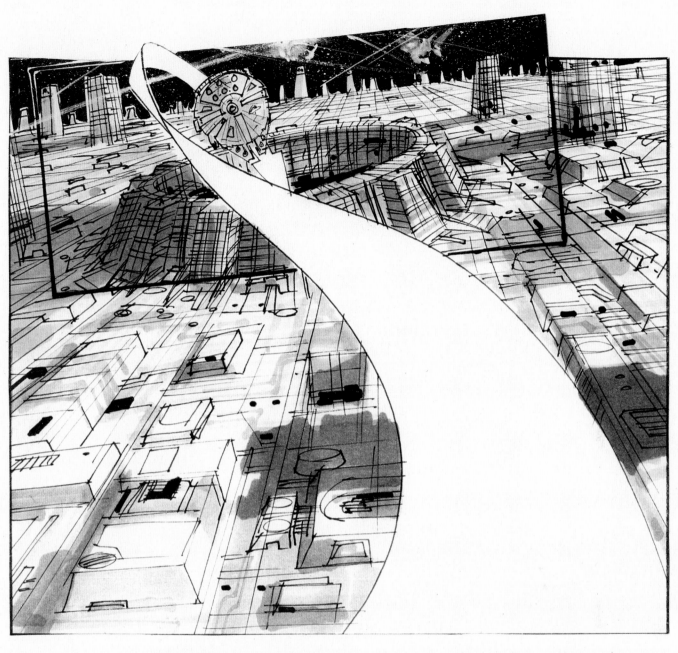

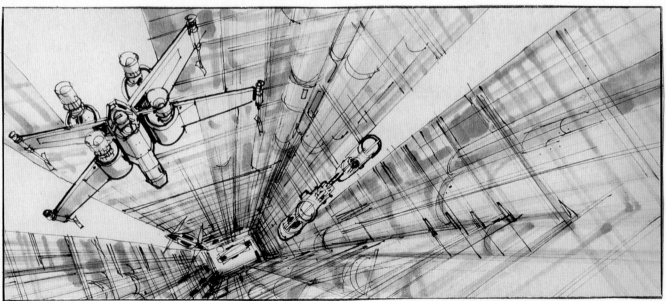

The *Falcon* leads the rebels into "Tunnel #1." » Johnston, **R1**; Rodis-Jamero, **R2**

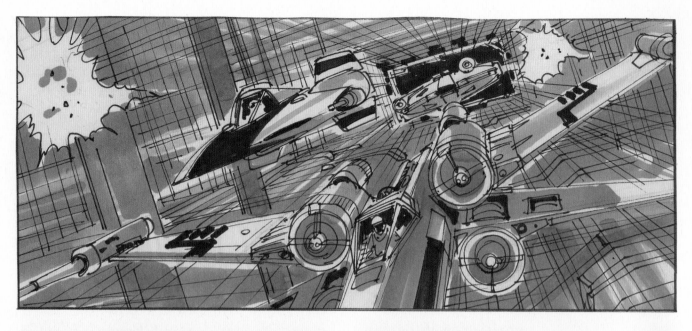

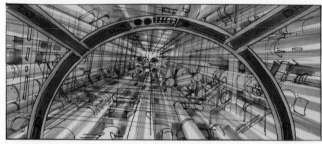

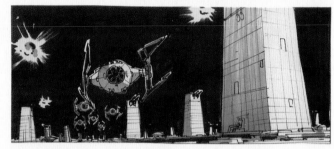

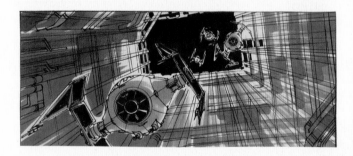

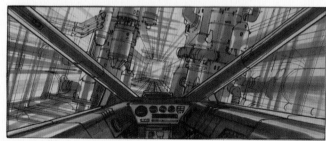

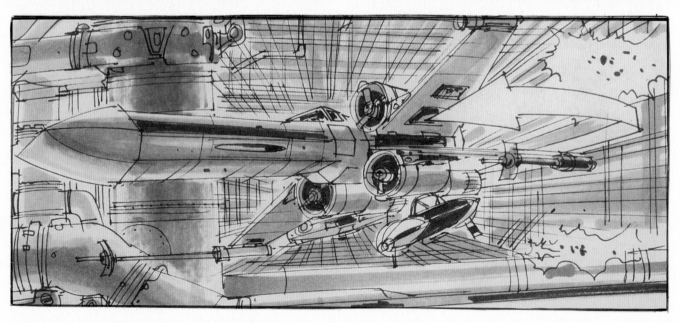

TIE Interceptors follow the rebel craft into the cramped, narrow tunnel. » Johnston, **R1**, **R4**; Rodis-Jamero, **R2:3**

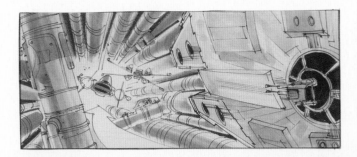

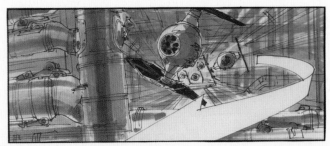

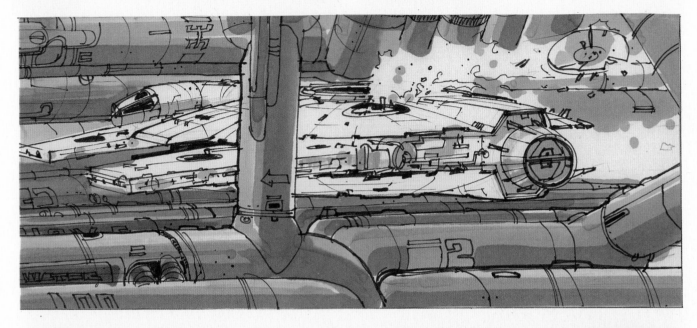

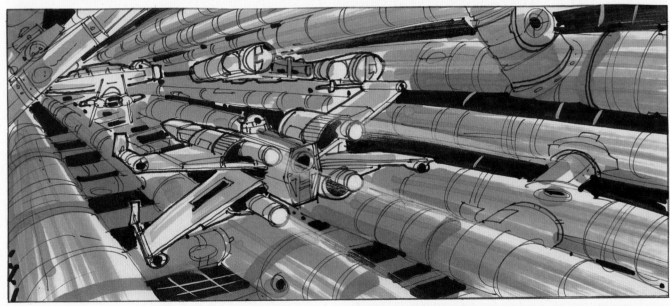

"Early on, Joe asked me to do some sketches showing what it might look like with X-wings flying inside the Death Star. I pictured the construction being girders and I-beams, with large beams in the foreground and lots of under-construction beams in the background. I had a hard time trying to get all those beams drawn without it taking forever."

Dave Carson

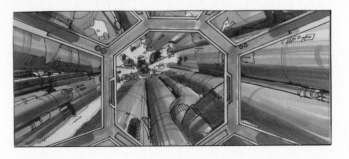

The fighters enter "Tunnel #2," which is even more cramped; a TIE fighter ricochets against the walls and disintegrates, but another TIE pilot blasts an X-wing. » Johnston, **R1**; Rodis-Jamero, **R2**, **R4R**; Carson, **R3**

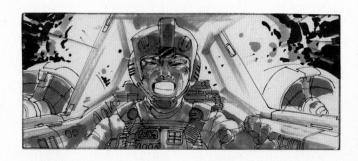

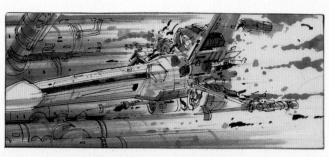

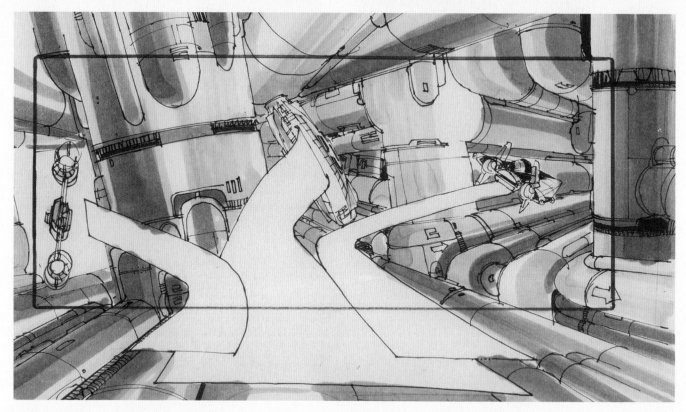

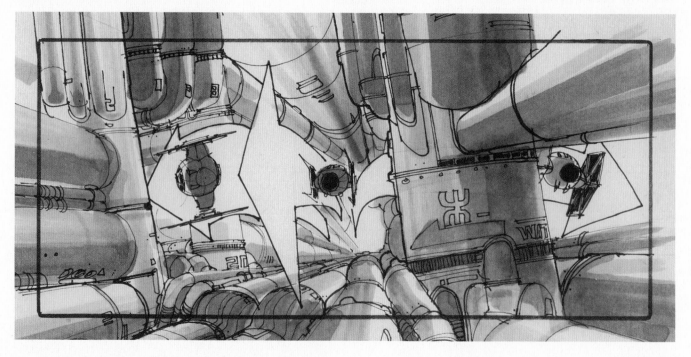

"The sign that looks like a spider along the pipes [R3] is actually a Hong Kong subway sign." **Nilo Rodis-Jamero**

An X-wing pilot screams as his craft bursts into flames. Then each rebel craft takes a different branching tunnel, hotly pursued by the TIEs. » Rodis-Jamero

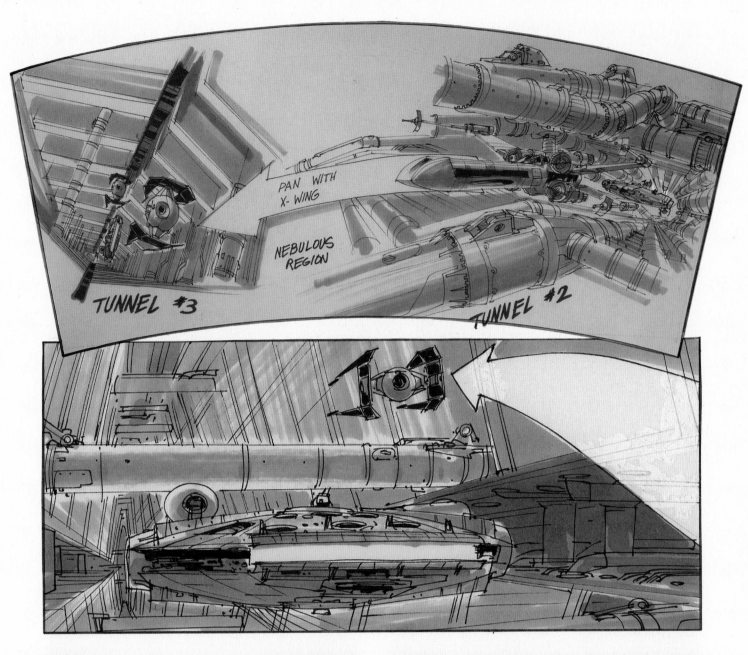

Inside the illustration: PAN WITH X-WING · NEBULOUS REGION · TUNNEL #3 · TUNNEL #2

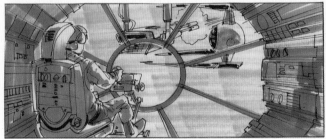

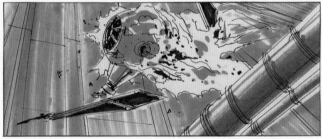

"*Nothing I did quite captured the look I had in my mind. When I turned over my boards to Joe, he studied them—and then he drew the sequence using pipes instead of girders. Of course, it was significantly better. They were easier to draw, easier to tell what you were looking at, and much easier for the Model Shop to build.*"

Dave Carson

The *Falcon* soars into "Tunnel #3"; when an Interceptor tries to overtake it, a gunner blasts it to pieces. » Johnston

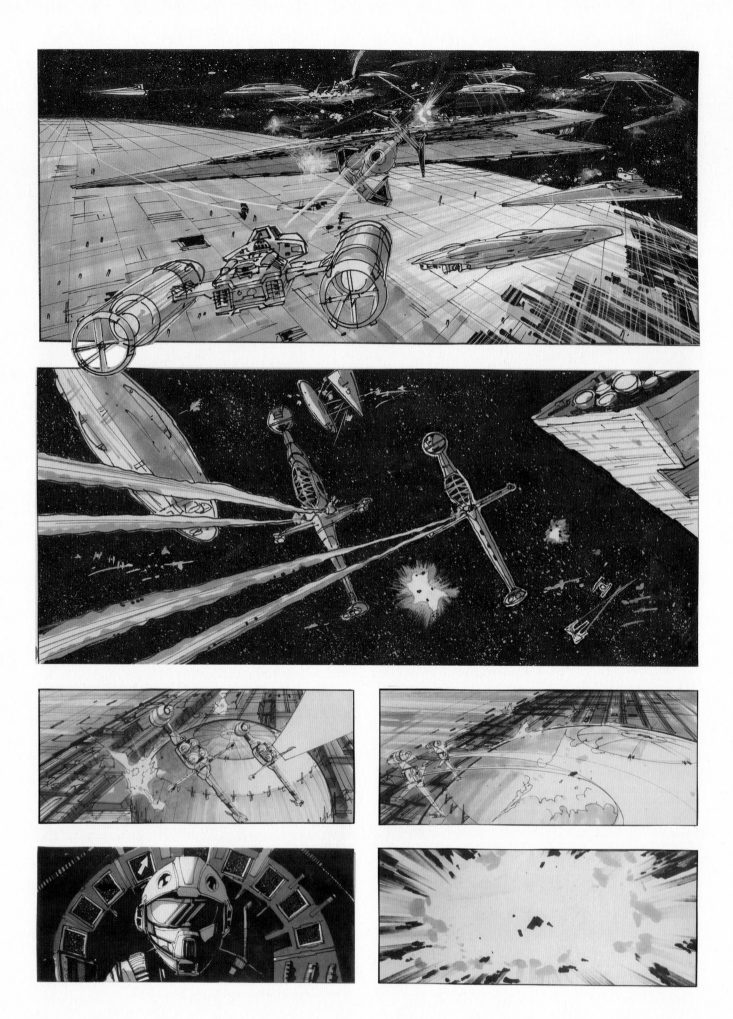

Meanwhile rebel fighters swarm around Vader's Super Star Destroyer; two B-wings fire "torpedoes" and obliterate its dome. » Johnston, **R1**; Artist unknown, **R4L**; Carson, **R2**; Rodis-Jamero, **R3**, **R4R**

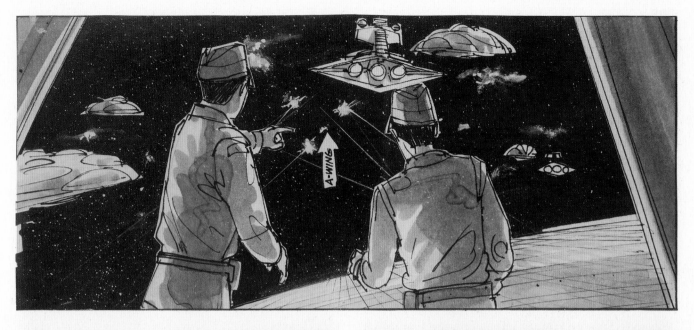

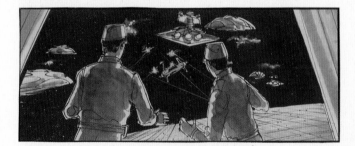

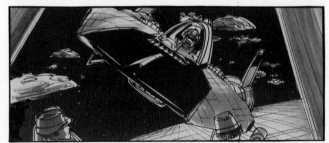

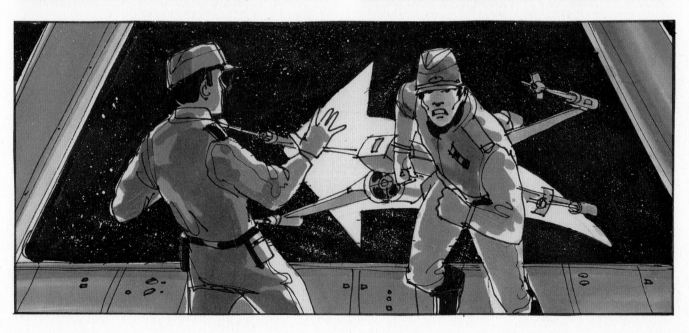

In a crippled ship (at first an X-wing and then an A-wing) rebel pilot "Mad Maxx" targets
the conning tower of Vader's ship, much to the horror of its officers. » Rodis-Jamero, **R1**, **R3**; Johnston, **R2**, **R4**

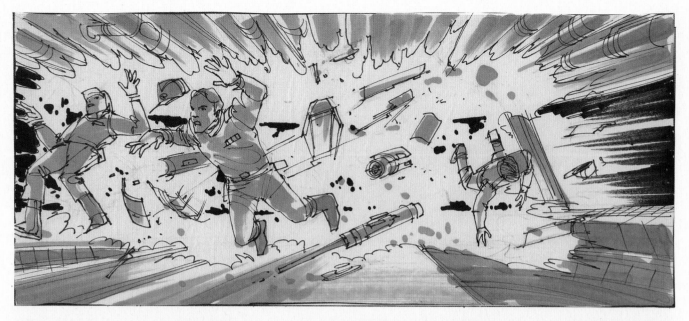

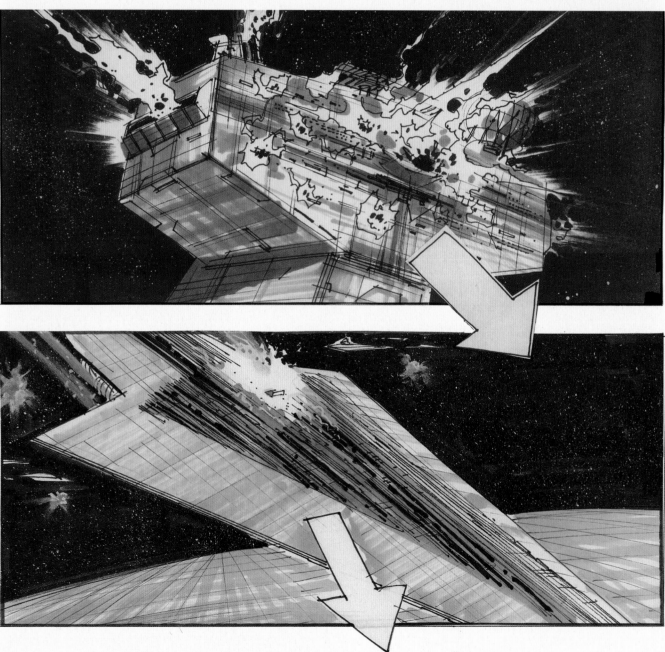

Explosions rip through the Imperial destroyer as it plummets through space . . . » Johnston, **R1**, **R3**; Rodis-Jamero, **R2**

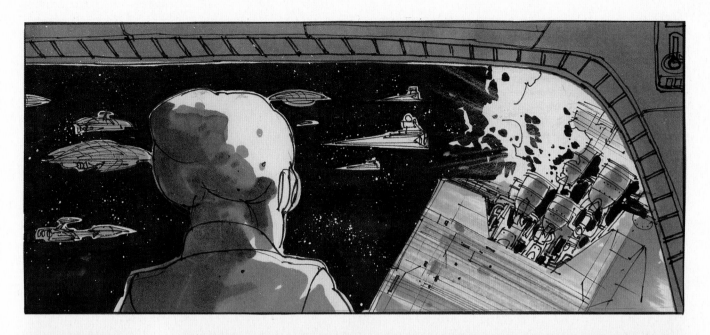

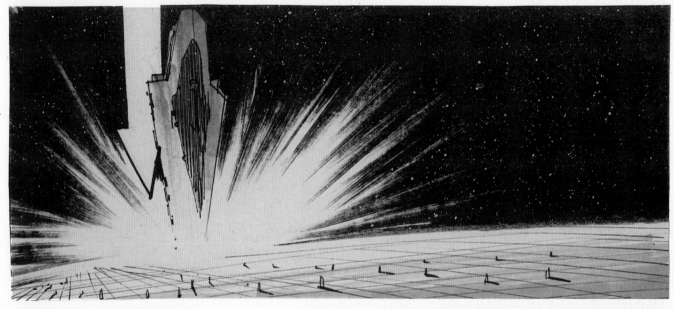

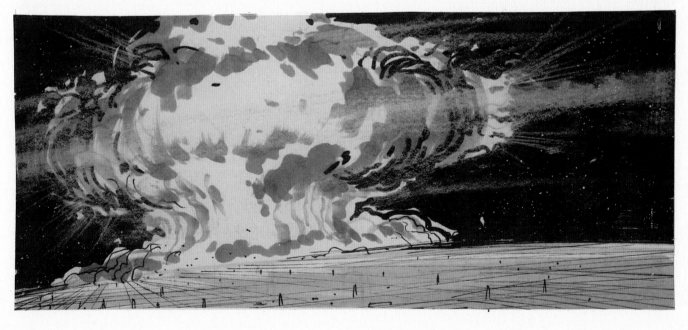

. . . exploding into the Death Star surface, as Admiral Ackbar watches. » Rodis-Jamero, **R1**; Johnston, **R2:3**

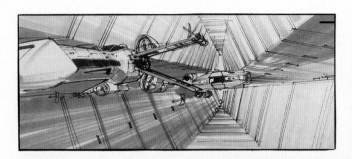
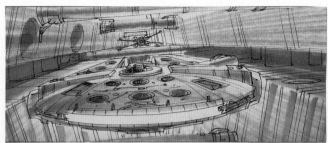
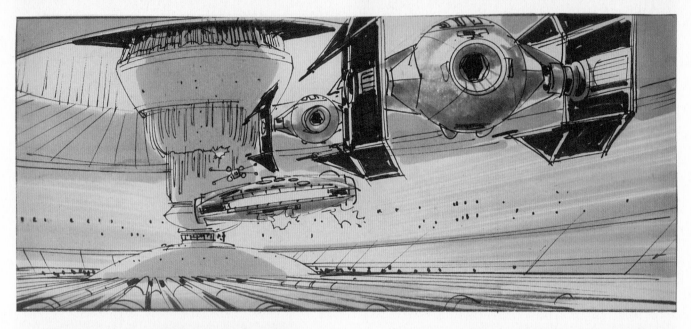
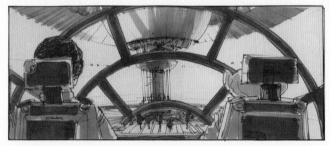
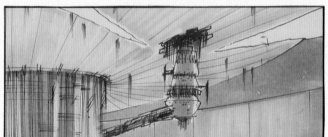
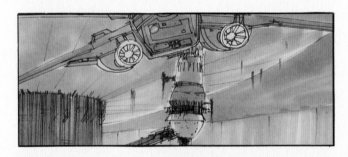
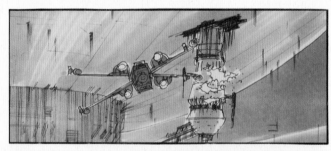
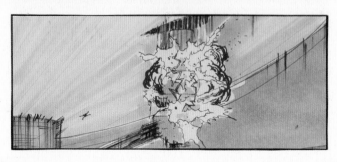
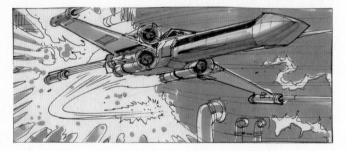

After penetrating the reactor chamber in his X-wing, Wedge fires two torpedoes at the "north tower." » Rodis-Jamero, **R1L**, **R3L**; Johnston, **R1R**, **R2**, **R3R**, **R4:5**

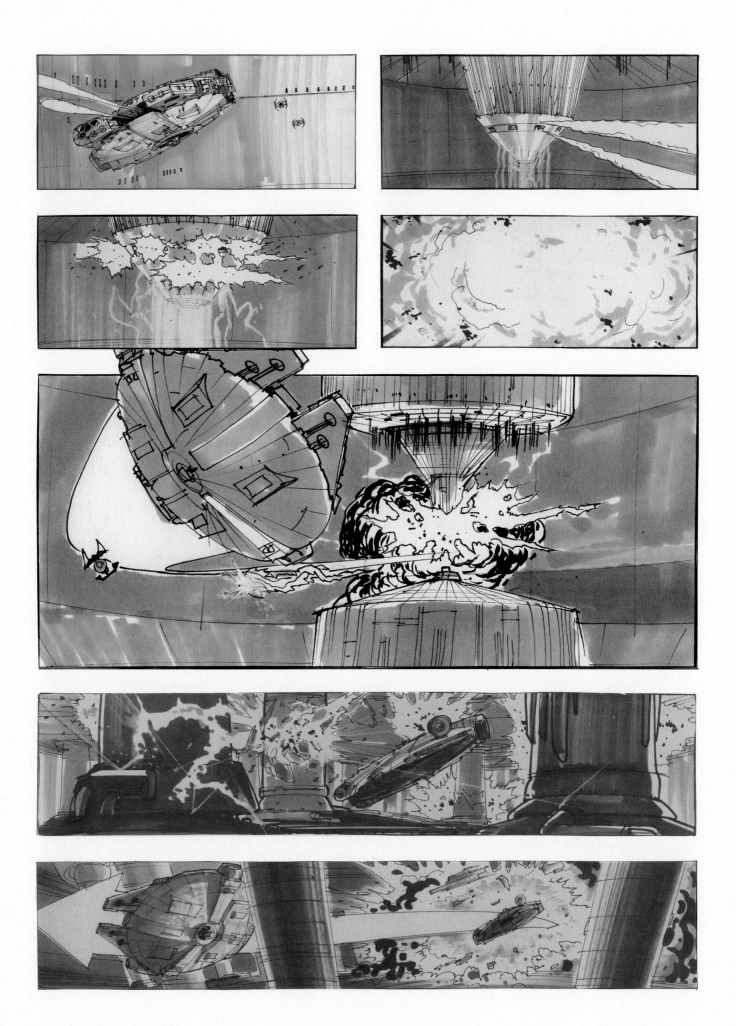

The *Falcon* shoots its lasers at the reactor core and then escapes through a maze of conduits; one of the Interceptors is zapped by a lashing electric "tongue" of the core's now erratic force field **[R3]**. » Rodis-Jamero, **R1L**; Johnston, **R1R**, **R2:5**

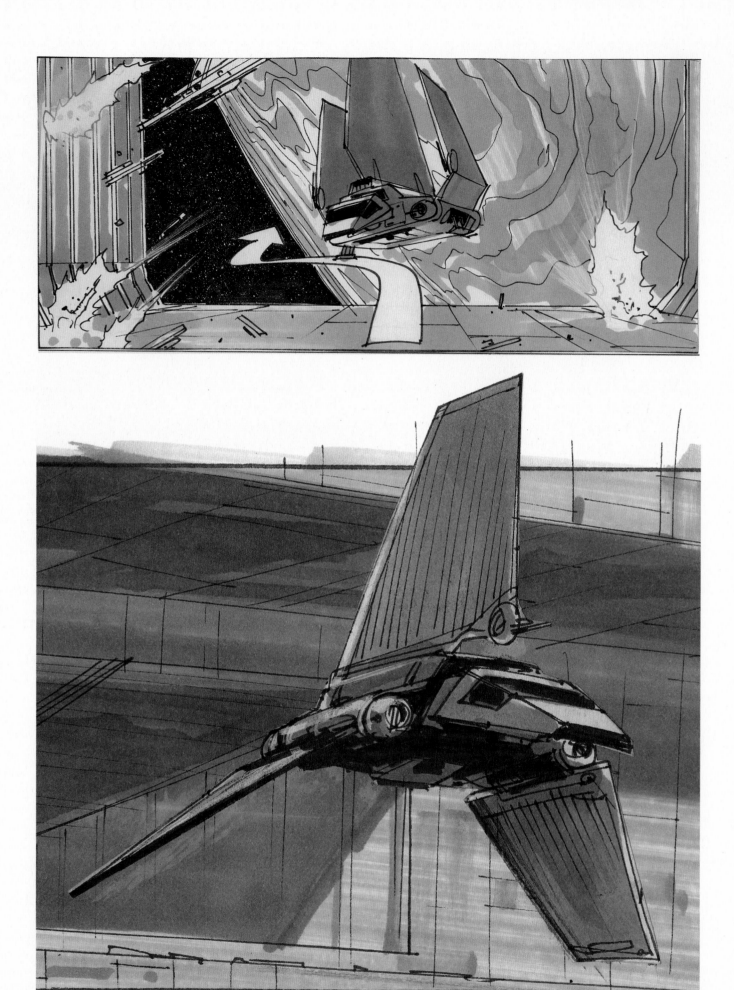

Luke pilots a shuttle out of the disintegrating Death Star. » Johnston

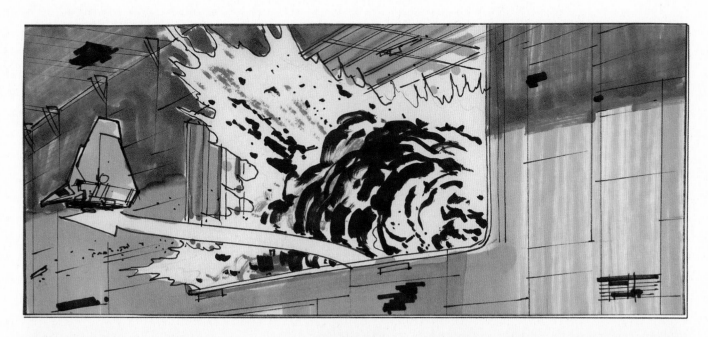

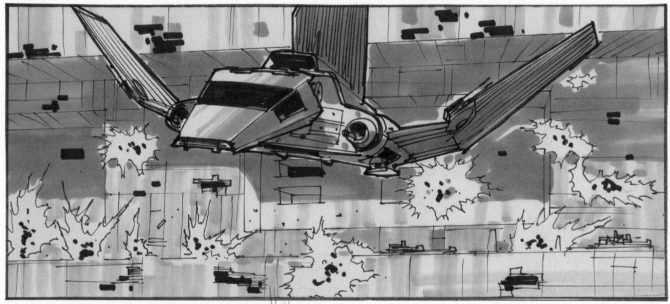

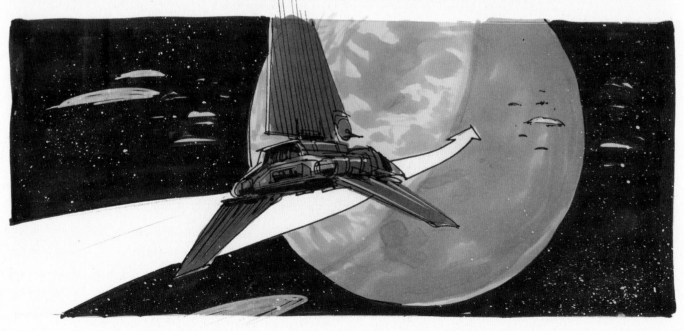

Leaving the docking bay amid increasingly violent explosions, Luke's shuttle escapes into space. » Johnston

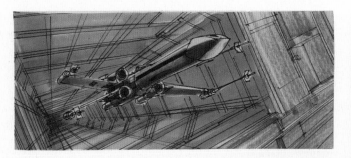
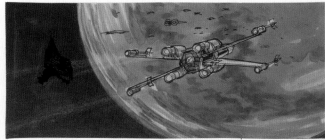

A storyboard pans with Wedge's X-wing as it exits the Death Star. » Johnston

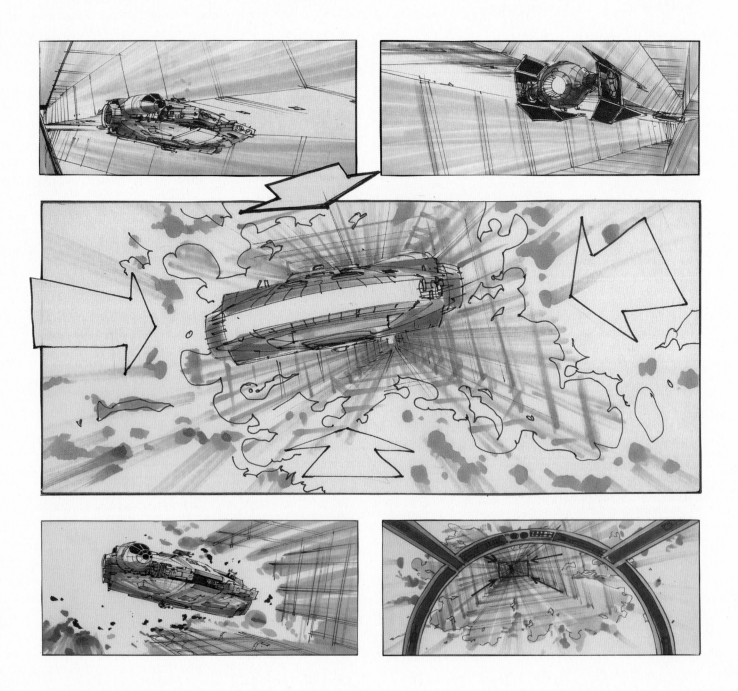

The *Falcon* is in danger of being overtaken by an exploding fireball. » Rodis-Jamero

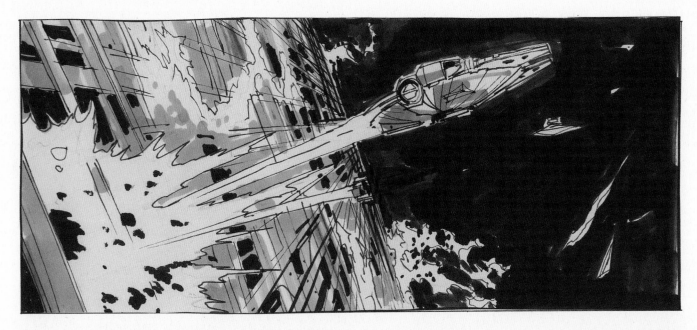

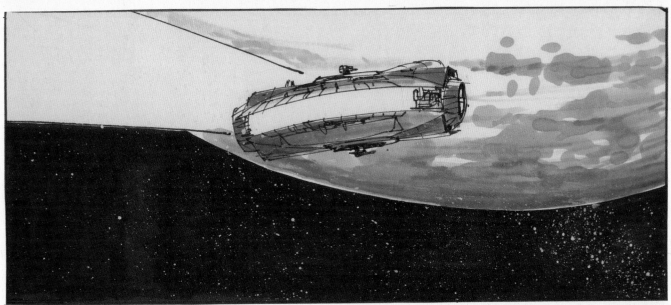

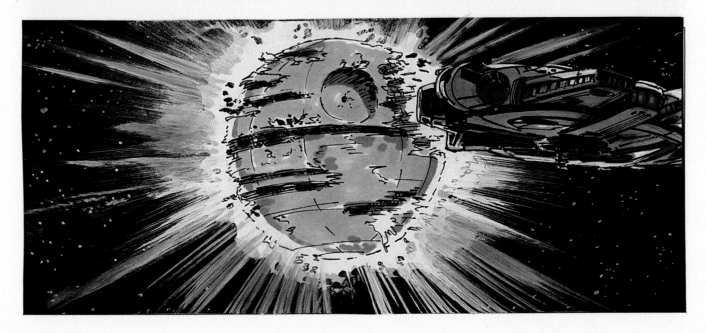

Just ahead of the conflagration, the *Falcon* exits—and the Death Star explodes. » Johnston, **R1**; Rodis-Jamero, **R2**; Russell, **R3**

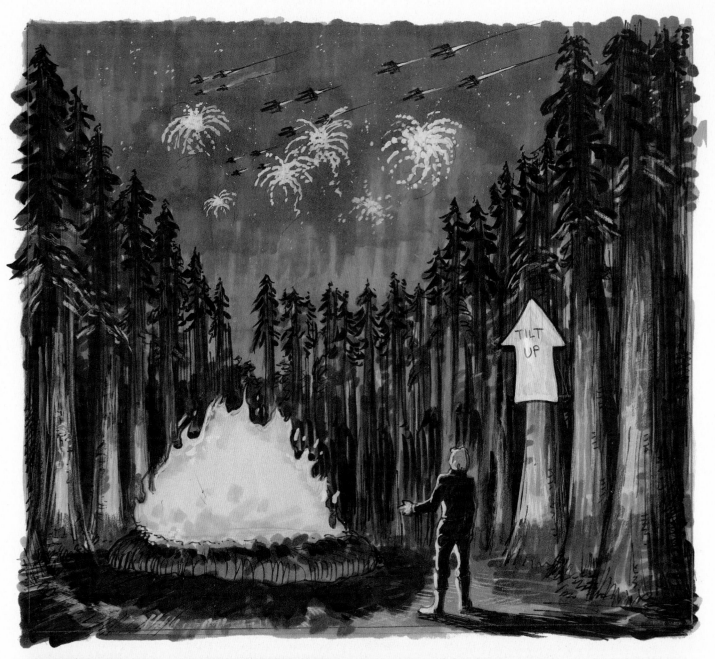

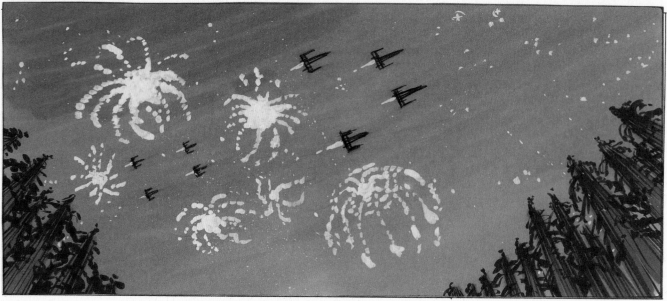

As Luke burns the body and armor of his father, Darth Vader,
X-wings streak by in formation amid celebratory fireworks. » Russell

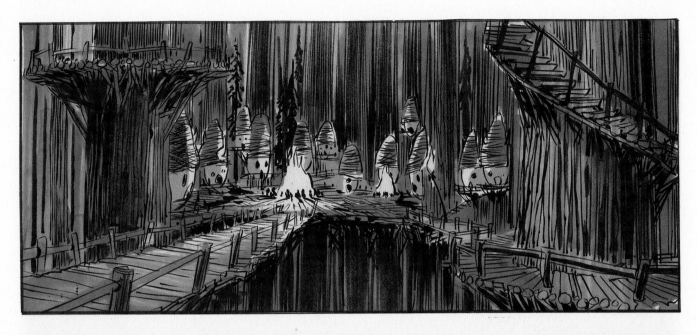

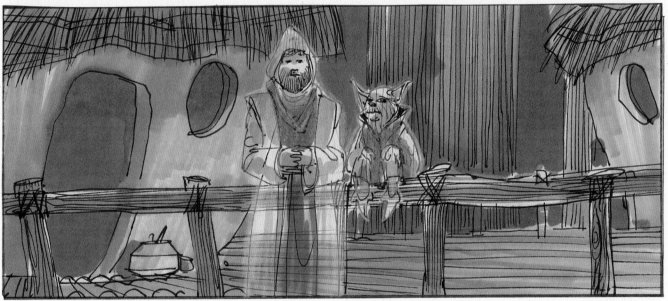

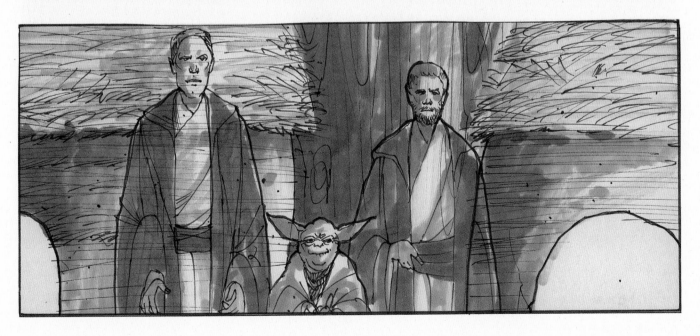

The celebration continues in the Ewok village where Luke sees the happy spirits of Yoda and Ben Kenobi (originally only these two were to appear), who are joined by a shimmering Anakin Skywalker. » Johnston, R1:2; Rodis-Jamero, R3

The storyboard notes that "12 fighters" streak through the sky as the camera tilts down to show the now peaceful Ewok valley. » Johnston

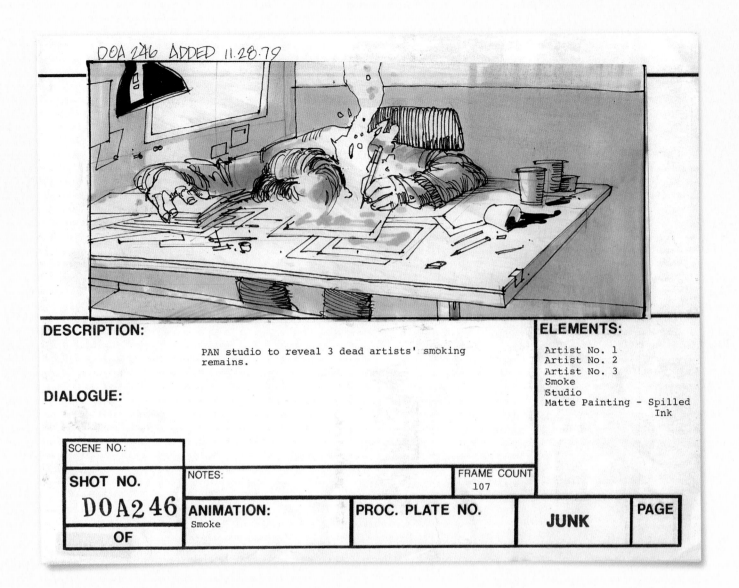

DOA 246 ADDED 11·28·79

DESCRIPTION:

PAN studio to reveal 3 dead artists' smoking
remains.

DIALOGUE:

ELEMENTS:

Artist No. 1
Artist No. 2
Artist No. 3
Smoke
Studio
Matte Painting - Spilled
Ink

SCENE NO.:

SHOT NO.

DOA246

OF

NOTES:

FRAME COUNT
107

ANIMATION:
Smoke

PROC. PLATE NO.

JUNK

PAGE

"DOA" gag. » Rodis-Jamero

ARTIST INDEX

ACKNOWLEDGMENTS

Lucasfilm would like to thank Brandon Alinger, John Bell, Paul Bremer, Dave Carson, Mollie Fitzgerald, Laela French, Paul Huston, Joe Johnston, Nilo Rodis-Jamero, Kathy Smeaton, Alex Tavoularis, Brook Temple, and Christian Short and the Prop Store for the photos of Roy Carnon's storyboards.

From the collections of John Bell: 4, 7, 8, 350, 351, 352; Paul Bremer: 30 [R1], 41 [R1], 66 [R1:2], 70 [R1]; and Joe Johnston: 43

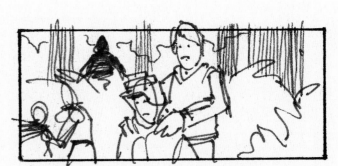

LUKE INSTANTLY PUTS THE "JEDI PARALYZER" ON HIS OPPONENT.

Early speeder-bike sequence thumbnail. » Johnston

FOR LUCASFILM LTD.

Image Archivists: *Tina Mills, Stacey Leong, Matthew Azeveda*
Skywalker Ranch Archivists: *Laela French, Katherine Smeaton, Joanee Honour*
Art Director: *Troy Alders*
Director of Publishing: *Carol Roeder*

FOR ABRAMS

Project Manager: *Eric Klopfer*
Designer: *Liam Flanagan*
Production Manager: *True Sims*

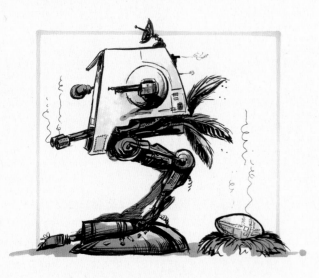

Library of Congress Control Number: 2013945693

ISBN: 978-1-4197-0774-2

Printed and bound in China
10 9 8 7

Abrams books are available at special discounts when purchased
in quantity for premiums and promotions as well as fundraising
or educational use. Special editions can also be created to specifi-
cation. For details, contact specialsales@abramsbooks.com or
the address below.

195 Broadway
New York, NY 10007
abramsbooks.com

Chicken walker gag. » Ralston